Degas in The Art Institute of Chicago

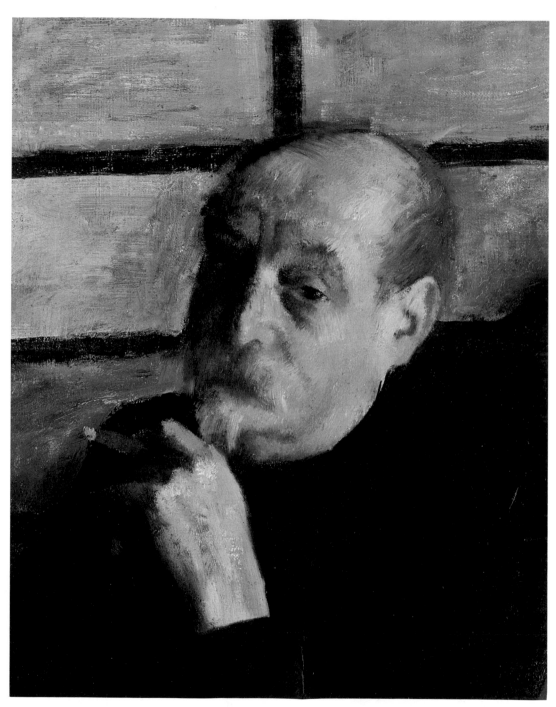

Degas. *Uncle and Niece*, 1875/78 (detail). Cat. no. 26.

Degas in The Art Institute of Chicago

Richard R. Brettell and Suzanne Folds McCullagh

The Art Institute of Chicago

and Harry N. Abrams, Inc., Publishers, New York

Degas in The Art Institute of Chicago is dedicated
to the memory and example of
Harold Joachim, Curator of Prints and Drawings, 1958-83.

The IBM Corporation has provided a generous grant to assist the funding of this book and the exhibition (July 19-September 23, 1984) it accompanies. Additional support has been received from a Special Exhibition grant from the National Endowment for the Arts, a Federal agency.

Designed by Michael Glass Design, Inc., Chicago, Illinois.
Typeset in Baskerville by Typoservice Corporation, Indianapolis, Indiana.
Printed by Eastern Press, New Haven, Connecticut.
Bound by Riverside Bindery, Rochester, New York.

Front cover: *The Star,* 1879/81. Cat. no. 41.
Back cover: *Mary Cassatt at the Louvre,* 1885. Cat. no. 53.

First published in 1984 by The Art Institute of Chicago and Harry N. Abrams, Inc., Publishers, New York.
Copyright © 1984 by The Art Institute of Chicago.
All rights reserved.

Manufactured in the United States of America. No part of this book may be used or reproduced in any way without written permission of the Publications Department of The Art Institute of Chicago.

Library of Congress Catalogue Card Number: 84-6409

Library of Congress Cataloging in Publication Data
Brettell, Richard R.
 Degas in The Art Institute of Chicago.
 Bibliography: p.
 Includes index.
 1. Degas, Edgar, 1834-1917—Exhibitions. 2. Art Institute of Chicago—Exhibitions. I. Degas, Edgar, 1834-1917. II. McCullagh, Suzanne Folds. III. Art Institute of Chicago. IV. Title.
N6853.D33A4 1984 709'.2'4 84-6409
ISBN 0-8109-0804-2 (hard: H. N. Abrams)
ISBN 0-86559-058-3 (pbk.)

Contents

Preface and Acknowledgments

JAMES N. WOOD
Director

Degas in The Art Institute of Chicago is a celebration not only of the 150th birthday of one of the 19th century's great artists but also of the extraordinary strength of this museum's holdings of his works. It is not always easy, in this age of major loan exhibitions, for museums to find the time or the support necessary to produce studies of aspects of their permanent collections. It is a unique donor who understands the potential and meaning of an undertaking such as *Degas in The Art Institute of Chicago*. We are extremely fortunate to have one: the farsighted generosity of the IBM Corporation made possible the several years of study that this ambitious project required, as well as the book and exhibition that resulted. We also wish to acknowledge the National Endowment for the Arts for the substantial grant awarded this project.

A project of this size and scope involved the dedication and assistance of many. I am deeply grateful to the organizers of the exhibition and authors of the book, Richard R. Brettell, Searle Curator of European Painting and Sculpture, and Suzanne Folds McCullagh, Assistant Curator of Prints and Drawings. Together, they have brought a new viewpoint to the many and fine works by Degas in their care. The result of their effort, one that involved several years of intensive study and preparation, is, we hope, a major contribution not only to the literature on the Art Institute's collection but to our appreciation of the achievement of the master himself.

The first period of intensive study was occasioned during a seminar for art-history students of Northwestern University. Focusing on the works in the Art Institute's collection by Degas, the class—held at the Institute—was taught jointly by Assistant Professor Susan Siegfried and Mr. Brettell and Mrs. McCullagh. We wish to thank Professor Siegfried and all the students in that course who instigated much provocative thinking about the collection. One of these students, Todd B. Porterfield, became the project's Research Assistant. For his unflagging devotion, wonderful organizational abilities, and his entries on the sculptures in this book, we are very grateful.

Degas scholar Professor Theodore Reff of Columbia University graciously agreed to read the manuscript and made many helpful suggestions. George Shackelford of Yale University and the National Gallery of Art and Janet Anderson of the University of Texas at Austin reviewed the ballet subjects, and Barbara S. Shapiro and Sue W. Reed of the Museum of Fine Arts, Boston, were very helpful with the prints. We are also grateful to Hollis Clayson of Northwestern University for her insights about the iconography of the brothel images and to Juliette Wilson Bareau for her advice on archival matters. Among the many dealers and collectors who have helped us, we would particularly like to thank Philippe Brame, Daniel Wildenstein, Charles Durand-Ruel, R. Stanley Johnson, and Robert Schmit.

Many members of the Art Institute staff—too numerous to name here—were instrumental in the successful realization of this project. The authors are indebted to their colleagues in the Department of European Painting and Sculpture and the Department of Prints and Drawings for their hard work and cooperation. In European Paintings and Sculpture, we would especially like to thank Katherine Haskins, Assistant to the Curator, who assembled the bibliography and did much additional research. Also to be thanked are Terry Brown, Mary Kuzniar, and Anna Leider, all of whom helped in innumerable ways. In Prints and Drawings, where much of the research actually took place, our gratitude goes to Esther Sparks, Anselmo Carini, Gloria Teplitz, and Martha Tedeschi, as well as two of our interns, Mary A. Young and Laura Hunt.

Timothy Lennon, Conservator, and David Chandler, Paper Conservator, were enormously helpful in our investigation of the physical properties of the works. To them and to the members of their staffs—Faye Wrubel, Inge Fiedler, Steve Starling, Catharine Maynor, Clyde Paton, and Chris Conniff—we extend our deepest thanks. We are also very grateful to Marion Gifford and Sue Ross of the Development Department; and Howard Kraywinkel, John Mahtesian, and Jerry Kobylecky of Museum Photography. Several visiting conservators offered valuable insights: Corrine Nathan (Zurich), Antoinette Owen (Hirshhorn Museum, Washington, DC), Shelly Fletcher (National Gallery, Washington, DC), and Margaret Ellis (The Metropolitan Museum of Art, New York).

In connection with the book, we are especially grateful to Terry Ann R. Neff and Susan F. Rossen, Editor and Coordinator of Publications, for their patient and able editing of the manuscript. Ms. Rossen also oversaw the design and production of the book. Others to be thanked from this department are Elizabeth Pratt and Cris Ligenza. We wish to acknowledge Michael Glass for his elegant design.

The guiding spirit behind *Degas in The Art Institute of Chicago* was Harold Joachim, Curator of Prints and Drawings at the museum from 1958 until his death late in 1983. During his tenure, 28 works by Degas entered the collection. His unerring sense of quality and his appreciation of the information that can best be discovered from intimate scrutiny of the actual work of art are standards that inspired us and that we tried to uphold throughout this undertaking. It is therefore especially fitting that *Degas in The Art Institute of Chicago* be lovingly and gratefully dedicated to his memory.

Introduction

RICHARD R. BRETTELL
Searle Curator, Department of European Painting
and Sculpture

SUZANNE FOLDS McCULLAGH
Assistant Curator, Department of Prints and Drawings

Museums, like universities, are divided into departments, each of which controls its own territory, studies its own objects, keeps its own files, and, in many cases, makes its own acquisitions. These departments are most often defined by artistic medium or by cultural/geographical divisions or both. That there are many advantages to such departments is attested by their almost universal presence in the museum world. Yet, their very existence makes certain kinds of inquiry difficult and encourages students of art both inside and outside the museum to study subjects that fit neatly into the departmental categories.

Thus, the enormous literature on French art between 1850 and 1930 concerns painters, printmakers, or draftsmen studied separately; it is rare that an integrated analysis of all the pictorial arts is attempted. For certain artists—Claude Monet, for example—such treatment is logical because he was pre-eminently a painter whose contributions to the graphic arts were minimal and to sculpture nonexistent. However, for most others, the rigorous separation of their careers into categories by medium has produced results that are both unfair to the artist and constraining to the student of his art.

Edgar Degas, whose career this publication celebrates on the occasion of his 150th birthday, is an exemplary case. Although he began his artistic life as a painter for whom drawing and printmaking were clearly subsidiary to the "final" oil painting, this situation soon changed, and Degas, like many artists of the French avant-garde, experimented with virtually every medium known during his lifetime, eventually relegating oil painting to a lesser role within his total oeuvre.

The Art Institute of Chicago's large collection of works by Degas is divided among three departments: Prints and Drawings, European Painting and Sculpture, and 20th-Century Art. The museum has published Degas's drawings in a volume devoted to 19th-century French drawings (Chicago 1979) and several of the oil paintings in a general catalogue (Chicago 1961). The museum has never published the prints or the bronzes, and never have the works by Degas owned by the museum been brought together for analysis and publication.

In order to correct that deficiency, the museum decided to overlook departmental structure and reintegrate the works by this artist in a single exhibition and publication. Degas was an obvious choice to inaugurate what we hope to be a series of exhibitions of artists whose work is represented in depth in the collections. Of the great 19th-century artists whose works constitute the central glory of the permanent collection of the Art Institute, Degas was the most fervent in his interest in the aesthetic and material properties of the various artistic media. He made etchings, drypoints, temperas, oils on can-

vas, oils on panel, pastels, gouaches, waxes, lithographs, photographs, graphite and wash drawings, chalk and charcoal drawings, and many hybrid objects whose material structures are various permutations and combinations of these separate media. For him, the stuff of art, the matter that made it actual, was as important as the subjects depicted.

For the very reason that Degas was a devoted materialist, this book has been structured around an analysis of the physical properties of the objects in the Art Institute collection. We have been able to write our text in the presence of each work of art, without the convenience and comforting abstractness of photographic reproductions. Many objects were examined with various nondestructive techniques (infrared reflectography, X-ray, microscopy, and reflected light); yet, in some cases, they stubbornly resisted analysis because of their very complexity. Although definitive knowledge of Degas's materials and working methods will be a long time in coming, our research taught us a great deal. We have been able to correct many small mistakes in the Degas literature (and undoubtedly have perpetrated others), to reinterpret several important works of art, to change many dates, to identify or reidentify a few sitters, and to remeasure and redescribe all the works by Degas in the museum.

Our most important task was to interpret the works of art in close, practical terms, trying not to stray too far from them for material to support our readings. Although the considerable Degas literature was certainly not neglected, our aims were not to compile previous insights and information, but to look—and look again—at the objects themselves. To sharpen our analysis, we have appealed to literature contemporary with Degas and to works by other artists, but these comparisons are clearly secondary to our task of "reading" each work of art.

In this unabashedly elementary aim, our most obvious American precursors are the proponents of the so-called New Criticism in the study of literature. These writers, most of whom have studied American and modern European poetry, have sought to wrest the study of literature from the literary historians and have endeavored to read a text as a text rather than ceaselessly to write the history of this or that genre, this or that writer, and this or that school. In similar fashion, we have chosen to "read" works of art as clearly and directly as we can. When we have problems, they are admitted. When the work of art evades us, we bring its evasions to light. For that reason, this book is in fact a series of entries—some long, others short, some resolved, others frankly perplexed. We have not tried to pull it all together and thereby create an artificial unity.

Degas emerged from our readings as an artist whose methods matched ours. More than any other great artist of the last half of the 19th century, he was a materialist, always excavating the tactile realms of experience; for that reason, his oeuvre is rendered particularly impotent in photographic reproduction. We have already mentioned his interest in the varieties of artistic media and his frank, unceasing experiments to alter and recombine them in new ways. Yet, we have been less insistent on another equally important and related point—that Degas conceived of the world in terms of touch. His images are as tactile as they are visual, and this quality gives them their unique place in the history of modern art.

Modern art, as it has been codified and criticized by five generations of writers, is, in reality, modern *painting* straining self-consciously toward acceptance as a flat surface on which color is placed. This view has held almost canonical power over the historiography and criticism of modern art since the reviews of the government-sponsored Salons written by Emile Zola in the late 1860s. In accepting the physical condition of the painting as a kind of aesthetic mission, the modern painter has been unable to "represent" the physical properties of the world around him precisely because his aim is "presentational"—the making manifest of the conditions of painting. In this critical and aesthetic conundrum, the art of Degas played no part. Although, like many of his contemporaries, he grasped clearly that the new art needed a new materiality, he was never able to create an aesthetic of flatness or to conceive of the world in sheerly visual terms. Quite simply, he was a sensual materialist striving always to represent the tactility of the world.

Evidence for this view of Degas can be found throughout this publication. As he fingered the paint around the nose and eye sockets of the milliner in *The Millinery Shop* (cat. no. 63) or sponged the thighs of the soft nude in *Retiring* (cat. no. 66), as he pushed and jabbed with his hands and his tools to make his wax horses and nudes and then altered them repeatedly, as if to give them renewed life through his manipulations—as he performed these and countless other actions, he forced us over and over to touch in our minds the flesh, the heads, the shiny flanks of horses, the stray strands of hair, the clasped hands, the scattered books, the floating hats, the piles of disheveled clothes, the bodies at rest and in motion that fill his images. In virtually every work of art by Degas, our own sense of touch is heightened, and in most, the figures themselves preen, bathe, and touch themselves or others. Pictorial space was of little interest to Degas. Rather, it was matter in all its wealth and physicality that obsessed him, and this is why his greatest works of art have such an astounding immediacy.

Although we, too, have made stabs in that direction, it is our feeling that Degas, like many artists, was moved to create by forces within him that are, in the end, too tenuous to grasp. To say that a particular pastel can be "explained" because it relates to a text by Zola or that another is "about" a particularly identifiable dance master is falsifying. A work of art by so great an artist holds more than such obvious meanings, even if their particular sources are obscure. That Degas's urge to make works of art was connected at a very important level with his own problematic—and elusive—sexuality is apparent, and there is room for considerably more discussion of the psychological aspects of his work.

Degas's art appeals strongly to our imaginations not because it is highly intellectual or because it succeeds in recreating the glittering ambiance of his Paris. Rather, it is the power and the clarity of his forms that cut through to the core of our somewhat overstimulated 20th-century sensibilities. By focusing all his attention on a small range of subjects, most of which seem to function as metaphors for art itself, he established a center from which his restless pursuits could venture. In a work by Degas, there is little that is wasted or extraneous. Thus, an incredible variety of form could be achieved without the loss of the clarity he so evidently wanted.

It is in many ways difficult to believe that Degas lived so far into our century. He was a disapproving witness to the advent of Fauvism and Cubism, movements that had produced all their seminal masterpieces before his death. His eyesight, a source of continual problems for him throughout most of his working life, failed all but completely sometime after the turn of the century, and his last years were spent in a pathetic isolation exacerbated by blindness. One can understand, in that state, his irascible temper and bouts of depression. His last masterpieces, the bathers and the dancers whose bodies fill almost the entire extent of whatever surface he used, leave little doubt that—along with Paul Cézanne—Degas was the greatest artist of his generation.

It has long been known that Edgar Degas was an intellectual artist. He read widely and maintained a small, supportive, and deeply cultivated group of friends, many of whom had little direct involvement with the fragile artistic community around the Impressionists. We know that he, like many Realist artists and writers, loved various kinds of urban entertainments—from the "high" arts of classical ballet and the opera to the "popular" arts of the café singer and the circus performer—and that his art therefore has a direct relationship to Parisian culture and society. These intellectual and cultural sides of Degas have appealed most to historians of his oeuvre, and the best recent scholarship has decoded the meanings of his images with great care.

Degas in The Art Institute of Chicago

I. The Formation of the Collection

RICHARD R. BRETTELL

When Edgar Degas was born on June 19, 1834, on rue de la Victoire in Paris, Chicago was a desolate trading town in a region where American Indians outnumbered the newer inhabitants. When he died 82 years later, also in Paris, Chicago was among the great mercantile centers of the world, and several of its most prominent citizens owned works of art by the French master. Degas never visited Chicago—indeed, he would have disliked it intensely— yet, its greatest collectors were unabashed Francophiles and so passionately committed to modern art that they were more capable of understanding his work than he was of understanding their city. Today, The Art Institute of Chicago houses one of the finest collections in the world of modern French paintings, drawings, and prints, and its holdings of works in all media by Degas is both large and comprehensive.

Unlike the Art Institute's great collection of Claude Monet paintings that results almost exclusively from the taste and determination of one person, Mrs. Potter Palmer (Bertha Honoré), the museum's holdings of works by Degas come both from many collectors of diverse tastes and from generations of acquisitive curators, particularly in the Department of Prints and Drawings. There is no hero, no single dominating sensibility behind the 91 works by Degas in the Art Institute, and, for that reason alone, the history of the collection is both lengthy and complex.

Degas was nearly 60 years old in 1893 when Chicago drew the attention of the world with its self-consciously civilized, brilliant, and, to some, rather vulgar World's Columbian Exposition. Degas would not have liked the fair. Its glazed halls of machines, banal symbolic fountains, and celebrations of the bounty of nature, women, and the vast theater of the world's goods and culture—all this would have fatigued him. At age 60, he was alone, at times nearly blind, and most often cranky. His social world consisted of a few close friends whom he saw habitually, and he shunned visitors. Even Paris, the glittering capital whose cafés, ballets, race tracks, and brothels had seduced him in his middle years, held little allure. He spent most of his time at home, working when his eyesight permitted it and devoting the remainder of his prodigious intellectual energy to the assembling of a great private art collection.

Yet, as Degas retreated from the world, the process of slow, relentless, and, one might even say, inevitable discovery of his art, commenced. In 1893, two of Degas's paintings were included in one important part of the vast Fine Arts section in Chicago's World's Columbian Exposition. Entitled rather laconically, "Loan Collection; Foreign Masterpieces Owned in the United States," this part contained 124 paintings—mostly 19th-century, mostly French, and mostly representative of

what today we call the avant-garde tradition. Designed to contrast with the "official" French exhibition—dominated by the great academic painter Jean Léon Gérôme and conceived to demonstrate the continued vitality of the Académie des Beaux-Arts—the American loan exhibition contained works by Degas, Manet, Monet, Pissarro, Renoir, and Sisley, none of whom were included in the official exhibition. All in all, the exhibit was wonderfully received, with at least one guide documented as rhapsodizing over this new "Impressionism" (Chicago 1893: 17). Clearly, the taste for Impressionism was as much, if not more, American than French, and the appeal of works by Degas must be seen as part of the larger American market for works of this movement.

Of the two greatest collectors of Impressionism in America, one, Mrs. Potter Palmer, was firmly established in the "Windy City" as queen of the arts and of society. The extraordinary picture gallery in her house on Lake Shore Drive revealed the extent of Mrs. Palmer's passion for pictures. The walls were covered with paintings, many of spectacular quality and most painted by French artists of her own and the previous generation. Although it is easy to recognize works by Corot, Daubigny, Delacroix, Monet, Pissarro, and Troyon in the many surviving photographs of her gallery, there is not a single work by Degas in evidence. We know from Mrs. Palmer's account books that she bought and sold paintings with the confidence and rapidity of an experienced consumer/collector, and those account books tell us that she owned six works by Degas, most of which were acquired in the first half of the 1890s, when her collection of Impressionism was largely formed. Yet, when one compares that group of works by Degas with those collected by Mrs. Horace O. Havemeyer (Louisine Elder) in New York or by the Cassatt family in Philadelphia, or even with the 90-some paintings by Monet that Mrs. Palmer owned, it becomes clear that Degas was not among Mrs. Palmer's favorite Impressionists. Perhaps his very crabbiness and inaccessibility annoyed the bilingual Chicagoan, who liked to feel at home with the artists she supported. Or perhaps—and more likely—her real love for landscape painting was not satisfied by Degas's cerebral, figural style. It is also important to note that Mrs. Palmer was a collector of oil paintings, and that by the time her collection began to take shape, Degas had virtually ceased to paint in oil and had become the greatest pastelist of his age. Whatever her reasons, Mrs. Palmer preferred Monet, Renoir, and others to Degas. Her only major Chicago competitor in art collecting, Martin A. Ryerson, owned many paintings by Monet in addition to superb Old Master pictures, but he had only three pastels (cat. nos. 39, 71, 89) and one slight drawing (cat. no. 25) by Degas. Clearly, Degas's art was not at the center of

advanced taste in late 19th-century Chicago.

In 1893, when the doors of its present building opened, The Art Institute of Chicago had a small collection of 19th-century French paintings, mostly given by Henry Field. This included a good selection of Barbizon paintings and works by later academic followers of these artists, like Jules Breton and Léon Lhermitte. Impressionist pictures, for which Chicago private collections were becoming internationally famous, were nowhere in evidence in this museum, stuffed as it was with recently acquired Old Master pictures, academic paintings, and plaster casts of famous sculptures. This situation did not change until the early years of the 20th century, at which time Mrs. Palmer began to loan to the museum important pictures from her collection and the people of Chicago could view a carefully culled selection of major paintings by Corot, Delacroix, Manet, Monet, Renoir, and Pissarro, as well as by Degas. It was through Mrs. Palmer's works by Degas that the artist was introduced to Chicago.

In 1922, nearly six years after her death, Mrs. Palmer's bequest of modern French paintings was received by the Art Institute. Chosen by her heirs and the director of the museum from her vast personal collection, this gift included only two pastels by Degas: *On the Stage* (cat. no. 29) and *The Morning Bath* (cat. no. 76). These pastels were announced in the *Bulletin* of the Art Institute (Chicago 1922: 47) and hung with other works from Mrs. Palmer's collection in two skylit galleries on the second floor of the museum's massive classical building. Both pastels are of splendid quality, and they inaugurated a series of gifts and acquisitions of ballet dancers and bathers—the two Degas subjects preferred in Chicago.

Mrs. Palmer's two Degas were not his first works to enter the Art Institute. Earlier that year, in January, a collector of drawings, Robert Allerton, gave four examples on paper by Degas to the newly established Department of Prints and Drawings; and in the prior year, 1921, the Art Institute acquired its first Degas print, *At the Louvre: Mary Cassatt in the Etruscan Gallery* (cat. no. 51). Although the print came to the Art Institute unheralded, the Allerton gift was announced in the January 1922 issue of the *Bulletin* and one of the drawings, *Jockey* (cat. no. 18) was reproduced (Chicago 1922: 11-12).

The pattern of Degas collecting that has been practiced by the museum to the present day was established in those initial acquisitions. First, Degas was represented in several media, with emphasis being given to his pre-eminence as a draftsman and printmaker. Second, the Department of Prints and Drawings played a very active role in the acquisition of works on paper by the artist. Third, a range of subjects was acquired: The early group included a drawing (cat. no. 16) for

the early Salon painting *Mlle. Fiocre in the Ballet of "La Source,"* two early studies for horse-race compositions (cat. nos. 18, 21), a pastel over monotype of the dance (cat. no. 29), a print of a modern-life subject (cat. no. 51), a bather (cat. no. 76), and a late drawing of a single dancer (cat. no. 84). Still lacking were oil paintings, sculptures, and portraits. These were to come to the museum very soon—a sculpture in 1925 (cat. no. 74) and a portrait and a major oil painting in 1933 (cat. nos. 26, 63).

If 1922 was a banner year for Degas at the Art Institute, 1933 even exceeded it. It began with the bequest from Mr. and Mrs. Lewis Larned Coburn of what are now the museum's two greatest paintings by the artist, *Uncle and Niece* (cat. no. 26) and *The Millinery Shop* (cat. no. 63), as well as its first truly important Degas drawing, *Four Studies of a Jockey* (cat. no. 17). The double portrait had already been celebrated in a short article by Daniel Catton Rich in the *Bulletin* of 1929, just after it was acquired by the Coburns from Georges Wildenstein (Rich 1929: 126-7). Although inaccurate in his dating of the work and identification of the sitters, the author brilliantly analyzed the painting as a portrait and recognized clearly the central role Degas was to play in the history of modern art. Written before any of the major books on Degas or Impressionism were published, this short article demonstrates that the Art Institute was well aware of the great works of modern art Chicagoans were acquiring.

As part of the 1933 World's Fair, the Century of Progress, held in Chicago, the Art Institute literally emptied its sky-lit paintings galleries and, drawing upon its own holdings, private collections in the city, and important loans from throughout the United States, created an exhibition designed to show the entire history of European and American art. For its time, the catalogue (Chicago 1933) was immense; the loans were distinguished and numerous; and works by Degas played an extraordinarily large part in what was Chicago's first comprehensive survey of Western painting. Gallery 42, one of the largest and most beautiful in the museum, was devoted exclusively to paintings by Degas and Monet. This gallery was part of a series of Impressionist rooms unrivaled in 1933 by any museum in the world. Chicago's version of the history of art was a history of Western painting that gathered momentum and significance as it approached Impressionism, for nearly one-quarter of the exhibition space was devoted to this one movement.

Of the twelve major examples by Degas in that exhibition, only four were from the museum's permanent collection—the two pastels from the Palmer bequest and the two Coburn oils. Two of the three other Degas from Chicago collections are now in the museum (cat. nos. 22, 47). The Art Institute staff went to Boston and New York for the remaining five works by Degas. Surprisingly, they disregarded the greatest collection in the United States, the Havemeyer Degas at the Metropolitan, borrowing instead *La Source* (L. 146) from the Brooklyn Museum; horse-race pictures from the Fogg Art Museum in Cambridge, MA (L. 76), the Boston Museum of Fine Arts (L. 281), and the newly formed Museum of Modern Art in New York (L. 767); and *The Laundresses* from the Paul J. Sachs Collection (L. 410).

This group of oil paintings and pastels was supplemented by two important Degas prints from the museum's permanent collection, which were included in a special exhibition of prints, also part of the Art Institute's contribution to the Century of Progress. The superb early etching *Self-Portrait* (cat. no. 5) and the important late lithograph *After the Bath* (cat. no. 82) had just been acquired—in 1932—along with three other prints (cat. nos. 11, 32, 85). This group added considerable range and distinction to the museum's small but burgeoning collection of prints by the 19th-century master. Another impression, *Mlle. Bécat at the Ambassadeurs* (cat. no. 32), was featured on the cover of the *Bulletin* in March 1933 as the lead to the first serious article about modern prints published by the museum (Chicago 1933a: 49-51). Thus, in 1932-33, the museum established the basis of its collection of Degas prints, now one of the largest and finest in the world.

In 1933, the museum owned 21 works by Degas. Smaller than that at the Metropolitan Museum after the 1929 Havemeyer gift, the collection still was choice and comprehensive in range. Although centered around the great Coburn oils and the superb Palmer pastels, the numerical strength of the collection lay in works on paper. Not surprisingly, the subsequent history of the Degas holdings has been presided over by the curators of the Department of Prints and Drawings. Half of the total number of works by Degas in the Art Institute are purchases as opposed to gifts. Of these, only one, *Young Spartans* (cat. no. 9), was not acquired through the Department of Prints and Drawings, a department whose determined quest for a Degas collection is one of the triumphs of the museum's history. With the support of knowledgeable trustees and members of the Committee on Prints and Drawings, the museum's two greatest curators of prints and drawings were able to buy major works on paper by Degas. Guided first by the expertise of Carl O. Schniewind, who was appointed the first professional curator of prints and drawings in 1940, and subsequently by Harold Joachim, curator from 1958 until 1983, the Department of Prints and Drawings has added to the collection with unwavering taste and dedication.

II. The Nature of the Collection

SUZANNE FOLDS McCULLAGH

Extensive collections of the works of Degas exist throughout the world, both because he was such a prolific artist and because his art is so appealing. In addition to that of The Art Institute of Chicago, the most significant include the Musée du Louvre, Paris; The Metropolitan Museum of Art, New York; the Museum of Fine Arts, Boston; the Glasgow Museum and Art Gallery; the National Gallery of Art, Washington, D.C.; and the recently formed and still expanding collections of the Norton Simon Inc. Foundation and the Norton Simon Foundation in Pasadena, CA.

First, it must be acknowledged that in both quantity and quality of representation of the various facets of the artist's career, the group of works by Degas in The Art Institute of Chicago ranks third in the world, behind those of the Louvre and the Metropolitan. Sheer numbers reflect the difference: The Louvre boasts about 300 examples (190 drawings, 34 paintings, and 76 sculptures [see Paris 1969]); the Metropolitan Museum possesses approximately 174 (19 paintings, 2 fans, 53 drawings and pastels, 26 prints, 5 monotypes, and 69 sculptures [see New York 1977]). Next in size are the two Norton Simon collections, with nearly 100 works (8 paintings, 18 drawings and pastels, 2 monotypes, 3 prints, and 71 sculptures)—including one-half interest in the most expensive Degas ever sold, the pastel *Waiting* (L. 698) formerly owned by the Havemeyer family. However, because Simon's collection is composed largely of the bronzes, it is rather lopsided and does not provide a true survey of Degas's activity as an artist. The Art Institute's collection, on the other hand, is a relatively balanced representation of the artist's major media: 7 oils, 37 drawings and pastels, 31 prints, 6 monotypes, and 7 sculptures. Despite its smaller size, the scope of the collection in Chicago is on a par with those of the two much larger institutions in Paris and New York.

The Louvre's Degas collection began while the artist was alive, with Gustave Caillebotte's bequest in 1894 of seven major pastels; these included some of Degas's most "modern" compositions. The second important addition to the collection during Degas's lifetime was the bequest of Isaac de Camondo in 1911, which brought in nineteen major works. Degas did not leave his estate to the Louvre; it is said that instead he contemplated establishing his own museum but was discouraged from pursuing this idea by the funereal atmosphere of the Musée Gustave Moreau, which opened in Paris in 1903 (Paris 1969: 360). In any case, the Louvre was in a good position to buy from the sales that followed the death of the artist, as well as from his heirs. Other gifts and bequests received by the Louvre from the early 1920s through the 1950s created what is clearly the most significant repository and complete survey of the works of Degas. However, one

critical aspect of the artist's achievement not fully represented at the Louvre is his printmaking. One must combine the vast holdings of that institution with the rich print and drawing collections of the Bibliothèque Nationale to appreciate the strength of these two Parisian museums in the art of their native son.

If the Louvre and Bibliothèque Nationale had a natural advantage in the development of their Degas collections, the Metropolitan Museum had the good fortune to receive as a bequest in 1929 the large and important group gathered by Mrs. Horace O. Havemeyer. A childhood friend of Mary Cassatt, Mrs. Havemeyer followed Cassatt's advice and assembled the single most comprehensive private collection of the works of Degas, rivaled only in number, but not in range, by Norton Simon's collection. Mrs. Havemeyer's contribution to the Metropolitan's total Degas holdings is substantial: 14 out of 19 paintings, both fans, 20 out of 53 drawings and pastels, 5 rare prints, and a complete set of his sculpture came as a result of her generosity, and many of these works are the most famous Degas in the museum. While Mrs. Havemeyer can be credited with forming a collection rivaling that of the Louvre in its range and importance and inspiring further acquisitions by the Metropolitan, the museum had begun to gather works by Degas even before the Havemeyer bequest, making substantial purchases at the sales of the artist's studio in 1918 and afterwards (Ventes I-IV, Vente d'estampes). Although no acquisitions were made during the artist's lifetime, the Metropolitan was among the first to build a Degas collection in a careful and meaningful way in the decade following the artist's death. As a result, the Metropolitan now boasts the most comprehensive survey of Degas's art that is housed under one roof.

The survey of Degas's art presented by The Art Institute of Chicago's collection reflects all periods of the artist's career, but it is especially rich in works produced at the height of his creativity, in the 1870s and 1880s. Roughly two-thirds of the museum's holdings date from those two decades. This is the period of Degas's most appealing and characteristic creations, which exhibit neither the academic polish of his earliest achievements nor the disintegration of form of those of his last years.

Along with this concentration of art from Degas's middle years is a decided preponderance of dance subjects, portraiture, bathers, and scenes of modern life, in that order, which must reflect the bias of the early Chicago collectors. Also revelatory of the taste of these patrons is the total absence of images of alienation and urban malaise, works of psychological or dramatic impact, and, curiously enough, major horse compositions or landscapes. The less typical and less

glamorous subjects did not appeal to those who built the collection. Scenes of lower-class working women were scrupulously avoided: the only image of laundresses to enter the museum is the small etching (cat. no. 57) purchased in 1977. Clearly, provocative paintings like *The Rape* (L. 348) or *Sulking* (L. 335) would not have been sanctioned by even the most far-sighted Chicago collectors. Although scholars now identify as prostitutes many of Degas's images of women—nudes, bathers, dancers, working women—such nuances of interpretation must have escaped the artist's early collectors in Chicago or perhaps even more discrimination would have been manifest. The extensive group of bather images began with the acquisition, through Mrs. Potter Palmer's bequest, of *The Morning Bath* (cat. no. 76) in 1922, but it was created largely by curatorial purchases from the 1940s on. Chicagoans preferred Degas's fashionable women—at the milliner's, after a costume ball, at the Louvre—or his dancers. In fact, the images of women in the Art Institute far outnumber those of men. While depictions of singers at the café-concerts were hung in Chicago homes, their counterparts in brothels were excluded, most notably those monotypes whose frankness borders on the vulgar.

Nonetheless, even though the Chicago collection exhibits such lacunae and even though it was not planned in any specific way, the sum of its parts yields an accurate and unusually broad view of the artist. Degas's earliest extant works are portraits, copies, and history paintings. The Art Institute is strongest in the first category. An exquisite profile drawing of the artist's brother René and a graceful study for a portrait of his sister Marguérite reflect the substantial early influence of Ingres (see cat. nos. 1, 7). Rare and exquisite etched portraits of the artist's family and fellow artists Joseph Tourny and Edouard Manet (cat. nos. 3, 4, 8, 11, 12) reveal the way in which Degas absorbed the lessons of Old Master printmakers, in particular Rembrandt, as well as the work and technique of modern masters in the Société des Aquafortistes. The Art Institute's earliest painted portrait, the mysterious *Mme. Lisle and Mme. Loubens* (cat. no. 15), both friends of Manet, reveals the influence of that artist on Degas. By good fortune, the museum also acquired the compositional study (cat. no. 14) for the painting, which offers insight into the artist's working methods. Perhaps the most compelling of all the portraits in the Art Institute is the sympathetic, small wash drawing of his Aunt Mathilde Musson and cousins executed during their self-imposed exile in France (cat. no. 13).

The area of copies, academic studies, and history paintings is reflected in the powerful *Italian Head* (cat. no. 2) executed in Rome around 1856; a delicate study of Leonardo's *Adoration of the Shepherds* (cat. no. 10) created in Florence in

1860; and the important, unfinished *Young Spartans* (cat. no. 9) of the same year. Inspired by an obscure literary text, this enigmatic canvas is interpreted here as having a subtle sociological and psycho-sexual meaning that is autobiographical in nature. *Young Spartans* is both a modern history painting and an allegorical self-portrait.

During the 1860s, other subjects began to interest the artist. His earliest ballet picture, *Mlle. Fiocre in the Ballet of "La Source,"* is represented by a preparatory graphite drawing (cat. no. 16) of an ancillary figure that is more evocative of the grace of the ballet than is the painting itself; a superb sheet of *Four Studies of a Jockey* (cat. no. 17) on brown paper glistens with the sheen of silk, carefully observed and assuredly rendered; two large, salmon-colored sheets depicting a *Gentleman Rider* (cat. nos. 19, 20) reveal the artist's efforts to achieve elegance of form; and a refined study of a horse (cat. no. 21) indicates Degas's careful preparation for one of his first great horse-racing pictures, *Race Horses,* in the Louvre. However, none of the artist's pastel landscapes, created around 1869, or any souvenirs of his voyage to America in 1872-73 as yet have entered the collection.

Following his return to France, Degas became increasingly absorbed in the ballet and other aspects of modern life. In the Art Institute are important works on this theme. The two drawings of the *Dance Master* (cat. nos. 23, 24) are crucial to the understanding of Degas's working method as well as to establishing the sequence of several major compositions. Similarly, two pastels over monotype, *Ballet at the Paris Opéra* and *On the Stage* (cat. nos. 31, 29), together with their related works, reveal the way in which he elaborated on a motif in numerous works over many years. Probably the first oil painting by Degas of the ballet to be shown in an Impressionist exhibition is *Dancers Preparing for the Ballet* (cat. no. 22), and one of the finest studies for the artist's famous Realist sculpture, *Little Dancer of 14 Years,* is *Three Studies of a Dancer in Fourth Position* (cat. no. 42).

Among the scenes of modern life Degas created in the 1870s are unusual and provocative portraits of his family and friends. *Uncle and Niece* of 1875/79 (cat. no. 26) is a sympathetic, semi-autobiographical work about dependence and alienation. The rare aquatint and etching of Alphonse Hirsch (cat. no. 27) and the haunting monotype portrait of Ellen Andrée (cat. no. 28) are among Degas's first essays in those media. Other prints from the end of the decade include another small portrait of Ellen Andrée (cat. no. 49) in *crayon électrique*; the arresting, voyeuristic *Actresses in Their Dressing Rooms* (cat. no. 44); and several unusual states and beautiful impressions showing Mary Cassatt at the Louvre (cat. nos. 50-54). Also from this time is the controversial, highly experi-

mental *Portrait after a Costume Ball* (cat. no. 47), yet another departure for Degas in the area of portraiture. A rare male double portrait in monotype, *The Two Connoisseurs* (cat. no. 36), may commemorate the first sale of a painting by the artist to a public museum, that of *The Cotton Exchange* to Pau.

The most modern of Degas's figurative subjects in the 1870s, however, are his depictions of café-concert singers and their sisters of the night—prostitutes. Some of the artist's most colorful and impressionistic works are his images of Mlle. Bécat at the Ambassadeurs and other personalities (see cat. nos. 32-35, 37, 38). Degas executed these works in a wide range of techniques—oil paintings made to look like pastels, monotypes heightened with pastel, lithographs, etchings, and small-scale monotypes.

The influence of Japanese art on Degas at the end of the 1870s is most evident in his print compositions, including the Mary Cassatt series and more intimate scenes such as the *Actresses in Their Dressing Rooms.* While the Art Institute does not have a major horse painting or pastel, it does own three drawings of horses (cat. nos. 21, 61, 62) and three of jockeys or riders (cat. nos. 17-20) that shed light on the artist's working methods, involving, as they do, reversals of images, tracings and repetitions of earlier drawings, and the use of sculpture in the exploration of a motif.

Representing the decade of the 1880s are several statuettes and studies of the nude in monotype, pastel, *crayon électrique,* and lithography. Two superb monotypes of female nudes (cat. nos. 67, 68) reveal the artist's working methods. Such works were intended by Degas to provide his closest friends with moments of private, visual delectation. Subtle and unusual small-scale prints of women at their toilettes co-exist with increasingly larger, more brilliant, and energetically worked pastels, such as *The Morning Bath,* reflecting Degas's concurrent work in wax sculpture as well as his interest in sequential photography and simultaneity of action.

Rapid studies of dancers from life also date from this period. In these drawings (see cat. nos. 69, 70), the artist seems to have been determined to keep his eye and hand "in shape." But the solidity of forms in such finished pastels as *Preparation for the Class* (cat. no. 71) reveals the continuing importance for Degas of wax sculpture as he worked in his studio. This example demonstrates the technique Degas often applied to his pastels after 1880 of steaming the pigments in order to coagulate and solidify them.

The sculptural forms that characterize Degas's work of the 1880s dissolve somewhat in the pastels of the 1890s, with their intense, coloristic effects. Nowhere is this more evident than such dance images as the charcoal drawing *Dancer Resting with a Fan* (cat. no. 84) and the pastel *Two Dancers* (cat. no. 83). The brilliant network of lines in the later, majestic pastel *Woman at Her Toilette* (cat. no. 89) and her lithographic equivalents (cat. nos. 78-82) demonstrate the moment in Degas's work when subject was completely subordinated to form. These variations on the female anatomy constitute Degas's response to Claude Monet's many series. Degas's desire to integrate figures in motion with their surroundings culminated in two sculptures (cat. nos. 77, 88), and a monumental pastel of bathers (cat. no. 91) in which nude female torsos and a landscape are merged in an ultimate, synthetic statement.

As we have seen, most important aspects of Degas's long career are represented in the Art Institute. The many interrelationships that exist among his works in various media in this one collection reflect the complex and incessant exploration of formal motifs that constitutes the foundation of Degas's oeuvre. Furthermore, comparative analysis of the works gathered here helps illuminate the artist's working methods and the expressive potential of the many and varied media he employed. It is hoped that the serious examination of the work of Edgar Degas in The Art Institute of Chicago attempted in this study yields not only greater appreciation for the museum's holdings but also a new understanding of the artist's achievements as a whole.

Editor's Note

The works of art are arranged roughly in chronological order. Dimensions are given in millimeters (mm) or in centimeters (cm); height precedes width precedes depth. Maximum dimensions (max.) are provided for irregular sheets. For the most part, references have been abbreviated; complete references are listed in the bibliography at the back of the book. As much as possible, the authors have identified works of art by Degas not illustrated in this book by providing their numbers from the critical catalogues of the artist's work: Lemoisne 1946 (L.), Adhémar 1974 (A.), Cachin 1974 (C.). Comparative illustrations have been grouped under the catalogue number of the work by Degas in the Art Institute to which they relate. The entries were prepared by Richard R. Brettell (RB), Suzanne Folds McCullagh (SFM), and Todd Porterfield (TP).

1. René de Gas, c.1855

Verso: landscape sketch in graphite
Black chalk on ivory laid paper
346 x 280 mm
Helen Regenstein Collection, 1961.792

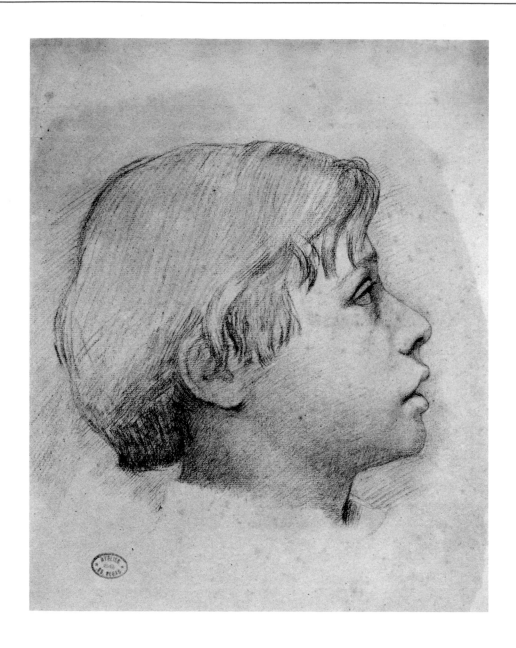

Family portraits are among the earliest datable works by Degas. A number of them, including this finely executed profile in graphite, feature the artist's youngest brother, René (1845-1926). Most significant of these is the three-quarter-length portrait in the Smith College Museum of Art (fig. 1-1). Sketches in the notebooks, dated 1854/55 (Reff 1976b:39,41, Notebook 2: 32,75) and 1855/56 (ibid.: 47, Notebook 4: 14), as well as head studies, compositional drawings (see Washington, DC 1974: 124-5, B), and an oil sketch (L. 7) document his careful preparatory procedure for the painting, which may well have been the young artist's most ambitious undertaking up to that time.

Judging from René's appearance in the works related to the Smith College painting, it would seem that they were created when he was ten years old, around 1855. This was a period of rapid transition and growth for Degas following his baccalaureate, a period of legal studies, and over a year's apprenticeship in the studio of Louis Lamothe, a follower of J. A. D. Ingres. The influence of Ingres has often been noted in these various portraits of René. It is seen in the refinement of the pencil drawings as well as in the polish of the oil painting, which may be compared in its formality, coloring, and Mannerist composition with Ingres's portrait of the Marquis de Pastoret, later owned by Degas and now in The Art Institute

16

of Chicago. It was in 1855, when Ingres had a one-man show at the Exposition Universelle, that Degas was introduced to his idol by a family friend, Henri Valpinçon. In fact, the young artist helped secure Ingres's great *Bather* (fig. 78/82-2) from Valpinçon, its owner, for that exhibition.

The Ingresque quality evident in the Art Institute's profile drawing and a second in the Stephen R. Currier Collection, New York (St. Louis 1966-67, no. 3, repr.), suggest these drawings were executed at the same time as the Smith College painting, although not necessarily as preliminary studies for it. Moreover, in addition to their direct connection with Ingres, these portrait drawings attest to Degas's study of Renaissance masters and antiquity. The strict profiles exhibit the coolness of ancient bas-reliefs; the careful delineation of the features, with the use of cross-hatching to create texture, reflect the practice of copying from engravings which Degas probably began around 1853. Such a method would have been confirmed for Degas when he studied briefly in 1855 at the Ecole des Beaux-Arts, where copying from engravings and the antique preceded any direct study from the model.

Walter Feilchenfeldt has suggested (oral communication) that the unusual tilted angle of the boy's head in the Chicago drawing might indicate Degas's familiarity with Hans Holbein's portrait of his wife and two eldest sons, since it echoes the profile of one of the children; if this is true, the artist probably knew the composition from a copy in Lille (thought to be the original in the 19th century) rather than from the original in the Basel Museum (fig. 1-2). Such a link makes it tempting to speculate that Degas might have been considering a similar family composition, perhaps to honor his mother, who had died in 1847.

Holbein's pristine style continued to attract Degas through 1862, when he made an oil copy of Holbein's portrait of Anne of Cleves (L. 80), but the majority of the copies made by the young artist around 1855 were of early Italian paintings. Two pencil studies (Russoli 1970, nos. 11, 12, repr.) drawn after Fra Angelico's *Coronation of the Virgin* in the Louvre reveal Degas's inclination to emphasize peripheral figures in his copies (Reff 1963: 255-6), and offer further comparisons with the strict profile and refined handling of the portrait of René in Chicago. By contrast, the extremely faint landscape sketch on the verso of this drawing is loosely executed and unfinished. Of less interest to Degas, it seems to be one of the earliest examples of his rare essays in that subject. This sheet, with its elegant and pristine portrait on one side and its rough and abandoned landscape on the other, thus may be seen as a synopsis of the young artist's choice of subjects, his influences, and his extraordinary draftsmanship from an early age. (SFM)

WATERMARK: KF

COLLECTIONS: Estate of the artist, stamp (Lugt 657) recto, lower left, in red; René de Gas, Paris; Paul Brame, Paris; acquired by the AIC from Marianne Feilchenfeldt, Zurich.

EXHIBITIONS: Oberlin 1963, no. 23, repr.; New York 1963, no. 100, repr.; Palm Beach 1974, no. 11.

LITERATURE: Chicago 1974, no. 79, repr.; Chicago 1979, 2D12.

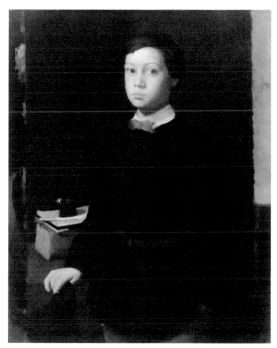

Fig. 1-1. Degas. *Portrait of René Degas,* c. 1855, oil on canvas (L.6). Northampton, MA, Smith College Museum of Art (1935:12). Photo: David Stansbury, Springfield, MA.

Fig. 1-2. Hans Holbein the Younger (German, 1497/98-1543). *The Artist's Family,* 152(8?), tempera on paper, mounted. Basel, Kunstmuseum.

2. Italian Head, c. 1856

Inscribed recto, lower right, in graphite: *Rome*
Charcoal with estompe on ivory wove paper
Max. 384 x 260 mm
Margaret Day Blake Collection, 1945.37

In July 1856, Degas left Paris for Italy, for reasons that probably were both professional and personal. While alternately attracted and repelled by traditional methods of training, he recognized the importance of a period of study in Rome and of exposure to the masters of antiquity and the Renaissance. This experience long had been considered an essential ingredient in an artist's education; since the 17th century, the French Académie, through the Ecole des Beaux-Arts, had sponsored a virtually annual competition, the Prix de Rome, in recognition of this need. In addition, most of Degas's relatives on his father's side had lived in Italy since the late 18th century. When the artist arrived in Naples, he must have stayed not only with his grandfather, René Hilaire de Gas, who had fled to Naples after the French Revolution in 1793, but also with his uncles Achille, Edouard, and Henri, who lived in the family home. Two aunts also resided in Italy Rose Adelaide de Morbilli in Naples, and Laure Bellelli in Florence. Portraits of many of these family members (see cat. nos. 3, 7) testify to the young artist's visits with them, but he preferred to live independently in Rome until August 1858, when he joined the Bellellis in Florence.

As indicated by the inscription, this unusual, virile head must have been executed while Degas was in Rome. Furthermore, the subject of the sheet links him to a circle of artist/friends he made there. Among the compatriots whom Degas found in Rome studying at the Académie in the Villa Medici were Jules Elie Delaunay, a colleague from Lamothe's studio; Léon Bonnat (who would become a collector); the engraver Joseph Tourny (see cat. no. 4); and the artist Gustave Moreau. The last became an extremely close friend; drawings in the Musée Gustave Moreau, Paris, demonstrate that he worked with the same model as Degas in this sheet. Richard Ormand recently observed (written communication) that a drawing by the English painter Frederick Lord Leighton also represents the same model as that in the Chicago drawing. Its inscrip-

tion, *"Giacomo Rome 18 FL 53,"* provides us with the sitter's first name.

Three other studies by Degas of the same model (Vente IV, 94a-c) indicate that he used Giacomo's unusual features to develop his ability to evoke expressiveness—following a traditional academic exercise known as the *tête d'expression* that was instigated by Charles Lebrun in the 17th century. So romantic and bold are the conception and execution of these sheets that they are difficult to reconcile with the fine, hard graphite drawings in the manner of Ingres that Degas made just before them, such as the *René de Gas* (cat. no. 1). The Italian head studies seem to register the impact of the Baroque city on the young artist and anticipate the later, less well-recognized influences on Degas of Romantic and Realist artists such as Eugène Delacroix and Gustave Courbet. Degas's friendship with Moreau may have encouraged such a departure from the classical (Moreau himself seems to have been torn between the legendary rivals Delacroix and Ingres), but even Ingres was known to have executed similarly bold, painterly studies of heads early in his career, between 1797 and 1806. The stylistic shift is echoed in technical terms by the use of estompe to rub the charcoal lines, indicating Degas's attempts to move away from his natural inclination toward precise delineation toward a broader approach using chiaroscuro effects. (SFM)

COLLECTIONS: René de Gas, Paris; Gustave Pellet, Paris; Maurice Exteens, Paris; Justin K. Thannhauser, New York (sale: New York, Parke Bernet, Apr. 12, 1945, lot 58, repr.); acquired by the AIC from Durlacher Brothers, New York.

EXHIBITIONS: Chicago 1946, no. 14, pl. XVI; Washington, DC 1947, no. 3; New York 1963, no. 101; St. Louis 1966-67, no. 6, repr.; Chicago 1970, no. 31, repr.

LITERATURE: Tietze 1947, no. 142, repr.; Chicago 1979, 2E1.

3. Auguste de Gas, the Artist's Father(?), c. 1856 and mid-1870s

Etching on ivory laid paper; only state
Plate 128 x 108 mm; sheet max. 331 x 247 mm
William McCallin McKee Collection, 1943.1059

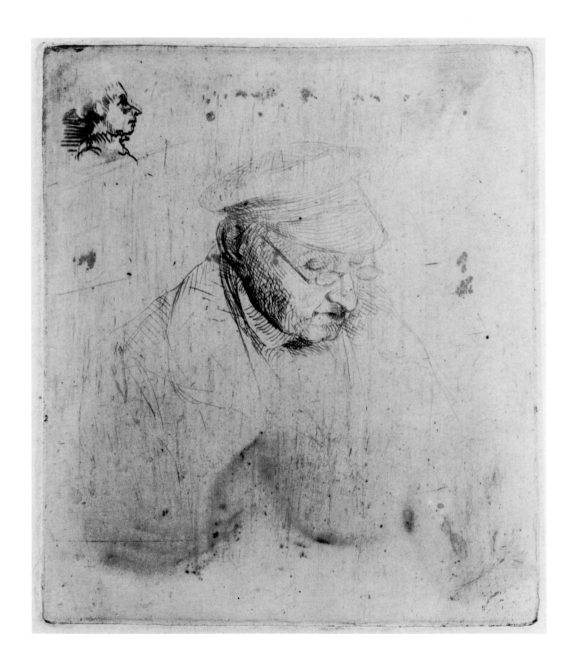

The portrait etching that Delteil entitled *Auguste de Gas, the Artist's Father* presents one of the most problematic images in Degas's graphic oeuvre. The tentative nature of its execution suggests that it is one of the artist's first attempts in the etching medium, but there is reason to believe that the plate was not actually printed until much later. Moreover, there has been considerable debate as to when, where, and under whose instruction Degas learned etching. Recently, even the identity of the subject has been questioned.

Delteil assumed that Degas's instruction in etching took place in Paris in 1856 under the tutelage of Félix Bracquemond, leader of a revival of etching in the mid-19th century. Rouart (1945: 74 n. 90) found little evidence to suggest that the two had met so early. According to popular legend, initiated by the artist's brother René, Degas was introduced to etching by the Greek Prince Soutzo, a print collector with a special interest in Claude Lorrain. Moses dated Degas's contact with Soutzo to the first few months of 1856, based on drawings in Degas's notebooks of that period which copy Soutzo's landscapes (Chicago 1964, no. 5). Adhémar dated Degas's work with Soutzo to early 1857, but, as Reff has pointed out (written communication), Degas was then in Italy. No doubt, Degas's printmaking activity was significantly nurtured during his stay in Rome by the engraver Joseph Tourny. In 1857, Degas etched a portrait of Tourny (cat. no. 4) which exhibits the same fragile lines and interest in peripheral remarks on the plate as *Auguste de Gas,* but the more successful evocation of substance and atmosphere in the Tourny portrait indicates that it was executed somewhat later.

The questions surrounding the identity of the sitter in cat. no. 3 hinder the understanding and the dating of the print. Adhémar and Reff recently have identified the subject of the print as Degas's Neapolitan grandfather, René Hilaire de Gas, based on its resemblance to what looks like a red-chalk drawing in the background of Degas's portrait of the *Bellelli Family* (fig. 3-1). Adhémar and Reff have argued that the drawn portrait in the *Bellelli Family* has iconographical significance: as the family is dressed in mourning, the portrait is Degas's memorial to his grandfather. René Hilaire died in August 1858, precisely when Degas had gone to Florence to live with his Aunt Laure Bellelli and her family; indeed, she was at her dying father's side in Naples when Degas arrived in Florence.

As attractive as this argument may appear, it is based on some unsupportable hypotheses and rather convoluted reasoning. First of all, no such red-chalk drawing has ever been located. In fact, Reff doubts that the red-chalk drawing in the *Bellelli Family* portrait ever existed. Furthermore, he suggests that, in contrast to the painted drawing, a preliminary study for an etching probably would have been oriented in reverse to the etching (Reff 1976a: 96). Following Reff's thinking, the red-chalk study in the painting would have been based by

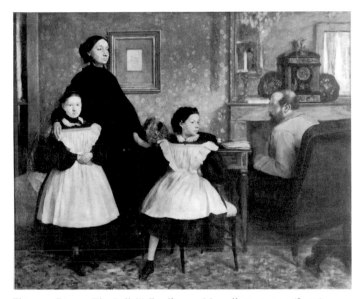

Fig. 3-1. Degas. *The Bellelli Family,* c. 1860, oil on canvas (L.79). Paris, Musée d'Orsay. Photo: Documentation photographique de la Réunion des musées nationaux.

Degas on the already existent etching in the same direction—a tenuous assumption involving a reversal of common procedure. Moreover, it is curious that Degas should have chosen such an unclear image to commemorate his grandfather when he had completed an ambitious, more formal painted portrait of him in 1857 (L. 27).

A painting that is similar to the "drawn" and etched composition exists (L. 33), although it bears no inscription nor other information to help verify the subject. The subject's features—his long, slightly bulbous nose, large, rounded ears, cleft chin, and jowly cheeks—could be those of either René Hilaire or his son Auguste, who is said to have aged rapidly following his wife's death in 1847 (see fig. 3-2). One could also argue for the iconographical significance of a portrait of Degas's father in the *Bellelli Family* because correspondence at the time indicates that he strongly advocated that Edgar devote himself to portraiture. But identification of the figure as a family member may be presumptuous. The sitter, wearing a cap, is bent over his work, etching on a copper plate. Neither Degas's father nor his grandfather would seem as likely to have engaged in such artistic activity as would Tourny or another artist friend in Rome.

An impression of this very rare etching in the Fondation Doucet, Bibliothèque d'Art et d'Archéologie, Université de Paris, bears the inscription *"Naples 1857,"* suggesting that the print was made during Degas's Italian journey and that its subject could be the artist's grandfather. However, as Moses pointed out, the unfinished drypoint profile of a woman in the upper left corner is of an altogether different and much later style and technique than the rest of the image and might well have been added in the mid-1870s, at the time of the first printing of the plate. The inscription on the Doucet impression then would have been made in retrospect. If the printing of the plate was so delayed, one would have to raise further questions about the identity of the sitter. It would have been less relevant in the mid-1870s for Degas to print a portrait of his grandfather (dead more than 15 years) than one of his father (who died in 1874). As Moses suggested, the print may have served as a commemoration of the artist's father; having long before put aside the uncompleted plate, Degas might well have picked it up again when he returned to Naples many years later, on the occasion of his father's death. That he was consumed at that time by reflections on the loss of a father is attested to in his painting *Uncle and Niece* (cat. no. 26). But even that may be ascribing too much significance to what may have been a simple portrait of a fellow artist. Thus, what is possibly Degas's first attempt on the copper plate may well commemorate his instructor in that medium.

While we may never know who this figure is, it is important to note that for many years no one questioned the identity of the sitter in this image as Auguste de Gas—not even his children and heirs—and it seems wise to use caution in doing so now. (SFM)

COLLECTIONS: Marcel Guiot, Paris (per Adhémar); acquired by the AIC from M. A. McDonald, New York.

EXHIBITIONS: Chicago 1964, no. 4, repr.

LITERATURE: Delteil 1919, no. 2, repr.; Adhémar 1974, no. 6, repr.(AIC); Reff 1976a: 96-7, fig. 63, p. 313 n. 21 (AIC).

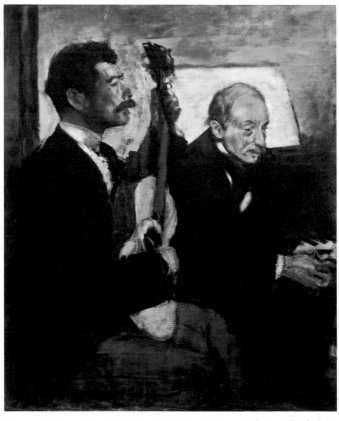

Fig. 3-2. Degas. *Degas's Father Listening to Pagans Playing the Guitar,* c.1869/72, oil on canvas (L.257). Boston, Museum of Fine Arts, Bequest of John T. Spaulding (48.533).

4. The Engraver Joseph Tourny, 1857

Etching on ivory laid paper; only state
Plate max. 231 x 145 mm; sheet max. 376 x 276 mm
Joseph Brooks Fair and Everett D. Graff Funds, 1978.20

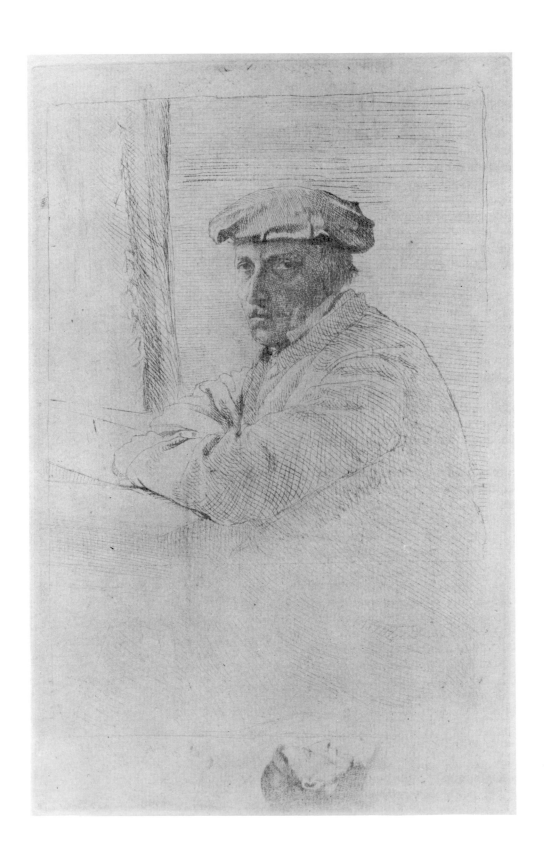

Joseph Tourny (1817-1880) won the Prix de Rome for engraving in 1846 (Alaux 1933, II: 407) and, as resident fellow in engraving, was an active member of the French artistic colony around the Villa Medici when Degas arrived in Rome in late 1856 or early 1857. Degas's senior by 17 years, Tourny nonetheless became the young artist's close friend and instructor in printmaking; Adhémar observed that their friendship lasted at least through 1871, as indicated by their correspondence (see also Reff 1976b: 121, Notebook 24: 105).

Tourny seems to have inspired one of Degas's most sensitive portrait etchings. Here, the printmaker is shown wearing a beret and seated before a copper plate in front of a window. In posture and costume, the image of Tourny clearly recalls Rembrandt van Rijn's etching *Self-Portrait at an Open Window* (fig. 4-1). Since Degas's interest in the work of Rembrandt can be documented to late in 1857—in his *Self-Portrait* (cat. no. 5), a sketch after Rembrandt (Reff 1976b: 64, Notebook 10: 13), and an etched copy in reverse of Rembrandt's etching *Young Man in a Velvet Cap* (cf. D. 13)—it seems safe to assume that this print dates from this time. Reff suggested (1964: 251) that Tourny was largely responsible for Degas's interest in Rembrandt. In the lower margin of the etching are two profile remarques, or sketches on the plate, which otherwise do not relate to the portrait above. Degas used Tourny as a model for the head of Dante in an oil sketch dated 1857 (L. 26), probably preparatory to his painting *Dante and Virgil at the Gates of Hell* (L. 34). As Moses pointed out (Chicago 1964), this may explain the distinctly Dantesque character of the profiles on the etched plate.

A number of impressions of this print reveal Degas's individual experiments in wiping and printing an intaglio plate to achieve painterly chiaroscuro effects. These may have been printed up to 20 years after the initial execution of the plate and possibly reflect Degas's earliest essays in the monotype medium (see B. Shapiro in New York 1980: 30-1) under the guidance of Viscount Ludovic Napoléon Lepic, an amateur etcher and entrepreneur. Lepic, a member of the Société des Aquafortistes, founded in 1862, advocated that artists print their plates themselves, and began to experiment with effects produced by leaving tone on an etched plate, a method he called *"eau-forte mobile."* Like his etched *Self-Portrait* (cat. no. 5), Degas's variants reveal his desire to create original translations of works by such Old Masters as Rembrandt, as well as his constant exploration of the multiple effects certain printing techniques permitted him. (SFM)

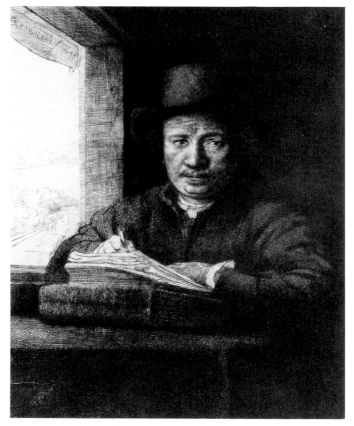

Fig. 4-1. Rembrandt van Rijn (Dutch, 1609-1669). *Self-Portrait at an Open Window*, 1648, etching, drypoint, and burin. The Art Institute of Chicago, Robert Forsythe Collection (1927.1731).

LITERATURE: Grappe 1908(?): 56, repr.; Delteil 1919, no. 4, repr.; Arms 1951: 26-8, repr. (in reverse); Boggs 1962: 11; Chicago 1964, no. 8, repr.; Adhémar 1974, no. 7, repr.; London 1983, no. 2, fig. 2.

5. Self-Portrait, 1857

Inscribed recto, lower left, in graphite:
Degas par lui-même à 23 ans 1857
Etching on ivory laid paper; third state of five
Plate max. 232 x 143 mm; sheet max. 324 x 231 mm
Joseph Brooks Fair Collection, 1932.1294

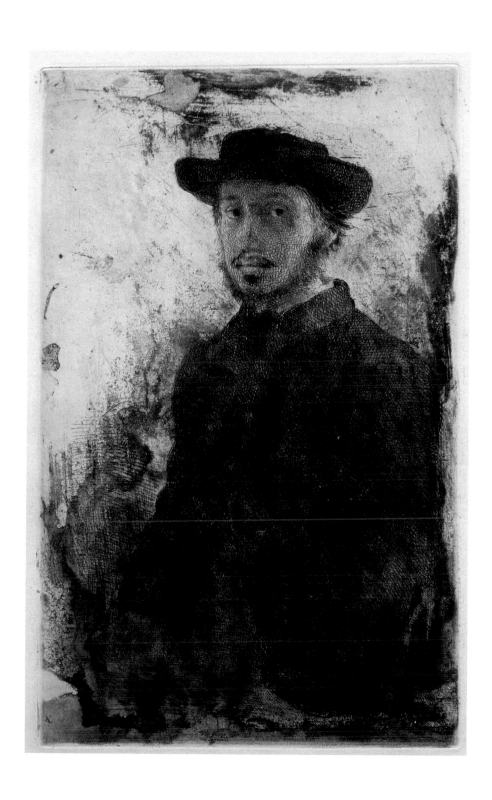

This early *Self-Portrait* ranks as Degas's first major achievement in printmaking; it is perhaps his most penetrating self-appraisal and is certainly among the most important etchings done in the mid-19th century.

A work of surprising sophistication for a relatively young practitioner of the art, this etching can be securely dated to 1857, based on inscriptions on this and other impressions. It was undoubtedly created in Italy in the winter of that year, at a period when the artist was intensely involved with self-portraiture. Like a contemporary self-portrait in oil in Williamstown, MA (L. 37), the etching depicts Degas garbed in artist's attire, posed at a three-quarter angle, and staring out with a sullen but penetrating gaze.

This etching was inspired by the early graphic self-portraits of Rembrandt van Rijn, in which the Baroque artist depicted himself in a similar pose and mood (see fig. 4-1). More than any specific stance or props, Degas adopted from Rembrandt his capacity to express the psychology of a personality and to interpret something as fragile and immaterial as genius not merely by features, position, or expression, but by creating an atmosphere from which a convincing presence emerges.

Degas even learned techniques for achieving this mood from the 17th-century master. He reworked the copper in five distinct states, transforming the image to achieve increasingly dramatic chiaroscuro effects with a variety of means few artists had employed since Rembrandt. Beginning with a very delicate, strictly linear approach, Degas heightened the contrasts by additional line work as well as perhaps by applying acid directly to the plate in the second and third states; in this fashion, he achieved the strikingly dramatic image seen here, where clarity has been completely and calcu-latedly sacrificed to a personal, painterly, even sensual effect. Despite the plate's accidental (or amateur) appearance, it exhibits a clear sense of Degas's utter control of his technical means. The flair for experimental manipulation that first appears here would characterize the artist's efforts in other media, as well, throughout his life. This impulse toward the individualization of impressions through the alteration, wiping, and printing of the plates was to be a hallmark of the etching revival and of the work of such contemporary printmakers as James McNeill Whistler.

A preliminary study (in reverse) for the print is in The Metropolitan Museum of Art, New York. The copper plate (now in the Los Angeles County Museum of Art) was among the effects left in the artist's studio upon his death; it testifies to Degas's "taming" of this potent image, brought about in the last two states by burnishing out areas and clarifying details. (SFM)

WATERMARK: Unidentifiable monogram.

COLLECTIONS: Roger Marx, Paris (sale: 1914 [per Lugt]); A. H. Rouart, Paris, stamp (Lugt Suppl. 2187a) recto, lower right, in purple, and stamp (not in Lugt) verso, lower left, in purple; acquired by the AIC from Marcel Guiot, Paris; The Art Institute of Chicago, stamp (Lugt Suppl. 32b) verso, lower left, in brown.

EXHIBITIONS: Chicago 1964, no. 9, repr. (fifth state).

LITERATURE: Delteil 1919, no. 1, repr. (first, second, and third [AIC] states); Lemoisne 1946, I, repr. opp. p. 18 (third state); Boggs 1962: 10-11, pl. 16 (AIC); Passeron 1974: 61-2, repr.; Adhémar 1974, no. 13, repr. (first state; third state incorrectly described; AIC also mistakenly cited as having fourth state); London 1983, no. 2, repr. (second state).

6. René de Gas, the Artist's Brother, c.1859

Soft-ground etching on cream wove paper; only state
Plate 87 x 72 mm; sheet max. 133 x 107 mm
Given in memory of Pauline K. Palmer by Mr. and Mrs. Arthur M. Wood, 1959.47

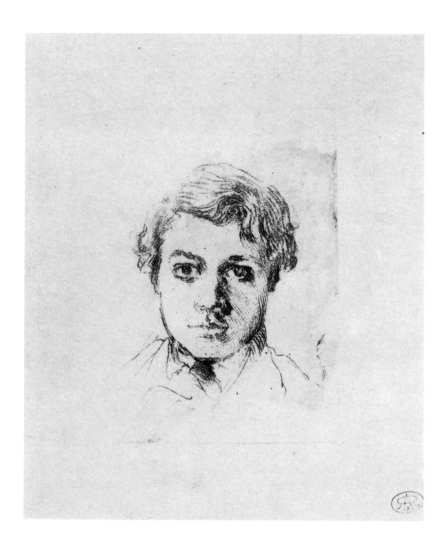

In comparison with the graphite drawings or even the oil paintings of René de Gas as a young adolescent, which are generally dated to 1855 (see cat. no. 1), this haunting printed portrait of the artist's brother depicts a more mature young man with tousled hair and a schoolboy's cravate.

This print is not a pure etching, but an example of the more sophisticated soft-ground technique, in which the artist draws directly on a sheet of paper placed over a soft etching ground covering the plate. When lifted, the paper removes the ground irregularly according to the design and the final print reflects the pressure of the artist's hand and the texture of the paper. In this case, the paper texture has broken up the various lines that describe René, giving the portrait a sense of atmosphere.

The apparent maturity of the model and the use of the soft-ground technique lead one to question the dating of this image by Delteil to 1857, when Degas's handling of the etch-ing needle was still somewhat stiff and when, moreover, the artist was in Italy, away from his younger brother. Thus, the etching may date just after Degas's return to Paris in 1859, when his youngest brother had turned 14. It then would coincide chronologically with the portrait studies the artist made of his sister Marguérite (see cat. no. 7), with which it is stylistically compatible. Adhémar dated this print to 1861/62, believing the model to be about 17 years of age. (SFM)

COLLECTIONS: A. H. Rouart, Paris, stamp (Lugt Suppl. 2187a) recto, lower right, in purple, and stamp (not in Lugt) verso, lower left, in purple; acquired by the AIC from Richard Zinser, New York.

EXHIBITIONS: Chicago 1964, no. 5, repr.

LITERATURE: Delteil 1919, no. 3, repr.; Adhémar 1974, no. 21, repr.

7. Study for a Portrait of Marguérite de Gas, c. 1859/60

Graphite on ivory wove paper
325 x 235 mm
Clarence Buckingham Collection, 1977.124

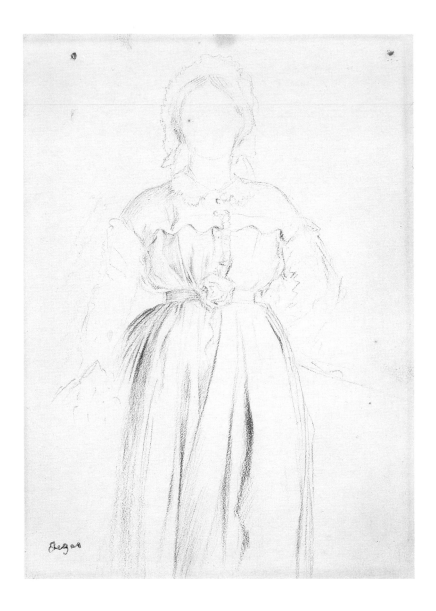

Degas was especially fond of his younger sister, Marguérite (1842-1895), who married the architect Henri Fèvre in 1865, bore him five children, and died in Buenos Aires. A gifted vocalist, Marguérite must have been spiritually and emotionally similar to her elder brother, as is indicated by the numerous sympathetic portraits he made of her, including three drawings and an oil sketch from as early as 1854 (Boggs 1962: 118).

Following his trip to Italy, Degas made additional portraits of his sister in such a variety of costumes and poses that it might have been difficult to recognize her in each instance if her daughter Jeanne, who assumed a vital role in the documentation of her uncle's work (Fèvre 1949), had not identified her.

Perhaps the most attractive and significant of all the representations Degas made of Marguérite are the three-quarter-length portrait (fig. 7-1) and its preparatory, bust-length oil sketch (L. 61). The final work presents the figure in a dramatic, fully frontal position. She stands between a chair and a mantle dressed in a simple monochrome dress accented by a white collar, black ruffle, and wide black belt. The painting exhibits clear references to Ingres's portrait style: in the older artist's masterful *Portrait of Mme. d'Haussonville* can be seen a comparable emphasis on the graceful folds of the dress and a similar ethereal expression on the subject's wide-eyed face. Ingres approached even his portrait compositions carefully and methodically. His preliminary studies for *Mme. d'Haussonville* include two sheets that concentrate solely on

facial features and another combining these two studies and roughing in other basic elements of the background and composition. Degas perhaps deliberately followed in his master's footsteps in preparing the portrait of Marguérite. Several studies testify to the careful construction of this portrait in the tradition ascribed to by Ingres. In the Chicago drawing, the dress received particular attention: here, Degas focused on the details and sensuous quality of the fabric, using simple outlines to suggest the features of the human form.

Dated by Lemoisne to the period between 1855 and 1860, the oil portrait does seem to represent a woman with a younger, fuller face than the Marguérite represented in an etched portrait (D.17) assigned to 1865. Although the striking frontal posture and costume used in the painting are very similar to those employed by the artist in *Rose, the Duchess of*

Morbili (fig. 7-2), dated around 1857 and certainly inspired by his visit to Naples, it is most unlikely that the painting of Marguérite and its preliminary studies predate Degas's return to Paris in 1859. Thus, a date of around 1859/60 seems more reasonable and would connect the work not only to the Bellelli family portrait (fig. 3-1), but also to studies for it—like the oil sketch of Giulia Bellelli (L. 69)—which display a similar concern with costume and with making an awkward frontal pose more graceful. (SFM)

COLLECTIONS: Estate of the artist, Vente IV, 89b, repr., stamp (Lugt 658) recto, lower left, in red; acquired by the AIC from Huguette Berès, Paris.

LITERATURE: Chicago 1979, 2E2.

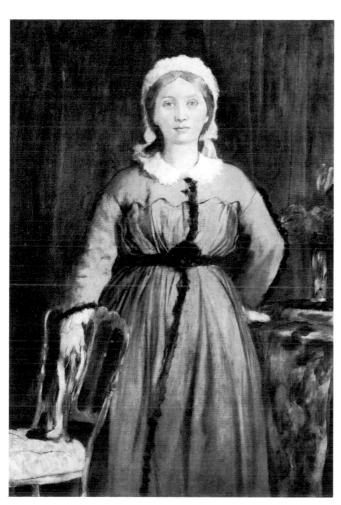

Fig. 7-1. Degas. *Portrait of Marguérite*, 1859/60, oil on canvas (L.60). Paris, Musée d'Orsay. Photo: Documentation photographique de la Réunion des musées nationaux.

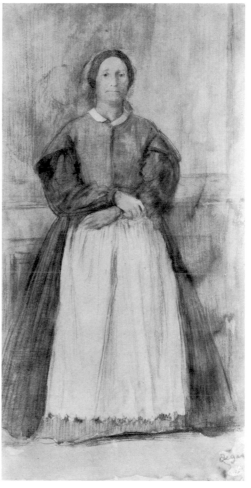

Fig. 7-2. Degas. *Rose, the Duchess of Morbili*, c.1857, wash on paper (L.51). New York, Mr. and Mrs. Eugene Victor Thaw.

8. Giovanna Bellelli (formerly Mlle.
N. Wolkonska) (second plate), c.1860

Etching on buff wove oriental paper; second state of two
Plate 120 x 88 mm; sheet max. 305 x 214 mm
Joseph Brooks Fair Collection, 1938.44

This enigmatic image of a young girl is difficult to situate in Degas's oeuvre, but even so, its significance to him is underscored by the fact that he worked the image on two separate plates, altering this, the second, in two states. The identity of the young woman in this print is as problematic as the place and date of its execution. Delteil was the first to date it 1860 and to call the figure Mlle. N. Wolkonska, although it is not known on what evidence he based his conclusions. Boggs suggested that she was a relative of Baron Bellelli in Florence and that the print was executed during Degas's brief trip there in 1860 (Chicago 1964). More recently, Adhémar maintained that the figure was Degas's niece (unspecified), the goddaughter of a Mme. Wolkonska, and that the Wolkonska family was living in Paris in 1860.

Some of this confusion may be attributed to the similarity of the print to Degas's Bellelli family portrait (fig. 3-1), which was noted by José Arguelles (Chicago 1964). Not only do the face, hair style, and dress of the sitter resemble that of Giovanna Bellelli, but the two works both include such compositional elements as the geometric design of the figures' costumes and the detailed patterning of the background wallpaper. These correspondences are sufficiently strong to confirm that they were both executed around 1859/60. Furthermore, the striking parallels between the etched portrait and a chalk study of Giovanna Bellelli (L. 68) make it possible to postulate the identity of the young girl in the etching as Giovanna.

Another work that deserves consideration in connection with this etching (which Marcel Guérin maintained was executed after a daguerreotype [Chicago 1964, no. 11]) is one Degas made after Diego Velázquez's *Infanta Isabella* (D. 12; Reff 1963: 241; Reff 1964: 252). This plate, said to have been etched on the spot before the painting in the Musée du Louvre, purportedly prompted Edouard Manet to take notice of Degas, commending his audacity for drawing directly on the plate and his intelligence for copying a painting by a master he himself revered. The similarities in pose (in reverse), expression, and lines of the costume between this etching and the printed portrait of Giovanna Bellelli surely are not coincidental, reinforcing the argument that both images date to around 1860, when Degas's association with Manet began. Moreover, sketches by Degas after the Velázquez and for the Bellelli family portrait appear in a notebook the artist used between 1858 and 1860 (Reff 1976b: 78-81, Notebook 13: 112). The influence of the Velázquez painting on the chalk study of Giovanna Bellelli cited above was noted by Russoli (1970, no. 142). (SFM)

COLLECTIONS: Estate of the artist, stamp (Lugt 657) recto, lower right, in red; SUCCESSION ED. DEGAS, stamp (Lugt 658 bis) recto, lower left, in red; Alfred P. Beurdeley and Moreau-Nélaton (per Adhémar); acquired by the AIC from Maurice Gobin, Paris; The Art Institute of Chicago, stamp (Lugt Suppl. 32b) verso, center, in brown.

EXHIBITIONS: Chicago 1964, no. 12.

LITERATURE: Delteil 1919, no. 8, repr. (first and second states); Adhémar 1974, no. 15, repr. (AIC); London 1983, no. 5, repr. (second state).

9. Young Spartans, c. 1860

Oil on canvas
97.4 x 140 cm
Charles H. and Mary F. S. Worcester Fund, 1961.334

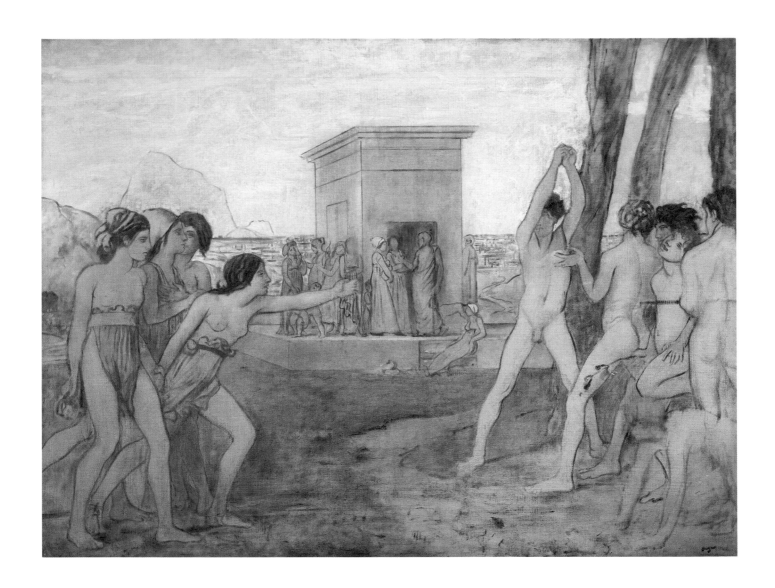

Left unfinished, unexhibited, and unexplained by Degas himself, *Young Spartans* is a persistent mystery. Its title and, hence, its subject never have been clearly established; the two versions he did of the subject have been given titles that can be roughly translated as follows: *Spartan Girls Provoking Boys* and *Young Spartans Wrestling*.

Whatever the correct title, the painting presents two groups of youths. On the left are what seem at first glance to be four semiclothed, pubescent girls, one of whom provokes or taunts an opposing group at the right of six young men, completely nude and engaged in several different athletic activities. Their confrontation is set in a spacious landscape contrived by Degas to complement the figures. Behind the young women is a distant world of jagged mountains that recalls the landscape background of Leonardo da Vinci's *Adoration of the Shepherds* (fig. 10-1), which Degas saw many times and copied at least twice (see cat. no. 10). The young men are arranged in front of a group of tree trunks that correspond to the rhythms of their bodies. In the middle distance and between the two groups of youths is a simple, flat-roofed pavilion before which Degas placed a friezelike arrangement of infants and adults who converse calmly, either unaware or unmindful of the antics of the adolescents. The youths, with their leaning, stretching, and moving bodies, are thereby as-

sociated with nature—the girls with the mountainous earth and the boys with growing trees—while their elders stand in relaxed, graceful poses utterly in keeping with the structure and order of the architecture. In the background, the ancient city of Sparta stretches across the plains.

Although Degas left a great deal of visual evidence relating to *Young Spartans* (sixteen drawings, four oil sketches, and two paintings of the subject survive), there are few passages in his notebooks or letters directly related to it. Two large versions of the subject exist: the painting in Chicago, traditionally dated 1860; and an even larger, more "finished" version in the National Gallery, London (fig. 9-1). This body of work attests to Degas's prolonged investigation of the subject; the fact that he chose the London version for inclusion in the Impressionist exhibition of 1880 is proof that this fascination lasted well into his career. Degas himself provided the date of 1860 for the London version, which is generally considered to be later than that in Chicago. However, there is ample evidence to suggest that, while he seems to have abandoned the Chicago canvas in 1860, he reworked the London version around 1865 and again in the 1870s (see Burnell 1969). The differences in conception between the London version and the earlier Chicago canvas have been discussed many times. In the London canvas, Degas not only enlarged the landscape setting and eliminated the architecture and vegetation but he also shifted from an "idealized" to a "realistic" conception of the human figure. As Lemoisne pointed

out, the Spartans in the Chicago painting become youths from Montmartre in the London version: indeed, the majority of the figure drawings made directly from models hired by Degas relate to the London rather than the Chicago composition (Lemoisne 1946: 42). In light of these differences, it is tempting to consider the London version a "solution" to the problems inherent in the one in Chicago. In fact, it is quite plausible that Degas worked on them virtually simultaneously in 1859 and 1860 and that he returned to the London version at a later date.

The Chicago *Young Spartans* has been worked most heavily in the background and in the figures of the young men at the right. The latter have been changed extensively, not by addition but by chemically dissolving the paint and scraping it away. Although there are alterations to the bodies of the young girls, particularly in their legs, it is on the crouching boy, the boy with the upraised arms, and the running boy that Degas lavished his attention, and it is these figures for which the most numerous and important drawings were made. Degas evidently created the composition from a series of multifigural drawings. He then seems to have worked not from models but directly from the preparatory drawings. Finally, he chose to abandon the archeological setting and to concentrate on the figures themselves. This decision resulted in a series of oil sketches and superb figure drawings from life done in preparation for the London composition.

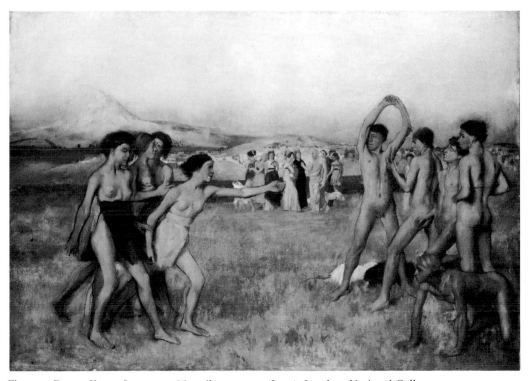

Fig. 9-1. Degas. *Young Spartans,* 1860, oil on canvas (L.70). London, National Gallery.

Numerous attempts to explain the subject of this composition have been made by appealing to classical literature and history. While several scholars have related the painting to texts by Plutarch and Pausanias, the closest connection seems to be with a passage from the Abbé Barthélemy's *Voyage du jeune Anacharsis en Grèce,* first published in 1780 and reissued many times in the 19th century: "The young girls of Sparta are not raised like those of Athens. . . . They learn. . . to wrestle with each other. . . [and] to do all sorts of exercises half-clothed in the presence of kings, magistrates, and all citizens, including young men, whom they excite to greater heights of achievement by their example, their flattery, and their taunts" (Davies 1970:50). The Abbé Barthélemy also discussed the costumes worn by these young girls, and his description is very close indeed to the details included in Degas's paintings. However, the most interesting passages are those involving Spartan courtship rituals, a subject that would have appealed strongly to the imagination of Degas, who in 1860 was 26 years old and unmarried.

Yet, parallels with a literary source—particularly an unimportant text like that of the Abbé Barthélemy—do not explain a work of art. The fact that Degas was inspired by a relatively modern rather than a classical text indicates that his intention was not of a highly intellectual order. While *Young Spartans* contains many stylistic and compositional references to the great Neoclassical tradition of history painting as exemplified by the works of Jacques Louis David, it offers none of the elevating moral character of those prototypes. It is significant that Degas based his composition on a passage from an accessible secondary source that did not deal with famous people but rather that described real life in the ancient world. In effect, in *Young Spartans* he was attempting what might be called a Realist history painting, or, conversely, a historical genre scene.

The exact meaning of Degas's *Young Spartans* is particularly difficult to clarify. Politically, Sparta was anything but a paradise. Its constitution, developed by the quasi-mythological figure Lycurgas (who often has been considered to be the male figure in the background of Degas's *Young Spartans*), was militaristic; Sparta's training of young men and women emphasized discipline, obedience, and physical strength over the intellect, creativity, or sensitivity. Such values would seem to have been totally opposite to those held by Degas. In the 19th century, just as today, Sparta was considered to have been the antithesis of Athens, the admirable, democratic city-state on which modern civilization is based. Reflecting this traditional prejudice, Spartan subjects appear only rarely among the voluminous studies of the Greek world produced in France during the 19th century: Salon paintings representing Sparta are particularly scarce, and there are no prototypes for the subject of Degas's painting.

Degas appears to have been attracted to Sparta not because of its political or dynastic history, but because of its peculiar training of young men and women. In fact, the Sparta he portrayed is one in which youth is liberated from the confines of parental guidance and is left to engage in sports and exercise freely in the countryside surrounding the city. It is tempting to say that this independence appealed to Degas for personal reasons, since his own family—both in France and Italy—had exerted what he might have felt to be an excessive influence upon him. Indeed, we do not know whether by 1859 or 1860 Degas's choice of a profession as yet had been fully sanctioned by his family, despite the fact that he had practiced it in earnest for several years.

However, the concerns that constitute the true subject of the painting are more sexual than professional in nature. Unfortunately, we know so little of Degas's romantic attachments that it is impossible even to speculate about their existence. In many ways, *Young Spartans* can be compared to the picnics and seductions painted by the young Paul Cézanne in the 1860s. But while Cézanne poured his sexual urges into paintings whose violence and brutality is almost unequaled in the history of art, Degas tamed his impulses and whispered his fears and failures, using art and history as controlling artifices. In *Young Spartans,* he came closer to a frank pictorial investigation of sex roles and adolescent sexuality than at any other time in his career.

It is perhaps only because the subject of *Young Spartans* was disguised as history that so little attention has been paid to its psychological meanings. By rigorously dividing the composition into masculine and feminine halves, Degas invoked the great ancient history paintings of the 1780s by J.L. David. Both *The Oath of the Horatii* and *Brutus* are composed as contrasts between male and female, between strength and sentiment. David's men respond immediately to the call of duty, the state for them always carrying greater meaning than family. His women, to the contrary, are bound to family and to the emotional ties that unite it. Unlike David, Degas did not consider classical history as a series of heroic deeds performed by men and reacted to by women. In *Young Spartans,* he was drawn to a social system in which men and women, though divided, were equal and trained in a like manner. Comparison of Degas's composition with that of *The Oath of the Horatii* reveals an element of satire on the part of Degas. Indeed, the gesturing girl at the left is almost a caricature of the young oath takers in David's famous painting. *Young Spartans* reflects the developing notions of the "Amazon," or independent woman, then a concern of Paris. That these ideas were opposite not only to the conservative beliefs of Degas's own family but to the ideologies and practices of the major 19th-century French institutions, both secular and sacred, makes the composition particularly remarkable. Despite its

apparently conservative formal structure, *Young Spartans* is truly idiosyncratic and radical in meaning.

Careful examination of *Young Spartans* reveals subtle, expressive details. The various athletic tasks in which the young men to the right engage allowed Degas to explore movement and tension in the male body. All of the boys are aware to one degree or another of the girls. One seems to be shielding himself from the provocations of the aggressive girl by raising his arms (a gesture that is altered in the London version of the composition). Two figures have just rushed into view from the right. One youth turns his face completely from the girls (this, too, Degas changed in the London version, making all the figures confront the opposition directly). Another figure, turned away from the viewer and balancing a pole against his back, glances obliquely at the girls. In fact, only the crouching youth, his body poised as if at the start of a race, looks right at them. In their various responses to the gesturing girl, the youths seem charmingly shy and evasive.

Even more fascinating is the female half of the composition. Although at first glance there appear to be four female figures, in fact, there are ten legs—two too many for the torsos. This disparity, occurring in both the Art Institute version and the most finished composition drawing (Fogg Art Museum, Cambridge, MA), suggests that the upper torso and head of one female figure is hidden behind the girl in the near left foreground. The two girls in the foreground differ from one another in virtually every way but their sex, costume, and age. The one at the far left appears timid, afraid of the boys. Her headdress and skirt neatly arranged, she stands motionless, her right arm hanging limply at her side and her left hand grasped by a bareheaded girl, who gestures aggressively at the boys. Behind this pair is another couple that in no way is analogous to the first. Unlike her companions, the female in profile is dressed in a costume that covers her breasts, and a cloth headdress is wrapped over her hair. She seems unaware that she is being stared at by another figure who could easily be mistaken for a male because of her short-cropped hair. This latter figure is alone among the females in showing no interest in the boys at the right. She is also the only figure to face the viewer, although her gaze is directed toward her carefully clothed companion.

The moment Degas selected for his historical genre scene is the first stage of courtship. The central female figure, clothed like a woman, her arms drawn protectively across her breasts, stares as if hypnotized at the posturing youths, who seem at once attentive to and afraid of her presence. The youth nearest to her appears to stretch, revealing the full extent of his body to her and to us. Thus, Degas marked him as her mate for a marriage that will never occur, trapped as it is in this state of pictorial anticipation. Clearly, Degas chose Sparta as an open-air laboratory for his own anxious exploration of courtship. Here, nude youths and semiclothed girls use their bodies to express their fears and hopes for physical love. That such a subject was directly relevant to Degas himself is clear, even though we cannot at present speculate about its meanings. It is worth remarking, however, that as a work of art, *Young Spartans* is in many ways analogous to Marcel Duchamp's *Bride Stripped Bare by Her Bachelors, Even,* called *The Large Glass.* In each, the artist analyzed the mechanisms of sex as they relate to marriage; also in each, the conditions for a marriage were created by the artist in such a way that the viewer—and the participants in the marriage "rite"—are left in a state of unfulfilled expectation. The psychological conditions that led to the creation and, to use Duchamp's word, "incompletion," of each masterpiece are surely not unrelated.

Why did Degas abandon the Chicago version of the composition and continue to work on a virtually identical figural construction set in a larger landscape with more "Realist" figures? Possibly, he wanted to make the meaning of the picture's subject clearer and more relevant to contemporary viewers. If he had chosen to "finish" the Chicago composition and to submit it to the Salon, he would have run the risk of its being misinterpreted as a conservative history painting because of its conventional form and setting. Degas intended to inject new and radical ideas into the receptacle of the classical history painting—and that is what is truly subversive about *Young Spartans.*

Another possible reason for Degas's stopping work on the Chicago *Young Spartans* involves Leonardo. If the landscape owes its forms to the background of Leonardo's *Adoration of the Shepherds,* so too does the "finish" of *Young Spartans* correspond to that of Leonardo's unfinished masterpiece. Indeed, it is possible that Degas intended to "finish" only one large version of the composition, and that he left the Chicago version in a state analogous to that of Leonardo's *Adoration.* The psychological resonance of such a notion is great indeed: a painting about the training and courtship of youth becomes an allegory of formation precisely because it is left partially unfinished. Leonardo's failure to "finish" must have moved and haunted the young Parisian artist, who was plagued on several levels with related fears. (RB)

COLLECTIONS: Estate of the artist, Vente II, 7, stamp (Lugt 658) recto, lower right, in red; René de Gas, Paris (sale: Paris, Nov. 10, 1927, no. 76, repr.); Durand-Ruel, Paris; Jean d'Alayer, Paris, 1950; acquired by the AIC from Sam Salz, New York.

EXHIBITIONS: Bern 1951-52, no. 2; Amsterdam 1952, no. 5; Paris 1955a, no. 9, repr.; Paris 1960, no. 2, repr.; Tokyo 1976, no. 4, repr.

LITERATURE: Lafond 1918-19, II: 4, repr.; Lemoisne 1946, no. 71, repr.; Chicago 1960-61: 11; Pool 1964: 309, no. 6, repr.; Maxon 1966: 216, fig. 8; Burnell 1969: 49-65, fig. 1; Russoli 1970, no. 89, repr.; Chicago 1971: 28.

10. Adoration of the Shepherds (after Leonardo), 1860

Inscribed recto, upper right, in graphite: *Florence 1860/Leonarde de Vinci*
Graphite on buff wove paper
Max. 265 x 216 mm
Worcester Sketch Fund, 1969.374

Degas made at least two drawings after Leonardo's famous *Adoration of the Shepherds* (fig. 10-1) on his visit to Florence in the summer of 1860. He copied the complete composition in a drawing (Vente IV, 85b; St. Louis 1966-67: 44-5). The central portion of the painting provided the focus of the sheet in the Art Institute. Both drawings, executed rapidly in graphite, record the painting in similar ways. Degas concentrated on the figural composition rather than pictorial space or particular forms, capturing the major figures with strongly drawn contours set off by diagonal hatching. It is interesting that he neglected the central element of the painting—the infant Jesus. Instead, the Madonna, Joseph, and the three Shepherds interact powerfully around the area of Christ's body, which is little more than a compositional void. The fact that Degas chose twice to de-emphasize—even omit—the figure of Christ is highly unusual and must have a psychological explanation as yet not understood.

Of all Degas's copies of famous works of art, it is appropriate that the Art Institute should possess one after Leonardo's famous painting drawn in the same year in which Degas worked on *Young Spartans* (cat. no. 9). The mysterious state of incompleteness for which the *Adoration* was famous even in Degas's day surely must have been in the young artist's mind when he abandoned (perhaps intentionally) *Young Spartans*. (RB)

COLLECTIONS: Estate of the artist, stamp (Lugt 657) verso, upper right, in violet; Vente IV, 85c, repr., stamp (Lugt 658) recto, lower left, in red; acquired by the AIC from Richard Zinser, New York.

LITERATURE: Chicago 1979, 2E3.

Fig. 10-1. Leonardo da Vinci (Italian, 1452-1519). *Adoration of the Shepherds,* oil on canvas. Florence, Galeria degli Uffizi. Photo: L. Goldscheider, *Leonardo da Vinci* (London: Phaidon Press, 1943), pl.72.

11. Edouard Manet, c.1862/65

Etching on white wove paper; first state of four
Plate 130 x 105 mm; sheet 314 x 226 mm
Joseph Brooks Fair Collection, 1932.1295

If the story of the meeting of Manet and Degas before the painting *Infanta Isabella* by Velázquez in the Louvre is legendary (see cat. no. 8), no less so was their friendship. Although it is difficult to date the beginning of this alliance, because of a preliminary sketch by Degas for his etching after the Velázquez that appears in a notebook dated 1859-60 (Reff 1976b: 81, Notebook 13: 112), it is now thought to have occurred around 1860.

One can well imagine how sympathetic the two artists would have found one another. Each had come from haut-bourgeois Parisian families and had received solid educations. Each wanted the discipline and recognition provided by the Académie, an institution for which they also felt irreverence. And each was torn between a profound admiration for Old Master paintings and a compelling need to break with the past. Their shared concerns seem to have extended into more personal realms, ranging from a love of music to the care these two short but dapper gentlemen took in their appearance.

The cosmopolitan Manet opened many new doors for the younger and more withdrawn Degas. For nearly a decade, Degas frequented with Manet the Café Guerbois, where he could engage with fellow artists and critics; he also attended musical soirées in Manet's home often accompanied by his father. The influence of Manet on Degas certainly was profound and multifaceted; that he himself realized the direction he gave his colleague is suggested by his remark, "When I was painting modern life, Degas was still painting *Sémiramis*" (Dunlop 1979: 53).

Degas's involvement with Manet is attested by a number of drawn, etched, and painted portraits he made of his colleague during the 1860s. Few of these are inscribed, but many have been dated between 1864 and 1866, for no apparent reason. Of the three etched portraits of Manet, this bust-length study is generally considered the earliest, probably because of its more conventional character. The plate went through four changes in state (according to Moses [Chicago 1964, no. 13], there seems no reason to accept Delteil's listing of a fifth state), in which a very forceful, linear portrait was reworked by the addition of cross-hatching and aquatint to build up the clothing and background.

The first state, shown here, is by far the most powerful. It is a pure etching in which the creative force and intelligence of the subject is clearly communicated. In this plate, Degas's etching style, in which he employed a summary, regular, and strong line to portray directly Manet's features and to evoke tone and substance, shows marked advances over the artist's previous efforts in the technique and may well reflect the influence of contemporary printmakers who were creating an etching revival in Paris. In 1862, the Société des Aquafortistes was founded to promote the art of etching. Manet very likely introduced Degas to this circle; the leader of the movement, Félix Bracquemond, is known to have advised Degas in printmaking. Moses pointed out that in this portrait of Manet can be felt the portrait style of the prolific etcher Alphonse Legros, with his emphasis on the features of the head and sketchy depiction of the body, or that of Whistler's portrait etchings of 1859, such as that of Brouet.

This print has been dated by Delteil to 1864, by Moses to 1865, and by Adhémar and Passeron to around 1861, without explanation. While it is tempting to link Degas's etched portraits of Manet to the early encounters of the two artists, around 1860, the influence on Degas of the Société des Aquafortistes after 1862, as well as the assured draftsmanship and incisive portrayal of character displayed in this print, supports a later date, between 1862 and 1865. (SFM)

COLLECTIONS: A. H. Rouart, Paris, stamp (Lugt Suppl. 2187a) recto, lower right, in purple; acquired by the AIC from Marcel Guiot, Paris; The Art Institute of Chicago, stamp (Lugt Suppl. 32b) verso, lower left, in brown.

EXHIBITIONS: Chicago 1964, no. 13, repr.

LITERATURE: Delteil 1919, no. 14, repr. (first and fourth states); Adhémar 1974, no. 17, repr. (fourth state); Passeron 1974: 62-4.

12. Manet Seated, Turned to the Right, c. 1862/65

Etching on ivory wove paper; third state of four
Plate 195 x 128 mm; sheet 315 x 225 mm
Charles F. Glore Collection, 1958.12

Among the fourteen portrait etchings Degas made in the first decade of his printmaking activity (1855-65), no subject occurs as frequently as Edouard Manet. In addition to a powerful bust-length portrait (cat. no. 11), Degas executed two etched compositions showing the artist seated in a three-quarter pose, his contemplative expression making him seem unaware that his likeness was being caught. The informal, unconscious pose marks a significant departure from Degas's previous traditional portrait formats in the mode of Ingres or Rembrandt. This attempt to capture an unguarded moment may reflect Manet's commitment to the depiction of modern life.

The portrait of Manet turned to the left (D. 15), with hat in hand and legs crossed, is rather circumspect. Of the two portraits, that of Manet turned to the right (cat. no. 12) is the more radical in its studied informality. The artist sits slumped astride a chair, his top hat lying on the ground and the back of a canvas propped against a wall behind him. That this image was originally drawn directly from the model is confirmed by a sheet of pencil studies, nervously executed and corrected, to which the etching corresponds almost exactly, in reverse (Lemoisne 1946, I, repr. opp. p. 50). The various states of the etching testify to Degas's deliberate construction of the image from this sheet. In the first state, he delineated the figure without including any surrounding attributes; he added the hat and canvas in the second state and clarified and strengthened the contours in the third. In the fourth state, the face, hat, and background were erased.

Technically as well as compositionally, Manet's influence is evident in this etching, which resembles such prints by him as *The Gypsies* (published in the Société des Aquafortistes' first portfolio, in September 1862) and *The Absinthe Drinker* (1861/62; published by Cadart in the same year). The latter print (fig. 12-1)—with its informally posed figure placed before a shadowy backdrop, inclusion of props (a bottle is seen at his feet), and use of regular hatchings throughout—displays many parallels with Degas's portrait of Manet seated.

Like the majority of Degas's portraits of Manet, this print and its preliminary study have been dated to between 1864 and 1866 and, more recently, by Adhémar to about 1861. Comparison of the sketches with Degas's somewhat tentative and flatly drawn *Portrait of Julie Bertin,* dated by the artist 1863, and the *Portrait of Mme. Hertel,* signed and dated 1865 (both Fogg Art Museum, Cambridge, MA), supports an earlier date for this composition. While clearly more masterful than the previous portraits (see cat. nos. 3-6), it still does not have the linear assurance of *Mme. Hertel.* (SFM)

COLLECTIONS: Estate of the artist, stamp (Lugt 657) verso, lower right, in red; acquired by the AIC from Marcel Lecomte, Paris.

EXHIBITIONS: Chicago 1964, no. 15, repr. (second state).

LITERATURE: Delteil 1919, no. 16, repr. (first state); Adhémar 1974, no. 19, repr. (AIC); Passeron 1974: 62-4, repr.

Fig. 12-1. Edouard Manet (French, 1832-1883). *The Absinthe Drinker,* 1861/62, etching. The Art Institute of Chicago, William McCallin McKee Memorial Collection (1953.532).

13. Mme. Michel Musson and Her Daughters Estelle and Désirée, January 6, 1865

Inscribed recto, upper left, in graphite: *Bourg en Bresse. 6 Janvier/1865/E. Degas—*
Graphite, brush with gray, brown, and red chalk wash, and black chalk, heightened with white gouache, on cream wove paper
350 x 265 mm
Margaret Day Blake Collection, 1949.20

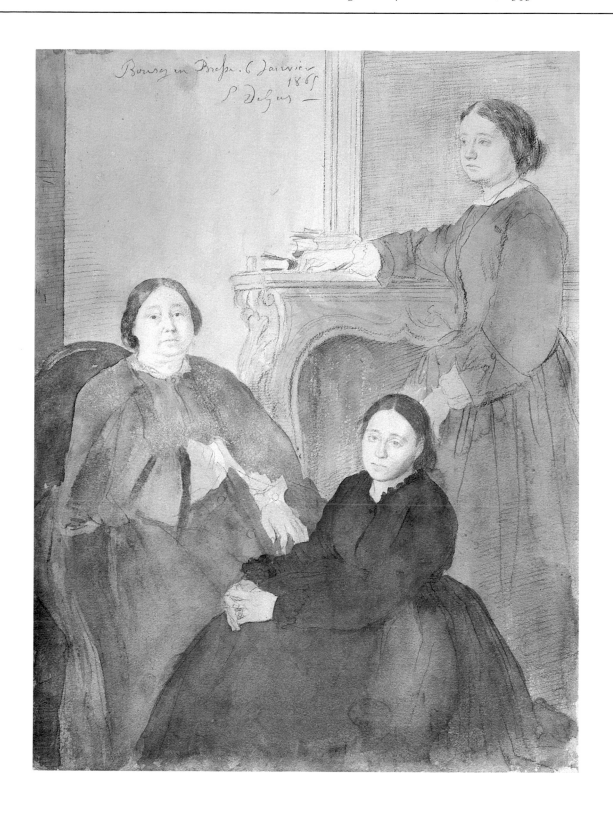

Degas was always particularly fond of his American relatives, the Mussons. Although his mother and her siblings—born in New Orleans—had returned to France for their educations, one of Degas's uncles, Michel, moved back to Louisiana to seek his fortune on the cotton exchange. Degas's most active association with this part of his family occurred during a ten-year span, from June 18, 1863, when he welcomed his aunt and her two daughters to France, to 1872-73, when he visited New Orleans. From the outset, these cousins seem to have captured the sympathy and interest not only of the artist but also of his brothers and sisters.

After his young, pregnant daughter Estelle lost her husband, David Balfour, in battle at Corinth, Mississippi, in 1863, Michel Musson decided to spare his wife, Mathilde; his daughters Estelle and Désirée; and Estelle's newborn daughter, Joe; any further ravages of the Civil War by settling them in Bourg-en-Bresse, just over 400 miles from Paris. They had been in France for over 18 months when Degas made this moving family portrait of them. The substantial, matriarchal Mme. Musson is seated at the left; at her feet is the sullen figure of Estelle, holding her knees and staring, like her mother, at the viewer. Désirée, the more beautiful, unmarried daughter, leans on the mantelpiece and gazes out beyond them.

One of the rare works that Degas both signed and dated, noting even the location of its creation, this drawing was executed on the Feast of the Epiphany, January 6, 1865. Correspondence describing the artist's visit to the family during the New Year's holidays of the previous year suggests that Degas might have paid his cousins an annual visit at this time (Boggs 1956: 60). Yet, even on what must have been at least their third reunion, the sadness of the situation that had brought this family to France continued to move the artist as much as it had when he first met them: "As for Estelle, poor little woman, one cannot look at her without thinking that before that face are the eyes of a dying man" (ibid.). In addition to Estelle's mourning, symbolized here by her dark dress, one can also feel her despair at her increasing loss of vision (she was to go blind by 1866); and one can almost sense her future burdens: in 1869, she would marry the artist's younger brother, René, bear him five children, and, eventually, be deserted by him.

Because of an inscription once made by the collector and Degas scholar Marcel Guérin on the back of the original frame, there has been some confusion about the identity of the daughter standing at the mantle. Guérin identified her as another daughter, Mathilde; however, from all accounts, she did not accompany her mother and sisters to France. The gracefulness of the figure in the drawing accords with family descriptions of Désirée. Further confusion exists over the identification of the sisters in other works in which they figure.

In such revealing details as Désirée's distracted gaze, Estelle's slumped form, and Mme. Musson's lazy stodginess, one can detect the "photographic" candor that would appear in Degas's later work. The family group, gathered before the fireplace as though posing for a daguerreotype portrait, is depicted in a casual but nonetheless formal arrangement, which, like that of the earlier *Bellelli Family* (fig. 3-1), was influenced by Ingres's portrait drawings such as *The Gatteau Family* (see Boggs 1962, pl. 26). Nonetheless, in the Chicago drawing, there is a compositional and emotional harmony not found in the Bellelli portrait, in which familial discord is expressed in the separation of the father from the rest of the group.

The unity of spirit in the Art Institute group portrait is enhanced by an almost monochromatic wash technique; subtle shifts from gray to brown to pink wash and touches of white gouache enliven the generally uniform effect. Its unusual palette, matched only by the portrait of *Rose, the Duchess of Morbili* (fig. 7-2), might be interpreted as Degas's attempt to echo the effects of contemporary photography. On the other hand, its cool, gray colors and modified classicism, as in Degas's portrait of Marguérite (fig. 7-1), may have been inspired by Ingres's painted portraits. The use by Degas of the difficult watercolor medium in such limited tones is rare.

The following year, 1866, Degas made another portrait (L. 137) using elements of the Art Institute wash drawing: he depicted Mlle. Dubourg (later Mme. Henri Fantin-Latour) before a mantle, in a slumped, frontal pose similar to that of Estelle. Yet, in the Dubourg portrait, the elements are portrayed in a more casual and daring manner: the mantel is cut off at the right, and an empty chair at the left distracts the viewer's attention. Ultimately, with the double portrait *Mme. Lisle and Mme. Loubens* (cat. nos. 14, 15), which may be only slightly later, Degas returned to a more classically composed, multifigured group before a fireplace.

The Musson family portrait is outstanding on many counts: as a rare signed and dated work, as a sympathetic family portrait in miniature, as an example of exquisite and unusual execution related perhaps to Degas's interest in photography, and as an unparalleled expression of emotion involving both a tragic past and future. Here, as Boggs said, "Degas himself was less an observer—a camera—than a sympathetic human being responding with a certain compassion to [his subjects'] loneliness. He seemed finally to have broken emotionally through the picture plane" (Boggs 1962). (SFM)

COLLECTIONS: Estate of the artist, stamp (Lugt 657) recto, lower right near center, in red; Henri Fèvre (the artist's nephew); Marcel Guérin, Paris; acquired by the AIC from Jacques Seligmann and Co., New York.

EXHIBITIONS: Detroit 1951: 84, no. 190, repr.; Paris 1955b, no. 68, pl. 59; New York 1963, no. 102, repr.; Chicago 1970, no. 32, repr.; Paris 1976-77, no. 57, repr.; Frankfurt 1977, no. 58, repr.

LITERATURE: Boggs 1956: 60-4, fig. 1; Boggs 1962: 21, pl. 40; New Orleans 1965: 52, pl. VI; Dunlop 1979: 44-8, pl. 44; Chicago 1979, 2E4.

14. Portrait of Mme. Lisle and Mme. Loubens, 1865/69

Graphite on tan wove paper, squared for transfer in black crayon
Max. 284 x 320 mm
Mr. and Mrs. Henry C. Woods Fund, 1977.311

15. Portrait of Mme. Lisle and Mme. Loubens, 1865/69

Oil on canvas
84 x 96.6 cm
Gift of Annie Laurie Ryerson in memory of Joseph Turner Ryerson, 1953.335

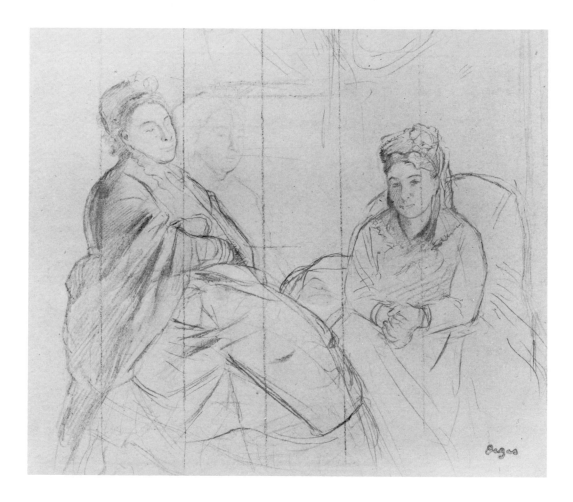

The two women seated comfortably together on a cushioned chaise in this dark interior were friends rather than relatives; in painting them, Degas explored a kind of intimacy rare in portraiture at the time. Mme. Loubens, on the right, was a friend of Manet's; it is likely that both she and her husband appear in his famous *Music in the Tuileries* of 1862 (fig. 14/15-1); she is the figure without a veil at the left. Both women were occasional visitors to Manet's salon during the last years of the Second Empire. Writing sarcastically about them, the artist Berthe Morisot noted the way in which Degas lavished all his attention on what she called these "two silly women" at the opening of the Salon of 1869 (Morisot 1950: 27). Thus, it has been customary to date the painting to the years 1869/70, although its style indicates that the portrait could have been painted as much as five years earlier.

Perhaps the most startling and interesting observation to be made about the portrait is its connection with Manet's *Music in the Tuileries,* in which Mme. Loubens's companion has always been identified as Mme. Lejoysne. Yet, if Degas based the poses of his two figures on an earlier representation of Mme. Loubens with a friend, he totally disguised his source. Manet placed the two women in the midst of a crowd; Degas isolated them. Manet dressed them in white; Degas dressed them in black. Manet situated them out-of-doors in a park; Degas put them in an interior. Manet surrounded the figures with dark-green chestnut leaves; Degas selected for his room almost the exact color opposite of Manet's green—a deep red. In light of this, one wonders whether Degas painted the two women after the deaths of their husbands. Each wears black, and both are enshrouded in a dark interior, as if in mourning.

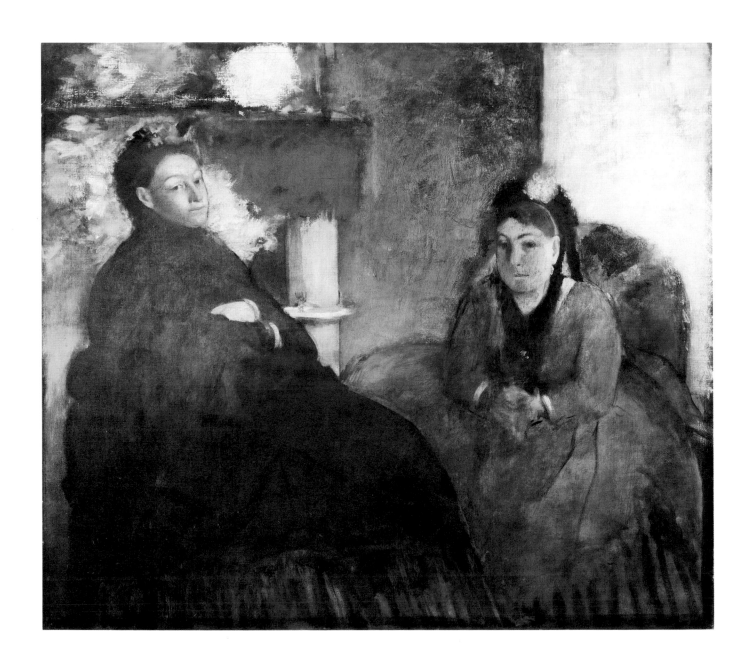

Unfortunately, as yet not enough is known about their lives to prove such an interpretation.

The Art Institute of Chicago is fortunate to possess not only the painting, but also a superb compositional drawing for it. The latter is a highly accomplished exercise in linear composition: the pencil has been pushed and jabbed into the paper, and the lines define at once the contour and structure of female finery. In the drawing, the head of Mme. Lisle was shifted from a vertical position to a more relaxed, tilted pose, creating a contrast with the masklike, frontal head of Mme. Loubens. There is barely a hint of setting in the drawing, although there are several transfer lines in the background that become elements of the setting in the painting. Interestingly, the drawing, which originally included two male figures standing between the two women, was later cut down to conform to the final composition. In a catalogue of the sale of the effects from the artist's studio (Vente II), the drawing is listed as 44 x 32 cm. When the sheet was sold in 1977, its present dimensions were given.

Degas's method of preparation and transfer is worthy of discussion. First, he drew and corrected the figures of the women in graphite on a sheet of paper. Then, he settled on transfer lines according to the major divisions he used most often in his canvases—halves, thirds, and quarters. In the painting, two of these lines became structural forms, one the edge of the mantelpiece and the other that of the window. It is clear that Degas did not paint either Mme. Lisle or Mme. Loubens from life. While the two women posed together for him, he determined the composition and then made detailed pastel portraits of each woman separately (L. 266, 267). Once he had translated the pastel portraits into oil, the painting took on a life of its own. Degas scraped areas in the background as well as around the hands and heads. He also altered repeatedly the colors surrounding the two monochromatic figures. And, most importantly, he seems to have called back his models, particularly Mme. Lisle, for he worked again on her head, which differs in the painting from both the pencil drawing in the Art Institute and her pastel portrait.

The painting was left unfinished and was never exhibited in Degas's lifetime. This and the fact that so little is known about the sitters make its interpretation difficult. We cannot know what prompted the artist to paint it until we know more about the subjects and their particular relationship to him. (RB)

14.

COLLECTIONS: Estate of the artist, Vente II, 337, stamp (Lugt 658) recto, lower right, in red; P. de Bayser, Paris; Mrs. Eliot Hodgkin, Chelsea (sale: London, Sotheby and Co., Mar. 30, 1977, no. 106, repr. [bought in]); acquired by the AIC from Mrs. Hodgkin.

LITERATURE: Chicago 1979, 2E9; Marandel 1979: 32, repr. p. 33.

15.

COLLECTIONS: Estate of the artist, Vente I, 105, stamp (Lugt 658) recto, lower right, in red; Jacques Seligmann, Paris (sale: New York, Jan. 27, 1929, no. 59); The Detroit Institute of Arts, 1921; deaccessioned by exchange in 1935 to E. and A. Silberman Galleries, New York; Mr. and Mrs. Joseph Turner Ryerson, Chicago; Mrs. Hugh A. Kirkland, Chicago.

EXHIBITIONS: Fort Worth 1954, no. 20, repr.; New York 1960, n.p.

LITERATURE: Detroit 1922: 39; Detroit 1927: 147, repr. (as "Two Women Seated"); Detroit 1930, no. 55 (as "Two Women Seated"); Lemoisne 1946, no. 265, repr.; Rich 1954: 22-4, repr. (frontis.); Chicago 1961: 119; Russoli 1970, no. 265, repr.

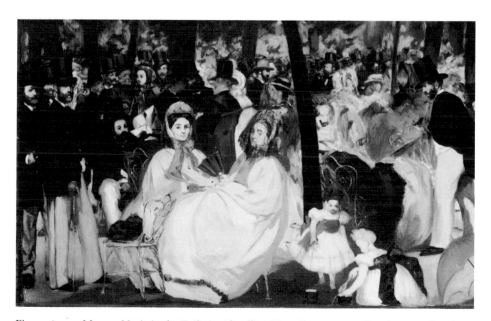

Fig. 14/15-1. Manet. *Music in the Tuileries* (detail), 1862, oil on canvas. London, National Gallery.

16. Young Woman Playing a Mandolin (Study for "Mlle. Fiocre in the Ballet 'La Source' "), 1866/68

Graphite on ivory laid paper
Max. 355 x 214 mm
Gift of Robert Allerton, 1923.293

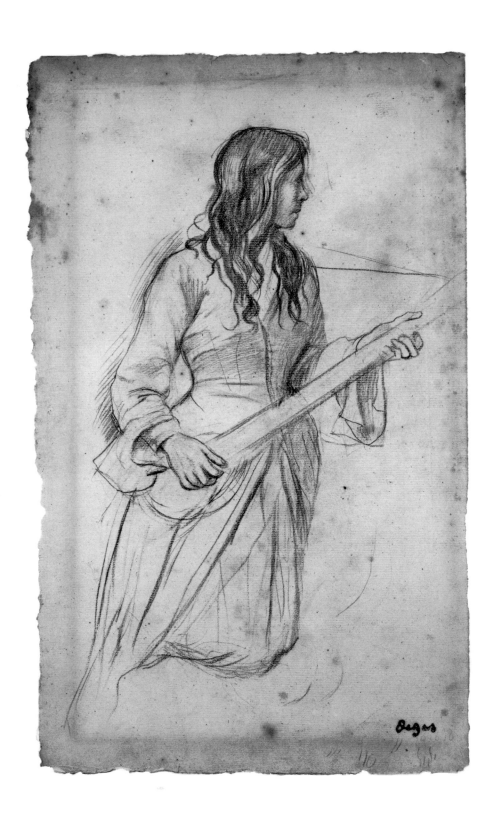

It is one of the ironies of Degas's art that just as his major history paintings do not depict historical subjects, so, too, his earliest image of the ballet, *Mlle. Fiocre in the Ballet "La Source"* (fig. 16-1), bears little reference to dance (aside from ballet slippers seen between the horse's legs) but rather resembles more closely a historical tableau. (The painting actually marks the second time Degas depicted a theatrical subject, his *Sémiramis* of 1861 [L. 82] having been inspired by Rossini's opera of the same name.) As if constructing a major history painting, Degas, in preparing *La Source,* relied on individual figure studies in pencil as well as on compositional oil sketches.

As the title suggests, the painting also functions as a portrait. Eugénie Fiocre was at the pinnacle of her career when she played the role of Nouredda in Saint-Léon's ballet *La Source,* which first opened at the Théâtre Imperiale de l'Opéra on November 12, 1866 (see Browse 1949:52, for details regarding this performance). Although ballet is said to have entered a general decline following its great flourishing with the stars of the Romantic era, this production was renowned. It included Louis François Mérante and Ernest Pluque, two of the foremost male dancers and themselves later subjects for Degas. In addition to its performers, what made the spectacle newsworthy was the use of a real horse and actual water, at least in the revival production of 1872, as attested by reviews in *Le Figaro* (Browse 1949: 51 n. 6). Not surprisingly, Degas responded to these realist elements. Selecting a scene from the first act of the ballet, Degas showed Mlle. Fiocre as Nouredda, in her oriental costume and mitred hat, seated by a pool and surrounded by two attendants and a horse drinking from the water. Although Paul St. Victoire, in his review of November 18, 1866 (Browse 1949: 51), described Mlle. Fiocre as holding a guitar and dancing in her mitred hat with her limbs floating in gauze pantaloons ornamented with gilt, Degas chose to depict a contemplative moment, one suggestive of inner conflict and melancholy. If the total pictorial effect seems staged and artificial, it is not because Degas did not prepare for it carefully but rather because, in this canvas, Degas did not succeed in penetrating the subject for a deeper understanding of the whole ballet. Precise pencil studies of the various figures indicate that Degas must have drawn from actual models; whether Degas used one of his earliest wax models for the horse in this composition also has been debated (Browse 1949: 35; Rewald 1957: 15, 141; Millard 1976: 5-6).

The sheet in Chicago depicts the most active member of the scene. In the painting, the graceful, standing attendant, seen in profile, contrasts markedly with the frontal, seated figures of the principal dancer and second attendant. That Degas arrived at this solution after some experimentation is suggested by a sketch of approximately equal size for the same figure in a three-quarter pose (Vente IV, 247a).

The handling of the Art Institute's refined drawing for the attendant to the left of Nouredda compares with that of Degas's portrait drawings of the mid-1860s, such as *Study for a Portrait of Marguérite* (cat. no. 7). The artist's indebtedness to Ingres can be felt in both the painting and in the preparatory studies. An oil sketch for two of the figures, placed in a landscape (L. 148), recalls Ingres's painting of an elegant nude in a natural setting, also called *La Source.* In the Art Institute drawing, the attention paid to contour and to the subtleties of graphite shading clearly resemble the older master's drawing style. (SFM)

WATERMARK: VANDERLEY

COLLECTIONS: Estate of the artist, stamp (Lugt 657) verso, upper left, in red; Vente IV, 79a, repr., stamp (Lugt 658) recto, lower right, in red; Robert Allerton, Chicago.

EXHIBITIONS: Iowa 1951, no. 136, repr.; New York 1958, pl. 10.

LITERATURE: Browse 1949, no. 2, repr.; Champigneulle 1952, no. 23, repr.; Chicago 1979, 2E5; London 1983, no. 6.

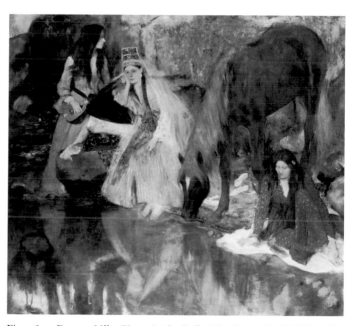

Fig. 16-1. Degas. *Mlle. Fiocre in the Ballet "La Source,"* 1866/68, oil on canvas (L.146). The Brooklyn Museum, Gift of James H. Post, John Underwood, and Augustus Healy (21.111). Photo: Courtesy of the Brooklyn Museum.

17. Four Studies of a Jockey, 1866

Brush with black ink, oil paint, and white gouache on tan
wove paper coated with brown essence (?)
450 x 315 mm
Mr. and Mrs. Lewis Larned Coburn Memorial Collection,
1933.469

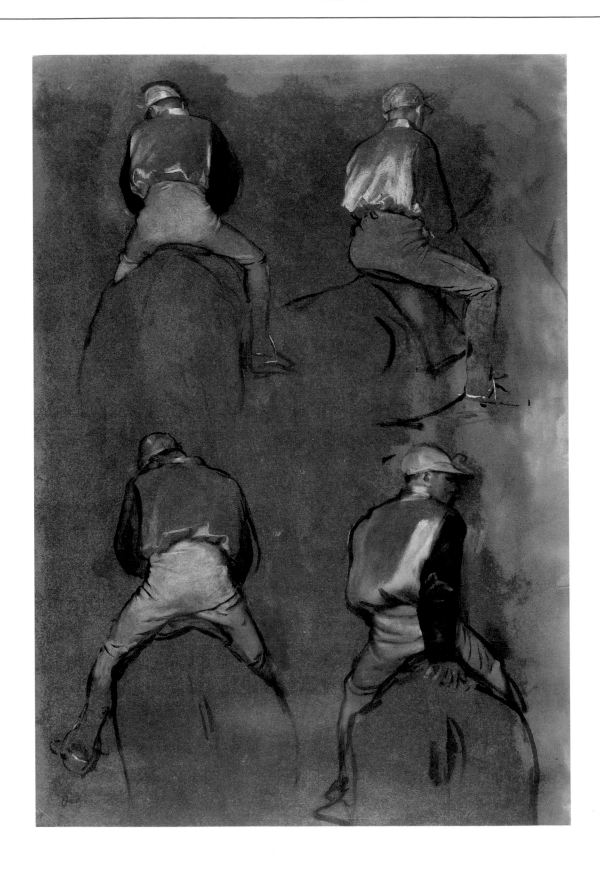

The four drawings (cat. nos. 17-20) in the collection of the Art Institute that depict riders—either gentlemen or jockeys—were all executed in the last half of the 1860s. In three cases, the individual riders are unidentified; and in the other (cat. no. 17), the model in effect is faceless and therefore anonymous. In them, Degas explored in detail the positions of variously clothed riders on mounts that remain unfinished.

This sheet of studies is at once brilliant and incisive, analyzing the form of a jockey viewed from the back. Skillfully executed in black ink, oil paint, and gouache, the drawing resembles an oil sketch or *ébauche*. This technique, recommended countless times by writers and teachers of painting in the 19th century, involved priming a canvas with a brownish monochrome layer of pigment on which the artist then worked in black and white, allowing the brown ground to show through liberally and to act as the middle tone between black and white. In fact, this sheet might even be called an *ébauche* on paper, because it brings to drawing qualities of form found more often in painting during Degas's lifetime (see Boime 1971, passim).

Yet, if the technique and coloring of this drawing owe a great deal to the practice of oil painting, the composition originated in drawing. An oil *ébauche* functioned as a study of the chiaroscuro of an entire composition rather than of a single figure or element. Here, Degas investigated a single subject. He divided his sheet into four parts, into each of which he placed a study of the model, recalling the multi-figured sheets of an artist like Antoine Watteau (see fig. 17-1). Indeed, Degas's debt to the great 18th-century painter and draftsman, whose career had been championed recently in the writings of the Goncourt brothers, extended beyond the composition of this sheet to its true subject: the sheen of racing silks covering the jockey's body. If Watteau investigated satin breeches and dresses with an enthusiasm unequaled in the 18th century, Degas was his 19th-century counterpart, and a jockey's brilliantly colored costume was perhaps the only 19th-century equivalent in male clothing to the silks worn by Watteau's courtiers, actors, musicians, and gentlemen.

Yet, comparison with Watteau, while appropriate at certain levels, must not be forced. His drawings are everywhere nervous and febrile—less descriptions than evocations of form composed of hundreds of short, delicate chalk lines. For Degas, the control of contour was an absolute value, and his single, long strokes of gouache or ink convey virtually the same visual information as a host of chalk lines by the Rococo artist. There is something assured, even calculated, about Degas's study; it is among the few such sheets from his entire career that have no apparent corrections or indications of doubt or indecision. This confidence is explained in part by the presence of traces of graphite and black chalk under the ink and gouache, suggesting that Degas first defined the

forms and then, when they were firmly secured on the page, turned to his brush to make a few unchangeable, perfectly placed strokes.

It is tempting to ransack Degas's finished pastels and paintings of races for related jockeys, since many of Degas's later jockeys are close in pose to one or another of the figures on this sheet. Yet, such an effort would be misleading. It is likely that Degas made this sheet as part of a general graphic analysis of what might be called the visual grammar of the horse race. Sheets such as this one must be viewed therefore as complex exercises that the artist intended to use in various ways at various times. Later, Degas may well have borrowed an eloquent contour from one part of one figure on this sheet and a sheen of silk from another. Any list of the related works would be long, and many would be distant in both style and date from this early example. Degas himself recognized the self-sufficiency of this brilliant drawing by authorizing a reproduction of it made by Goupil about 1897. At that time, the drawing was dated 1866, and there is no need to alter that date. (RB)

WATERMARK: **FRERES**

COLLECTIONS: Estate of the artist, Vente III, 114, repr., stamp (Lugt 658) recto, lower left, in red; M. Fiquet, Paris; Nunes, Paris; Mrs. Lewis Larned Coburn, Chicago.

EXHIBITIONS: New York 1963, no. 103; St. Louis 1966-67, no. 46, repr.; Palm Beach 1974, no. 10, repr.; Paris 1976-77, no. 58, repr.; Frankfurt 1977, no. 59, repr.

LITERATURE: Paris 1898, pl. 7; Lemoisne 1946, no. 158, repr.; Mongan 1962, III, no. 778, repr.; Russoli 1970, no. 186, repr.; Chicago 1978: III, repr.; Chicago 1979, 2E6; London 1983, no. 7.

Fig. 17-1. Jean Antoine Watteau (French, 1684-1721). *Four Studies of Italian Comedians,* chalk on paper. The Art Institute of Chicago, Gift of Tiffany and Margaret Blake (1954.1).

18. Jockey, 1866/68

Graphite with estompe on tan wove paper, formerly laid down
328 x 246 mm
Gift of Robert Allerton, 1922.5518

Like the other sheets depicting jockeys in the collection of the Art Institute, this splendid study was made far from the noise, excitement, and motion of an actual racecourse. Degas captured the clear, light eyes, drooping mustache, incipient goatee, and short, slightly curled sideburns of a man who sat for the artist in his studio in the cap and jacket of a jockey. His costume actually is incomplete: lacking are the requisite riding boots that cover the pants to the mid-calf. Degas seems to have had difficulty and finally to have become bored with the shoes and the position of the feet in what ought to have been stirrups. In the end, it was the sheen of the satin riding jacket and the glazed, somewhat dreamy expression of the model that fascinated Degas, and he barely suggested either the horse or the saddle on which the jockey supposedly was mounted.

Although the drawing often has been dated 1878/80, Ronald Pickvance realized that this is surely too late (Edinburgh 1979: 12). Despite the fact that it bears no precise relationship to any painting from the late 1860s, its style is consistent with that of *Studies of a Horse* (cat. no. 21). Like Degas's other graphite drawings of that period, *Jockey* was drawn first with a hard pencil, the tip of which broadened as he worked. When he settled on a contour, Degas pushed harder with his pencil, digging it into the paper and reinforcing or strengthening the tentative lines below. To convey the quality of satin, Degas used a very soft graphite which he rubbed with a stump, thereby creating an almost gestureless, lithographic sheen. (RB)

COLLECTIONS: Estate of the artist, Vente IV, 215b, repr., stamp (Lugt 658) recto, lower left, in red; Durand-Ruel, Paris; Robert Allerton, Chicago, inscribed recto, lower right, in graphite: *153*.

EXHIBITIONS: St. Louis 1966-67, no. 80; Edinburgh 1979, no. 7.

LITERATURE: Chicago 1922: 11-12, repr.; Janis 1967b, pl. 43; Chicago 1979, 2F1.

19. Gentleman Rider, 1866/70

Graphite with traces of brush and white gouache on pink wove paper, laid down
Max. 435 x 270 mm
Charles Deering Collection, 1945.16

20. Gentleman Rider, 1866/70

Brush with black ink and white, yellow-white, and gray-brown gouache over graphite on pink wove paper, laid down
440 x 280 mm
Gift of Mrs. Josephine Albright, 1967.240

During the 1860s, Degas made many drawings of men, probably both friends and hired models, posed as riders or jockeys. The high level of visual detail, coupled with the fact that in none of them is the horse visible, indicates that they were made in the studio with the use of artificial mounts. That many of the drawings of seated jockeys dispersed throughout the catalogues of the Degas studio sales are closely related in style and that one group is of nearly identical size suggest that Degas devoted one or two sketchbooks to scenes of the race in which he treated horses and riders separately (see Vente III, 92a, 128/1, 128/3; Vente IV, 215a-b, 223b-c, 274).

These two drawings, executed on a brilliant, almost vulgar, salmon-pink paper, represent what has always been known, in French as in English, as a "gentleman rider." (Coincidentally, the two sheets entered the Art Institute separately, although they had been matted together and placed in a single frame in the third Degas sale.) Clearly, they depict the same model: a middle-aged man with full cheeks, bags under his eyes, and a mustache. Both sheets were drawn initially with a soft graphite pencil; cat. no. 20 was finished with black ink and heightened with white, yellow-white, and gray-brown gouache. When compared to this work, cat. no. 19 seems at first like an underdrawing. Yet, this notion is incorrect. If one mentally removes the ink and gouache from cat. no. 20, the resulting pencil drawing is both confused and tentative in comparison with the careful, even confident, pencil lines of cat. no. 19. It is possible that Degas chose to work further on cat. no. 20 with dark ink and gouache not only because these media functioned as visual counterpoints to the middle-value pink of the paper, but also because they unified dramatically the various penciled feet, legs, and arms with which Degas was experimenting.

What is interesting about these two sheets is that they have no clearly verifiable relationship to any painting and are therefore difficult to date precisely. They share general affinities with Degas's earliest racing paintings in which the spectator, both on foot and on horseback, plays a prominent role. Perhaps the closest is *On the Race Course (The Field)* (L. 77), dated 1860/62 by Lemoisne. The drawings also have been related to *The Departure for the Hunt* (c. 1864/68; L. 119), but there are no similarities between the hunting costumes seen in this painting and that of the bourgeois gentleman depicted in the two drawings. The drawings are looser and more confident than others by Degas of this period, suggesting that they date from the latter part of the 1860s, when he returned to the subject of horse racing and riding.

The gentleman represented here is dressed in good daytime clothing, complete with a top hat, yellow kid gloves, and silk-striped trousers. In cat. no. 19, he sits idly on a motionless mount, barely holding the slack reigns. In cat. no. 20, he leans forward as if either to dismount or kick the horse into forward motion. Thus, the pencil drawing is a representation of relative stasis, while the ink drawing conveys a state of transition. In cat. no. 20, the multiplicity of separately drawn hands, legs,

and feet lend an almost cinematic character to the sheet, as if the rider had been frozen at several points in his activity. This quality, however, must not be interpreted as evidence of an early interest on the part of Degas in sequential movement, but rather as his attempt to find the correct position for the limbs in order best to convey a movement.

Who was the gentleman rider? Degas was very precise in his delineation of the features of his subject, and there is no doubt that we are dealing here with an identifiable person. Given the close fit of his clothing, it is unlikely that the man was a model wearing a costume provided by Degas. More likely, he was a friend of the artist. A careful perusal of Degas's portraits does not produce a conclusive case for one or another sitter. However, there are certain similarities between the gentleman depicted in these sheets and Degas's boyhood friend Paul Valpinçon, whose portrait Degas did in the late 1860s (L. 197). Indeed, Paul's father, Henri, owned a celebrated breeding farm for race horses near Haras-le-Pin, which Degas visited frequently in the 1860s.

Whoever this gentleman may have been, he was most likely intended to represent a spectator at a horse race—not just any horse race, but one of the open-field contests held near Paris away from the large grandstands and tracks of such famous courses as Longchamps in the Bois de Boulogne. In fact, Degas often depicted these informal races, apparently preferring the simultaneity of racing, riding, walking, and watching that occurred there to the orderly procession of events at a grandstand racecourse like Longchamps. The fact that these two sheets are so large and that they were drawn on colored paper indicates that Degas made them less as studies for later use than as drawings in their own right (there are drawings on similar paper in the Louvre, the Metropolitan Museum, and the Fogg Museum). It is even possible that the color of the paper is the racing color of the stable of the gentleman represented; such salmon hues are not uncommon in the silks of many of Degas's jockeys. If this supposition is true, the sheets were made as drawn portraits of a horse owner in action, portraits that Degas abandoned and left in his studio. (RB)

19.

COLLECTIONS: Estate of the artist, Vente III, 165/1, repr., stamp (Lugt 658) recto, lower left, in red; Dr. G. Viau, Paris; acquired by the AIC from Jacques Seligmann and Co., New York.

EXHIBITIONS: Washington, DC 1947, no. 23.

LITERATURE: Chicago 1979, 2E8.

20.

COLLECTIONS: Estate of the artist, Vente III, 165/2, repr., stamp (Lugt 658) recto, lower left, repr.; Mrs. Josephine Albright, Woodstock, VT.

EXHIBITIONS: Tokyo 1976, no. 68, repr.

LITERATURE: Chicago 1979, 2E7.

21. Studies of a Horse, 1868/70

Graphite with estompe on tan wove paper, formerly laid down
Max. 304 x 246 mm
Gift of Robert Allerton, 1922.5519

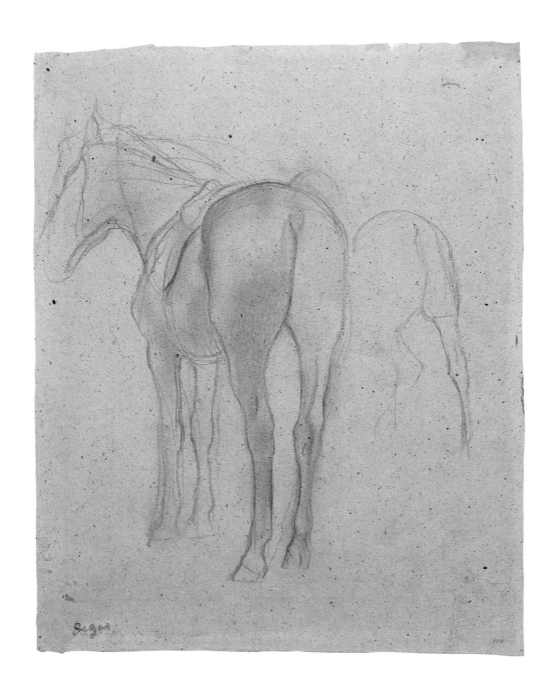

Studies of a Horse has been related to the painting *Race Horses at Longchamps* (1873/75; L. 334), but surely it was made in preparation for Degas's first great painting of a racecourse, *Race Horses* (fig. 21-1). The principal horse in the Chicago sheet is identical in its stance and proportions to the horse at the left-hand side of the famous canvas. The major difference between the two is the position of the horses' heads: Degas drew the horse's head at least three times before he decided to concentrate on the animal's flanks. In fact, the profile of the painted horse's head can be found among the overlapping lines on the Chicago sheet. The tentative form of another horse at the right of the Chicago drawing is related in reverse to one of the horses at the right of the painting.

A study first of linear contour and form and then of delicate graphite shading that defines surface, this sheet exhibits much of the Ingresque quality seen in many early Degas drawings. Degas indicated the contours initially with a very hard pencil, making fine, almost metallic strokes that have the quality of engraved lines. These were then reinforced many times with softer and thicker pencils applied with varying pressure. After he had defined his form with the correct contours, Degas used an even softer pencil to represent with almost imperceptible parallel lines the satin sheen of the horse's carefully brushed coat. These were further softened with a stump or the artist's fingers to create an elegant patina. Neither the horse's tail nor a jockey mars this splendid ana-

tomical study, although both are present in the final painting. Indeed, Degas was unable to convey the seductive gleam of the animal's coat as well in the painting as he did in this drawing.

The beauty, subtlety, and clarity of purpose that characterize this sheet indicate that it is not among the earliest equestrian drawings by Degas. Not only are there at least two sheets in a notebook made by Degas in 1860-62 that precede it (Reff 1976b: 104, Notebook 19: 31, 35), but Degas had copied and drawn equestrian figures for at least fifteen years by the time he made *Studies of a Horse* between 1868 and 1870. In both the pose of its subject and the control of form it demonstrates, Degas's sheet invites comparison with the drawing of a saddled horse from Pisanello's Vallardi Sketchbook in the Louvre (Fossi Todorow 1977: 72, pl. XLII) and with the stationary horse at the right of Andrea Mantegna's *Christ and the Two Thieves,* a painting in the Louvre copied by Degas (1868/72; L. 194). Degas, like his friend Manet, saw the modern world of horse racing through the eyes of the Old Masters. (RB)

COLLECTIONS: Estate of the artist, Vente IV, 223b, repr., stamp (Lugt 657) recto, lower right, in red; Robert Allerton, Chicago, inscribed recto, lower right, in graphite: *154* ; The Art Institute of Chicago, stamp (Lugt Suppl. 32b) verso, center, in brown.

LITERATURE: Chicago 1979, 2E11.

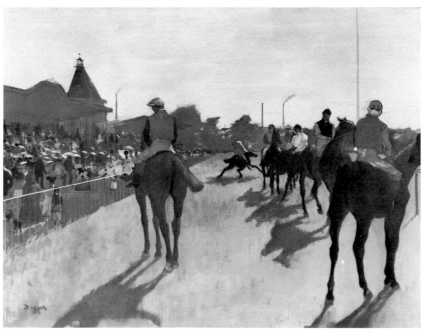

Fig. 21-1. Degas. *Race Horses,* 1869/72, oil on canvas (L.262). Paris, Musée d'Orsay.
Photo: Documentation photographique de la Réunion des musées nationaux.

22. Dancers Preparing for the Ballet, c. 1872/76

Inscribed recto, lower right, in oil: *Degas*
Oil on canvas
73.5 x 59.5 cm
Gift of Mr. and Mrs. Gordon Palmer, Mrs. Bertha P. Thorne, Mr. and Mrs. Arthur M. Wood, and Mrs. Rose M. Palmer, 1963.923

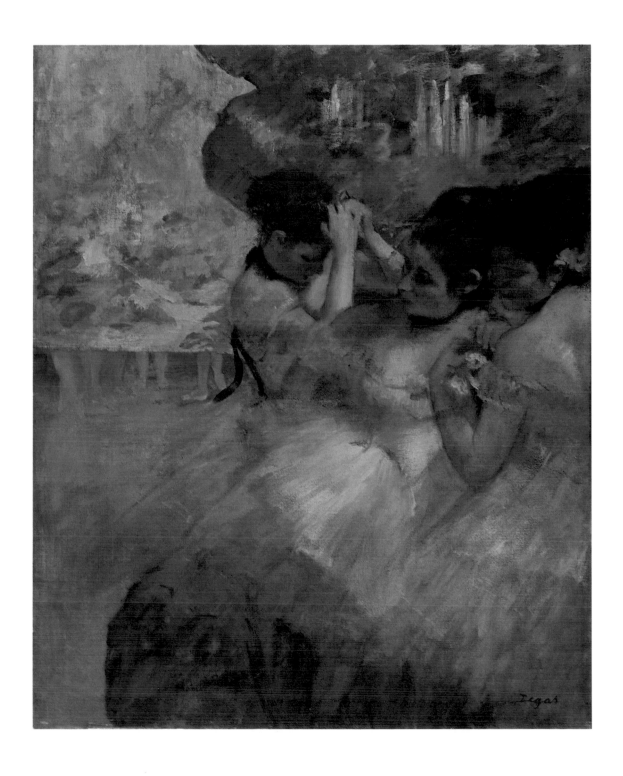

Approximately half of Degas's entire output of paintings and pastels concerns dancers (Edinburgh 1979: 17); what began in 1872 with two small oils of rehearsals had developed by the end of that decade into an obsession, with the artist depicting dance motifs not only in paintings and pastels, but also in sculpture, prints, drawings, and even fan decorations. By examining the dancer at rest, in rehearsal, on and offstage, he transformed the approach to this subject from the glamorization of starlets characteristic of the popular imagery of the time to an in-depth, almost documentary examination of women at work. It has been aptly remarked, "After Degas, the world of the ballet has never been the same; his observations have proved so just and so telling that it has been nearly impossible for any later painter to tackle the subject without appearing to imitate him" (Dunlop 1979: 120).

Three dancers primp and preen in the foreground of this very radical, abstract composition. Their curvaceous forms are echoed by the shape of the stage flat behind them; beyond that artificial barrier, one can glimpse the calves and feet of a number of dancers beneath a partially lowered curtain. The influence of Japanese prints—with their unexpected juxtapositions, cut-off forms, and two-dimensional compositional patterning—is clearly visible in this canvas, where Degas used such effects not only to heighten the sense of intimacy and immediacy but also to add a touch of humor to the scene.

Dancers Preparing for the Ballet, the one oil painting of a ballet subject by Degas in the Art Institute, is distinguished by an important, early, documented history. Purchased by Bertha Honoré Palmer in Paris in 1891 (Rewald 1973: 90), it recently has been identified as one of the works included in the second Impressionist exhibition, of 1876. Although dated by Lemoisne to 1878/80, the painting has been redated by Reff to 1875/77 based on a list of works Degas projected for the 1876 exhibition (Reff 1976b). Entitled *Yellow Dancers (Danseuses jaunes)* on Degas's list, the painting apparently appeared in the exhibition under the title *Wings (Coulisses),* according to a review by J. K. Huysmans and an oblique reference to the composition by Edmond Duranty in *La Nouvelle Peinture:*

> If one now considers the person, whether in a room or in the street, he is not always to be found situated on a straight line at an equal distance from two parallel objects; he is more confined on one side than on the other by space. In short, he is never in the center of the canvas, in the center of the setting. He is not always seen as a whole: sometimes he appears cut off at mid-leg, half-length, or longitudinally (Nochlin 1966).

Clearly, then, *Dancers Preparing for the Ballet* was completed before April 1876. Moreover, recent scientific examination has revealed that the canvas was painted quickly and decisively; its thin pigment layer and few *pentimenti* indicate that the painting was not altered at a later date. Signed at the lower right, it was considered finished by Degas and ready for display and sale. The deliberate prettiness of this intimate scene of dancers primping offstage—as compared with Degas's later depictions of performers who often appear awkward or distorted—reinforces its relatively early place among the artist's dance pictures and may also reflect a commercial intent on the part of the artist.

Although the three dancers in the foreground are viewed from very close range, it is not possible to identify any of them. Nonetheless, their costumes and the floral head piece of the figure at the right resemble those of a dancer recently demonstrated by Reff (1981: 126-7) to be a model who posed in 1872 for Degas and his friend the artist Evariste de Valernes. Indeed, a strong similarity exists between the Art Institute painting and both works cited by Reff: a large oil sketch (L. 1025) and, especially, a smaller oil composition in the National Gallery of Art (fig. 22-1) of a dancer and a visitor behind a flat. In both the Chicago oil and that in the National Gallery, Degas set large foreground figures against decorative stage flats with allusions to distant activity. The inclusion of the onlooker in the National Gallery oil confirms a meaning underlying the preparations of the dancers in the Art Insti-

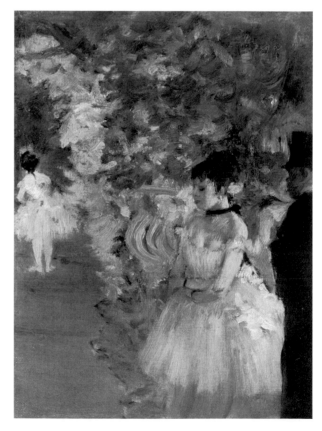

Fig. 22-1. Degas. *Dancers Backstage,* 1872/76, oil on canvas (L.1024). Washington, DC, National Gallery of Art, Ailsa Mellon Bruce Collection.

tute composition: offstage, these visions of feminine grace often played another part—that of the kept woman—so that their primping was just as much in anticipation of this role as it was for the ballet itself. However, Reff's reluctance to draw any conclusions about the interrelationship of the large oil sketch and the National Gallery work must be applied here, as well. Thus, the most that can be deduced is that the Art Institute painting was created between 1872 and 1876. Like the small oil in the National Gallery, it probably falls toward the end of that period.

Dancers Preparing for the Ballet is an early and important statement of a theme Degas pursued throughout his career, especially in later years—that of dancers adjusting their costumes offstage. Most of the early dance pictures focus on broad views of dancers at practice, in rehearsal, or on stage; relatively few include figures grooming themselves offstage, and when they do appear, it is more often at the periphery of his compositions (see fig. 23/24-1). When, around 1876, Degas began to concentrate on the principal dancer, he also became interested in exploring more fully unguarded moments backstage. Two other related oils in this vein are *Dancers in Pink Before the Ballet* (L. 783), in which Degas emphasized the last-minute toilette of five dancers in the wings seen against the cut-off, illuminated, distant form of a dancer on stage; and *Dancers Behind the Wings* (L. 617), in which he captured primping dancers from a raised viewpoint that shows their figures and costumes to best advantage.

Actually, some of the closest comparisons to cat. no. 22 are two monotypes heightened with pastel—*Dancers in Yellow*

(L. 514) and *The Curtain* (fig. 22-2). In both, Degas placed foreground figures against decorative, two-dimensional backdrops. In *Dancers in Yellow,* as in the Chicago canvas, the stage flat pushes the cluster of dancers forward, increasing both their tangibility and their intimacy with the viewer. The second monotype includes a device used by Degas in *Dancers Preparing for the Ballet*—that of obstructing with a curtain our vision of a group of dancers above the knee. *The Curtain* also contains the figure of the man waiting in the wings. While it is risky to relate these two prints chronologically to *Dancers Preparing for the Ballet,* it is noteworthy that thematically the painting finds its closest equivalents in Degas's intimate monotypes. In the late 1870s in monotypes heightened with pastel, Degas would explore further the ideas he introduced in *Dancers Preparing for the Ballet.* (SFM)

COLLECTIONS: J. S. Forbes, London; Goupil, Paris; Mrs. Potter Palmer, Chicago.

EXHIBITIONS: Chicago 1933, no. 283; Northampton 1933, no. 2; Springfield 1935, no. 12; New York 1941, no. 40, fig. 43; Cleveland 1947, no. 33, pl. 34; Albi 1980, no. 7, repr.

LITERATURE: Duranty 1876 (cited in Nochlin 1966:6); Huysmans 1883: 127; Manson 1927: 47; Northampton 1934: 17, repr.; Slocombe 1938: 20, repr.; Lemoisne 1946, no. 512, repr.; Browse 1949, no. 174, repr.; Maxon 1970: 88-9, 280, repr.; Russoli 1970, no. 726, repr.; Chicago 1971: 29; Rewald 1973: 88, 90, fig. 35; Gaunt 1970: 224-5; Reff 1976b: 125, Notebook 26: 74.

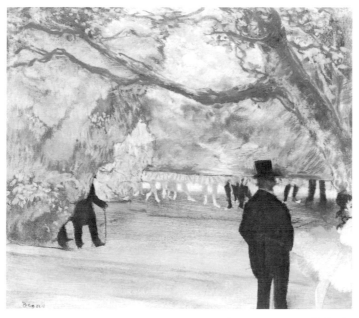

Fig. 22-2. Degas. *The Curtain,* 1872/76, pastel over monotype (L.652). Upperville, VA, Mr. and Mrs. Paul Mellon.

23. Dance Master I, 1874

Brush with watercolor and gouache with pen and black ink and touches of brown oil paint, over graphite and charcoal, on buff laid paper, laid down
Max. 450 x 262 mm
Gift of Robert Sonnenschein II, 1951.110b

24. Dance Master II, 1874

Graphite and charcoal with estompe on buff wove paper, squared in charcoal
Max. 410 x 298 mm
Gift of Robert Sonnenschein II, 1951.110a

Few images among the wealth of Degas's dance subjects depict male dancers. Because of a decided preference for female dancers in the post-Romantic era, many male dancers immigrated to Russia at mid-century, leaving their secondary roles to be filled by women. Yet, in Degas's earliest datable dance compositions, a prominent role is played by the dance master, a male dance instructor. The few male dance personalities in Degas's work are more easily identifiable than the famous female stars, although it will be shown that the identity of even these individuals was subordinated by the artist in favor of their role as compositional elements.

The Art Institute's two sheets of a dance master seen from the back have proved elusive to Degas scholars in terms of their technique and the identity of the subject. They are clearly studies for the same figure. Cat. no. 23 is a very spontaneous and free sketch which Reff (1971) determined was "begun in pencil, reworked in pen and ink, shaded with watercolor or gouache, and finally revised in diluted oil paint." Cat. no. 24 is a refined, fairly detailed drawing in graphite and charcoal which is squared for transfer. The awkward and rough handling of cat. no. 23 indicates that it preceded the second, more careful graphite representation, whose squaring suggests that it was intended as preparatory to another work.

The identity of the figure in these two drawings, which has been debated by several scholars, involves several of Degas's most famous dance pictures. Boggs first likened his stance to a figure, identified as Louis François Mérante, in *The Foyer of rue le Peletier* of 1872 (L. 298) in the Louvre; indeed, the shape of the head and muscular neck of the man in cat. no. 24 seems close to that of the 44-year-old Mérante in the painting. However, here the similarity ends.

Russoli proposed that the Art Institute's watercolor is a study of Jules Perrot, based on comparison with a signed and dated profile sketch in the Henry P. McIlhenny Collection, Philadelphia, PA (L. 364). Jules Perrot was one of the 19th century's finest male dancers and an internationally renowned choreographer, as well; with the Opéra's ballet master, Jean Coralli, he created such famous ballets as *Giselle* and *Pas de Quatre*. After his retirement from the stage, he occasionally directed classes at the Opéra. Two of Degas's major rehearsal compositions portray Perrot leaning on his stick. *The Dance Class* in the Louvre (fig. 23/24-1) and another in the Bingham Collection, New York (L. 397). The McIlhenny drawing (dated 1875) and another drawing in graphite (Vente III, 157/2), both showing the dancer/teacher in profile, were preparatory to these paintings. Like the Art Institute pair, they display different techniques and handling.

The Art Institute dance-master drawings play an integral role in determining the sequence of these important early dance pictures. X-rays taken of the Louvre *Dance Class* revealed traces of another stance under the familiar profile posture of Jules Perrot. George Shackelford was the first to

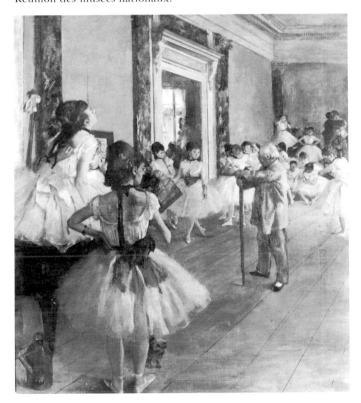

Fig. 23/24-1. Degas. *The Dance Class*, 1874, oil on canvas (L.341). Paris, Musée d'Orsay. Photo: Documentation photographique de la Réunion des musées nationaux.

recognize these outlines as those of the figure in the Art Institute drawings; he surmised (oral communication) that Degas's first conception of this famous composition did not include the majestic profile of Perrot seen in the Louvre version and may not even have involved the legendary figure. Inasmuch as the man in the Art Institute drawings, with his short-cropped hair and muscular energy, suggests someone younger than Perrot (who would have been 65 in 1875), the existence of the two profile portrait drawings of Perrot dating from 1875 must signal the artist's decision at that time to alter the Louvre composition by including in it the figure of the older man. Once Degas had established this presence, he went on to purify and elaborate the composition in the Bingham Collection version.

In addition to helping establish the sequence of these various compositions, the Art Institute drawings help clarify the relationship of the pastel *The Dance Lesson* (fig. 23/24-2) to these works. The pastel's energetic, relatively young dance master, in a baggy suit, conforms more closely to the figure seen from the back in the two Art Institute drawings than it does to the image of Jules Perrot in the group of works just discussed, despite attempts to identify him as such. The reversal of the core of the Bingham composition—with the dancer in the *arabesque* and the Art Institute-style dance master substituted for Perrot—reveals that Degas was still interested in doing a composition around this decidedly different teacher, whom he had originally intended for *The Dance Class.*

Who was this mysterious, younger dance master? Lillian Browse (1949: 55) tentatively identified the figure in *The Dance Lesson* as Eugène Coralli. The son and pupil of Jean

Coralli, Eugène first appeared in the Opéra register in 1840 and became "Dance Manager of the Opéra." Certainly, the age and the prominence of Coralli lend credence to Browse's identification. Moreover, Browse mentioned that Coralli was a noted mime, which would explain the expressiveness of the figure not only in *The Dance Lesson* but also in the two Art Institute drawings. As Manager, Coralli was sufficiently prominent that it is no wonder Degas repeatedly tried to work him into a dance composition; and, certainly, Degas would have been intrigued by the body of an accomplished mime, at once mute and expressive. (SFM)

23.
WATERMARK: J Iversay

COLLECTIONS: Estate of the artist, stamp (Lugt 657) verso, lower right, in red; Vente IV, 206b, repr., stamp (Lugt 658) recto, lower left, in red; Robert Sonnenschein II, New Freedom, WI.

EXHIBITIONS: St. Louis 1966-67, no. 66, repr.

LITERATURE: Lemoisne 1946, no. 367bis, repr.; Browse 1949, no. 40a, repr.; Russoli 1970, no. 483, repr.; Reff 1971: 149, fig. 13; Reff 1976a: 282, pl. 196; Chicago 1979, 2G1.

24.
COLLECTIONS: Estate of the artist, stamp (Lugt 657) recto, lower right, and verso, lower right, in red; Vente IV, 206a, repr., stamp (Lugt 658) recto, lower left, in red; Robert Sonnenschein II, New Freedom, WI.

EXHIBITIONS: St. Louis 1966-67, no. 65, repr.

LITERATURE: Chicago 1979, 2F12.

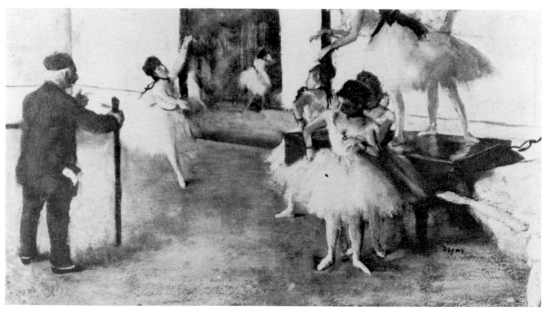

Fig. 23/24-2. Degas. *The Dance Lesson*, pastel (L.403). Private Collection. Photo: Lemoisne 1946.

25. Dancer Bending Forward, 1874/79

Inscribed recto, lower right, in charcoal: *Degas*
Charcoal and pastel on blue laid paper, squared in charcoal
460 x 304 mm
Mr. and Mrs. Martin A. Ryerson Collection, 1933.1230

Degas intended a few large pastel drawings of dancers for purposes and effects different from those of the countless rapid studies he made of young girls exercising. The monumental *Dancer Bending Forward* is characteristic of some sketches first described by Lillian Browse (1949, nos. 192-5), which were broadly executed in black chalk or charcoal and heightened with pastel accents that enliven the dancer's imposing form. In this group, Degas seems to have concentrated on the play of light on the figure of the dancer. Although such drawings may have functioned as specialized studies preparatory for a painting—an idea supported by the existence in the Art Institute sheet of a grid (like those used for transfer) —such traditional methods were not always characteristic of Degas, and it now seems likely that well over a decade may have separated this relatively early drawing from its eventual realization in a painted composition, the Louvre's *Dancer Mounting the Stairs* (fig. 69/70-2) of around 1890. In the painting, Degas elongated the dancer's body and lowered the skirt—another instance in which he reused and varied older motifs. Recently, Janet Anderson and George Shackelford have questioned (written and oral communications) the traditional dating of *Dancer Bending Forward* to 1885, citing the relatively short, stocky proportions of the figure and the high-waisted costume as more characteristic of Degas's work in the 1870s.

A drawing of an almost identical pose in the Rhode Island School of Design (fig. 25-1) frequently has been linked with the Art Institute sheet, not only in relation to the Louvre painting, but also because in both Degas employed a large format and used colored paper and pastel highlights to set off the sculptural figure. As suggested by Deborah Johnson (Providence 1975: 46-7, no. 17), the handling of the figure in the Providence drawing is more mature than that of the Chicago sheet. Further comparison reveals totally different concerns: Whereas the Rhode Island figure is convincingly described within a three-dimensional space by a line searching for the correct form, her bodice and legs attenuated as they would be in the painting, in the Art Institute pastel the dancer is defined with bold and abstracting contour lines that do not evoke a unified form as much as they differentiate the various parts of the bending figure. The grid served more as a matrix for this difficult posture than as a means of transfer. It seems likely that such generalized studies accumulated in Degas's early years of exploration of the dance, to be used or not as he liked from that point on. The independent status of this large pastel finds ultimate confirmation in the signature it bears. The Providence drawing, then, may be considered a later repetition and revision of the earlier theme, perhaps with a specific composition in mind.

Most depictions of dancers with their arms akimbo clearly date to the later years of Degas's career, but, even without related works, the Art Institute sheet can be anchored to the mid-1870s, based on comparison with the major dance paintings of the period. The similarity of proportions and the use of decorative or analytical poses (not always fully unified or convincingly substantial) amply justify dating the sheet to that time. Degas exhaustively explored such poses in works stretching from *The Dance Class* compositions of the early and mid-1870s (see fig. 23/24-1) to the friezelike compositions recently redated to 1878/79 (L. 625, 900, 902, 905; Reff 1976b: 151, Notebook 31: 70). (SFM)

COLLECTIONS: Joseph Hessel, Paris, Apr. 1920; Mr. and Mrs. Martin A. Ryerson, Chicago.

EXHIBITIONS: Chicago 1933, no. 862; Chicago 1946, no. 12, pl. XV; Washington, DC 1947, no. 12; New York 1963, no. 104; Northampton 1979, no. 17, repr.

LITERATURE: Browse 1949, no. 191, repr.; Providence 1975: 46-7; Chicago 1979, 2F11.

Fig. 25-1. Degas. *Ballet Girl,* pastel on gray paper (L.901). Providence, Rhode Island School of Design, Museum of Art, Gift of Mrs. Gustav Radeke (23.038).

26. Uncle and Niece (Henri de Gas and His Niece Lucie de Gas), 1875/78

Oil on canvas
99.8 x 119.4 cm
Mr. and Mrs. Lewis Larned Coburn Memorial Collection,
1933.429

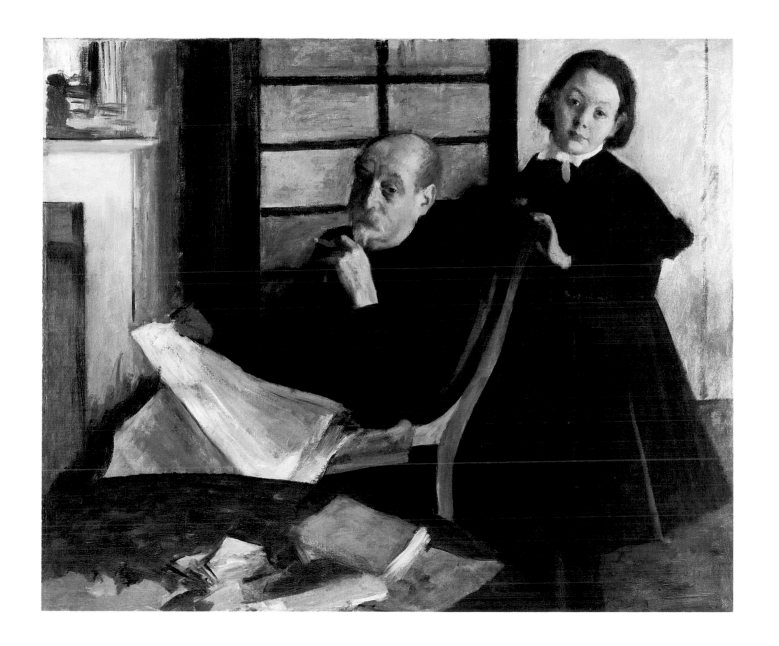

This superb double portrait was painted entirely in Italy, where it remained until its highly acclaimed acquisition by Wildenstein's in 1926 and its subsequent purchase by Mr. and Mrs. Coburn of Chicago. When seen today in a gallery of the Art Institute devoted to Degas's dancers, singers, jockeys, and other habitués of Paris, *Uncle and Niece* looks totally at home, that is, totally Parisian. Yet, no matter how typically Parisian Degas has always been considered to be, his family was as much Italian as it was French, and more of his relatives lived in Naples and Florence than in Paris.

Uncle and Niece is a portrait of Degas's uncle Henri de Gas, and his first cousin Lucie, daughter of another uncle, Edouard. The painting remained in Lucie's family until its discovery in 1926 at the French pavilion of the 15th Venice Biennale, where, juxtaposed with Degas's famous *Bellelli Family* (fig. 3-1), it caused a sensation. At that time, and when it was acquired by the Art Institute, the figure of Lucie was considered to be one of the Bellelli children, and thus the painting was thought to date from the early 1860s. In 1932, Marcel Guérin gave the sitters their present identification. Although neither Guérin nor subsequent writers divulged the sources for this identification, Guérin's familiarity with the Degas family, together with the style and provenance of the painting, suggest that he was correct at least in his identification of the girl as Lucie.

Degas's series of portraits of his relatives are unique visual investigations of the psychology of family relations. Family history, although often tedious and trivial, is essential to an understanding of family portraiture. We know from Degas's letters, as well as from accounts of witnesses, that he was almost obsessed by his extended family. Although he changed the spelling of his name from de Gas to Degas, undoubtedly to disassociate himself from the aristocratic spellings of *ancienne France,* his fidelity to his family and to its honor was so great that he expended most of his personal fortune in 1875 to save his bankrupt younger brother, René. Degas seems to have projected his own identity into his images of his relatives, many of which are strongly oriented toward what might be called the painter/viewer. It is significant that Degas's earliest major painting, *The Bellelli Family* (fig. 3-1), was a portrait of his French aunt with her Italian family, and that this picure remained the largest and, in some ways, the most ambitious composition of his career.

Degas's father's family were bankers whose origins were Lyonnais. Her grandfather fled France with his fortune at the time of the French Revolution and formed a major family bank in Naples. With the exception of his eldest son, the painter's father, Auguste, the children of this family remained in Italy and several married Italians of noble blood. When the political and economic climate in France improved, Auguste de Gas was dispatched to found a branch of the family bank in Paris. There, he married Celestine Musson, daughter of another expatriate French banking family, from New Orleans. Her family also maintained close ties with its distant members in America. Thus, Degas may have been a *"bourgeois de Paris,"* as Georges Rivière called him, but his family was certainly not Parisian (Rivière 1935).

Lucie de Gas was born in Naples in 1865 to Edouard de Gas and Candide de Montejasi. Orhpaned at an early age, she was cared for first by her uncle Achille de Gas, who died in 1875, and then by another uncle, Henri, who died in 1878. Both Achille and Henri were brothers of Degas's father. In fact, the artist's decision to paint Lucie with their Uncle Henri was made a short time after the death of Auguste in Italy early in 1874. The painter was with his father when he fell ill in Turin, nursing him there for nearly two months and finally accompanying him to Naples, where he died. It was during this period that Degas saw again not only his young cousin Lucie, for whom he perhaps felt empathy because she, like him, was without parents, but also his Uncles Henri and Achille, both bachelors like Degas himself and the only surviving brothers of his father. Although it is possible that *Uncle and Niece* was conceived and begun in 1874 and that it represents not Henri but Achille, Lucie's guardian at that time, it is more likely that the portrait was begun in 1875, when Degas was again in Italy, Achille was dead, and Lucie (then aged ten) was under the protection of Henri.

Uncle and Niece may have been painted entirely in 1875, but surely it was finished by the time of Henri's death in 1878. The painting addresses questions of death and family allegiance—concerns that must have been central to Degas in 1875 as he settled his father's and brother's debts. He was at that time 45 years old, alone, and at least relatively impoverished. His debut as an independent artist with the Impressionists had occurred—and failed—in 1874, and he was not in any way at the pinnacle of his career.

Degas achieved this complex portrait with a startling economy of means. Executed with rather large brushes, the painting is forcefully, even strjdently, composed. Lucie's mourning dress is defined with long, straight strokes made with a wide brush dipped generously into the pigment. Many commentators have noted the somber qualities of *Uncle and Niece.* Its palette is dominated not by the bright hues and wonderful pale greens, light blues, and pinks then favored by Degas, but by the blacks then almost banished from the palettes of his colleagues, the Impressionists. The darkness, indeed blackness, of the palette fools one into thinking that the painting is earlier than it is. In fact, *Uncle and Niece* was painted entirely on a white ground and has many similarities in facture and composition with portraits of the middle and latter part of the 1870s. The painting of the heads is remarkable. Each has been carefully observed and is clearly a likeness, while notably simple as a construction in paint (see frontispiece, p. 2). The notions of conciseness and economy were central to French modernist aesthetics—both literary and visual—during the latter half of the 19th century.

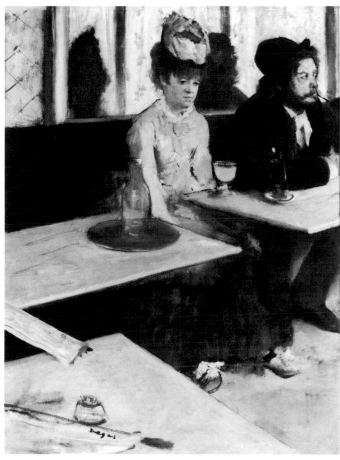

Fig. 26-1. Degas. *The Absinthe Drinker,* 1876, oil on canvas (L.393). Paris, Musée d'Orsay. Photo: Documentation photographique de la Réunion des musées nationaux.

The rapport between the sitters and the painter/viewer makes *Uncle and Niece* a family portrait in two senses: The viewer not only witnesses a familial relationship but is part of the family represented, as well. Yet, Henri in his chair is utterly detached from Lucie who stands behind it, and the two of them are isolated from the viewer. Thus, each of the three persons is given his own discrete area as Degas guards the privacy and separateness of viewer and viewed.

The surface of the painting is divided into rigid geometric areas by the mullions of a screen set next to the fireplace. The structure of this screen becomes part of the geometry of the painting itself: its center is the vertical center of the painting, and its edges divide the pictorial surface into exact thirds. Lucie inhabits the right third, her face illuminated by daylight from an unseen window and her hands barely touching the back of her guardian uncle's chair. Henri sits squarely in the center, about to take a puff from his cigar. The viewer finds himself on the opposite side of a table strewn

with papers and an unbound book. Although the viewer is clearly "at home" with the sitters, it is evident that he has interrupted them. Henri has been perusing the daily newspaper in front of the fire, and his niece has been reading over his shoulder. Degas devoted special attention to Lucie's hands: at first, they held the chair firmly, straying over into the central third of the painting; in the final composition, they have returned to her section of the canvas and seem almost tentative in their placement.

It is clear that this strange double portrait is a study, in one sense, of two relatives and, in another, of the painter's identification with them. Interestingly, each sitter had some affinity with Degas that is greater than a familial one. Although 30 years younger than the artist, Lucie was a member of Degas's own generation in the family and, more importantly, was alone in the world, unprotected by parents. Henri was what the French call *un vieux garçon,* a bachelor who continued to be supported by and to live with his family. In this way, the portrait becomes a grouping of isolated or lonely people. The painting pairs opposites, like the young girl and old man in *The Absinthe Drinker* (fig. 26-1). And yet, in *Uncle and Niece,* a viable unity is achieved; one feels that Lucie is clearly with Henri, and, moreover, that they are not alone, for Degas is also present. (RB)

COLLECTIONS: Mme. Bazzi Collection, Naples; Bellelli-Cicerale Collection, Naples; Wildenstein and Co., New York, purchased Nov. 1926; Mrs. Lewis Larned Coburn, Chicago.

EXHIBITIONS: Venice 1926: 326, 329, no. 1525, repr.; Cambridge 1929, no. 34, pl. 22; Chicago 1932, no. 6, repr. p. 39; Northampton 1933, no. 17; Chicago 1933, no. 289, pl. 54; Chicago 1934, no. 204; New York 1934, no. 1; St. Louis, City Art Museum, "Paintings by French Impressionists," Apr.-May 1934 (no cat.); Philadelphia 1936, no. 24, repr.; Pittsburgh 1936, no. 10; New York 1949, no. 35, repr.; Bern 1951-52, no. 22, repr.; Amsterdam 1952, no. 13, repr.; Albi 1980, no. 5, repr.

LITERATURE: *Art News* 1926: 1-2, repr.; *Kunst und Künstler* 1926-27: 40, repr. (as *"Father and Daughter"*); Manson 1927: 48, pl. 5; Rich 1929: 125-7 (cover ill.); Hausenstein 1931: 162, repr.; Guérin 1931-45: 108; *Fine Arts* 1932: 23, repr.; Rich 1932: 68; Walker 1933: 179, 182, repr.; Mongan 1938: 296; Slocombe 1938: 23, repr.; Chicago 1941: 188-93; Grabar 1942, repr. opp. p. 60; Lemoisne 1946, no. 394, repr.; Raimondi 1958: 157-8, pl. 24; Chicago 1961: 119, repr. p. 287; Boggs 1962: 45-6, pl. 86; Sweet 1966a: 203; Russoli 1970, no. 401, repr.; Chicago 1971: 27; Dunlop 1979, pl. 122; Marandel 1979: 34, repr. p. 35; Levin 1982: 149, fig. 4.

27. Alphonse Hirsch, February 20, 1875, and c. 1879

Drypoint and aquatint printed in blue on oatmeal laid paper; second of two states
Plate 112 x 60 mm; sheet 185 x 126 mm
Gift of Dr. and Mrs. Martin L. Gecht, 1983.282

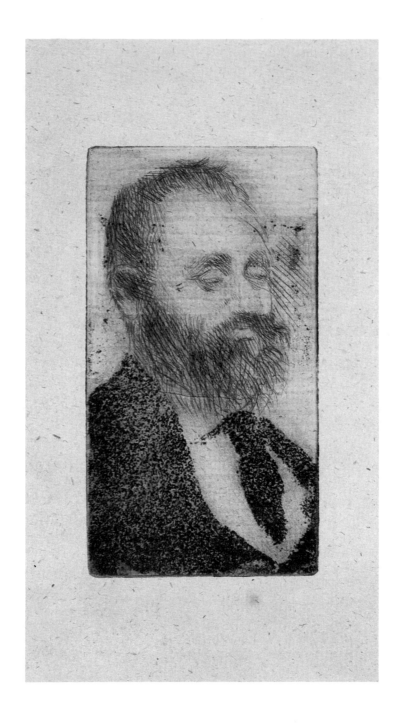

The small dimensions of this bust-length male portrait belie its importance within the development of Degas's graphic oeuvre. It is one of the rare prints by Degas in which the original drypoint work can be dated precisely. The first intaglio print he created after ten years in which he made no prints, this small drypoint and aquatint plate heralded a period of intense and experimental printmaking by Degas; moreover, in both of its states, it reflects his interchange with other artists, for him a relatively infrequent occurrence.

According to the noted critic, connoisseur, and collector Philippe Burty, it was on February 20, 1875, that Degas gathered with his friends Marcellin Desboutin (a playwright and etcher), Giuseppe de Nittis (a painter active in London and Paris), and Alphonse Hirsch (1843-1884; a painter and etcher) to etch portraits of one another. The occasion was apparently prompted by Burty, the great advocate of the *peintre-graveur* in mid-19th-century France, and by Desboutin, who specialized in drypoint portraits. Impressions of the portraits by de Nittis and Desboutin in the Bibliothèque Nationale, Paris, bear Burty's inscriptions indicating that this was the date of their execution. A similar inscription on the first state of Degas's portrait of Hirsch in the Fondation Doucet, Bibliothèque d'Art et d'Archéologie, Université de Paris, would seem to indicate that only the drypoint portion of the print can be securely dated to that occasion.

Paul Moses (Chicago 1964) postulated that the unusual character of this work must have resulted from the collaborative nature of the venture, although it was difficult for him to identify the prevailing influence in the group without knowing any works by Hirsch. According to Adhémar, there is a single etching by Hirsch in the Bibliothèque Nationale, and it is after Francisco Goya. It is tempting, therefore, to hypothesize that while the drypoint style of the portrait reflects Desboutin's authority in this exercise, the use of pure aquatint to describe Hirsch's coat and tie may be due largely to Degas's renewed interest in Goya, for which Hirsch may have been responsible. It is likely, however, that the second state, with its use of aquatint to create the bold pattern of the clothing, dates to a slightly later period, around 1879, when Degas, under the spell of Japonism, was particularly interested in the broad, colorful effects of such compositional de-

vices and etching techniques. This was the moment of his collaboration with Camille Pissarro and Mary Cassatt on the ill-fated publication of *Le Jour et la Nuit* (see cat. nos. 50, 51). Cassatt's work in particular excited Degas; the bold design of her soft-ground etching and aquatint print *In the Opera Box* for that publication may have provided further stimulus for Degas's addition of aquatint to the Hirsch plate.

Edmond de Goncourt, in his *Journal* (1877: 488, cited in Adhémar 1974), described Alphonse Hirsch as an entrepreneur who, not unlike today's corporate art advisors, supported himself by building collections for businessmen and retaining a ten-percent commission for himself. Degas's portrait, even in its summary treatment, reveals the satisfied air of a self-made man and may be compared with his authoritative contemporary portraits of Jules Perrot (see fig. 23/24-1).

Although Adhémar (1974: 13) cited this print as Degas's unique intaglio effort between 1862 and 1877, it perhaps should be seen as a synthesis of Degas's etched portraiture of the 1850s and 1860s (including the portraits of Manet [see cat. nos. 11, 12], as well as those of family members [see cat. nos. 5, 6]), and the tonal explorations he made in aquatint in the late 1870s, in works such as *On Stage, Dancers in the Wings*, and those of Mary Cassatt at the Louvre (cat. nos. 30, 43, 50-54).

Alphonse Hirsch demonstrates the degree of intimacy and individuality achieved by Degas in his prints. He pushed to an extreme the then-current advocacy of the original print, making impressions that were almost antithetical to the medium. Working in unusually small editions and experimenting almost intuitively with techniques, he altered the perception of prints from mass-produced multiples to treasured, personal statements. The bluish hue of the ink and the lush texture of the gray wove paper in this case heighten the unique quality of the impression. (SFM)

COLLECTIONS: Robert M. Light, Santa Barbara, CA.; acquired by the AIC from Robert Light and Co., Santa Barbara, CA.

LITERATURE: Delteil 1919, no. 19, repr. (first state); Chicago 1964, no. 17, repr. (second state); Adhémar 1974, no. 24, repr. (second state).

28. Portrait of Ellen Andrée (formerly Portrait of a Woman), c. 1876

Monotype printed in brown-black ink on ivory wove paper, laid down on ivory laid paper
Plate 215 x 160 mm; sheet 235 x 183 mm
Mrs. Potter Palmer Memorial Fund, 1956.1216

It is difficult to believe that this exquisite portrait of a woman, with all its richness, subtlety, and precision, was created by the indirect monotype process. A superb example of the light-field manner, the image was painted with printing ink directly on the copper plate and then put through a press and printed; no lines or textures were incised into the plate to allow for multiple printings. What emerged was a printed drawing, a unique image that Degas made even more individual by his manipulation of his material. As Eugenia Janis pointed out (Cambridge 1968), the ink used for the monotype was thinned in some places with turpentine to create an effect that is altogether very painterly—at once watery in consistency and warm in tone. The print is virtually unequaled among Degas's monotypes, not only in its daring execution, but also as a sensitive portrait of a specific woman rather than of a type. Clearly not linked to the realms of the ballet, brothels, and boudoirs around which so many monotypes center, the image betrays none of the qualities of caricature so often found in Degas's monotypes of those subjects.

Françoise Cachin first suggested that the subject might be Ellen Andrée, based on a comparison with *The Absinthe Drinker* of 1876 (fig. 26-1), for which she was a model. Indeed, the resemblance is striking—including not only physiognomy but also elements of the hat and dress. The expression of the figure in the monotype, while slightly melancholy, is sweeter than that of the woman in the painting. These connections with *The Absinthe Drinker* prompt re-evaluation of Janis's dating of the monotype to around 1880: the painting, probably exhibited in the second Impressionist exhibition, likely dates to 1876 (see cat. no. 26). However, as Reff has pointed out (written communication), the identification of Ellen Andrée as the subject of these two works is not, in itself, sufficient reason to date them to the same year.

Further evidence relating this image to *The Absinthe Drinker* and to the period about 1876 is offered by another, much smaller monotype portrait by Degas entitled *Man Smoking a Pipe* (fig. 28-1). In this print, the sitter, Desboutin, closely resembles his appearance as the second figure in *The Absinthe Drinker*; Degas's unorthodox, thin manipulation of the light-field manner created a washlike effect similar to that of the Art Institute monotype. Janis correctly dated this print to 1876 (Cambridge 1968, no. 52, checklist no. 233) and cited Desboutin's famous letter of July 1876 to Mme. Giuseppe de Nittis describing Degas's enormous enthusiasm for the monotype process:

> Degas. . . is no longer a friend, he is no longer a man, he is no longer an artist! He is a *plate* of zinc or copper blackened with printers [*sic*] ink, and this plate and this man are rolled together by his press, in the meshing of which he has disappeared completely!—He is in the metallurgic phase for the reproduction of his drawings with a roller [*au rouleau*] and runs all over Paris in his zeal to find the equipment which corresponds to his fixed idea!—It is altogether a poem!

It seems justifiable, then, to identify the subject of this monotype portrait as Ellen Andrée and to assign it to 1876. If the handling of the plate seems sophisticated for such an early date, this is perhaps the result of the great strides Degas made during his most intense period of experimentation with the monotype. Janis suggested that some of the precision in the area of the eyes and lips may be due to later additions of Degas by hand. Certainly, such tinkering and careful adjustments would have been more understandable in 1876 than in 1880, when the artist turned out in great quantities freely drawn images with little if any alteration. Thus, *Portrait of Ellen Andrée*, one of the most unusual and hauntingly beautiful of all of Degas's monotypes, should also be considered one of his earliest masterpieces in this medium. (SFM)

COLLECTIONS: Estate of the artist, stamp (Lugt 657) verso, lower right, in red; Vente d'estampes, no. 280; Marcel Guérin, Paris, stamp (Lugt Suppl. 1872b) recto, lower left, in black; Otto Wertheimer, Paris; Knoedler and Co., Paris; Hammer Galleries, New York; E. V. Thaw, New York; acquired by the AIC from the New Gallery, New York.

EXHIBITIONS: Paris 1924, no. 236; Paris 1931, no. 173, pl. XIII; Cambridge 1968, no. 54, repr., checklist no. 238.

LITERATURE: Cachin 1974, no. 48, repr.; Dunlop 1979, pl. 162.

Fig. 28-1. Degas. *Man Smoking a Pipe,* 1876, monotype. Private Collection. Photo: Cachin 1974, no. 35.

29. On the Stage, 1876/77

Inscribed recto, upper left, in monotype plate: *Degas*
Pastel over monotype on cream laid paper, laid down;
second of two impressions
592 x 425 mm
Potter Palmer Collection, 1922.423

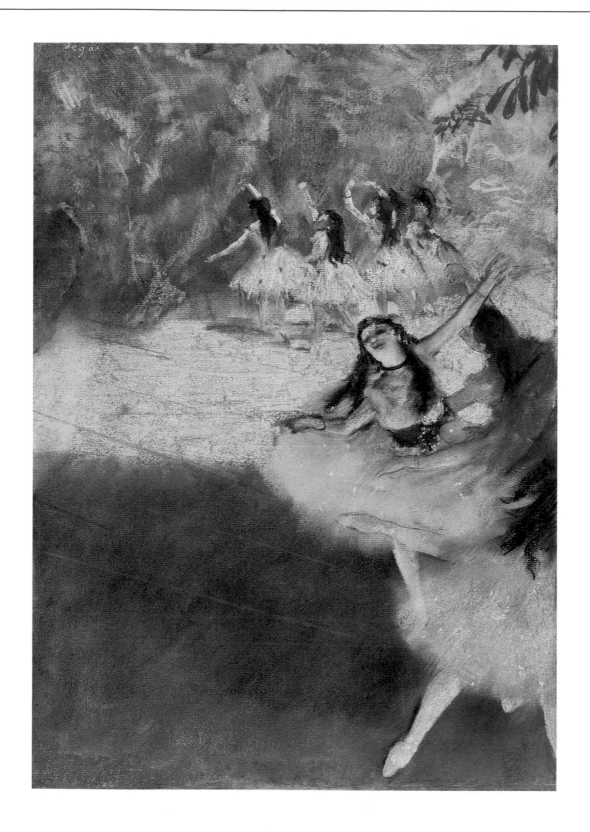

As Degas continued to explore the possibilities of monotype in the years 1876-77, utilizing large plates for complex ballet compositions, he increasingly turned to the dark-field manner of monotypes, heightening them with pastel to strengthen and vary his designs. Unlike the light-field monotype (see p. 69), the dark-field manner is a process in which the copper plate is totally inked and the image drawn by wiping away the ink to produce white lines against the dark ground. In fact, only two pure dark-field monotypes of dance subjects without pastel are known: *The Ballet Master* (C. 1) and *Three Ballet Dancers* (C. 2). It appears that the first impressions of other dance monotypes either have been lost or covered with pastel (see p. 73).

The excitement Degas must have felt in the challenge of creating two quite different compositions from the same monotype base is especially evident in *On the Stage*. The weak second of two impressions, its cognate is a pastel-heightened monotype in the Louvre entitled *The Star* (fig. 29-1). The two works are composed so differently that Lemoisne separated their dates of execution by two years: that in the Louvre he placed in 1878, and that in Chicago in 1880. No one recognized their close relationship until 1967 (Janis 1967a, I, figs. 46, 50; II: 72, 75). There seems no reason to assume that they were not contemporaneous, even simultaneous explorations. However, each expresses different aspects of Degas's themes of around 1876-77.

Both compositions emphasize the principal dancer performing on stage, and in both the scene is viewed from a raised vantage point like that of a box at stage left. This dramatic angle, probably introduced by Degas into his dance imagery for the first time in *Two Dancers* (L. 425), created a somewhat distorted depiction of the ballerina's execution of an *arabesque* or an *attitude* (one cannot discern the exact position because her back leg is obscured), and permitted description of the stage behind her more clearly than was possible with the lower viewpoint and wider format of *Ballet at the Paris Opéra* (cat. no. 31). The play of the harsh stage lights on moving forms in *Ballet at the Paris Opéra* was incorporated to new effect in cat. no. 29 and in fig. 29-1, dissolving the shadows that would define the dancer's chin and emphasizing the graceful line of her outstretched limbs against the background.

The principal dancer of *On the Stage,* with her long black hair and the wide, red bodice of her special costume, stands out from a group of other dancers whose torsos and faces are cut off on the right; behind her, the rest of the corps de ballet dance into the wings on the left. Whereas the foreground is dark, the back is flooded with light; the division of the stage by lighting and the depiction of the synchronized movement of the corps (their harmony extends to their long dark hair and elaborate white tutus) are very similar to those of *Ballet at the Paris Opéra*, which would suggest that cat. no. 29 was done just before or around the same time, about 1876/77.

In the Louvre composition, by contrast, the principal dancer is alone on the stage (her hair is no longer flowing and

her bodice is different), with only a hint of the supporting cast included in between the stage flats behind her. The scenery has assumed a more important role in this composition than it has in *On the Stage*. Among the figures in the wings is the dark form of a man in street clothes, an anecdotal element that relates the Louvre version to the monotype illustrations Degas made for his friend Ludovic Halévy's epic serial novel, *La Famille Cardinal*— where the figure of Halévy himself figured in a number of the compositions (see fig. 44-1). Barely a dozen years after its execution, *On the Stage* was acquired by Mrs. Potter Palmer. (SFM)

COLLECTIONS: Durand-Ruel, Paris; Mrs. Potter Palmer, Chicago, 1889.

EXHIBITIONS: Chicago 1910, no. 20; Chicago 1933, no. 281; Chicago 1934, no. 200.

LITERATURE: Lemoisne 1921: 227; Chicago 1922: 39, repr.; Chicago 1925: 133, no. 817; Manson 1927: 47; Slocombe 1938: 26, repr.; *Life* 1941: 213, repr.; Burkholder 1943: 85, repr.; Lemoisne 1946, no. 601, repr.; Browse 1949, no. 143, repr.; Rich 1951: 92-3, repr.; Kelley 1952: 64, repr.; Chicago 1961: 120-1; Carandente 1966, pls. 14-15; Janis 1967a, I, fig. 50, II: 75; Cambridge 1968, checklist no. 6, repr.; Russoli 1970, no. 752, repr.; Chicago 1971: 27; Chicago 1979, 2F4.

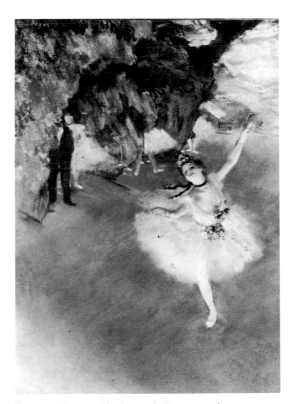

Fig. 29-1. Degas. *The Star,* 1876/77, pastel over monotype (L.491). Paris, Musée d'Orsay. Photo: Documentation photographique de la Réunion des musées nationaux.

30. On Stage (second plate), late 1876(?)

Soft-ground etching on ivory laid paper; fifth state of five or sixth state of six
Plate 98 x 125 mm; sheet 107 x 130 mm
Gift of Mr. and Mrs. Joseph R. Shapiro, 1956.605

31. Ballet at the Paris Opéra, 1877

Inscribed recto, lower left, in white pastel: *Degas*
Pastel over monotype on cream laid paper
Plate 352 x 706 mm; sheet 359 x 719 mm
Gift of Mary and Leigh Block, 1981.12

Among Degas's earliest representations of ballet subjects are works depicting performances as seen from the orchestra pit. Reff has demonstrated that this particular compositional approach and subject may have been rooted in Daumier's popular illustrations of the 1840s (Reff 1976a: 77). But, within Degas's development, they may be considered natural transitions from the artist's general preoccupation in the late 1860s with portraiture, predominantly of musicians, to his absorption with the ballet in the 1870s and beyond. Just as he did several canvases featuring musical soirées in Manet's home—with Degas's father listening to the Spanish vocalist and guitarist Lorenzo Pagans (see fig. 3-2) or Manet reclining behind his wife at the piano (L. 127)—in his initial views of the orchestra pit, Degas executed what amount to intimate and precise portraits of the performers, many of them his friends. The first among these, *The Orchestra of the Opéra* (L. 186), showing ten of his musical associates, can be dated to before 1870. The portraits—with their refined execution and sensitive characterizations—dominate the composition; only a

thin strip at the top of the canvas, indicates the truncated feet and legs of dancers beyond the stage lights. In a related painting, *Musicians in the Orchestra* (fig. 30/31-1), generally dated to 1872, the zones of the composition are more evenly divided between fully visible dancers and the musicians in the pit who, reduced in number and shown with their heads turned to face the stage, are less individually recognizable. In a further variation on this theme, signed and dated 1872, Degas depicted a performance of Meyerbeer's opera *Robert le diable* (L. 294). Albert Hecht (the first owner of the work) and the bassoonist Désiré Dihau are clearly recognizable, but now over half the canvas is devoted to the performance in progress and to the vast backdrop. A second undated, but undoubtedly later, version of this scene (L. 391) is both larger and wider than the first, but in it Degas further reduced the portion allocated to the orchestra and its individual members, who have become a jumble of heads and instruments at the edges of the composition. Flickering white scores and starched shirts create abstract patterns that echo the forms above.

32. Mlle. Bécat at the Ambassadeurs, 1875/77

33. Mlle. Bécat at the Ambassadeurs, 1876/78

Lithograph on cream wove paper; only state
Image 207 x 193 mm; sheet 344 x 273 mm
William McCallin McKee Memorial Collection, 1932.1296

Inscribed recto, lower right, in pencil: *Degas*
Lithograph on ivory wove paper; only state
Image 293 x 245 mm; sheet 351 x 275 mm
Clarence Buckingham Collection, 1952.235

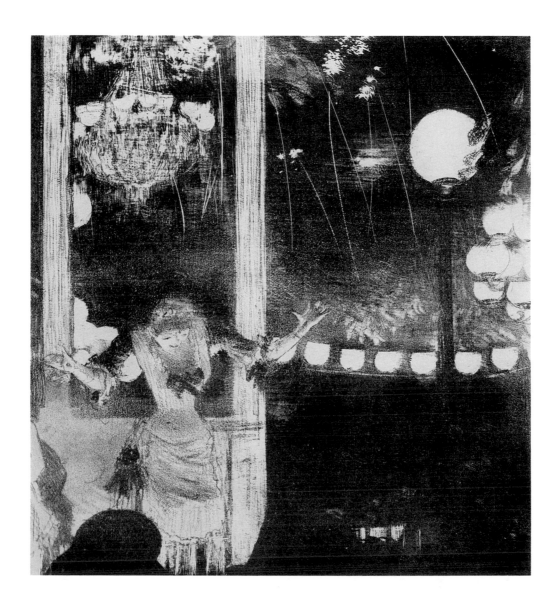

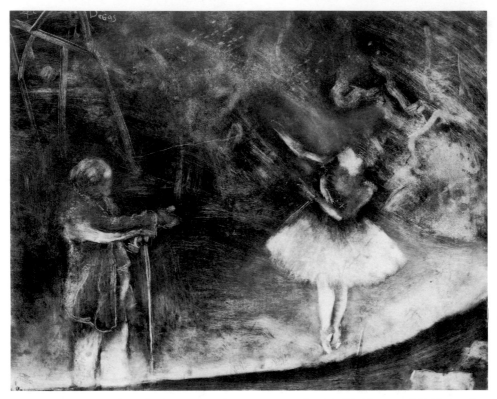

Fig. 30/31-2. Degas. *The Ballet Master,* 1874/75, monotype (L.364). Washington, DC, National Gallery of Art, Rosenwald Collection (1964).

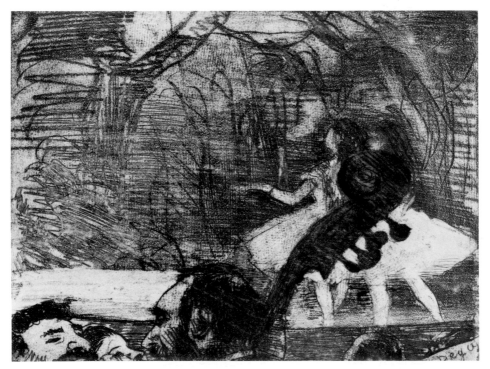

Fig. 30/31-3. Degas. *On Stage,* 1876, soft-ground etching, third plate. Chicago, Dr. and Mrs. Martin L. Gecht.

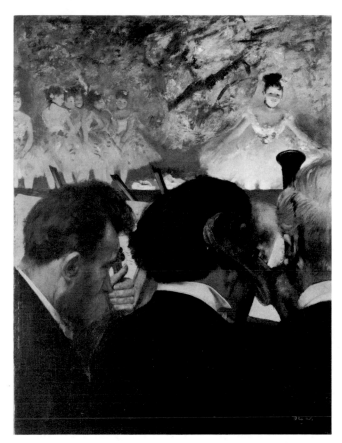

Fig. 30/31-1. Degas. *Musicians in the Orchestra,* 1872, oil on canvas (L.295). Frankfurt am Main, Stadtische Galerie im Stadelschen Kunstinstitut.

The third plate (fig. 30/31-3), which Adhémar considered a probable study for the second plate, exists in four states and would appear to postdate the second, as the plate, dancers, orchestra members' heads, and bass violins have been enlarged and more fully defined. All these elements, reversed and perfected from the second plate, link the third plate to the Art Institute's *Ballet at the Paris Opéra,* where the two dancers perform with the corps de ballet, the middle stage is similarly illuminated, and at least two of the musicians, including the one with the mustache, reappear. It is risky to speculate whether the monotype preceded or followed the third plate. That they share unreversed elements may reflect the almost invisible monotype base of *Ballet at the Paris Opéra,* since virtually all elements of the composition are executed in pastel and gouache. Viewing the pastel with transmitted light reveals that Degas adopted an idiosyncratic approach, executing the stage decor at left and right and the three principal dancers in the dark-field monotype manner while wiping clean a large area in the right half of the composition to allow for later additions by hand of the members of the corps de ballet in their luminous skirts. This suggests that there never was a first impression or cognate monotype that could stand alone, but that, from the outset, Degas created such plates with their pastel heightening in mind. One at least may assume that the third plate was executed just after cat. no. 30, which was published in January 1877.

The exaggerated, prominent neck of the bass violin in the third plate and in *Ballet at the Paris Opéra* occurs in later works by Degas that focus increasingly on the principal dancer and decreasingly on the orchestra. The device of the bass violins (later used to great effect by Henri de Toulouse-Lautrec in his posters of the 1890s) acts as a *repoussoir* and reminder of the now unseen orchestra; eventually, Degas would give them even greater definition and substantiality than the figure of the dancer herself.

In all of these works, Degas sought to convey the experience that a member of the audience might have had of an actual performance. Whereas the majority of his dance subjects are of a behind-the-scenes nature—affording glimpses of dressing rooms, the studio, the wings—in these more formal representations, the artist became more and more intrigued with expressing the excitement of the moment, which even the merest suggestion of the orchestra could communicate. (SFM)

not coincidentally, related by medium: the figure of the lead dancer recurs in a pair of pastels (c. 1877/78; L. 448, 449), one executed over monotype and the other including the device of the bass violins. However, in order to date *Ballet at the Paris Opéra* and to understand its achievement, the most relevant comparisons are to be made with three intaglio plates entitled *On Stage,* which can be placed in 1876. In the so-called first small plate, known in a unique proof (A. 25), Degas set the dark, silhouetted forms of two dancers against a rich, pure aquatint ground and vaguely suggested the heads of the orchestra below. It is perhaps unwise to assume, however, that this ambitious, if largely unsuccessful print, was the artist's first attempt at the composition. Far better known is the so-called second plate (cat. no. 30), which exists in five or six states. Here, the two dancers are joined by a third; the stage set is summarily described with cursive lines and rubbed textures in the soft-ground etching medium. The prominent bass violins loom in front of the figures, and a glimpse of the musicians in the orchestra pit can be discerned at the bottom. What was once described as a pen-and-ink study for the print (Vente IV, 137b) was tentatively identified by Moses as a pre-first state (Chicago 1964). The final state of the print (cat. no. 30) was published in a catalogue of an exhibition (Pau 1877) that opened on January 8, 1877; therefore, one may date the print securely to late 1876.

30.
COLLECTIONS: Mr. and Mrs. Joseph R. Shapiro, Oak Park, IL.

EXHIBITIONS: Chicago 1964, no. 23, repr.

LITERATURE: Pau 1877; Delteil 1919, no. 32, repr. (first state); Adhémar 1974, no. 26, repr. (fifth state of five or sixth state of six).

31.
COLLECTIONS: Albert Hecht, Paris; M. and Mme. E. Pontremoli, Paris (per Lemoisne); Mr. and Mrs. Leigh B. Block, Chicago.

LITERATURE: Lemoisne 1946, no. 513, repr.; Russoli 1970, no. 724, repr.

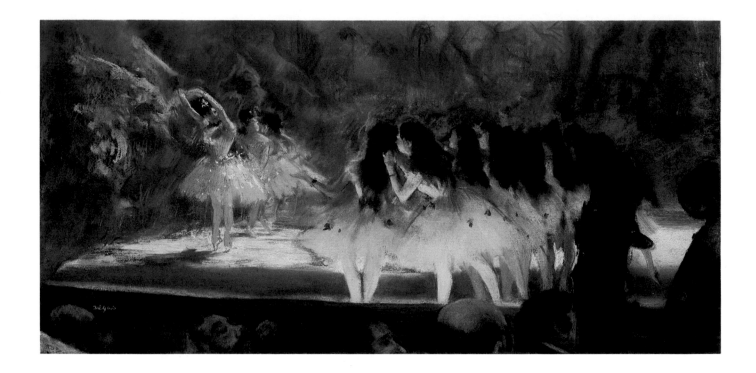

The next significant exploration of this theme can be seen in *Ballet at the Paris Opéra* (cat. no. 31), which was described by Lemoisne as a pastel and dated by him to around 1878/80. It is, in fact, a monotype heightened with pastel. The monotype was executed in the dark-field manner (see p. 71). Only the distinct platemark that delimits the bottom and two sides of the composition reveals the monotype base. One of the widest monotype plates used by Degas, it must have extended beyond the current sheet, as the cut paper and absence of any platemark at the top would indicate. No cognate of the monotype is known, and only one image compares to it in scale: *The Ballet Master* of 1874/75 (fig. 30/31-2) is exactly the same width but is just under twice the height (560 x 700 mm); the plate used for this legendary first monotype executed by Degas and his friend the artist Viscount Ludovic Lepic may well have been that used later for *Ballet at the Paris Opéra* before the sheet was cut down. *The Ballet Master* exists in a cognate version (second impression) heightened with pastel (L. 365), which certainly was executed by 1875, when it was purchased by Louisine Elder (the future Mrs. Horace O. Havemeyer). It is not clear, however, when Degas next used the larger plate for the Art Institute monotype heightened with pastel, for which no cognate is known.

Ballet at the Paris Opéra, like the earlier works mentioned above, depicts a performance on stage as well as musicians in the orchestra. Janet Anderson (written communication) has suggested, however, that the random positioning and free-flowing hair of the corps de ballet in the foreground may indicate that this scene represents a rehearsal. Achieving a fine balance between the dancers and the musicians, this is one of the most evocative of Degas's performance images. The monumental yet jewel-like *Ballet at the Paris Opéra* finds few exact parallels in Degas's oeuvre, yet it shares many features with works executed throughout the 1870s. The fifth position on point of the principal dancer can be found in a number of important early dance compositions where the figure is often shown silhouetted against the light (*contre jour*). Degas used an extremely broad format in other works, including studio scenes and stage performances; the intrusion into the dancer's zone of the necks of the bass violins occurs frequently in dance pictures of the 1870s. In the works dated before 1876, space is defined through the use of *contre-jour* silhouettes, diagonal recession, and the placement of the principal dancer in the middle ground beyond a cluster of figures. In later works, after 1878, can be seen an increasing emphasis on the horizontal, with movement paralleling the picture plane. Thus, *Ballet at the Paris Opéra* plays a pivotal role between these two groups and can be dated to 1877.

The works most analogous to *Ballet at the Paris Opéra* in terms of composition, movement, and lighting are, perhaps

Like Renoir, Manet, and, to a lesser extent, Caillebotte, Degas was fascinated by the spectacle of the café-concert. These establishments existed in Paris throughout the 19th century but were at their height during the Second Empire and Third Republic. Ranging from the squalid to the splendid, café-concerts were places where one could drink while watching an entertainment, and their very existence gave rise to a floresence of popular singing and dancing in 19th-century Paris. Because they were better paid and more securely employed than the street performers depicted by artists from Daumier to Seurat, the entertainers at café-concerts perfected their art to a higher degree. Famous singers and dancers were extolled in the press; the modern idea of the "Star" was firmly established by the time that Degas turned his attentions in the mid-1870s to the most spectacular of them, the Café aux Ambassadeurs, a seasonal outdoor café-concert on the Champs Elysées. While Renoir preferred to depict the daytime delights of another outdoor establishment in Montmartre, the Moulin de la Galette, in his paintings of 1876 Degas withdrew into the shadows to study urban entertainment at night. This

world of artifice was lit artificially: the gas globes, fireworks, and chandeliers were as much his subjects as the performers and their audiences.

Degas was captivated by the performances of a café singer named Emilie Bécat, who sang at various café-concerts in Paris between 1875 and 1885 (Shapiro 1982: 156-7). She debuted in the summer of 1875 at the Café aux Ambassadeurs, and she worked for the next three seasons in its "twin" establishment on the Champs Elysées, the Alcazar d'Eté. Accounts of her singing focus less upon her voice than upon her frenetic gestures and movements. She originated a performance style that came to be known as the *"style épileptique."* Degas, an habitué of these outdoor cafés along Paris's most fashionable promenade, made numerous drawings of her in his notebooks.

Many writers on Degas have stressed the vulgarity of the café singers he represented and have contrasted their world with the upper-class entertainment at the opera and the ballet, which he also loved. In fact, the two café-concerts he frequented were among the most glamorous in Paris, and

their outdoor location in a public park gave them considerably greater propriety than the disreputable café-concerts—whether indoors or out—of Montmartre. The audience for a performance by Mlle. Bécat at the Café aux Ambassadeurs would have been at once well-to-do and, as the establishment's name suggests, international; popular prints indicate that a good many ladies were present.

It is not known precisely when Degas made his superb lithographs of the Café aux Ambassadeurs, two of which are represented in the Art Institute's collection. He seems to have exhibited none of them in the Impressionist exhibitions; because of their private nature, they seem to have escaped inclusion in the Dépôt Légal, the standard repository of French "popular" prints. Delteil dated both of the prints in the Art Institute to 1875, perhaps because Mlle. Bécat, the subject in each, performed there in that year; but other Degas scholars have placed them in 1877 or 1878. This later dating is justified on two grounds, one historical and the other stylistic. First, Mlle. Bécat was still performing at the architecturally similar Alcazar d'Eté in the years 1876-78; and second, cat. no. 33 is closely related in technique to Degas's early monotypes, many of which were exhibited in the third Impressionist exhibition, in April 1877. It is difficult, however, to date cat. no. 32, because it is technically unrelated to the monotypes and could have been made at any time between 1875 and 1878. One can, however, posit that cat. no. 32 was done between 1875 and 1877, and that cat. no. 33 was done between 1876 and 1878 based primarily on stylistic analysis.

Cat. no. 32 either was drawn directly on the stone with lithographic crayon or was transferred from another source before being fully worked with layers of crayon and tusche (lithographic ink), especially in the dark areas of the foreground. When the stone was fully darkened, Degas began to scrape at it with knives and needles to define the light of the chandeliers and the bursts of holiday fireworks against the nocturnal background. The remainder of the print was conceived initially in "positive" terms, but even the figure of Mlle. Bécat and her surroundings have been delicately defined with the aid of a needle or pin. The whole was printed on a sheet of cream paper that helps to soften the contrasts. In this print, Mlle. Bécat performs directly to two gentlemen whose hats seem to bob rhythmically in response to the movements of the singer.

Cat. no. 33 is more lyrical and full of light. It was printed on a bright white paper and, because of its technique, is wittier than cat. no. 32. Degas obviously chose to include three images of a single subject on the same plate so as to explore further the variations in Mlle. Bécat's gestures and to capture her from several vantage points in the seating area in the park. Each vignette offers an immediacy made all the stronger by the fact that the viewer's eye darts back and forth among all three figures, none of which is treated preferentially. Degas did cut certain impressions into three parts; at least one of the top scene, finished in pastel, was presented by the artist to his friend the still-life painter Zacharie Zacharian (L. 831; see Reff 1976b: 134, Notebook 30: 198). It is likely that cat. no. 33 was transferred to the stone from a wet monotype and reworked in tusche by Degas.

In both prints, Degas located the singer within her ambience. Indeed, he seems to have been less concerned with her gesticulations than with the atmosphere of a summer night's entertainment—a small, animated figure performs amidst rustling chestnut leaves, luminous globes of light, sparkling chandeliers, an orchestra in full swing. She becomes an amusing, almost incidental, part of the Parisian night life in which Degas—a *flâneur de la nuit*—participated almost obsessively. This is not to say that he was bored by her antics or that he totally de-emphasized them. Indeed, we learn more about the performance of Mlle. Bécat from Degas's lithographs than we do from any other visual source of the period. Michael Shapiro, the most thorough student of the café-concert in Degas's oeuvre, says little about these prints and was unable to publish other popular representations of Mlle. Bécat at the Café aux Ambassadeurs with which to compare the artist's lithographs (Shapiro 1982). Thus, Degas was the chief visual documentor of a remarkable performer, some of whose lyrics have survived. The "Song of the Turbot and the Shrimp," which she sang in 1875, is a rhythmic and alliterative ditty, its text in complete accord with the puppetlike gestures captured in Degas's prints. The naive mimicry of animal sounds and movements that played such a large role in the performance of popular songs was transformed into a high art by both Mlle. Bécat and Degas.

In these prints, Degas achieved everything that was then and is now considered to be Impressionist. They seem to have been executed spontaneously; they show a world alive with light and motion, and they illustrate leisure activity in the context of modern urban life. Both prints capture an aspect of 19th-century Paris that has been long lost and, through them, will be long remembered. (RB)

32.
COLLECTIONS: Estate of the artist, stamp (Lugt 657) recto, lower right, in red; acquired by the AIC from Marcel Guiot, Paris; The Art Institute of Chicago, stamp (Lugt Suppl. 32b) verso, lower left, in brown.

LITERATURE: Delteil 1919, no. 49, repr.; Lemoisne 1946, I, repr. opp. p. 136; Reff 1971: 154-5; Adhémar 1974, no. 42, repr.; Passeron 1974: 64-5, 68, repr.; London 1983, no. 26, repr. (as impression heightened with pastel).

33.
COLLECTIONS: Ch. Jacquin, stamp (Lugt Suppl. 1397a) recto, lower right, in black; acquired by the AIC from Guy Mayer, New York.

LITERATURE: Delteil 1919, no. 50, repr.; Adhémar 1974, no. 43, repr. (AIC); Passeron 1974: 68.

34. Café Singer, 1877/80

Monotype on ivory laid paper
Plate 80 x 71 mm; sheet 183 x 161 mm
Potter Palmer Collection, 1963.822

Among Degas's most exquisite monotypes are those of very small scale depicting single figures. This bust-length profile portrait of a woman has been identified as that of a café-concert singer—not only because of her costume, with its neck ribbon and decorative, plunging neckline, but also because of her open mouth. There are no props or figures to define her role more precisely. The ambiguity and mystery surrounding the woman are qualities that characterize another monotype portrait of a woman, seen bust-length and in a similar costume, which has variously been titled *Café-Concert Singer* and *Woman in a Loge* (Cambridge 1968, no. 9, checklist no. 36). Yet, while in the Chicago monotype Degas has limited any suggestion of a performance in progress to the singer's open mouth, her appearance compares with that of the figures in other, more elaborate café-concert compositions by the artist in which more of the setting has been indicated (see C. 9, 11, 12). And, with characteristic aplomb, Degas was able to evoke—by creating a glowing area in the inky patch in the upper right corner—the dramatic illumination of the gas globes that lit the boulevard café-concerts that he frequented in the mid-to-late 1870s (see cat. nos. 32, 33, 37, 38, 58-60).

The monotype exhibited here relates even more closely in scale and execution to several monotype portraits of women without any clear social role, the most alluring of which is entitled *The Jet Earring* (C. 39) (fig. 34-1). Françoise Cachin noted that many of the monotype portraits were taken from a small plate measuring approximately 80 x 70 mm (C. 35-40, 43-45, 47; to which may be added nos. 11 and 12, noted above). Allowing for discrepancies of one-to-two millimeters, there is no reason to doubt that this plate was used for the Art Institute impression. Most of these monotypes have been dated to around 1880 by Cachin, and to between 1877 and 1880 by Janis (Cambridge 1968). Moreover, although Cachin believed that Degas's greatest interest in doing café-concert subjects occurred during the winter of 1876-77, she acknowledged that some works, including the Art Institute monotype, exhibit a slightly later style and can therefore be dated to 1879/80 (Cachin 1974: 269).

Degas's notebooks in the Bibliothèque Nationale contain a number of drawings of similar figures of café-concert singers, notably notebook 28, which has been dated definitely to 1877 (Reff 1976b: 129). These hasty, caricaturelike sketches do not in themselves signal an earlier dating for the Chicago monotype, but perhaps it would be wise to follow Janis's less narrow dating for the work, to around 1877/80.

Although more refined than the sketches just mentioned, the monotype possesses a humorous aspect that differentiates it from the other portraits of ladies. The impish, exaggerated features of the woman recall those of the prostitutes that were the focus of Degas's powerful series of brothel monotypes, executed between 1876 and 1885, according to Cachin.

Although no artist's estate stamp appears on this print, it is possible that it is one of the monotypes sold in the Vente d'estampes at the Galerie Manzi-Joyant in 1918 following the artist's death. A sheet, listed under lot no. 273 and described as *Buste de chanteuse, de profil à droite* and measuring 82 x 72 mm, could be identified as the Chicago monotype; however, the lot included both the first and the second, weaker impression taken from the monotype plate, and no second impression of this image is known today. (SFM)

COLLECTIONS: Estate of the artist, Vente d'estampes, 273 (?); acquired by the AIC from Richard Zinser, New York.

EXHIBITIONS: Cambridge 1968, no. 13, checklist no. 50, repr.

LITERATURE: Cachin 1974, no. 13, repr.

Fig. 34-1. Degas. *The Jet Earring*, 1877/80, monotype. New York, The Metropolitan Museum of Art, Anonymous gift in grateful memory of Francis Henry Taylor (59.651).

35. Four Heads of Women, c. 1877

Lithograph on white wove paper, only state
Image 220 x 190 mm; sheet 358 x 275 mm
Clarence Buckingham Collection, 1952.236

Only three impressions of this lithograph are known; the other two are in Paris (Fondation Doucet and the Bibliothèque Nationale). Like many of the rare lithographs left by Degas, this print is a compilation of several distinct images placed on the same stone, which may have been the result of technical experimentation on the part of the artist as much as it is an original translation of popular imagery of his day. In scale and in handling, the four images of women—each in its own quadrant and each apparently unrelated to one another—resemble the small monotype portrait of a café singer (cat. no. 34), as well as others identified by Cachin (C. 37-46).

An exact monotype version of the portrait at the upper right (fig. 35-1) indicates that this image was transferred to the stone by rolling it through the press with a fresh, wet monotype impression. The monotype was much weakened by this process; the slight differences between the monotype and lithographic images may have resulted from later additions by

hand to the former or additional burnishing and work on the stone for the latter. Although no other monotype sources for the other images in this print survive, it is likely that they were applied to the stone in the same way. Adhémar was able to identify tentatively three of the figures: the singer Thérésa at upper left, the actress Ellen Andrée at upper right, and the vocalist Mme. Faure at lower right.

Why did Degas construct a lithograph using such an indirect process and why did he risk ruining a monotype in this way? It seems possible that, aside from his ceaseless and imaginative technical experimentation, Degas might have been seeking a means to perpetuate his monotypes, his unique "anti-prints." But since so few impressions of this lithograph survive, it appears that he did not intend a large edition. Perhaps it was the rich, lustrous black that he obtained with the monotype tusche that Degas sought to transfer to the grainer lithographic stone. Certainly, these portraits are un-

usual for their thick, dense blacks which, in some cases, Degas scraped for additional luminosity, texture, and three-dimensionality.

Other lithographs of multiple subjects, also constructed from or closely linked to monotypes, suggest the way Degas explored the transfer process. One of the earliest datable experiments was with the monotype portrait of Marcellin Desboutin (fig. 28-1), dated to 1876, which was transferred to a lithographic stone along with two other, unrelated motifs (D. 54, A. 46). The lithographic *Plate with Two Subjects* (cat. no. 45) and *Mlle. Bécat at the Ambassadeurs* (cat. no. 33) are likely to have been constructed in the same way. Degas's exploration of the transfer process and of multiple, juxtaposed compositions resulted eventually in the relatively unified image of Mlle. Bécat. Because of the unconnected nature of the four head studies in cat. no. 35 and the placement of these small images at such a distance from one another, it is likely that this lithograph was created fairly early within this process. Each portion of the image may have originated as a monotype on the artist's favorite small plate (see p. 79). As with so many of Degas's printmaking efforts, one senses the vitality and curiosity that underlie the making of this image as much as one is enchanted by the image itself.

If the lithograph seems to lack coherence in its surface design or technical makeup, its content is consistent and provoking in its apparent simplicity and allusions. The juxtaposition of these portraits bears comparison with anonymous scientific and ethnographic illustrations of the period and thus prompts one to consider the four women as sociological types. Although not clearly identified as performers, they nonetheless communicate an aura of "public service" of another nature: these figures are displayed as commodities. Executed as part of a private, limited edition, this print tantalizes with its daring compositional technique and suggestive content. (SFM)

COLLECTIONS: Estate of the artist, stamp (Lugt 657) recto, lower right, in red; Vente d'estampes, 178 (?); Maurice Fenaille, Paris (?); acquired by the AIC from Guy Mayer, New York.

LITERATURE: Delteil 1919, no. 54, repr.; Adhémar 1974, no. 44, repr. (AIC).

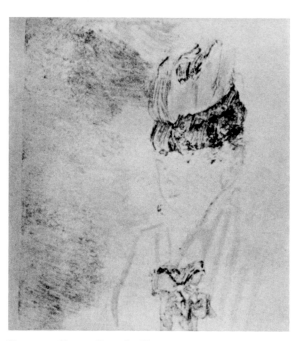

Fig. 35-1. Degas. *Bust of a Woman*, c. 1877, monotype. New York, Private Collection. Photo: Cachin 1974, no. 38.

36. The Two Connoisseurs, c. 1878

Monotype printed in dark gray on white wove paper, hinged to old mount
Plate 298 x 270 mm; sheet max. 335 x 305 mm
Clarence Buckingham Collection, 1951.115

One of the largest and most unusual monotypes by Degas is this painterly image of *The Two Connoisseurs.* Janis (Cambridge 1968) has identified the man in the bowler hat on the left as Paul Lafond, curator of the museum at Pau, based on the relationship of this image to a painting of the same subject, *The Amateurs* (fig. 36-1). The more commanding figure of a second connoisseur wearing a top hat in the monotype bears little resemblance to his counterpart in the painting, identified as Alphonse Cherfils, a collector who owned at least one other monotype by Degas (*The Three Dancers* [C. 2]), as well as the painting in which he is depicted.

The mysteriousness of this figure underscores the fact that Degas used monotype less for specific portraiture than for the intimate evocation of a scene, vignette, or type. Thus, the slightly melancholy *Portrait of Ellen Andrée* (cat. no. 28) is less important as a likeness than as an expression of a mood.

So, too, the smaller busts of singers or actresses (see cat. nos. 34, 35), although occasionally identifiable, are portrayed as types. Often the tendency toward caricature in Degas's draftsmanship helps create this abstracting quality. This is especially true in his monotype illustrations for Halévy's *Famille Cardinal* (Cambridge 1968, checklist nos. 195-231) which—in their frequent depiction of Halévy in a top hat (see fig. 44-1)—bear the closest resemblance to this image of *The Two Connoisseurs.* Janis likened the Art Institute's unknown connoisseur to "the persistent, ever-present observer behind the *coulisses . . .* the hero of the *scènes de maisons closes* and *cabinets particuliers.*" Although it is equally possible that this figure may represent a particular person, his imprecise depiction and the somewhat detached attitude with which he considers the work of art lend him an "everyman" status which elevates the scene from the specific to the general.

83

As Reff has suggested (1976a: 84-5), the influence of Honoré Daumier can be directly felt in Degas's *Two Connoisseurs*: indeed, Degas made numerous oils and watercolors of the subject, the source of which could have been either the older artist's similarly titled painting of 1860/63, which was exhibited in the major Daumier retrospective in Paris in 1878, or a study of a similar scene which Degas himself owned. Daumier, like Degas, included specific portraits in his paintings, but created more generic representations in his broadly executed wash drawings and lithographs (see fig. 36-2). It was undoubtedly the graphic art of Daumier that inspired Degas's lush black outlines in this monotype, allowing him to achieve an intimate and persuasive atmosphere with a great economy of means.

The very subject of *The Two Connoisseurs* is reflected in its execution. Degas's own passion for the monotype—in effect, a printed drawing comprised of rich blacks and haunting grays—is expressed most emphatically in the subjects' careful contemplation and delectation of an image. While it is impossible to verify exactly what the two men are studying, from the size and shape of the object we can deduce that it is a work on paper of some sort. This monotype, then, may well express Degas's love for the intimacy of the graphic arts, and, as such, finds no parallel in his oeuvre.

Although up to now no one has questioned Lemoisne's date of around 1881 for the painting and Janis's assigning of the same date to the monotype, the importance of the 1878 Daumier exhibition and the relationship to Degas of the portrait subject in both works might suggest an earlier dating to that time. It was in 1878 that Paul Lafond became the first curator of a public museum to purchase a painting by Degas, *The Cotton Exchange* (L. 320), executed in New Orleans in 1873. Moreoever, as we have seen, the museum in Pau provided Degas with one of the few commissions for his graphic work, publishing *On Stage* (cat. no. 30) in 1877. Perhaps this monotype commemorates this relationship of 1877-78. Finally, the bold and imaginative execution of this sheet seems more characteristic of Degas's early, single monotypes in the 1870s than of his later, more broadly treated series of monotypes dealing with bathers, brothels, and landscapes. (SFM)

COLLECTIONS: Estate of the artist, stamp (Lugt 657) verso, at center of mount in red; Vente d'estampes, 179; Ambroise Vollard, Paris (per Cambridge 1968); acquired by the AIC from Henri Petiet, Paris.

EXHIBITIONS: Cambridge 1968, no. 53, checklist no. 234, repr.

LITERATURE: Cachin 1974, no. 50, repr.

Fig. 36-1. Degas. *The Amateurs*, c. 1878, oil on oak panel (L.647). The Cleveland Museum of Art, Leonard C. Hanna, Jr., Collection (58.25).

Fig. 36-2. Honoré Daumier (French, 1808-1879). *The Print Collector*, after 1869, pen, ink, and wash. The Art Institute of Chicago, Gift of the Joseph and Helen Regenstein Foundation in honor of Frank B. Hubachek (1968.1).

37. Singers on the Stage (formerly Café-Concert, Singer on Stage at the Café-Concert), c. 1877/79

Signed recto, lower right, in margin, in graphite: *Degas*
Pastel over monotype on ivory wove paper, laid down on board; second of two impressions
Plate 120 x 169 mm; sheet 138 x 182 mm
Bequest of Mrs. Clive Runnells, 1977.773

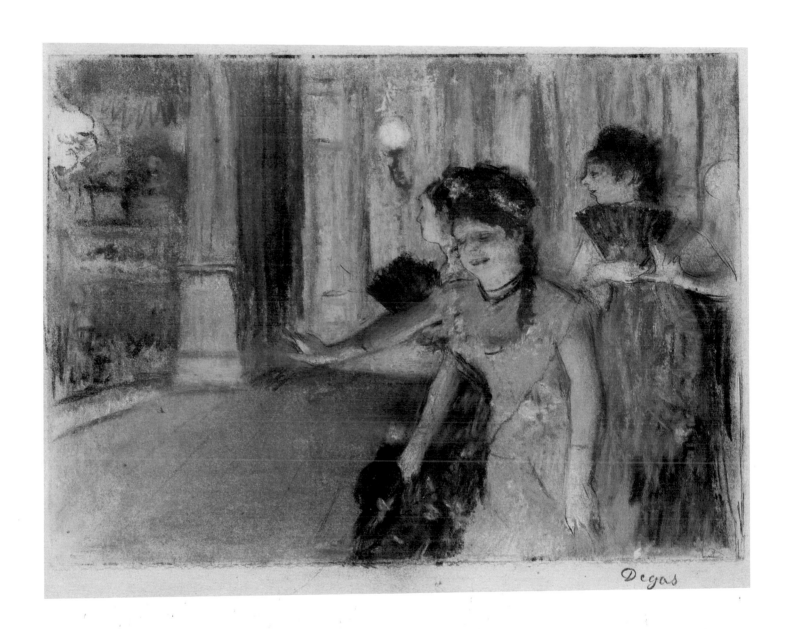

The three performers in this pastel over monotype appear to huddle at the back of the stage, far from the entreaties of their admirers in the audience. They are completely unlike the accessible café singers whom Degas depicted performing and taking bows at the front of the narrow stage at the Café aux Ambassadeurs (c. 1876/77; L. 404). Soon they will move into the wings, where we, the viewers, are about to greet them, particularly the wonderful woman with chestnut hair and a bright pink dress who turns toward us.

Traditionally, this sheet has been called the *Café-Concert* or *Singer on Stage at the Café-Concert,* but both titles are surely wrong. For, here, Degas took pains to describe a fully operational stage with its wings and lights and a theater with its tiered boxes and seats. The same location is elaborated further in a related pastel over monotype, *The Duet* (fig. 37-1). In this composition, two singers perform before an audience while being directed from the orchestra pit and a prompter's box. In both prints, we are dealing with one of the many theaters in Paris, one that has not yet been identified. There were many precedents for this subject in popular imagery, but the most accessible body of such images is to be found in the work of Daumier (see fig. 37-2), a relationship that has been much discussed in the Degas literature. Here, as in most cases, Degas not only departed from Daumier's compositions but he represented his performers without the linear exaggeration of caricature that is a hallmark of the older artist's approach. Rather, we see a world of wood paneling and silks casting bright reflections from the stage lights.

The pastel in *Singers on the Stage* was applied directly to an impression of the monotype owned by Kornfeld and Klipstein, Bern (Cambridge 1968, no. 8). The monotype has been published as the first impression, but it is in fact possible that the first impression lies underneath the Chicago pastel. The difference between the two works is striking; the monotype has virtually no definition of a stage or physical setting and could easily represent a performance at an outdoor café. Indeed, Degas initially might have conceived the composition this way, later changing the setting—and therefore the meaning—by adding in pastel the architectural features of a popular theater. It is tempting to link cat. no. 37 directly with *The Duet,* for they are identical in size and were both acquired from Degas by a friend during the artist's lifetime. When they are considered as a pair, the Art Institute sheet can be seen as depicting a moment after a performance similar to the one pictured in *The Duet.* It is likely that this pastel and the Art Institute's pastel over monotype were made between 1877 and 1879, because the handling of the pastel, while appropriate to the scale and quality of the monotype, seems timid when considered with the magisterial pastels Degas made between 1879 and 1880. (RB)

COLLECTIONS: Georges Viau, Paris (per Cambridge 1968); Mrs. Clive Runnells, Chicago.

EXHIBITIONS: Paris 1924, no. 225.

LITERATURE: Lemoisne 1946, no. 455, repr.; Cambridge 1968, checklist no. 30, repr.; Russoli 1970, no. 453, repr.; Chicago 1979, 2E12; London 1983, no. 15.

Fig. 37-1. Degas. *The Duet,* c. 1877, pastel over monotype (L.433). USA, Private Collection. Photo: Prudence Cuming Associates, London.

Fig. 37-2. Daumier. *The Usefulness of a Family for a Singer (De l'Utilité d'une famille pour une cantatrice),* from *Croquis dramatiques,* pl.14 (pub. Jan. 28, 1857), lithograph. The Art Institute of Chicago (55.1159).

38. Café Singer, c. 1878

Inscribed recto, lower left, in brown oil: *Degas*
Oil on linen
53.5 x 41.8 cm
Gift of Clara Lynch, 1955.738

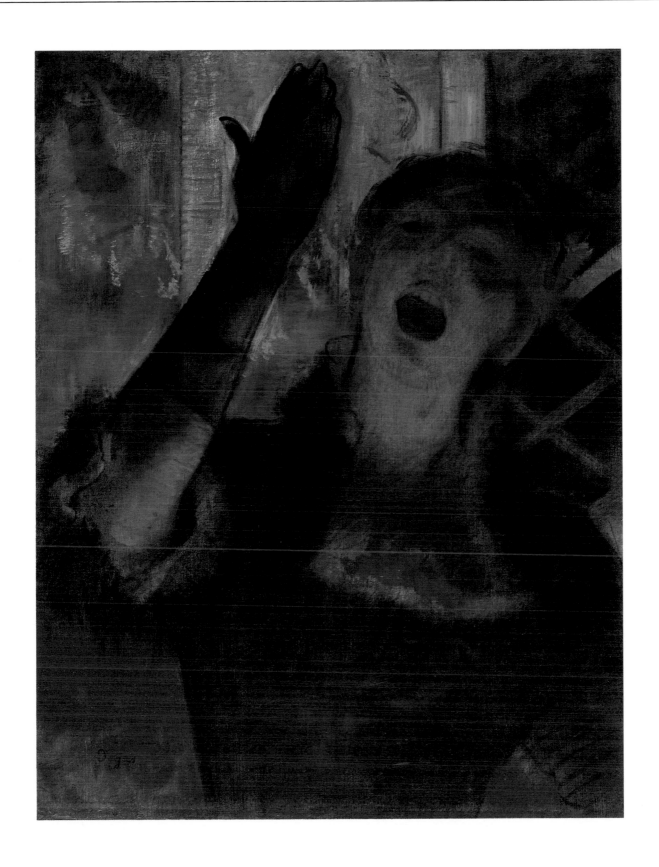

In this dynamic composition, the café singer seems almost to thrust herself upon the viewer. Her head is thrown back to provide a good view of her open mouth and teeth, and the abrupt movement of her right arm is reinforced by the tilt of her head. The meaning of her gesture is unclear; it is certainly not typical of the graceful and evocative movements associated with singers of opera or lieder. A remarkably similar posture occurs in an earlier Degas painting representing a serious musical performance of a classically trained singer in a domestic setting. The painting, *The Song Rehearsal* (fig. 38-1), depicts two women, one singing and the other directing. The performer's stance is conventional: her left hand is extended in a form of entreaty, and her right hand touches her heart to suggest her sincerity. The other woman, who has been identified as Degas's sister, Marguérite Fèvre, raises her arm as if to cut off the last note. This movement, resembling that of a conductor, is directive rather than expressive. Ironically, when Degas decided to give such a gesture to his café singer, he stressed her vulgarity and assertiveness rather than her grace and femininity.

The setting in cat. no. 38 identifies the subject as a café singer; the trellis in the background and the leaves in the upper left corner indicate that we are dealing here with an outdoor café-concert. Comparison with Degas's prints of such places (see cat. nos. 32-33, 58-60) reveals that this composition is totally contrived. No seats could provide such a view of a singer: we gaze directly at the performer's upper torso and arm while at the same time looking up at her face. In a strange way, *Café Singer* and its related drawings and pastels (see below) are unique in Degas's oeuvre because, although genre paintings, they center the singer as if in a portrait. Most often, Degas chose to place his singers in fully realized settings with leaves, lamps, orchestra, and audience. Here, there is simply the singer.

Café Singer is one of four related works, the most brilliant of which, *Café Singer* at the Fogg Art Museum (fig. 38-2), was included by Degas in the 1879 Impressionist exhibition (Shapiro 1980: 161-2). This pastel and the Chicago oil are unalike in every way except size. In each, the figure is differently placed, wears a different color dress, and dominates a different environment. Where the pastel is absolutely confident, hard, and strong, the Chicago oil is dreamy and soft. The light breaks dramatically across the double chin of the singer in the pastel and is kinder to the more finely proportioned face in the painting. Tradition has it that the model for the Chicago oil and for one of the preparatory pastels (L. 478) was Alice Desgranges, a classically trained vocalist and the wife of another singer and pianist, Théodore Ritter. If this is correct, Degas decided to do a portrait of a café-concert singer, then asked a concert musician of his acquaintance to pose, and, finally, based a preparatory pastel (Vente III, 342) and the Art Institute oil painting on that model. Two additional pastels (L. 478 and 478 bis), one of which is the Fogg pastel, represent either another model or a complete alter-

ation of the features of Mlle. Desgranges, for the performer appears here with full cheeks and a pronounced double chin.

The Chicago painting was first published (Lafond 1918-19) as a pastel and later as a study for the Fogg pastel (L. 477). Both notions are incorrect because not only is the work done in oil on linen but it was also signed by Degas and sold during his lifetime, indicating that he considered it finished. However, both misconceptions are understandable. The painting, like most by Degas between 1878 and 1882, does have a pastel quality. Degas used a viscous paint to block in the masses of color. He then scraped the entire canvas with a palette knife or similar tool to allow passages of white, primed canvas to flicker through the paint. Following this, he painted thinly and selectively in the light background, in the glove, and in some parts of the head and dress. The overall effect is one of a certain dryness of execution. These factors, together with the tentative treatment of the head, give the finished painting the quality of a sketch, especially when compared to the fully worked Fogg version of the composition. Again, as at other times in his career, Degas undercut the viewer's expectations both in terms of medium and finish.

Did Degas intend to paint an "oil sketch," complete with signature, as preparation for a finished pastel (fig. 38-2)? Unfortunately, we cannot know the answer. It is possible, though unlikely, that Degas rendered the subject in a conventional medium as a gift (never given) to the sitter, Mlle. Desgranges. A more plausible explanation lies in Degas's intense fascination with various media and his decreasing interest in culminating a series of works with a finished oil painting. By 1878-79, his experiments with pastel, tempera, gouache, monotype, various printing methods, sculpture, and maybe even photography all but overwhelmed his oil painting. *Café Singer* was never intended to look like a finished oil. Instead, the artist emphasized the indeterminate aspects of the technique and allowed certain of his corrections to remain visible. He evidently felt that the right side of the composition was weak and tried first to lengthen the model's dress and then to omit any indication of her left arm. With all its apparent tentativeness, there is much to admire in the Chicago painting, especially in comparison to the Fogg pastel, where the wonderfully luminous and delicate atmosphere of the Chicago canvas has become an abrasive, vulgar glare, and the beautiful woman a hefty athlete. (RB)

COLLECTIONS: M. de Bonnières, Paris (sale: Jul. 2, 1894); Durand-Ruel, Paris; John A. Lynch, Chicago, 1894.

EXHIBITIONS: Baltimore 1962, no. 41; Tokyo 1976, no. 28, repr.; Edinburgh 1979, no. 43, repr.; Albi 1980, no. 6, repr.

LITERATURE: Lafond 1918-19, II, repr. opp. p. 40; Grappe 1920: 36, repr.; Meier-Graefe 1920, pl. 50; Jamot 1924a, pl. 55; Bazin 1931, repr. p. 305; Mauclair 1937, repr. p. 107; Lemoisne 1946, no. 477, repr. (erroneously listed as pastel; collection erroneously listed as "Lynd"), also see 478 bis; Cabanne 1958, no. 74, repr.; Chicago 1961: 120; Russoli 1970, no. 449, repr.

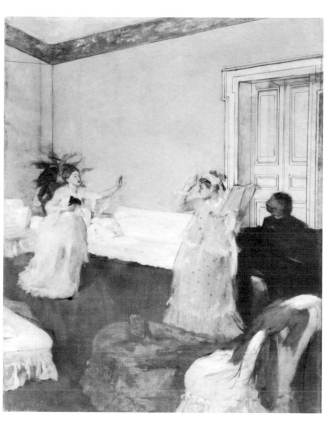

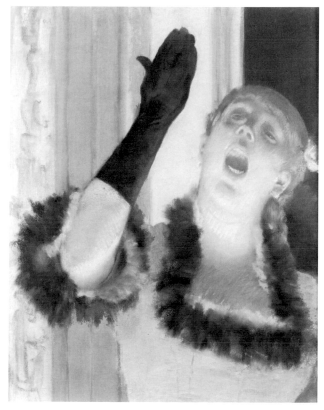

Fig. 38-1. Degas. *The Song Rehearsal*, c. 1873, oil on canvas (L.331). Washington, DC, Dumbarton Oaks House Collection.

Fig. 38-2. Degas. *Café Singer,* 1878, pastel and distemper on canvas (L.478). Cambridge, MA, Harvard University, Fogg Art Museum, Bequest of Maurice Wertheim (1951.68).

39. Dancer Stretching at the Bar, c. 1877/80

Inscribed recto, lower right, in orange pastel: *Degas*
Pastel with estompe on cream laid paper
316 x 235 mm
Mr. and Mrs. Martin A. Ryerson Collection, 1933.1229

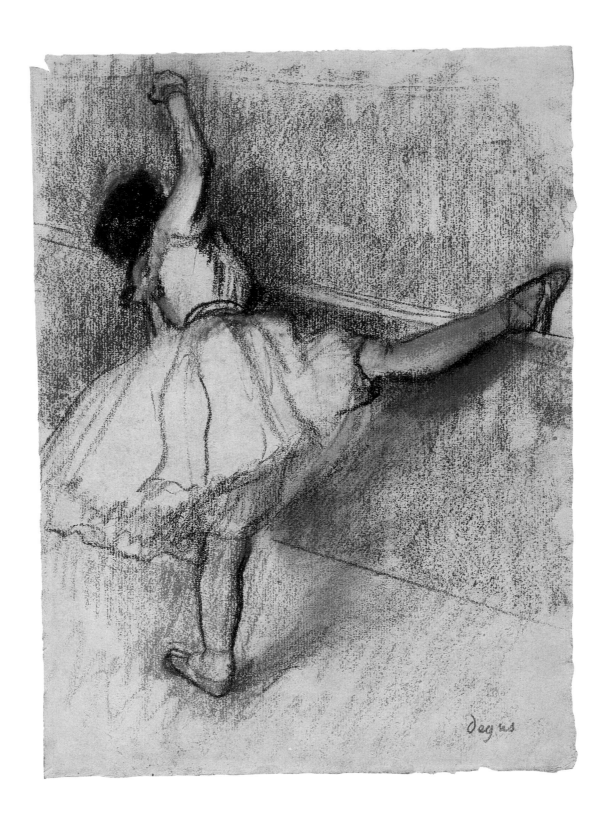

In Degas's lifetime, the Realist author and art critic Emile Zola wrote derogatorially of him: "I cannot accept a man who shuts himself up all his life to draw ballet girls as ranking co-equal in dignity and power with Flaubert, Daudet, and Goncourt" (Reff 1976a: 166). Yet, Edmond de Goncourt himself is said to have been greatly impressed by Degas's technical knowledge of dance as well as delighted to perceive him "on the tip of his toes, his arms held out, mingling the aesthetic terms of the painter with those of the ballet master." Comprehending the anguish as well as the accomplishment of this artist, Goncourt wrote, "an original fellow this Degas, sickly, neurotic, and opthalmic to such an extent that he is afraid he will lose his sight; but on that very account an exceptionally sensitive being who feels the subtle character of things. Of all the artists I have seen up to now, he is the one who best catches the spirit of modern life in his depiction of that life" (letter of Feb. 13, 1874, quoted in Goncourt 1971: 133-4).

Much of the modernity of Degas's ballet subjects derives from his interest in informal moments—ones in rehearsal, at practice, or at rest. These intimate scenes far outnumber those of performances; so, too, the majority of his figures are anonymous, not identifiable like the stars he portrayed, for example, in cat. nos. 41 and 42. A large portion of these works seems to have been drawn from life, but in the artist's rather than the dancer's studio. Degas preferred to work in the quiet isolation of his atelier; it was not until the early 1880s that he asked his friend Albert Hecht, an art collector and passionate opera lover, to secure a pass for him to see a dance exam.

The pastel *Dancer Stretching at the Bar* is one of the drawings of single dancers that Degas either gave away or sold himself. The signature indicates that he considered it a completed work, ready to be released; it was both published (Mauclair 1903) and resold at least once during the artist's lifetime. Including an overall setting, it is one of the most complete descriptions he made of a dancer exercising. This works cannot be directly connected with any of Degas's paintings. Indeed, because it betrays an awkwardness and exaggeration in the distribution and description of limbs that is more Mannerist than Realist in approach, former Art Institute curator Carl O. Schniewind questioned its authenticity (Print Department files). Yet, one can well imagine that these distortions resulted from the artistic ends that Degas, avoiding any servitude to his subject, strove to achieve with this sort of material. In a drawing such as this, he sought to express the beauty of movement in the most elementary stretching exercises, even, in this case, from an unattractive angle that discloses a hint of the dancer's bloomers beneath the tutu.

Although it is difficult to date Degas's individual images of dancers, the completeness of this study points to its being a relatively early work, from the mid-1870s, when Degas did a number of such studies including background hatching (L. 354, 379, 426). Moreover, during this period, he was fasci-

nated by rehearsal scenes, as indicated in the famous *Dancers at the Bar* of around 1876/77 (fig. 39-1). This painting does not exhibit the interest in three-dimensionality characteristic of Degas's works after 1880 (see cat. no. 42), nor the elongation of limbs evident in pastels of the 1880s (such as L. 807-11).

The graceful movement of this figure helps explain the enormous appeal Degas's dancers have had since his works on this subject were first noticed in England in 1876. Degas is reported to have stated: "They call me the painter of dancers, not understanding that for me the dancer has been a pretext for painting beautiful fabrics and rendering movements" (New York 1949, intro.). He noted further: "It is the movement of people and things that distracts and even consoles, if there still is consolation to be had for one so unhappy. If the leaves of the trees did not move, how sad the trees would be and we too" (Guérin 1947, no. 100). (SFM)

COLLECTIONS: Jacques Doucet, Paris (sale: Paris, Hôtel Drouot, Dec. 28, 1917, no. 73, repr.); Mr. and Mrs. Martin A. Ryerson, Chicago.

EXHIBITIONS: Chicago 1933, no. 860; Northampton 1979, no. 16, repr.

LITERATURE: Mauclair 1903: 381, repr.; Jamot 1924: 34; Chicago 1979, 2F6.

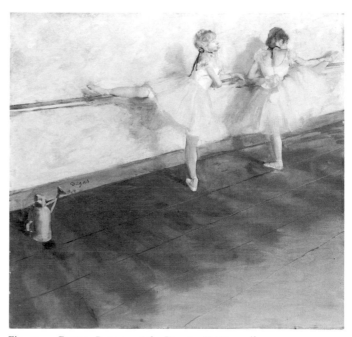

Fig. 39-1. Degas. *Dancers at the Bar*, c. 1876/77, oil on canvas (L.408). New York, The Metropolitan Museum of Art, Bequest of Mrs. H. O. Havemeyer (29.100.34).

40. Dancer Turning, c. 1878

Charcoal heightened with white chalk on gray laid paper
Max. 608 x 448 mm
Bequest of John J. Ireland, 1968.82

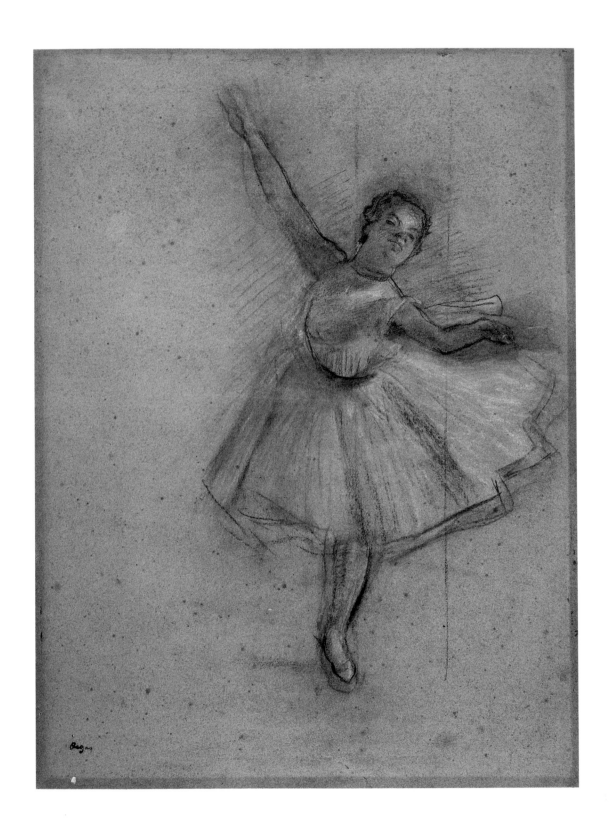

This monumental study depicts a principal dancer such as that featured in *On the Stage* (cat. no. 29) and in its cognate at the Louvre, *The Star* (fig. 29-1), in the same position but reversed. Janet Anderson has noted (written communication) that in this drawing the treatment of the dancer's hair and the bodice of her costume is actually closer to that of the figure in the Louvre pastel than in the Art Institute version.

Unlike the works in pastel, a medium Degas used to create colorful atmosphere and unabashedly glamorous forms, this charcoal drawing describes a bluntly foreshortened and relatively unattractive pug-nosed figure. Clearly, Degas was interested here in balancing the figure's arm, hands, and stance, as the many corrections and other *pentimenti* in the drawing reveal. The light charcoal grid may mean that the image was to be transferred to, or had been transferred from, another support. On the other hand, these indications simply could have served as plumb lines against which the figure was composed. The existence of an abstracted charcoal drawing of the same dancer on tracing paper (Vente III, 166/3), of apparently the same scale, suggests that the Art Institute drawing was copied, possibly to study the effects of reversal that the tracing paper would allow. In fact, the design drawn onto the monotype plate that served as the basis for *On the Stage* and *The Star* would have had the same orientation as this drawing; however, the discrepancy in size between the drawings and the monotype plate precludes direct transfer from either of them to the other.

Since no painted or pastel composition by Degas is known that contains the figure of the Art Institute's dancer drawn to scale, it must be assumed that the grid on the drawing aided the artist in visualizing the reduction of the dancer's form just as its abstracted copy on tracing paper allowed him to see the figure in reverse. Most likely, these drawings were executed in preparation for an oil sketch, *Entrance on the Stage* (fig. 40-1), in which a much-reduced version of the dancer appears in the upper right with an empty stage in the foreground. Undoubtedly drawn from life, *Dancer Turning* demonstrates Degas's careful examination of his often-used poses and suggests some of the ways he transformed his life studies into finished works. (SFM)

WATERMARK: SM

COLLECTIONS: Estate of the artist, stamp (Lugt 657) verso, center, in red; Vente II, 336, repr., stamp (Lugt 658) recto, lower left, in red; John J. Ireland, Cleveland.

LITERATURE: Chicago 1979, 2F3.

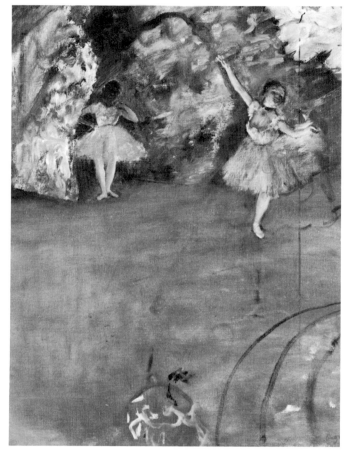

Fig. 40-1. Degas. *Entrance on the Stage*, 1877/79, oil on canvas (L.453). Private Collection. Photo: Robert Schmit, Paris.

41. The Star, 1879/81

Inscribed recto, lower right, in brown pastel: *Degas*
Pastel on cream wove paper, laid down
Max. 733 x 574 mm
Bequest of Mrs. Diego Suarez, 1980.414

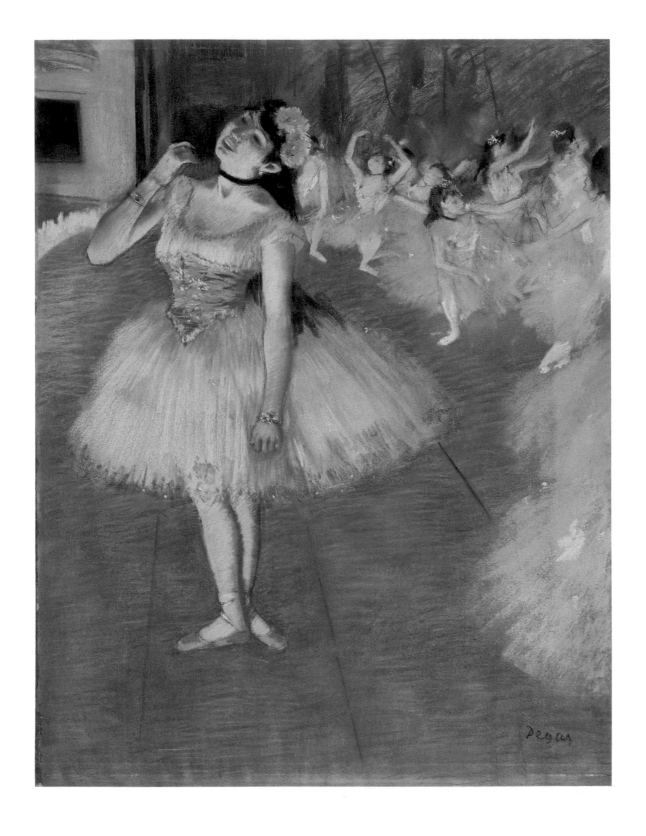

The Star is as close to a portrait as is any of Degas's dance compositions. The receding lines of the floor boards, the curve of the stage at the upper left, the halo of tutus that surround the lead dancer at the right—everything works to focus attention on the ballerina, whose unusual features Degas described precisely.

Although relatively few of Degas's many dancers can be identified today, two young dancers, renowned for performing with their hair down, can be recognized in certain compositions. One of them, Marie van Goethen, was the model for the sculpture *Little Dancer of 14 Years* (see cat no. 42 and fig. 42-1). The other star with a celebrated thick mane of dark hair was Rosita Mauri, who enjoyed great popularity between 1878 and 1898, according to Janet Anderson (written communication). Browse was the first to associate her with the Art Institute pastel (1949: 57); Anderson recently has identified her as the figure in the Louvre's *Dancer Bowing with a Bouquet* (fig. 41-1), whose broad mouth, almond eyes, long, thin nose, and rich, dark hair are depicted from a different angle than that in the Art Institute sheet. However, Browse, who maintained that Mauri made her debut at the Opéra in 1878, retreated from her identification of Mauri in the Art Institute pastel, believing it unlikely for Degas to depict such a young artist as a star (Browse 1949: 358). Anderson, however, has confirmed this identification through two photographs of the ballerina taken in 1880 and portraits of her by Anders Zorn and Théophile Steinlen of 1889/90.

While the dancer's identity is now certain, the proper dating of the Art Institute and Louvre pastels remains in question. On purely stylistic grounds, two seemingly contradictory impulses can be seen in *The Star*: on the one hand, the principal figure is described with a convincing sense of weight and three-dimensionality, suggesting that Degas had begun by this time to work in sculpture; on the other, the diagonal pattern of the floor and the rather flat, ornamental treatment of the background figures (which can also be seen in *Ballerinas on the Stage,* a composition Lemoisne [571] dated to around 1879) reflect Degas's avid interest in Japanese compositional techniques, particularly evident in his fan designs.

A third pastel (L. 650), which has been dated around 1881, perhaps can be linked with these depictions of Rosita Mauri: it combines the vertical format and the prominent dancer of *The Star* with the frontal movement and bouquet of the ballerina in *Dancer Bowing with a Bouquet*. In addition, the isolated figure, who resembles Rosita Mauri so closely, is set against a darkened stage floor, which lends a convincing sense of weight to her form. Perhaps it is not coincidental that the stance of the dancer (fourth position) or the way she leans back slightly in *The Star* are comparable to the studies for *Little Dancer of 14 Years* of 1879/80, where Degas explored not only a figure in space but also provided the realistic attributes and gestures so essential to portraiture.

One final series of associations helps to anchor the Art Institute pastel in the years 1879/81 and clarifies its significance within Degas's oeuvre. *The Ballet* (L. 476) is a pastel variation on the Louvre composition of Rosita Mauri bowing. Recently discovered to have a monotype base (Johnson 1981:

28-31), this sheet is unusual because it includes a later addition in the foreground of a female observer whose face and fan partially obstruct our view of the principal dancer. In another pastel, *At the Theater* (L. 577), in which this device is repeated and elaborated, the figure is depicted so precisely that she invites identification. While she does not exhibit the Latin features of Rosita Mauri, she does have long hair, and her resemblance to the model seen in the studies for the *Little Dancer of 14 Years,* particularly the inscribed sheet in the Louvre (fig. 42-2), suggests that she is Marie van Goethen.

The existence of a closely interrelated group of images featuring Marie van Goethen and Rosita Mauri suggests that, for a brief period between 1879 and 1881, Degas was interested in depicting individual ballet personalities—two young, promising dancers rather than older, established stars.

Recent examination of *The Star* under an infrared vidicon revealed that in the process of its execution, Degas eliminated incidental details, such as a fan hanging from the wrist of the principal figure and some dancers in the corps de ballet. (SFM)

COLLECTIONS: Mme. X, Paris (sale: Feb. 1919, no. 76, repr.); Roger G. Gompel, Paris; César de Hauke, New York; Jacques Seligmann and Co., New York; Mrs. Diego Suarez, New York.

EXHIBITIONS: Paris 1924, no. 152, repr.; Paris 1936a, no. 28, repr.; Paris 1937, no. 113, pl. XXVI; New York 1938; New York 1939, no. 18, repr.; Cleveland 1947, no. 37, repr.; New York 1949: 52, repr. p. 41; Los Angeles 1958.

LITERATURE: Frankfurter 1938: 11, repr.; Rouart 1945: 17, repr.; Lemoisne 1946, no. 598, repr.; Browse 1949, no. 58, repr.; Russoli 1970, no. 751, repr.

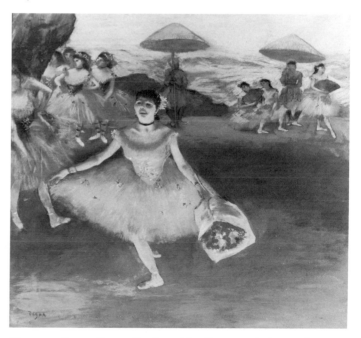

Fig. 41-1. Degas. *Dancer Bowing with a Bouquet,* 1878, pastel (L.474). Paris, Musée d'Orsay. Photo: Documentation photographique de la Réunion des musées nationaux.

42. Three Studies of a Dancer in Fourth Position, 1879/80

Inscribed recto, lower left, in black pastel: *Degas*
Charcoal and pastel with estompe, over graphite,
heightened with white chalk, on buff laid paper
480 x 616 mm
Bequest of Adele R. Levy, 1962.703

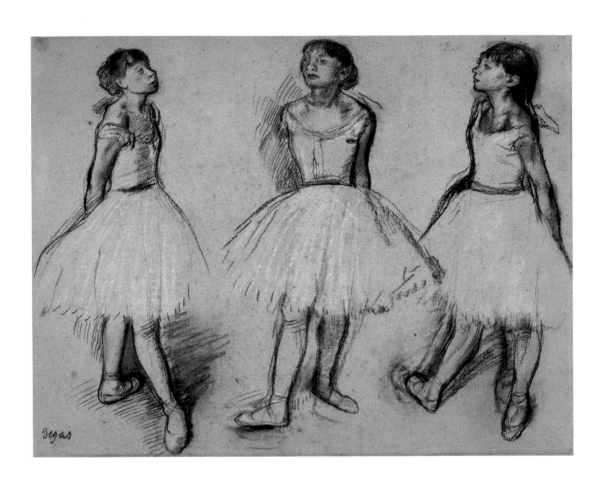

For the fifth Impressionist exhibition, in 1880, Degas promised a sculpture of a small, 14-year-old dancer. It was listed in the catalogue and a vitrine was even installed, but, as the sculpture itself was not finished on time, the case remained empty (Reff 1976a: 242). When the wax statue (fig. 42-1) was shown the next year in the sixth exhibition, it stirred a flurry of controversy. Its subject is a young girl, two-thirds life-size, standing in a relaxed fourth position with her hands behind her back, her chin out, and her nose raised in a somewhat arrogant fashion; even more startling was the fact that Degas had attired her in a gauze tutu with a linen bodice, real ballet slippers, and a blue silk ribbon around a long braid of human hair. J. K. Huysmans, in an article in *L'Art Moderne* in 1883, described the effect as "at once refined and barbarous," and observed the modernity of this creation:

> The fact is that, at the first blow, M. Degas has overthrown the traditions of sculpture, just as he had long ago shaken the conventions of painting. While taking up again the methods of the old Spanish masters, M. Degas

has immediately made [sculpture] thoroughly personal, thoroughly modern, by the originality of his talent (Huysmans 1883: 250-1).

It seems only logical that such an emphatically naturalist sculpture must portray an actual person; she has been identified as the Belgian dancer Marie van Goethen, who made her debut at the Opéra in 1888 (Reff 1976a: 245). Like her colleague Rosita Mauri (see cat. no. 41), she reportedly was terribly proud of her long black hair, which she preferred to wear down when she danced.

In preparation for this sculpture, Degas made a nude statuette and at least sixteen preparatory studies on six sheets. In addition to those cited by Reff (1976a: 333 n. 17; L. 586 bis, ter; Vente III, 277, 341b, 386; Vente IV, 287a), five other sheets (L. 578, 579, 593, 599; Vente III, 369) containing sixteen more studies may be connected with the project, although some of them are views of Mlle. van Goethen from all angles and thus are less directly related to the final posture.

It is difficult to establish the exact sequence of these drawings. The studies showing the dancer in movement or focusing solely on her head would seem to be the earliest in the series. As Degas established the pose for the sculpture, his characterization of the ballerina became increasingly exaggerated. George Shackelford (oral communication) believes that the sheet of studies in the Louvre (fig. 42-2) may be one of the earliest in the series because on it Degas noted the model's name and address. Yet, here Degas's harsh realism has been carried to an extreme—the model's features have been radically caricatured—and she has assumed the pose of the sculpture. On some sheets, the artist explored his subject—both clothed and unclothed—from different points of view and in various positions. While, traditionally, nude studies precede clothed figure drawings, here the sequence is not clear; in fact, the nude studies seem to have been used by the artist to ground his conception in a structure that was at once naturalistic and abstract.

There is little doubt that the drawing in the Art Institute's collection culminated the series. The drawing of the model from three vantage points exhibits not only a completeness of description but a pose that is very close to that of the sculpture. Despite some corrections made to the figure at the right, the sheet was executed with a control that reflects the extensive preparation behind it. Degas's signature at the lower left confirms that he considered it a finished work; the fact that it was owned during Degas's lifetime by the connoisseur Roger Marx suggests that it was a gift from the artist to his friend.

Like a second sheet of the same dimensions (L. 586 bis) depicting Marie from three other angles (back, profile, and front), the Art Institute drawing evokes the three-dimensional nature of sculpture, unfolding different aspects as if one were circling the figure. But apart from its role as a preparatory study for *Little Dancer of 14 Years*, these sheets—both of which are heightened with pastel—should be considered as significant works in their own right. Like other independent studies of about the same time, they reveal Degas's desire to achieve in his images substantiality and presence within a two-dimensional format. (SFM)

COLLECTIONS: Roger Marx, Paris (sale: Paris, 1914, no. 124); Bibliothèque d'Art et d'Archéologie, Paris (?) (per Lemoisne); Adele R. Levy, New York.

EXHIBITIONS: New York 1961: 14, repr.; Edinburgh 1979, no. 76, repr.

LITERATURE: Grappe 1936: 35; Mauclair 1937: 150, repr.; Rewald 1944: 21, 62, repr.; Lemoisne 1946, no. 586 ter; Browse 1949, no. 91, repr.; Chicago 1979, 2F2.

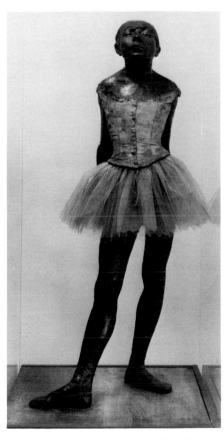

Fig. 42-1. Degas. *Little Dancer of 14 Years,* c. 1881, wax and costume. Paris, Musée d'Orsay. Photo: Documentation photographique de la Réunion des musées nationaux.

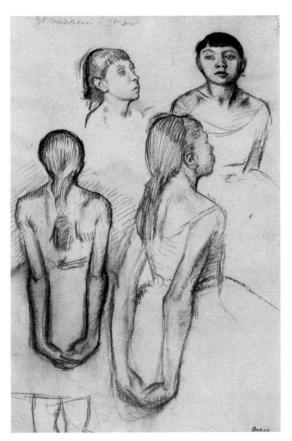

Fig. 42-2. Degas. *Studies for "Little Dancer of 14 Years,"* charcoal and white chalk. Paris, Cabinet des Dessins, Musée du Louvre. Photo: Documentation photographique de la Réunion des musées nationaux.

43. Dancers in the Wings, c. 1878/80

Etching and aquatint on ivory wove loose China paper;
seventh state of eight or eighth state of nine
Plate max. 141 x 104 mm; sheet max. 246 x 169 mm
Joseph Brooks Fair Collection, 1955.1009

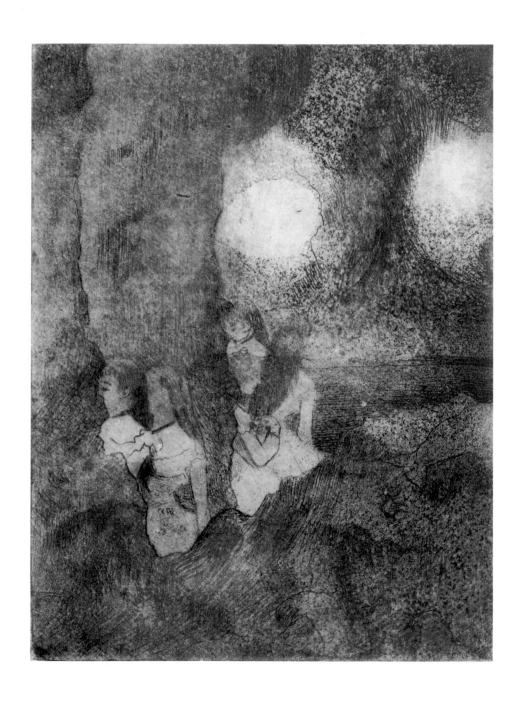

In the etching and aquatint *Dancers in the Wings,* Degas exhibited new concerns with spatial arrangement and artificial illumination. Rather than featuring one principal dancer performing on the stage, the small-scale work shows five figures from the corps de ballet as they wait among the stage flats. This informal glimpse reveals none of the dancers fully— their forms are cut off by the scenery. In fact, the prominent stage flats and large, round glowing lamps are the primary subject of the image; like so many works by Degas from the late 1870s, this theatrical subject allowed him to introduce the abstracting compositional techniques he admired in Japanese prints.

The successive states of this print demonstrate the artist's intentions. Originally, the plate featured three dancers; in the second state, Degas introduced aquatint to create a stage flat on the right. A fourth dancer was added in the third state; and, thanks to Marcel Guérin's unpublished supplement (1942) of the original catalogue by Delteil, a new fourth state was identified in which the fourth dancer was completed. In the next state, Degas included the fifth and last dancer; and in subsequent states he refined the dancers' hair, faces, and height. In the final state, he adjusted the flat on the left to conceal further the dancer second from the front, reinforcing the dominance of the set over the figures. Throughout these transformations, the balance between the richly etched lines and the sumptuous expanse of aquatint was changed, with the odd result that the last state appears darker and fresher than the next to last state. These variations undoubtedly reflect Degas's manipulation and wiping of the plate and his use of different papers to achieve the effects of recession and illumination he desired. He employed the burnisher to remove lines as often as he used the needle to etch new ones. More than in most prints up to this time, Degas sought in this densely patterned, small plate to approximate coloristic effects, and thus it is not surprising that the print finds its closest compositional equivalents in Degas's painted works of around 1878-80. The most obvious comparison is one in distemper and pastel, *Ballet Dancers* (fig. 43-1), dated by Lemoisne around 1878, which also exhibits a flatness and decorative quality that are distinctly Japanese in flavor.

Stage flats figure in a number of other works from the 1870s, among them those related to *On the Stage* (see cat. no. 29). But the only works that show similar abstraction are Degas's most oriental compositions, such as the fans of around 1879; however, no fan has that other crucial element of the etching—the haunting halos of stagelights glowing in the velvety darkness. Other aquatints of around 1878 contain similar lamps, but they function more as decorative geometrical devices than as creators of a sultry atmosphere. Its radiance links *Dancers in the Wings* instead with the dark-field monotypes of the 1880s (see cat. no. 68), where the warmth of the paper tone is allowed to shine through the inky blackness of the plate.

The very inquisitive nature of Degas's printmaking efforts around 1879 is confirmed in two other graphic works of that period of the same subject: *Two Dancers* or *In the Wings* (A. 36) of 1878/79 (according to Moses [Chicago 1964] and Adhémar), a rare example of Degas's use of the *crayon électrique* (see p. 112); and *In the Wings* (A. 35), which is a lithograph. The small plate in *crayon électrique* is closest to the etching, repeating the fourth dancer in reverse and making the stage flat more prominent. In the more descriptive lithograph, the dancers are more fully defined, the suggestion of an onlooker is introduced, and the stage decoration becomes more understated. Neither work achieves the luminosity and atmosphere of the etching-aquatint, which perhaps explains Degas's fascination with the aquatint process around 1879. (SFM)

COLLECTIONS: Estate of the artist, stamp (Lugt 657) verso, upper left, in red; Vente d'estampes, 76; acquired for the AIC from Gerald Cramer, Geneva (cat. no. 9, Nov. 1953: 11-12, no. 22a, repr.).

EXHIBITIONS: Chicago 1964, no. 26, repr.

LITERATURE: Delteil 1919, no. 26, repr. (first and eighth states of eight); Adhémar 1974, no. 28 repr. (fifth state).

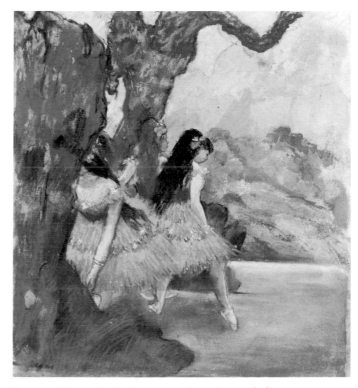

Fig. 43-1. Degas. *Ballet Dancers,* c. 1877/78, pastel, distemper, and gouache (?) over monotype (L.481). Washington, DC, National Gallery of Art, Ailsa Mellon Bruce Collection (1970).

44. Actresses in Their Dressing Rooms, c.1878/79

Etching and aquatint on cream wove paper; second state of six (?)
Plate 160 x 214 mm; sheet 277 x 361 mm
Albert H. Wolf Memorial Collection, 1935.185

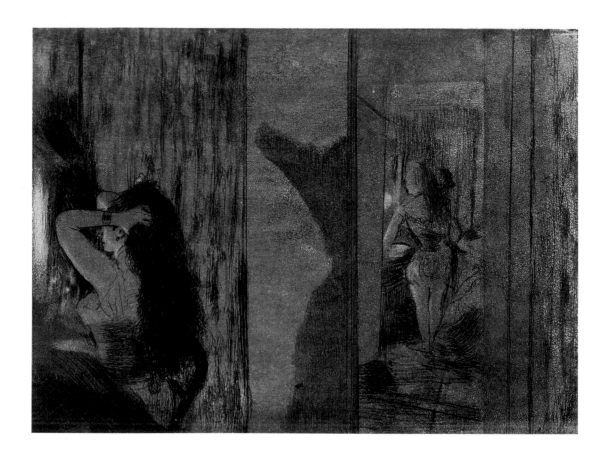

Degas rarely portrayed the dressing rooms of actresses. In fact, only this superb print and one painting (L. 516) of the subject exist; a pastel of a dancer at her dressing table (L. 561) is the only other comparable image in his oeuvre. In each of these works, an artist is engaged in final preparations for her performance. The actress depicted in the painting has just been helped into her dress by an attendant, and her pasty, bovine face stares out at us from a mirror. The ballet dancer in the pastel is more beautiful and more like the glamorous actress whose dressing room is depicted in cat. no. 44. Unlike the dancer, who turns toward us as she looks in the mirror, thereby acknowledging and even sanctioning our existence, the woman in the Chicago print seems unaware of any presence besides her own.

In *Actresses in Their Dressing Rooms,* Degas concentrated on a relatively tranquil moment before the performance and, therefore, before the onslaught of gentlemen. The exotically beautiful woman before us, clad only in her undergarments, arranges her cascade of hair. An invisible light on the dressing table casts her shadow onto the partially open door, behind which is a hallway leading to other dressing rooms. Through the doorway can be seen the room across the hall, where another actress, also still in undergarments, dresses for the performance with the aid of an attendant whose head appears directly behind her. Although there is a relaxed, natural quality to their activities, the flattened, ambiguous spaces and the dark shadows lend a distinct sense of mystery to the print.

The pictorial space of *Actresses in Their Dressing Rooms* is its most fascinating and problematic element. Arranged in a series of bands that appear to be strictly parallel to the picture plane, the print actually describes a complex sequence of obliquely oriented spaces interconnected by partially open doors. These spaces are differentiated one from the other by Degas's manipulation of light and texture. It is perhaps easier to decipher them when they are compared to the actresses' dressing rooms illustrated in the monotypes Degas made for Ludovic Halévy's *Famille Cardinal* around 1880. In several of these prints (see fig. 44-1; also C. 62, 67, 78), bourgeois gentlemen in evening attire hang around the dressing rooms of the ballet dancers, arranging alliances in a maze of halls, doors, and staircases that seem almost to prefigure the sets for the early 20th-century Expressionist film *The Cabinet of Dr. Calligari.*

When confronted with the Chicago print, the viewer is at first unable to define the two figures with respect to each other or to himself. The shadow of the actress looming at the left is also disconcerting because its central placement allows it to become in some ways the principal "subject" of the print. This deliberately puzzling play of two and three dimensions resembles the "intimist" panels Edouard Vuillard would do in the 1890s. Like Vuillard, Degas juxtaposed plain and patterned surfaces, figures, and their shadows to create a pictorial world in which surface and space are at odds with each other. By omitting both the floor and the ceiling of the dressing room, Degas freed the edges of walls and doors from their position in space and allowed them dominance as lines.

Technically, the complexity of the print relates to those representing Mary Cassatt on which Degas was working for *Le Jour et la Nuit* in 1878-79 (see cat. nos. 50-54). From the title of that unrealized publication, it might be surmised that Degas conceived this as his "night" print for the journal. It is the same size as Camille Pissarro's famous *Effect of Rain* of 1879 (fig. 57-1), at least one impression of which Degas printed; and it is certainly possible that the two exactly contemporary etchings were conceived as a pair of opposites—city and country, interior and exterior, night and day. In both, the artists made extensive use of aquatint, manipulated with a stump and their fingers, as indicated in an undated letter from Degas to Pissarro (Guérin 1931-45, no. XVI, pp. 33-6). In fact, the entire plate of *Actresses in Their Dressing Rooms* was covered with aquatint, which interacted in a variety of subtle ways with the bitten, etched lines.

The impression in the Art Institute has always been identified as the second of five states, despite the fact that various writers have noticed the absence here of the actress's chairback, one of the defining features of that state as described by Delteil. Therefore, it is likely that this impression, made before the addition of the chairback, reflects a true second state and that the print went through at least six states. In later states, the doorway to the second room, minimally and confusingly indicated in this impression, was darkened and made more legible. Like Rembrandt's night prints, which Degas knew so well, *Actresses in Their Dressing Rooms* gained greater contrast and clarity as it progressed from state to state. (RB)

COLLECTIONS: Estate of the artist, stamp (Lugt 657) verso, lower left, in red; Vente d'estampes, 55; acquired by the AIC from R. H. Franklin, St. Louis; The Art Institute of Chicago, stamp (Lugt Suppl. 32b) verso, center, in brown.

EXHIBITIONS: Chicago 1964, no. 32, repr.; Edinburgh 1979, no. 103, repr.

LITERATURE: Delteil 1919, no. 28 (third state); Adhémar 1974, no. 31, repr. (third state); Edinburgh 1979, nos. 104-05, repr. (third and fifth states).

Fig. 44-1. Degas. *La Famille Cardinal*, c. 1880, monotype. Cambridge, MA, Harvard University, Fogg Art Museum, Bequest of Paul J. Sachs.

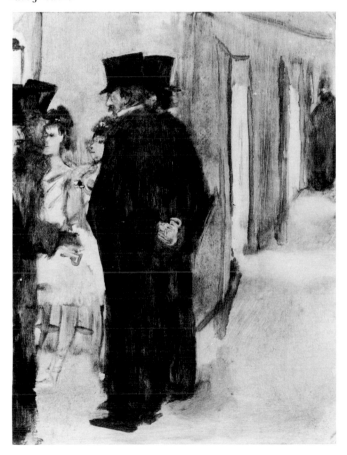

45. Plate with Two Subjects, c. 1879

Lithograph on white wove paper; only state
Image 199 x 310 mm; sheet 276 x 352 mm
Clarence Buckingham Collection, 1952.234

This print appears more curious in its present form than perhaps it ought to, for Degas, like many lithographers of the period, used the same stone for two grease-crayon lithographs, each of which could be cut and sold separately after printing. Thus, the most obvious connection between the two images—one of a circus, the other of a brothel—is their similar scale and virtually simultaneous date. On this plate, Degas juxtaposed two common 19th-century performers, an animal trainer and a prostitute—one public, the other private.

In the circus scene, the trainer is placed in the center of the ring. His back to the viewer, he faces the other half of the audience. He holds a paper-covered hoop through which a

dog on the opposite side of the ring is about to jump; the man's legs are firmly planted around a second dog which turns to face the viewer. Another dog exits at the left. Degas witnessed this charming act at the Cirque Fernando, which was established in 1877 as Paris's first permanent, commercial circus. That it was visited by scores of artists in the late 19th and early 20th centuries (when it became known as the Cirque Médrano) is attested by numerous representations. The Art Institute owns works by Renoir, Toulouse-Lautrec (fig. 45-1), Bonnard, and Léger that depict it.

This straightforward representation of an animal act was made at the moment when Degas was preparing his major painting, *Miss Lala at the Cirque Fernando* (L. 522), finished for the Impressionist exhibition of 1879. Curiously, the lithograph is very different from the painting and its many related drawings. In them, the viewer looks up into the elaborate cast-iron structure of the ceiling from which a young woman dangles, suspended by her teeth. In the lithograph, for which there are no surviving drawings, Degas structured the ring and act into a schematic, almost geometric construction that appeals more to modernist sensibilities than does the finicky and anecdotal *Miss Lala*. In its particular spatial construction, the print relates clearly to early lithographs by Daumier (D. 105, 108, 131). The composition in Degas's small lithograph would find echoes in the many later drawings and paintings of the same subject by Lautrec (see fig. 45-1) and Bonnard, and in Picasso's many studies of the alienated performer. The fact that in the print Degas chose not to represent the audience, except for the suggestion of a gentleman at the far left, creates an intense mood—the performer appears totally alone, intent only on his act.

The prostitute of the other image is also alone; like the circus trainer, she, too, is depicted from the back. Yet, she stands not in the center but at the edge of her room, the space of which is defined and dominated by a rug. She is either about to open the door further or to close it. The tentativeness, indeed the ambiguity, of her action was clearly intended: Degas characteristically was intrigued by the visual poetry of a pause or a moment of indecision. The identification of the subject is made clear by the implied narrative of the image. The woman's head is bent forward; perhaps she is listening for footsteps in the hall or adjacent room. She is ready: Her clothes and boots have been removed and piled in front of the daybed that appears in the lower left of the print; the armchair from which she may have just risen is empty; and the bed is freshly made, its pillows plumped and its sheets turned down in anticipation. In the upper left corner glows the light that marks the actual center of the room, in counterpoint to the slit of darkness behind the door. The delicacy, even poignancy, of the print is communicated in every detail. It is remarkable that an image so seemingly simple and generalized should contain such a wealth of information. Its clarity and succinctness may be explained by the fact that it is a refinement of a slightly earlier monotype (C. 128), which may have been used in the initial stages of preparing the lithograph.

It is tempting to trace this tiny prostitute's pose to one of Degas's first historical compositions, the unfinished *Wife of Candaulus* of 1855/56, an oil sketch for which appeared recently on the market (see also Paris, Bibliothèque Nationale, Degas Notebook 6, sheet 62). The text for this early exercise was Herodotus, but, as is always the case with this kind of subject for the artist, it served as the vehicle for his exam-

ination of a basic human situation made archetypal by its roots in classical history. In this early composition, a standing woman, her back to the viewer, looks over her shoulder as she prepares to enter her bed. Even after Degas moved beyond his youthful academic style, the nude or slightly clothed human figure continued to carry classical significance for him; he altered many of his early figures and used them again and again in modern contexts. In his introduction of classical motifs in representations of the quotidian, Degas resembled the novelist Gustave Flaubert. Yet, once Degas renounced the strictly classical, once he moved from Spartans to jockeys, from *The Wife of Candaulus* to bathers and prostitutes, he seems never to have regretted his decision. (RB)

COLLECTIONS: A. H. Rouart, Paris, stamp (Lugt Suppl. 2187a) lower right, in purple, and stamp (not in Lugt) verso, upper right, in purple; acquired by the AIC from Guy Mayer, New York.

LITERATURE: Delteil 1919, nos. 46, 47, repr.; Adhémar 1974, no. 45, repr. (AIC).

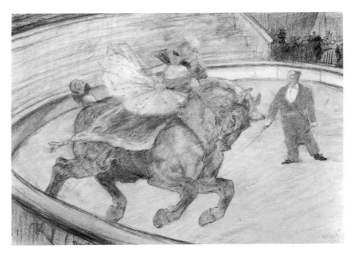

Fig. 45-1. Henri de Toulouse-Lautrec (French, 1864-1901). *At the Circus: Work in the Ring*, 1899, pastel. The Art Institute of Chicago, Gift of B. E. Bensinger (1972.1167).

46. Waiting (formerly Le Coucher), c. 1879

Monotype printed in blackish brown ink on light gray wove paper
Plate max. 109 x 161 mm; sheet 163 x 188 mm
Gift of Mrs. Charles Glore, 1958.11

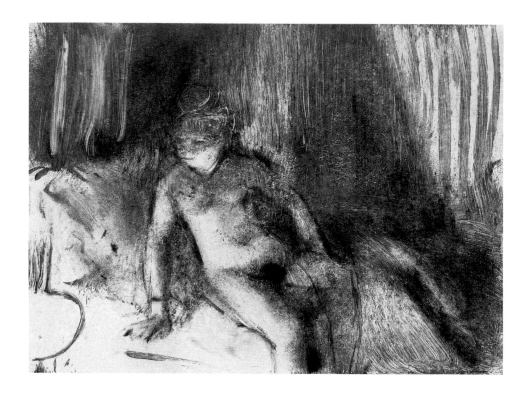

Waiting is among a group of small monotypes made by Degas in 1879-80 depicting the interiors of brothels. Degas used the medium for his most intimate, sexually explicit representations of the female nude, preferring to generalize and, thus, disguise his prostitutes when making drawings, pastels, and paintings. Here, a prostitute, with ribbons around her neck and right arm, uncovers her leg as she rises from her bed, apparently moving toward the light that shines from the lower left. Like the prostitute in cat. no. 45, she has been depicted in a moment of delicate equipoise, neither lying down nor sitting up but rather in transition between the two. The shadow of her body looms large behind her, creating a mysterious effect as it obliterates areas of the striped wall-covering. Perhaps she is only going to turn off the light, but she seems to look past it in anticipation, maybe at a client who enters the room.

This monotype is as intimate in its technique as in its subject. One feels the motion of the artist's hands; he has left traces of his brushes, sponges, rags, and, on occasion, even fingers, which he used directly to model the figure's breasts, belly, and thighs. The shadowy areas of the print were worked—perhaps after printing—with a brown-gray grease crayon which gives these passages a velvety indefiniteness. In this way, the palpable softness of the pillow, flesh, and bedclothes in the light is paralleled in the tactility of their execution; it is perhaps because of its very directness as a trans-

mitter of tactile sensation that Degas chose the monotype for his scenes of intimate life.

The scale of *Waiting* reinforces its intimate quality. It was meant to be held in one's hand and caressed with one's eyes; as such, it was conceived as a private, sensual pleasure for a connoisseur or two, a practice in which Degas (see cat. no. 68), Daumier, and others indulged. Precisely because of this, *Waiting* loses much in reproduction and even in exhibition. Plates of the same size were used frequently by Degas; other monotypes of the period are nearly identical in their measurements (see Cambridge 1968, checklist nos. 60, 66, 67, 69, 73, 79-81). The scale of these prints is similar to that of the monotype illustrations Degas made at the same time for his friend Ludovic Halévy's *Famille Cardinal*. Understanding the nature of *Waiting,* the great dealer and publisher Ambroise Vollard chose to reproduce it as an illustration in his 1934 edition of Guy de Maupassant's story about a prostitute, *La Maison Tellier.* (RB)

COLLECTIONS: Estate of the artist, Vente d'estampes, 228; Gustave Pellet, Paris; Maurice Exteens, Paris; Paul Brame and César de Hauke, Paris; acquired by the AIC from de Hauke.

EXHIBITIONS: Paris 1937, no. 195; Cambridge 1968, no. 26, checklist no. 103, repr.; Edinburgh 1979, no. 95.

LITERATURE: Rouart 1948, pl. 39; Cachin 1974, no. 107, repr.

47. Portrait after a Costume Ball (Portrait of Mme. Dietz-Monnin), 1877/79

Gouache, charcoal, pastel, metallic paint, and oil on canvas
85.5 x 75 cm
Joseph Winterbotham Collection, 1954.325

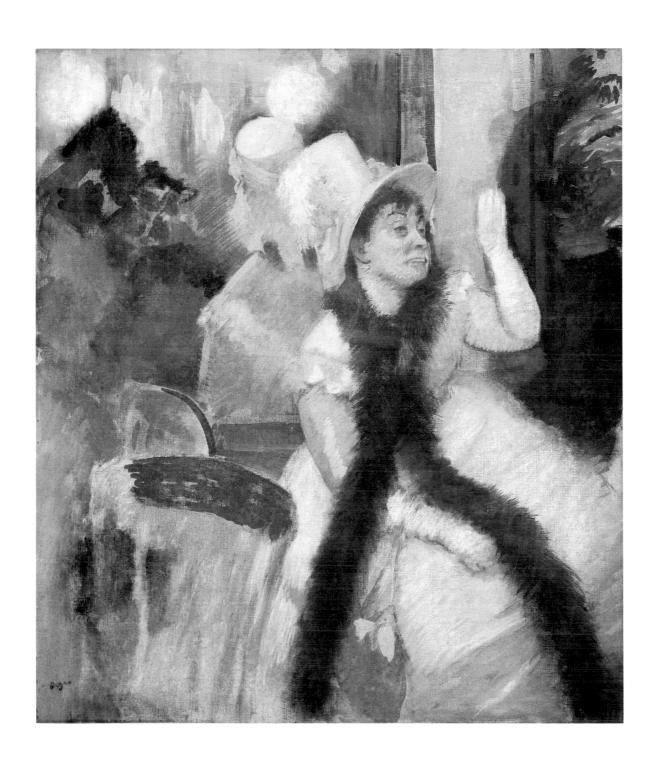

Degas titled this painting *Portrait after a Costume Ball* when he listed it in the catalogue of the Impressionist exhibition of 1879. However, it seems either that it was never sent to the exhibition or that it was excluded in the hanging process for reasons of space. His initial decision to include it along with the now famous portraits of Diego Martelli (L. 519) and Théodore Duret (L. 517) is proof both that he valued it highly and that he considered it "finished" enough for public exhibition, despite large areas that are thinly painted and that, at first glance, seem unresolved. The anonymity of the sitter preserved in the title was in no way unusual. In fact, Degas and his contemporaries in and out of the Académie frequently exhibited important portraits without naming the subjects. In this way, the privacy of the model was respected, and the public was encouraged to evaluate the portrait as a painting rather than as a likeness.

We know the sitter here was Mme. Dietz-Monnin because Degas left in his studio an unsent letter to this lady that makes specific reference to the portrait. The letter is frequently quoted because it reveals so clearly Degas's extreme sensitivity and because it discusses an identifiable work of art. Unfortunately, since the letter is not dated, it is difficult to know just when the portrait was begun.

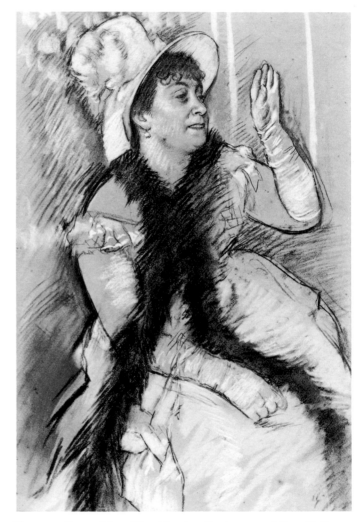

Fig. 47-1. Degas. *Mme. Dietz-Monnin,* 1877/79, pastel (L.536). Los Angeles, Norton Simon Inc. Foundation (M.76.7.P).

Dear Madame,

Let us leave the portrait alone, I beg of you. I was so surprised by your letter suggesting that I reduce it to a boa and a hat that I shall not answer you. I thought that Auguste [Auguste de Clermont, painter-friend of Degas and brother of Mme. Dietz-Monnin's son-in-law] or M. Groult [Camille Groult, a manufacturer and famous collector of 18th-century art] to whom I had already spoken about your last idea and about the absolute lack of taste to which I must submit if I follow it, would have informed you about the matter.

Must I tell you that I regret having started something in my own manner only to find myself transforming it completely into yours? That would not be too polite and yet. . .

But, dear Madame, I cannot go into this more fully without showing you only too clearly that I am very much hurt.

Outside of my unfortunate art, please accept all my regards (Guérin 1947: 60-1).

The following assumptions consistently have been based on interpretations of this letter in the Degas literature: first, that the portrait was commissioned from Degas by the sitter; second, that she repeatedly refused to sit for it and sent her hat and boa instead of herself; and third, that Degas destroyed a final oil-on-canvas version of the portrait because it compromised his principles. In fact, the letter supports none of the assumptions unequivocally. Although it does indicate that the

portrait was commissioned, it is perfectly possible to assume that, like many of Degas's other portraits of the later 1870s, it resulted from a collaborative discussion between the sitter and the artist. Second, the letter says only that Mme. Dietz-Monnin wanted to "reduce it to a boa and a hat," not that she refused to sit and sent these props instead. It is just as easy to interpret this sentence to mean that she favored a literal reduction of the canvas to exclude the large areas of mirrored interior to her left. A rather conventional pastel related to the Art Institute painting, *Portrait of Mme. Dietz-Monnin* (fig. 47-2), could be such a reduction. That the Chicago version of the composition was painted on canvas in oil and tempera and that it was both signed and listed in the catalogue of the exhibition by Degas indicate clearly that it is the final version.

Fortunately, another, earlier letter sent by Degas to Mme. Dietz-Monnin was published by Reff (1968). It suggests a true collaboration between sitter and painter and reconfirms the key role played in the commission by Camille Groult:

Monday [c. 1878]

Madame,

Would you like me to come on Wednesday at one-thirty? I write also to M. Groult. If the thing is all right with you, let me know. I think that the umbrella is useless. But M. Groult, if he has found something else, can persuade me to change my mind.

The boa, on the contrary, is very good, and also the long suede gloves with the big folds.

I am at your service, Madame, and excited about our session together.

A thousand compliments.

Degas
19 bis rue Fontaine St. G.

This letter makes one curious to know more about Mme. Dietz-Monnin and the origins of this rare commissioned portrait.

Mme. Dietz-Monnin was born Adèle Monin in Belleley, Switzerland, adopted by a wealthy uncle, and brought up in Paris. She married Charles Frédéric Dietz-Monnin somtime in the 1850s, and they had two children, Gabrielle and Jules. Dietz-Monnin, a wealthy industrialist and politician active in France during the 1870s and 1880s, was involved in the planning for the French section of the Centennial Exposition of 1876 in Philadelphia as well as for the Agriculture and Commerce section of the Exposition Universelle of 1878 in Paris. During the mid-1870s, he served as a member of the National Assembly, where he authored several laws involving taxes and tariffs. During the 1880s, he was a senator, again writing legislation about shipping, transport, and tariffs. It is clear that Dietz-Monnin was a powerful bourgeois interested in commercial progress and in the modernization of the French economy. There is no indication that he was involved with the arts.

While all this can tell us something of the status of Mme. Dietz-Monnin relative to her husband's, it gives us few clues to her own life and interests. That she was bourgeois or even haute-bourgeois can be assumed, but this alone tells us little. The fact that her portrait was commissioned from Degas is extraordinary, as many writers have remarked. Boggs (1962) asked why Mme. Dietz-Monnin had not "shopped among the more accommodating portrait painters who exhibited at the Salon," offering the names of Bonnat and Clairin as typical members of that group and expressing veiled surprise that such a silly woman would have chosen Degas even over Manet or Renoir. And Alfred Werner (1968) contrasted the "society" portraits of those two colleagues of Degas's to this unflattering depiction of what Werner contemptuously called "a plain, uninteresting, middle-aged bourgeois woman."

These interpretations are overly simplistic. To assume that Mme. Dietz-Monnin was stupid because she was bourgeois (Degas, after all, was equally bourgeois) is to misinterpret the portrait as a form of explicit social criticism. And to decide that she was a ridiculous woman simply because Degas had problems with her in the course of painting the portrait discounts the fact that Degas was known to have been difficult even with his friends. Degas never flattered his sitters, and he certainly was no more critical of Mme. Dietz-Monnin in this portrait than he had been of other friends and family in earlier portraits.

The letter and the Art Institute portrait tell us only that Degas agreed to paint Mme. Dietz-Monnin, that she wanted the portrait for her own collection, that it was decided to portray her "in costume"—exotically rather than primly or properly dressed—and that, most likely, she was to be shown at a costume ball. Perhaps she imagined from this something more like Renoir's later representations of specific women dancing, culminating in his *Ball in the City* of 1883 or even Maurice Quentin de la Tour's pastels of society women at masked balls mentioned in the Goncourts' *Painting in the Eighteenth Century* (Goncourt 1948: 166). If so—and knowing Degas's work either directly or from those friends mentioned in the letter—why did she choose Degas?

According to family tradition, Mme. Dietz-Monnin was a brilliant and occasionally caustic conversationalist with a highly developed interest in music. A world traveler, she socialized not only with members of the haute-bourgeoisie, but with artists, musicians, and connoisseurs. Her life intersected with that of Degas around 1875, when her daughter married Herman de Clermont, the brother of Degas's friend Auguste de Clermont, the painter mentioned in the letter quoted above.

At this point, the story, as relayed recently by family members (written communication), becomes more complex.

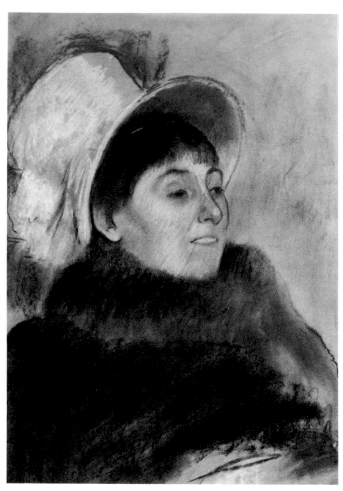

Fig. 47-2. Degas. *Portrait of Mme. Dietz-Monnin*, 1879, pastel (L.535). Washington, DC, National Gallery of Art, Gift of Mrs. Albert J. Beveridge (1951).

Degas apparently borrowed large sums of money from the Clermont brothers after the collapse of his family's finances in 1876. He is known to have given works of art to Herman de Clermont as a form of repayment; when Degas was in need of more money, Herman arranged for the artist to paint a portrait of Mme. Dietz-Monnin for a set price. Degas worked extensively on the portrait, and she sat for him many times before he sent it to her. According to her great-granddaughter, she thought that she looked either drunk or like a prostitute soliciting a client and returned the picture to Degas with full payment for his services. Degas attempted to negotiate a settlement, only to find that his modern aesthetic principals were at odds with the desires of his client; his much-quoted letter to her was evidently written at that point.

Degas made two closely related pastels from life—fig. 47-1 and Vente II, 348 (now lost)—in preparation for the painting. Then, he finished the painting, which, as we have seen, the sitter disliked and returned. Although Degas was upset, he decided to include it in the Impressionist exhibition in April 1879. Like the other great portraits selected for that exhibition, it remained in his collection until his death. As discussed above, he seems to have made a pleasant pastel (fig. 47-2) for Mme. Dietz-Monnin, but either he never sent it or it was returned, since it was in Degas's collection at the time of his death.

Why, in painting the portrait, did Degas choose to use several media—tempera, oil paint, pastel, and metallic paint—rather than one? The answer perhaps is related to the fact that he experimented continually, and in this case was as interested in the representation of light as he was in the forms themselves. Indeed, the lost study for the painting is a vigorous description of light falling boldly across the form of the woman, with little regard for her features. Degas's use of various kinds of paint indicates a desire to manipulate his media in order to represent various reflective surfaces in nature—satin, fur, gilded paint, and mirror. For this reason, he never varnished the painting, which allowed the properties of the several media to be expressed without the unifying sheen of varnish. This approach resembles the Cubists' witty use in the first decades of the 20th century of both glossy and matte paints within the same picture.

The reflections in the painting are particularly curious. Those to the left of the figure, cast by the mirror, are blurred because we, the viewer, are focused on the sitter. They relate not only to what we see in the painting (particularly the costume of the lady herself), but also to the forms in the room in which both Mme. Dietz-Monnin and the viewer are present. All the gilded chairs surrounding her are now empty; and she seems to be waving goodbye to a friend or departing guest. Yet, if everything to the left of the sitter is reflection, what is going on to her right? The dark shape, with its highlights of red, blue, and gold, is surely a male figure, also in costume. Degas denied him solidity of form by drawing two lines of gold paint across him, thereby suggesting that what we are actually seeing is an out-of-focus reflection in yet another mirror. The figure began as a man in military dress (clearly visible are his epaulette and a plumed military hat held in his hands); his peering, bearded face is almost a caricature. Was this supposed to have been M. Dietz-Monnin in a costume? Did Degas at one time intend the portrait to be a double study of a husband and wife dressed in costume for a ball?

These issues cannot be resolved without further evidence, but they point out the ambiguities of this mysterious portrait. When seen as a commissioned portrait that was refused by the sitter, the painting can be too easily interpreted

as a critical analysis of a particularly crude bourgeois woman for whom Degas worked because he was relatively poor during the late 1870s. However, when considered within the context of what one might call Degas's genre portraits, many of which were exhibited in the 1879 Impressionist exhibition, the painting takes on a greater richness and meaning. In the latter case, we can interpret it as a portrait not so much of Mme. Dietz-Monnin, but of a bourgeois woman in costume. The painting thereby can be seen as the social counterpart of Degas's *Portraits at the Stock Market* (L. 824), which also was exhibited in 1879. In both, Degas analyzed the world of the bourgeoisie—the men at work and the women at leisure.

The painting is perhaps most interesting in relationship to contemporary and slightly later works by Manet. Indeed, the juxtaposition of a strongly three-dimensional female figure and an ambiguous, mirrored environment fascinated both painters. Manet is said to have begun the studies for his masterpiece, *The Bar at the Folies Bergère,* just months after *Portrait after a Costume Ball* was finished. The connections between these two works are very strong. They demonstrate Degas's familiarity with Manet's café pictures of 1877-78, most of which make active use of mirrors, as well as with Manet's familiarity with this portrait when he began to prepare for the *Bar.* Indeed, the image of the costumed female figure in a world of flux can be found in the prose of Charles Baudelaire, and indicates that each painter may have been striving to be the poet-critic's painter of modern life. Standing at the center of that delicious but dangerous world of reflections, Manet's barmaid seems to appeal to us for rescue. In contrast, Degas shows us a costumed woman waving pathetically to departing guests. She never acknowledges the viewer; we feel ourselves present only because there is a chair for us. Her gloved hand is raised, while her other arm hangs limply at her side next to the drooping boa. She is tired. The evening is at an end. She is about to be alone again. (RB)

COLLECTIONS: Estate of the artist, Vente I, 116, repr., stamp (Lugt 658) recto, lower left, in red heightened with orange pastel; Jacques Seligmann, Paris (sale: New York, Jan. 27, 1921, no. 34, repr.); Henry D. Hughes, Philadelphia (sale: New York, Jan. 28, 1926, no. 171, repr.); Durand-Ruel, Paris and New York; Reinhardt Collection, New York; Joseph Winterbotham, Chicago.

EXHIBITIONS: Cleveland 1929, n.p.; Chicago 1933, no. 290; Chicago 1955, no. 13, repr.

LITERATURE: Paris 1879, no. 59; Charles 1918: 4, repr. (as "Portrait d'un Mondaine Artiste," unsigned"); Mauclair 1937: 64, repr.; Lemoisne 1946, no. 534; Guérin 1947: 60-1, no. 37; Chicago 1961: 120; Boggs 1962: 52; Reff 1968: 90-1; Werner 1968: 22; Maxon 1970: 267, repr. p. 268; Russoli 1970, no. 562, repr.; Chicago 1978, no. 62, repr.; Marandel 1979: 36, repr. p. 37.

48. Portrait of Mme. Dietz-Monnin (formerly Head of a Woman), 1877/79

Graphite on ivory laid paper
240 x 220 mm
Gift of Mrs. Gilbert W. Chapman in memory of Charles B. Goodspeed, 1947.810

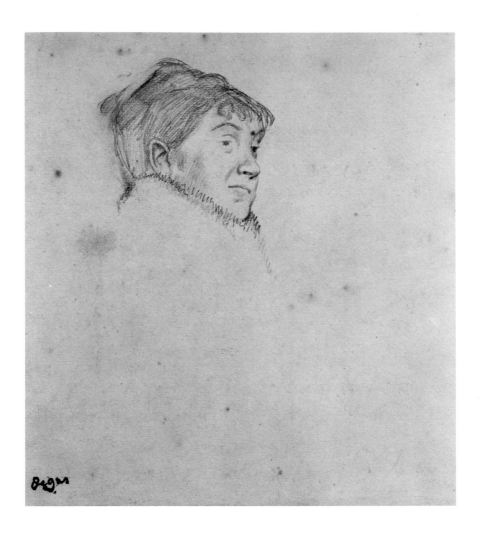

Portrait of Mme. Dietz-Monnin was given its former generic title in the catalogue of the Degas studio sale in 1917. Since that time, the sitter has been identified tentatively as Degas's friend Mary Cassatt, presumably because of her general resemblance to *Miss Cassatt Seated and Holding Cards* (L. 796). It is more likely, as Ronald Pickvance has pointed out (Edinburgh 1979: 60), that the drawing represents Mme. Dietz-Monnin and that it was made early in the preparatory process for the final portrait of this lady (cat. no. 47). The comparison of their facial features and hair style makes this identification probable, but the inclusion of a boa in the drawing is convincing proof. The drawing is similar to a pastel of Mme. Dietz-Monnin in the National Gallery of Art, Washington, DC (fig. 47-2).

The subject has been carefully observed and seems rather somber in mood. She sits quietly, absorbed in her own thoughts. Degas was careful in his delineation of the arched eyebrows (which the sitter undoubtedly strengthened with eyebrow pencil), ear, nose, and crooked mouth—all of which are repeated in the painting. The boa sits high on the model's shoulders, obscuring the ample, fleshy neck depicted in the painting. (RB)

WATERMARK: TH. . .

COLLECTIONS: Estate of the artist, Vente IV, 136, repr., stamp (Lugt 658) recto, lower left, in red; Mrs. Charles B. Goodspeed (later Mrs. Gilbert W. Chapman), Chicago.

EXHIBITIONS: Edinburgh 1979, no. 66.

LITERATURE: Degas 1973, no. 77, repr.; Chicago 1979, 2G3.

49. The Actress Ellen Andrée, c. 1879

Etching and *crayon électrique* on cream laid paper; third state of three
Plate 113 x 79 mm; sheet max. 218 x 156 mm
Clarence Buckingham Collection, 1979.649

Ellen Andrée was a pantomine artist who performed in various Parisian theaters. By her own account a model for Degas, Manet, and Renoir (Joly 1967: 374), she figures as well in several works of different media by Degas, who apparently knew her well. In 1876, she posed with Marcellin Desboutin (see cat. no. 27) at a table in the Café de la Nouvelle Athènes for Degas's *Absinthe Drinker* (fig. 26-1). The dissolute pose that Ellen Andrée adopted for this work was but one of her many guises. Lucretia Giese (1978: 45-6) has argued persuasively that she also might figure in two paintings of around 1876/78 depicting the reactions of women visiting an exhibition.

She assumed an altogether different look in the Art Institute's small etching. Arsène Alexandre (1918) was the first to single it out:

I don't want to leave his etchings without citing a very small print to which it would be a shame not to give

attention. It is a young woman, standing in a jacket and a "Niniche" hat, her nose in the air, her hair in a mess. In several scribbles, Degas has evoked no more, no less than the charming Ellen Andrée who, by her urchinlike grace, her insidious and light Parisian tact, illuminated the small group of Halévy, Degas, Meilhac, Renoir, and *tutti quanti*. It is only a little nothing, but a perfect, exquisite nothing.

The actress stands attentively, with an air of youthful inquiry and dignity, in the right half of the plate, a book under her arm. Moses likened the figure to a "modest shopgirl out for a stroll. . .[in] the tradition of the *lorette* [woman of easy virtue], the *grisette* [coquettish shop-girl] and the *midinette* [dressmaker's apprentice]. . ." (Chicago 1964). On the other hand, as Reff has pointed out (1970: 287-9), there is an "awkward assertiveness" in her stance that is not unlike that of Degas's sculpture of a schoolgirl, which he made

111

around 1880, or of his pastel *Woman in a Violet Dress and Straw Hat* of around 1881 (L. 651).

The work closest to this etching, however, is *Project of Portraits for a Frieze* of 1879 (fig. 49-1), a sheet in pastel and black chalk which Degas's inscription identifies as preparatory for a decoration in an apartment and which he included in the sixth Impressionist exhibition, in 1881 (Edinburgh 1979, no. 67). A note in one of the artist's sketchbooks around 1860 outlines his idea for a frieze of about one meter high depicting the family in the city waiting for a bus and another of the family in the country (Reff 1976b: 100, Notebook 18: 204). Lemoisne identified the seated figure as Mary Cassatt and the woman on the right as Ellen Andrée. Indeed, except for its large scale, the pastel drawing of Andrée is identical to the etching in reverse and could well have served as a model for it. Another pastel (St. Louis 1966-67, no. 87, repr.), clearly related to *Project of Portraits for a Frieze,* depicts a figure attired similarly to Ellen Andrée but seen from the back, leaning against her parasol like the image of Mary Cassatt in the Louvre (see cat. nos. 50-54), as well as from the front, holding a book like the figure of Miss Cassatt's companion in those prints. This has led to some confusion regarding the identity of the figure in this pastel and of those in the etchings (see Giese 1978). It is sufficient, however, to note the very close relationship of these works and their probable creation around 1879.

This etching and the prints of Mary Cassatt at the Louvre are linked technically, as well. In all of them, Degas apparently utilized a *crayon électrique,* the mysterious instrument that he introduced to printmaking. The *crayon électrique* seems to have been a carbon filament from a lamp that Degas used to scratch the plate (see Reff 1976a: 260, 292). It produced fragile, silvery marks which, like drypoint burr, must have lasted only a few impressions. Adhémar (1974, no. 52) published a hitherto unknown first state of this print; altogether, fewer than ten impressions are known of all three states. It is tempting to speculate that Degas might have tried out his unorthodox technique first on a plate of miniscule dimensions; because of its purity and simplicity, it reveals the qualities of the *crayon électrique* better than other such prints of around 1879 and, given its somewhat tentative and even awkward execution, could very well have preceded them. (SFM)

COLLECTIONS: Estate of the artist, stamp (Lugt 657) verso, lower right, in red; Vente d'estampes, 105; Gustave Pellet, Paris; Maurice Exteens, Paris; Kornfeld and Klipstein, Bern (auction 157: Jun. 10, 1976, no. 246, pl. 116); acquired by the AIC from C. G. Boerner, Düsseldorf.

EXHIBITIONS: Edinburgh 1979, no. 108, repr.

LITERATURE: Alexandre 1918: 14; Delteil 1919, no. 20, repr. (first state); Boggs 1962: 49-50, pls. 108-10; Chicago 1964, no. 28, repr. (second state); St. Louis 1966-67: 136; Reff 1970: 287-93, fig. 16; Adhémar 1974, no. 52, repr. (first state); Reff 1976a: 260, pl. 176; Edinburgh 1979, nos. 107-08, repr. (third state).

Fig. 49-1. Degas. *Project of Portraits for a Frieze,* 1879, pastel and black chalk (L.532). Private Collection. Photo: Reff 1976a, pl.170.

50. At the Louvre: Mary Cassatt in the Etruscan Gallery, c. 1879

Inscribed recto, lower right, in graphite: *Degas*
Etching, drypoint, and *crayon électrique* with additions in graphite on ivory laid paper; second state of six
Plate max. 268 x 231 mm; sheet max. 429 x 311 mm
Carter H. Harrison Memorial Collection, given by Mrs. Sterling Morton, 1962.804

51. At the Louvre: Mary Cassatt in the Etruscan Gallery, c. 1879

Etching, drypoint, aquatint, and *crayon électrique* printed in black, retouched with red chalk, on ivory Japanese tissue; sixth state of six
Plate 269 x 237 mm; sheet max. 357 x 269 mm
Albert Roullier Memorial Collection, 1921.368

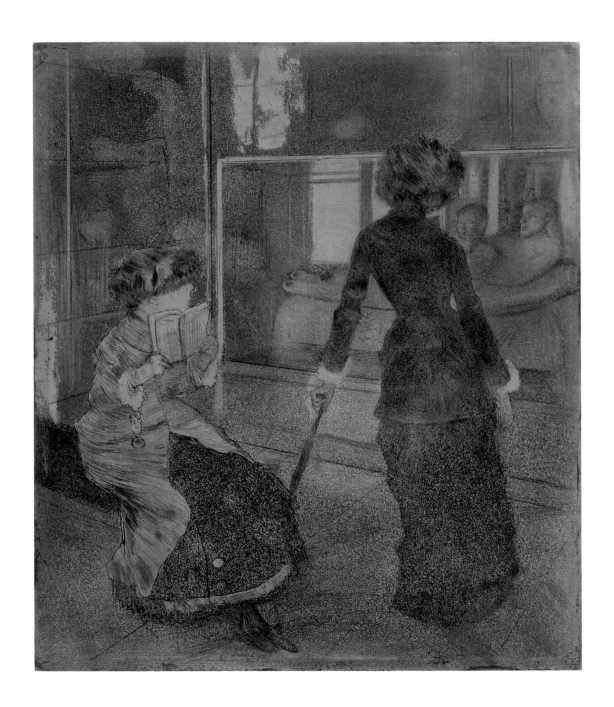

In the first comprehensive catalogue of Degas's graphic oeuvre, Delteil identified the print he entitled *Au Louvre: Musée des Antiques* (which he inexplicably dated to 1876 [?]) as the plate Degas produced to include and advertise the first issue of the projected journal *Le Jour et la Nuit* in conjunction with the fifth Impressionist exhibition, in 1880. *At the Louvre* is significant as the only print Degas clearly intended to publish and one, moreover, that he chose to include with his other works in that exhibition.

In 1879, Degas enthusiastically planned and worked on the *Le Jour et la Nuit* project with Mary Cassatt, Camille Pissarro, Félix Bracquemond, Marcellin Desboutin, and Jean François Raffaelli. Degas, Cassatt, and Pissarro were particularly close at this time. The publication, which Gustave Caillebotte was going to underwrite, was intended to answer one of the proclaimed ambitions of the original Impressionist group charter of 1874: to create a magazine devoted to the art of that circle. But, for Degas, it also offered a forum for the exploration and dissemination of sophisticated printmaking techniques and compositions.

Under Degas's leadership, particular modes of printmaking were selected for the enterprise, among them soft-ground etching and aquatint—media that offered a range of tonal effects and new technical challenges. Degas's letters document his enthusiasm for the project: in many, he begged the acknowledged master, Bracquemond, for technical advice on how to lay an aquatint ground or achieve special effects; in others, he shared Bracquemond's tips and his own discoveries with Cassatt and Pissarro. Apparently, Bracquemond was somewhat reluctant to become seriously involved with the volatile Degas and his printmaking efforts. Evidently undaunted, Degas took the opportunity to experiment on his own. As he was the only one of the three to own a printing press at that time, Degas frequently pulled impressions for Cassatt and Pissarro. Moreover, his direction of their productions was as much stylistic as technical, as can be seen in the comment he made in an often-quoted letter to Pissarro:

> Also try something more finished. It would be delightful to see the contours clearly defined. Remember that we have to begin with one or two very very beautiful plates of yours. (Trans. by Moses in Chicago 1964, no. 30, from Guérin 1931-45, no. XXV).

Therefore, it is not surprising that Degas put a great deal of thought into what was to be his public debut as a printmaker. A number of preliminary drawings and six different states went into the preparation for the final composition of *At the Louvre*. As part of the journal, the image would have been assured of wide distribution. Also, although the size of the projected edition is unknown, Degas intended to enlist the assistance of the printer Salmon of rue St. Jacques for its mass production. Degas may well have been motivated partly by financial considerations, since, having assumed the family debts following his father's death in 1874, he was forced to think more seriously about marketing his work. His own financial straits, coupled with the withdrawal of Caillebotte's support, in fact may have prevented the journal from being realized, although some scholars contend that one issue was published (Giese 1978: 44 n. 8). Ironically, the image that was intended originally for a mass-produced periodical resulted in a series of states and impressions that are among the most varied and individual examples of Degas's printed oeuvre.

As seen in the final state (cat. no. 51), the print is a complex compilation of tones, textures, and surfaces. Two women are absorbed in studying a tomb sculpture in the Etruscan gallery of the Louvre. As they observe it, we are allowed to look over their shoulders, to admire the juxtaposition of their tailored forms against the massive bulk of the sculpture, and to appreciate the flickering reflections of the vitrine within the intimate atmosphere of the gallery. Delteil identified the elegant figure leaning on a parasol as the well-bred, dignified American artist Mary Cassatt, and there is no doubt that he was correct. Cassatt had arrived in Paris in 1874 but apparently did not meet Degas until 1877, when he paid her a visit with his friend the engraver Joseph Tourny (Sweet 1966b: 32; see also cat. no. 4). Perhaps their interest in a collaborative printmaking effort dates from that time.

The identity of her companion, however, is uncertain. She is sometimes associated with Cassatt's older sister, Lydia, but she also bears a slight resemblance to Degas's contemporary depictions of the pantomine actress Ellen Andrée (see cat. no. 49 and St. Louis 1966-67, no. 87). Lydia Cassatt, seven years Mary's elder, and her parents went to live with the artist in Paris in 1877 (Wells 1972: 131). Apparently afflicted by Bright's disease, Lydia died six years later. Having been severely limited in her activities most of that time, she could have filled her days by modeling for her sister. Sweet's identification of the seated figure in the print as Lydia is supported by a study in charcoal and pastel (St. Louis 1966-67, no. 86); the features of the seated figure resemble those for which Lydia is known to have posed, such as Cassatt's *Cup of Tea* of 1879 (Wells 1972, fig. 12).

Three drawings from Degas's studio reveal the care with which he constructed this composition (Vente IV, 249b, 250a, 250b). One (250a) shows the Etruscan sarcophagus in its case with the windows of the Louvre gallery behind it; these were suppressed in the final state to accentuate the reflection of other windows on the front of the case. The design of this vitrine is said to have inspired that used by Degas for the *Little Dancer of 14 Years* (fig. 42-1), which was exhibited in two Impressionist exhibitions: without the sculpture in 1880 (see cat. no. 42) and with the sculpture in 1881 (Reff 1976a: 242-3). In another drawing (L. 249b), the case, figures, and other details of the room were drawn to allow for the reversal of the etching process. In a third study (fig. 50/51-1), Degas concentrated on

Fig. 50/51-1. Degas. *Study for "At the Louvre,"* 1879, pencil (L.250b). Upperville, VA, Mr. and Mrs. Paul Mellon.

This is persuasively communicated in the Art Institute's rare second state of *At the Louvre* (cat. no. 50), once owned by Degas's friend and patron Alexis Rouart. Its signature indicates that Degas considered it a finished work, although the graphite addition of a third foot to Miss Cassatt's companion undermines this effect somewhat.

Even in the last state, the artist could not leave the image alone: in addition to the rich tonal and atmospheric effects achieved with aquatint, in this impression Degas heightened the jacket of Mary Cassatt with red chalk, which not only identifies the figure more exactly (as Miss Cassatt was renowned for her russet jacket) but also expresses Degas's need—even in the largest projected edition of his printmaking efforts—to experiment with and individualize his work.

As Moses pointed out (Chicago 1964, intro.), if there is any question about the other works included by Degas in the Impressionist exhibition of 1880—the only time he showed his prints—there can be little doubt that at least one impression of the etching intended for *Le Jour et la Nuit* was among them. It is tempting to speculate that the sixth state, with its subtle hand-coloring, was one of the versions shown. The transformation that Degas wrought in these varied impressions, from the linear construction of the forms in the second state to the painterly suggestiveness of the last, reflects the artist's struggle in other media to move from his own natural inclinations as a draftsman to an ever more sensual, coloristic vision. Cat. no. 50, it should be noted, entered the Art Institute collections just four years after the artist's death. (SFM)

50.

WATERMARK: ARC[HES]

COLLECTIONS: A. H. Rouart, Paris, stamp (Lugt Suppl. 2187a) recto, lower right, in purple; Dr. Herbert Michel, Chicago; acquired by the AIC from the Sterling and Francine Clark Art Institute, Williamstown, MA.

EXHIBITIONS: Chicago 1964, intro. and no. 30, repr.; Edinburgh 1979, no. 110, repr.

LITERATURE: Delteil 1919, no. 30, repr. (first and third states); Boggs 1962: 50-1; Joachim 1968: 15, repr. (AIC); Adhémar 1974, no. 53a, repr. (AIC); Passeron 1974: 69-70, repr. (first state).

51.

COLLECTIONS: Albert Roullier, Chicago, stamp (Lugt 170) verso, lower right, in blue; The Art Institute of Chicago, stamp (Lugt Suppl. 32b) verso, lower right, in brown.

EXHIBITIONS: Chicago 1964, intro. and no. 30, repr.

LITERATURE: Delteil 1919, no. 30 (first and third states); Boggs 1962: 50-1; Adhémar 1974, no. 53b, repr. (sixth state); Wells 1972: 134, fig. 12 (sixth state); Passeron 1974: 69-70, no. 30 (first and third states); Giese 1978: 42-53, fig. 4; Edinburgh 1979, nos. 112-14, repr. (third and sixth states).

the figures in greater detail, adding a geometrical overlay that not only served to unify the composition, but that also may have aided in the transfer of the design to the copper.

Mary Cassatt in the Etruscan Gallery is linked inextricably to a second print of the same time showing the artist and her sister in the Grand Gallery at the Louvre (cat. nos. 52-54). The narrower, more daring composition of the painting gallery print has led scholars to believe that it was done just after the Etruscan gallery print. It is hard to say how two pastels of Mary Cassatt at the Louvre (L. 581, 582) relate to these compositions. They are oriented in the same direction as the preliminary studies for the Etruscan gallery (opposite to the print) and as the print of the painting gallery (except for the seated companion). In one of the pastels (L. 581), Degas combined the placement of the figures in preparatory drawings for the Etruscan gallery with the setting of the painting gallery. This pastel apparently was an intermediary step between the two prints.

However, it appears that the pastel study (L. 582) in the Henry P. McIlhenny Collection, Philadelphia, which Degas dedicated to his friend the sculptor Bartholomé, must have been a precursor to both prints: its rich, furry texture is precisely what Degas sought to duplicate in his drypoint work.

52. Mary Cassatt in the Painting Gallery of the Louvre, c. 1879

Etching, aquatint, drypoint, and *crayon électrique* on ivory wove Japanese tissue; 15th state of 20 (?)
Plate max. 305 x 126 mm; sheet max. 340 x 175 mm
Gift of Walter S. Brewster, 1951.323

53. Mary Cassatt at the Louvre, 1885

Inscribed recto, lower left, in black chalk: *Degas/85*
Etching, aquatint, drypoint, and *crayon électrique*, heightened with pastel, on tan wove paper
Plate 305 x 127 mm; sheet 313 x 137 mm
Bequest of Kate L. Brewster, 1949.515

54. Mary Cassatt in the Painting Gallery of the Louvre, after 1885

Etching and aquatint on cream wove paper; from cancelled plate
Plate max. 305 x 127 mm; sheet max. 320 x 248 mm
Gift of Ethel Schmidt, 1982.1568

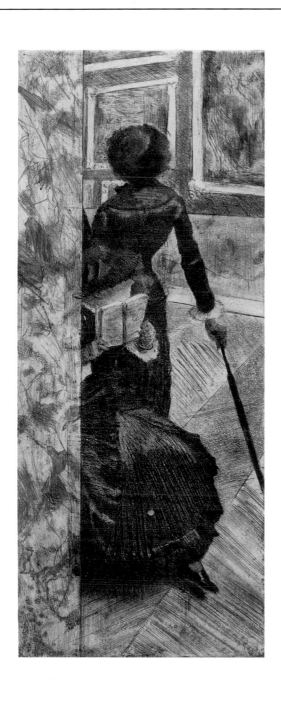

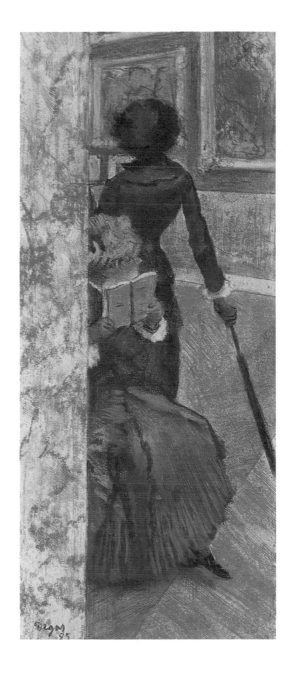

Although a foreigner, Mary Cassatt (1845-1926), from the time of her arrival in Paris, exhibited her paintings in the official Salons (1872-74, 1876), and so it is not surprising to see her feeling at home in the galleries of the Louvre. Degas must have seen her paintings long before he met her in 1877. When that finally occurred, Degas invited her to exhibit with the Impressionists (or Indépendants, as he preferred to call them), if she would give up sending her work to the Salon, to which she agreed. Degas and Cassatt developed a warm friendship and a fruitful working relationship. There has even been speculation of a more intimate alliance between them, but most important is the truly sympathetic bond that they shared in their approaches to life and to art. In his several compositions of Mary Cassatt at the Louvre (see also cat. nos. 50, 51), Degas conveyed her intelligence, taste, and dignity, even with her back turned.

One of Degas's most technically complex prints, transformed over the course of at least twenty states, this image of Mary Cassatt, probably with her sister at the Louvre, is clearly dependent upon the drawings, pastels, and print discussed in connection with cat. nos. 50 and 51. In an unusually tall and narrow format, Degas placed the seated woman's form so that it overlaps the confident figure of Mary Cassatt (whose stance is in reverse to the print but similar to the various pastels). As noted in the entry for cat. nos. 50 and 51, one large pastel, showing the two women in the poses of the first print but in the picture gallery of the second, may have been an intermediary study. Another study (Vente IV, 249a) outlines this new figural arrangement, accenting the props but omitting most of the description of the central part.

Mary Cassatt in the Painting Gallery of the Louvre was not the only instance when Degas showed women in front of paintings in a museum. Two oil paintings of the subject (L. 464, 465), which Giese (1978: 52) dated around 1876/78, clearly relate to the Mary Cassatt series. One in the Mellon Collection (L. 465) shows a figure seen from the back—a silhouette somewhat less elegant than Cassatt's. The other (fig. 52/54-1), clearly more satirical, shows a buxom female—her nose in the air—sailing past a bench where another woman sits consulting a catalogue.

The distinctions among the many states of this print continue to remain elusive; it is hoped that research currently being conducted by the staff of Boston's Museum of Fine Arts will yield some clarification. The catalogue of the studio sale of the artist's prints lists 15 different states; in 1919, Delteil expanded that number to 20—relying on Alexis Rouart's collection for some of the rarest, earliest states—and noted that the copper plate was cancelled. Neither Moses, who exhibited ten different states (Chicago 1964, no. 31), nor Adhémar (A. 54) could clarify further the extremely subtle progression between the states that Delteil had enumerated, but both asserted that more than 20 states must exist for this highly complex print. (It must be noted that Adhémar's recording of

the states in the Art Institute collection is far from accurate, in any case.)

It is clear that the main lines of the composition were present from the beginning and that successive states witnessed the elaboration of the pictures on the wall (see Reff 1976a, pl. 96), the dado, and the parquet floor. Throughout the various states, Degas played with the texture of the foreground wall at the left, which has both an obstructive and supportive function. What this prominent and bizarre feature reflects is not only Degas's interest in the flattened designs of Japanese prints and the unposed naturalism seen in photographs but also his desire to evoke color and texture in the black-and-white medium of etching.

In *Mary Cassatt in the Painting Gallery,* as in cat. nos. 49-51, Degas seems to have scratched the plate with the *crayon électrique* in addition to using etching, aquatint, and drypoint. Moreover, he played with various results yielded by different papers, as cat. nos. 52 and 54 demonstrate. Although the impression from the cancelled plate (cat. no. 54) is probably posthumous, it illustrates the variable quality of such a rich intaglio print (which resulted not only from the paper but also from the inking and wear of the plate) and highlights the sumptuous, delicate quality of the earlier state (cat. no. 52), which was printed on light Japanese tissue.

One of the treasures of the Art Institute collection is cat. no. 53, an impression of this print that was heightened with pastel and signed and dated by the artist in 1885. What is especially unusual about this pastel is that it was executed over an intaglio: Lemoisne considered the work a pure pastel (L. 583), while Adhémar erroneously described it as a "reproduction touched with pastel." As we have seen, many pastels by Degas were executed over faint monotype bases; it is much more rare to encounter pastels over the more detailed intaglios. Even so, in the case of cat. no. 53, the pastel additions were applied in a very painterly way over what seems to have been a rather weak impression, possibly of the 17th state. The date this sheet bears would seem to call into question that of the etched composition (which Delteil mistakenly assigned to 1876[?], the year before Degas met Cassatt), generally dated around 1879/80, along with the other print of Mary Cassatt at the Louvre (cat. nos. 50, 51). Rather, at a later time, Degas simply must have picked up one of the many impressions in his studio and reworked it. The layering of the pastel for luminosity and even the notation of the date are characteristic of Degas around 1885. One can cite, for example, *Harlequin* (cat. no. 75), and *At the Ambassadeurs* (L. 814), another print that Degas translated into pastel in 1885. (SFM)

52.
COLLECTIONS: Estate of the artist, stamp (Lugt 657) verso, lower left, in red; Walter S. Brewster, Chicago, stamp (Lugt Suppl. 2651b) recto, lower right, in red, and verso, lower left, in red.

EXHIBITIONS: Chicago 1964, no. 31, repr.; Edinburgh 1979, no. 117, repr.

LITERATURE: Delteil 1919, no. 29, repr. (first, second, third, seventh, and twentieth states); Lemoisne 1946, I, repr. opp. p. 134; Boggs 1962: 50-1; Reff 1971: 151-2, fig. 18; Adhémar 1974, no. 54, repr. (AIC); Passeron 1974: 70; Reff 1976a: 285, pl. 201; Dunlop 1979, pl. 160; Edinburgh 1979, nos. 115, 116, 118, repr. (thirteenth state); London 1983, no. 29, repr. (ninth state).

53.
COLLECTIONS: Ivan Stchoukine; Durand-Ruel, Paris, Dec. 28, 1900; Kate L. Brewster, Chicago.

EXHIBITIONS: London 1905, no. 49 (per Durand-Ruel; not among selected plates); Chicago 1964, no. 31.

LITERATURE: Lemoisne 1946, no. 583, repr.; Russoli 1970, no. 576, repr.; Adhémar 1974, no. 54 (erroneously cited as reproduction); Giese 1978: 44 n. 9, fig. 6; Chicago 1979, 2G2.

54.
COLLECTIONS: Ethel Schmidt, Chicago.

LITERATURE: See cat. no. 52 (no mention of impressions from the cancelled plate).

Fig. 52/54-1. Degas. *Visit to the Museum,* 1876/78, oil on canvas (L.464). Boston, Museum of Fine Arts.

55. The Dressing Room, c. 1880

Etching, drypoint, and *crayon électrique* on yellow-beige
Japanese wove paper; third state of four
Plate 118 x 77 mm; sheet 205 x 150 mm
Print Department Purchase Fund, 1955.1100

56. The Dressing Room, c. 1880

Etching, drypoint, and *crayon électrique* on cream laid paper;
fourth state of four
Plate 119 x 79 mm; sheet 303 x 218 mm
William McCallin McKee Collection, 1951.123

The Dressing Room is one of a group of prints that relate clearly to Degas's series of monotypes depicting prostitutes at work. The print was made in at least four states, the last two of which are represented in the Art Institute. The print developed from a pure etching with little tonal contrast in the first state to an image heavily worked with drypoint and other tools and exhibiting a high degree of contrast in the later states. In the last state, Degas made liberal use of the *crayon électrique.* What is most interesting about the evolution of this print through its various states is that, despite the fact that it gained in visual incidence and spatial clarity, most of the essential ambiguities of the subject remain in all states. This prompts us to ask, therefore, just what it was that Degas intended.

Only one thing is clear: We are looking at a tiny image of a private room in a house of prostitution. This small, nude woman in her room is clearly a prostitute—her dark neck band identifies her as such. Beyond this simple observation, questions abound. What is the figure doing? Degas was very careful to represent the small cabinet with its pair of wash-basins, pitcher, sponge, and bottles of perfume, and yet the prostitute's attention is directed elsewhere. She leans forward, her hand moving behind the table, revealing herself perhaps to an unseen person behind the partly open door. Her pose is virtually identical to that of a bowing cabaret singer in an etching of about the same time (see cat. nos. 58, 59); this three-quarter view from the back was used frequently by Degas to suggest that the actual viewer of the figure is within the space represented in the work of art, even if invisible, and is most emphatically not the viewer of the work of art itself. What seems at first to be a poorly defined bowler hat at the lower right is surely the curved wooden back of a side chair from which the woman has just risen. One finds similar chairs in other of Degas's brothel scenes (C. 92, 116); such a reading of the form accords well with the expression of expectancy implied by the figure's forward motion.

All of this, however, does little to explain the collection of clotted dark lines placed over the overstuffed armchair at the lower right of the print. Can these be read as a heap of di-shevelled clothes placed there before the toilette? If so, the print represents a sequence of events that move forward in time as one's eyes move back into the print. The woman has undressed, thrown her clothes on a chair, washed herself briefly, tidied up the toilette articles, and then waited in the small chair next to the door for the arrival of her customer. He—or someone—has just arrived, and she has risen to receive him. When read in this way, *The Dressing Room* becomes a narrative rather than a simple recording of a prostitute amidst her surroundings. Time, for Degas, as for all the major

Impressionists, was a critical component of art. This print locates specific action within a context of other actions that have already occurred or will soon occur.

Precisely because it encapsulates time, or process, *The Dressing Room* resembles an illustration to a literary text. Indeed, it could have served as a generic illustration for any of the many novels, stories, and plays about prostitutes written in France between 1850 and 1880. Yet, the discreet charm of the print lies in its evocation not of a particular personality, but of a "type" in a secret, interior realm. As such, it relates even more to the intimate interiors Pierre Bonnard and Edouard Vuillard began to paint in the 1890s. The young Nabi artists were quite taken with these smallest and most private of works by Degas when they visited the aging master in the last years of his life. Degas's evocations of contemporary people in particular interior contexts appealed to their turn-of-the-century imaginations more than did the exterior and public worlds of his fellow Impressionists Monet, Renoir, and Caillebotte. (RB)

55.
COLLECTIONS: A. II. Rouart, Paris, stamp (Lugt Suppl. 2187a) recto, lower right, in purple; acquired by the AIC from Marcel Lecomte, Paris.

EXHIBITIONS: Chicago 1964, no. 34, repr.

LITERATURE: Delteil 1919, no. 34, repr. (fourth state); Adhémar 1974, no. 48, repr. (AIC).

56.
WATERMARK: ARC[HES]

COLLECTIONS: Acquired by the AIC from Gerald Cramer, Geneva.

EXHIBITIONS: Chicago 1964, no. 34, repr.

LITERATURE: See cat. no. 55 above.

57. The Laundresses, c. 1880

Etching and aquatint on cream laid paper; fourth state of four
Plate 117 x 158 mm; sheet max. 212 x 287 mm
Daniel Catton Rich and Joseph Brooks Fair Funds, 1977.56

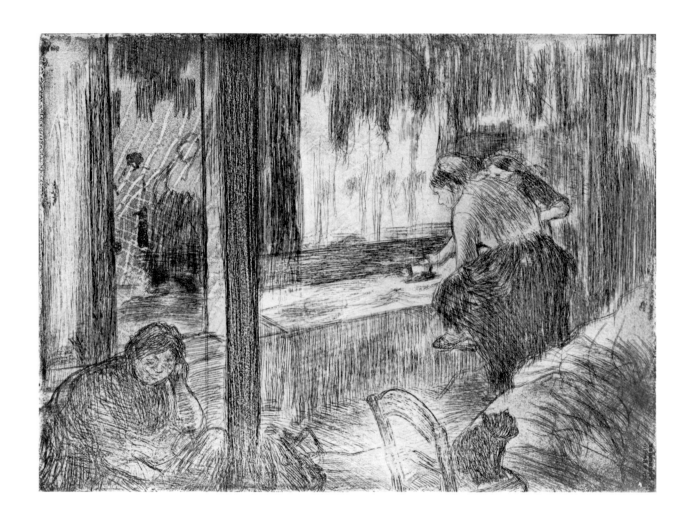

"Everything is beautiful in this world of people. But one Paris laundry girl, with bare arms, is worth it all for such a pronounced Parisian as I am," Degas wrote to James Tissot in 1872 (Guérin 1947: 18). Although Lemoisne dated Degas's first major painting of a Parisian laundress (L. 216) to 1869, his sustained investigation was prompted by the publication of Emile Zola's *Assommoir,* which features life in and around a Parisian laundry. The first of the novelist's famous Rougon-Macquart series to gain widespread popularity, *L'Assommoir* appeared in installments during 1876 and as a whole in 1877, and the majority of Degas's representations of the laundry postdate it. Although there are many passages in the novel that relate indirectly to Degas's famous paintings of the subject (L. 685, 776, 785), nowhere is the book's depressing,

faintly grimy shop better described by Degas than in this small etching, made around 1880.

Two laundresses—perhaps Zola's Gervaise Coupeau and her assistant Clémence—iron vigorously in front of the window of a laundry—maybe Gervaise's shop on rue de la Goutte d'Or. Another woman—perhaps Gervaise's mother-in-law, Mama Coupeau—sleeps on the floor at the lower left, while a cat occupies the only chair. Here, the reference to Zola is specific, for Gervaise associated her taking in of her mother-in-law with the sheltering of a homeless cat. "I'll take care of Mama Coupeau, do you hear?" she yelled at her unemployed husband. "The other night I took in a stray cat, so I might as well take in your mother" (Zola 1962: 178). Piles of dirty laundry, described so graphically by Zola, are seen in the

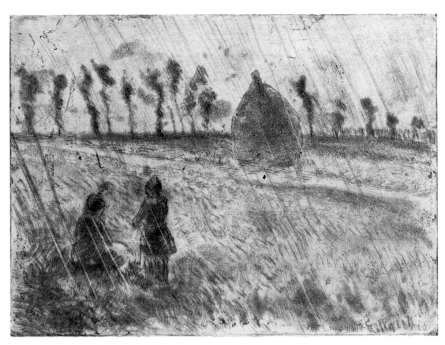

Fig. 57-1. Camille Pissarro (French, 1830-1903). *Effect of Rain,*
1879, aquatint. New York Public Library.

corner of the print; and drying clothes hang like rags from
the ceiling, creating patterns in which both the novelist and
the artist delighted. The door is open to allow the intense heat
of the shop to escape, and anonymous passersby hurry along
the street in an aquatint rain.

As a graphic representation of an unremarkable scene in
an ordinary, working-class laundry, the print can be con-
trasted with the many earlier representations of laundresses
in French art—from those of Boucher, Greuze, and Boilly, to
Gavarni and the young Degas—scenes in which the coquetry
and even eroticism of the laundress are emphasized. In *The
Laundresses,* however, the women are dumpy and appear in-
tent on their work; the viewer most certainly is not encour-
aged to be a "voyeur" with seduction in mind. Degas's etching
differs as well from the many carefully composed and most
often ennobling representations of laundresses by the Realist
artists of mid-century France. Neither Millet nor Bonvin were
capable of Degas's extraordinary detachment from his subject
(Cleveland 1981: 68-9). There is nothing staged about Degas's
laundresses. In their small shop, they perform their tasks
simply and naturally as the light reflected off the façades
across the street filters through the hanging clothes.

The print is curious for two reasons: First, it was etched
with a multipronged tool, almost like a small broom of nee-
dles, that created a sequence of roughly parallel lines with
each gesture of the artist's hand. Second, it emphasizes less
the physical work of the laundresses—a constant theme of
Degas's other laundry compositions of the later 1870s and

early 1880s—than the ambiance or setting of the laundry
itself. In this way, it can be seen as a narrative print in which
the viewer is asked to construct a tale to explain its diverse
characters or to understand it as dependent upon Zola's text.

Because of its technique and, to a certain extent, its in-
tentionally awkward, indeed graceless, figural style, the print
approaches Pissarro's graphic work of the same period more
closely than it does any other work by Degas. In fact, Pissarro
used a similar multipronged tool when making his great print
of 1879, *Effect of Rain* (fig. 57-1), and the bending figures in
the foreground as well as the women in the street are closely
related to the figures in such contemporary prints by this
artist as *The Fair of St. Martin at Pontoise,* an impression of
which was in Degas's collection. In *The Laundresses,* Degas
employed aquatint in a limited but highly effective way, par-
ticularly in the area of the doorway, and he worked into the
aquatint with tools to add white lines to the print. The Art
Institute's impression reflects the last of four states, where
Degas worked principally in the area of the foreground chair,
which he burnished to lighten its effect, thereby emphasizing
further his—and Zola's—laundresses. (RB)

COLLECTIONS: Sagot-Le Garrec, Paris; acquired by the AIC from
James A. Bergquist, Boston.

LITERATURE: Delteil 1919, no. 37, repr. (second state); Chicago
1964, no. 33, repr. (fourth state); Adhémar 1974, no. 32, repr.
(fourth state); Edinburgh 1979, nos. 101-02, repr. (first and fourth
states); London 1983, no. 18, repr. (fourth state).

58. At the Ambassadeurs, c. 1880

Etching on cream laid paper; trial proof of second state of three
Plate 266 x 295 mm; sheet max. 360 x 436 mm
Print and Drawing Purchase Fund, 1968.52

59. At the Ambassadeurs, c. 1880

Etching on cream wove paper; from cancelled plate
Plate 248 x 293 mm; sheet 248 x 330 mm
Print and Drawing Purchase Fund, 1968.53

60. Singer at a Café-Concert, c. 1880

Inscribed recto, lower right, in pencil: *Degas*
Lithograph on white wove paper; first of two states
Image 259 x 199 mm; sheet max. 310 x 230 mm
Charles Deering Collection, 1927.2685

seems to have intended here would have been that of a person standing backstage waiting for the act to end or hovering around the edges of the stage. In either case, the view is not from the vantage point of the seated audience. Because the viewpoint is oblique, making the relationship of viewer to scene unclear—a characteristic of Degas's work around 1880—the etching can be dated to this time and is somewhat later than the lithographs of the Café aux Ambassadeurs (cat. nos. 32, 33).

A closely related lithograph, *Singer at a Café-Concert* (cat. no. 60), is more precisely delineated and clearer than the etching but no less ambiguous. The figure must be Mlle. Bécat; her dress, with its little bows and gathers, is nearly identical to that worn by the singer in cat. nos. 32 and 33. Yet, Degas lavished his attention less on the costume than on the tiny black choker with its bow. Like the performer in the etching, Mlle. Bécat takes her bow, but she has no flowers and there is only a single gas globe at the far right. Actually, she is illuminated by an invisible fixture below her which reveals the lower parts of her arms and neck. In this image, one can sense the irony of stage lighting, because the lights allow the audience to see the performer but prevent him or her from seeing the audience.

Cat. no. 60 is a very beautiful impression of the first state. The only surviving example of the second state is in the Boston Public Library; it includes some indications of foliage. Degas seems to have been at once exhilarated and intimidated by the provocative blankness he allowed within the confines of his lithographic space. It almost liberates the paper from all but the most fragile of constraints. In this way, the lithograph, in its first state, anticipates Gauguin's superb zincographs of 1889, where image and paper are allowed to engage in a delicate dialogue. (RB)

Degas made two prints, an etching and a lithograph, with the same subject: a café singer seen from the back taking her bow before an invisible audience. Both prints were in many ways failures, and neither led Degas to explore this subject further. The etching, of which the Art Institute owns a rare impression of a previously unrecorded second state (cat. no. 58), as well as an impression from the cancelled plate (cat. no. 59), is both evocative and ambiguous. Degas chose to represent the scene on a large copper plate which he worked with an etching needle, drypoint, and aquatint to suggest the nocturnal atmosphere of an outdoor café-concert. The setting for this print traditionally has been identified as the Café aux Ambassadeurs, yet the details seen here, such as the awning and what appears to be a tree trunk, suggest another establishment.

The print is centered on the bowing figure of the singer (also present in the first state), who holds in her right hand a bouquet of flowers wrapped in paper. She is accompanied by a woman with a fan—either a dancer or a member of the chorus—who bows in another direction. The partial shape of a larger fan is included at the left. Both women are illuminated and silhouetted by a cluster of gas globes at the far left, like those in many other representations of the café-concerts along the Champs Elysées. The vantage point Degas

58.
WATERMARK: HP (in coat of arms)/HALLINES

COLLECTIONS: Acquired by the AIC from C. G. Boerner, Düsseldorf.

LITERATURE: Delteil 1919, no. 27, repr. (second state); Chicago 1964, no. 25, repr. (third state). Adhémar 1974, no. 30, repr. (third state); Edinburgh 1979, nos. 99-100, repr. (second and third states).

59.
COLLECTIONS: Acquired by the AIC from C. G. Boerner, Düsseldorf.

LITERATURE: See cat. no. 58.

60.
COLLECTIONS: Charles Deering, Chicago, stamp (Lugt 516) verso, center, in blue; The Art Institute of Chicago, stamp (Lugt Suppl. 32b) verso, center, in brown.

LITERATURE: Delteil 1919, no. 53, repr. (first state); Adhémar 1974, no. 33, repr. (AIC).

61. Horse and Rider, 1878/82

Charcoal on buff wove tracing paper, laid down
254 x 303 mm
Joseph Winterbotham Collection, 1954.329

Horse and Rider appears to have been transferred by Degas from another charcoal drawing that is now lost. A closely related drawing, also a transfer but of a slightly larger scale, was sold as one of the *"impressions en noir"* (black prints or impressions) in the final Degas sale (Vente IV, 379b). Both are closely related to Degas's wax sculpture *Horse Walking* and to a single horse and rider in two paintings and one pastel, all of which date from the period between 1878 and 1882 (L. 502, 503, 597).

In the oil paintings, the horse and rider are oriented in the same direction as in the drawings, whereas the horse in the pastel (L. 597) is reversed from that in the Chicago sheet. In the drawings and in the wax, there is a slight, but important difference in the front leg, which is more decidedly bent than it is in any of the finished paintings or in the pastel. This indicates either that the drawings were used in the transfer process, after which Degas changed the pose to suit the demands of his new composition, or that the drawings relate to other, presumably lost, works of the same date. Although not an important or independent drawing like *Studies of a Horse* (cat. no. 21), *Horse and Rider* provides insight into the complexity of Degas's working process as well as into his reliance on "imprinting" (the printing of drawings) and other techniques to achieve reversal. (RB)

COLLECTIONS: Estate of the artist, Vente III, 106/2, repr., stamp (Lugt 658) recto, lower left, in red; Joseph Winterbotham, Chicago.

LITERATURE: Chicago 1979, 2G4.

62. Horse Turned Three-Quarters, c.1880

Black crayon on buff tracing paper, formerly laid down
Max. 320 x 221 mm
Gift of Justin K. Thannhauser, 1945.30

Fig. 62-1. Degas. *Horse and Rider,* graphite. Private Collection. Photo: Vente IV, 223c.

Horse Turned Three-Quarters is a direct tracing from *Horse and Rider* (fig. 62-1), which probably was made in preparation for the painting *At the Races* (L. 184), dated around 1868 by Lemoisne and often considered among Degas's earliest racecourse compositions. Because of this connection to the painting, *Horse Turned Three-Quarters* has always been assigned a corresponding date, but surely this is not correct.

At the Races is a very small oil on panel that Degas reworked many times. In 1958-59, when it came on the London market, it was cleaned back to its earliest stage, causing some controversy (see Nicholson 1960: 536). It shows several horses in various positions, including one, being reined to a stop near two spectators, that relates directly to the horse in *Horse and Rider.* The major differences between the two drawings and the related horse in *At the Races* are the animals' ears and hind legs. In the painting, the horse's ears are flattened against its head, while in both drawings they stand free; the hind legs, bent in the painting as if prancing, are straight in *Horse and Rider.* This may indicate that *Horse and Rider* was made after Degas had begun *At the Races* and that it is connected to one of the lost layers removed in the panel's controversial cleaning. Whatever the case, the Chicago sheet was not traced from the painting (the analogous horse in it is much smaller) but rather from *Horse and Rider.* The Art Institute sheet actually exhibits greater stylistic affinities with Degas's later single studies of horses. In all probability, it was traced from the earlier drawing at a time closer to 1880 than 1868 and most likely served as a linear matrix or even a direct-transfer source for a horse of identical size and pose at the right of an 1880/81 pastel, *Jockeys in the Rain* (fig. 62-2). Degas chose to concentrate on the animal's head, shoulders, and front legs because he knew that the hind legs would not be necessary in his new composition, where the form of the horse would overlap the right edge.

In fact, Degas used the image of a horse in this particular pose several times in the late 1870s. A larger, but identically posed horse occurs in the famous painting *Jockeys Before the Start* (L. 649). A drawing even more closely related to this painting was sold at the final Degas studio sale (Vente IV, 231c). In two earlier sheets, Degas drew the same horse without its flanks (Vente IV, 232a,c). All of these drawings and tracings may relate to one of Degas's waxes, *Horse Walking,* which is identical to the drawings in every way except that it is reversed. In making the transition from a three-dimensional to a two-dimensional image, Degas could have used either mirrors or drawings on tracing paper that are now lost. Whatever his working method may have been, it is clear that Degas often appropriated forms and figures from his early work at a considerably later date. (RB)

COLLECTIONS: Estate of the artist, stamp (Lugt 658) verso, lower right, in red; René de Gas, Paris; Gustave Pellet, Paris; Maurice Exteens, Paris; Justin K. Thannhauser, New York.

LITERATURE: Chicago 1979, 2E10.

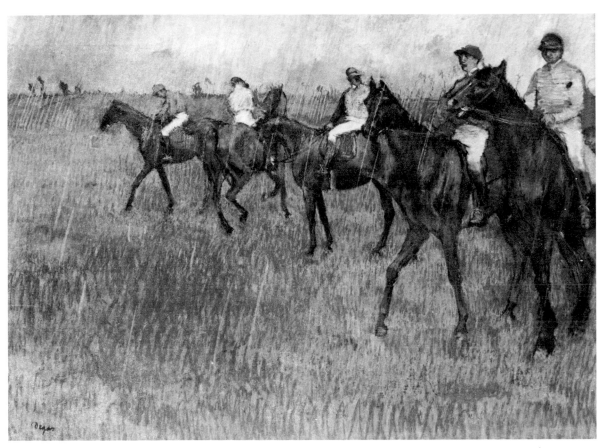

Fig. 62-2. Degas. *Jockeys in the Rain*, c. 1880/81, pastel (L.646). Glasgow Museums and Art Galleries, Camphill Museum, Burrell Collection.

63. The Millinery Shop, 1879/84

Oil on canvas
100 x 110 cm
Mr. and Mrs. Lewis Larned Coburn Memorial Collection,
1933.428

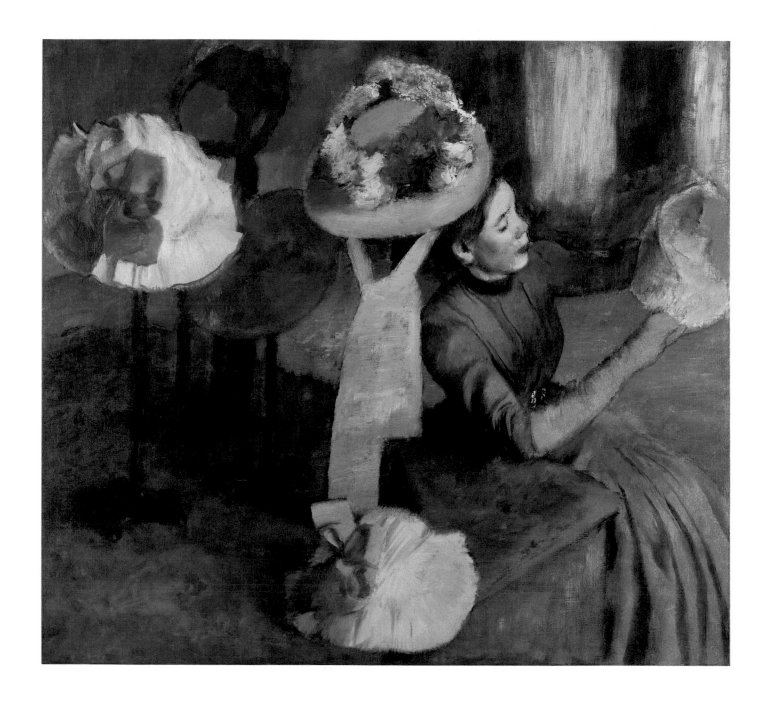

The Millinery Shop depicts a modestly clothed young woman in the act of creating a hat; her mouth is pursed around an invisible pin, and her hands are gloved to avoid soiling the delicate material. She leans back to examine the hat and moves it about, searching for its proper shape. Occupying the right half of the composition, she turns her back to the finished and partially finished hats of various colors and textures on the display table which occupies the other half of the canvas. The worker thus is juxtaposed with the tangible results of her labor, which she is not destined to wear and, in her present position, is even unable to see. Her head is positioned just behind a particularly glorious tawny yellow hat covered with light green flowers that is placed in the center of the composition. The hat seems to hover in space, its ribbon masking our view of the wooden stand on which it actually rests. The worker almost appears to wear the hat she has made, evoking what George Moore called the "sweet and sad poetry of female labor" (Moore 1890: 424).

Degas conceived the composition so that we, as viewers, are both present and absent—present, because the hats are obviously arranged for our elevated and, hence, privileged view, and absent because the shop girl is unaware of us. In this way, Degas created a world of double inaccessibility. The shop girl is denied access to the hats she has made, and we are denied access to the girl.

It is possible that Degas intended to represent the interior of a millinery shop seen from the street through a window which becomes, in the framed painting, a sheet of protective glass. This would account for the girl's intense absorption in her work and accords well with the fact that Degas often glazed his oil paintings in the 1880s. It would also suggest that he conceived of the viewer as a bourgeois woman out to purchase a hat. Many fashion plates of the period represent just such modish strollers out window shopping. Other artists of the Impressionist group had already placed the spectator in the position of purchaser (see particularly Gustave Caillebotte's *Still Life* in the Museum of Fine Arts, Boston, and Edouard Manet's *Bar at the Folies Bergère*).

The figure in this painting was not always a shop girl. Recent X-ray photographs and the preparatory drawings for the painting indicate that she began her pictorial life as a customer. Two of the drawings (fig. 63-1 and L. 834) repre-

Fig. 63-1. Degas. *At the Milliner's,* 1879/84, pastel (L.833). Private Collection. Photo: Robert Schmit, Paris.

Fig. 63-2. Eva Gonzales (French, 1850-1883). *The Milliner,* c. 1877, pastel.
The Art Institute of Chicago, L. L. Coburn Fund (1972.362).

sent a well-dressed woman wearing a hat and examining an-other in her hands; this figure is clearly discernible in the X-ray, her hat under the head of the present figure and her hands holding a finished hat with flowers and ribbons. In a third drawing (L. 835), the bareheaded shop girl is intro-duced, but this figure is not identical to the one in the final painting: although the tilt of her body and head, as well as the plainness of her costume, correspond, her head is shown in three-quarter view, her arms are in a tighter configuration, and the hat she examines is larger and more finished. The X-ray also indicates that Degas altered the woman's clothing in many ways before settling on the almost colorless gray-green blouse and skirt enlivened by a shiny belt buckle. At one point, the blouse had a bodice with carefully described buttons; at another, the sleeves were trimmed with lace or fur, like that on the collar. All these changes demonstrate both the pre-cision of Degas's pictorial process and his special interest in props and costumes. They also make clear that the social significance of the painting did not occur to Degas initially, but was arrived at after a lengthy gestation period.

The numerous revisions come as a surprise to those fa-miliar with *The Millinery Shop.* Far from being a thickly painted record of the artist's struggles, the paint is thin in most places and has more the consistency of underpainting than that of a finished work of art. The X-ray of the areas in which the most reworking occurred reveals that Degas did not paint over earlier experiments, but rather scraped at the can-vas with his palette knife, removing, wherever possible, the residue of his indecision. Paradoxically, visual evidence of the alterations remains not in the areas of greatest change, under the figure, but in the hat she is making. Clearly, Degas in-tended certain portions of the painting to be read as un-finished so as to make a visual metaphor of creation. Thus, we experience both the hats and the painting as they come into being: the unfinished areas of the painting correspond ex-actly to the unfinished hats. The finished hats, on the other hand, are overlaid with richly textured paint and stand out from the areas that are softly painted or stained.

Degas first worked the canvas throughout with thinned paint applied both with small brushes to draw the main forms

and large brushes to stain whole areas with single colors. As we have seen, the artist used thick paint in selected areas; in certain portions of the hats and the table top, the paint surface is so active that he must have brushed it coarsely when the paint was almost dry. The most extraordinary facture is found in the head of the shop girl. Its original structure changed at least three times. The head is both a profile and a three-quarter view, both flat and fully modeled. Degas used thick paint that he worked not only with brushes but also with his fingers and thumb, as if modeling the face from clay or wax. The resulting texture lends to this human form a directly tactile quality deliberately absent from the rest of the painting.

George Moore (1890:424) referred correctly to Degas's various representations of the millinery shop as "contrived." Every important form in the painting was placed in accordance with certain basic rules of pictorial order. Degas first divided the canvas in half (the center axis is that of the two major hats), then in thirds (one of which is defined by the axis of the figure and the other by the hat stand immediately left of center), then in quarters (the hat stand furthest from the viewer), and finally in eighths (the hat stand to the far left). This vertical order serves to anchor the floating hats and to connect the shop girl with her creations. The diagonal spatial order of the painting is only a bit less rigorous. The table meets the left edge of the painting exactly at its center, and the corner of the table near the shop girl occurs exactly at a point one-quarter away from the bottom of the painting.

In the 19th century, woman and her changing attire seems to have been a metaphor for modern civilization, and painters devoted prodigious energies to the subject. Some, like Manet, Monet, and Tissot, saw the woman as a kind of decorative ensemble, at one with her clothes and accessories. Others, Degas chief among them, focused on the separate components of this ensemble. The hat—more than the bustle, brooch, or parasol—was for Degas the prime symbol of the modern bourgeois woman. Degas, however, avoided the sexual association of the milliner theme, an aspect of the profession exploited by Tissot, Manet, and, ironically, Eva Gonzales (see fig. 63-2).

Degas seems to have preferred hats for several reasons, not the least of which was convenience. With a minimum of expense and effort, he easily could have purchased (or have had purchased for him) a small number of hats in order to re-create in his studio the atmosphere of a small millinery shop. Yet, there were undoubtedly other reasons. Unlike the handbag, parasol, or fan, the hat changed in form and color as rapidly as the "costume" itself; in addition, it could be refurbished and thus recycled. Also, the hat, unlike dresses or other accessories, was particularly conducive to display; wooden hat stands, with their knobby, turned "vertebrae," served as supports for the stuffed "heads" in countless shops

and display windows throughout Paris. Degas must have enjoyed the visual play of hats, hat stands, customers, and working girls in the many modest shops of the city.

Milliners of the sort pictured by Degas trafficked in affordable fashions and helped their clients to look like great ladies without great expense. Nonetheless, Degas's hats, no matter how modest the system of retail enterprise in which they fit, were quintessentially fashionable. Hats and bonnets figure prominently not only in the voluminous publicity of the 19th-century French fashion industry, but also in the early books and articles written about fashion and class structure. Thorsten Veblen, in *The Theory of the Leisure Class*—the greatest study of consumer society published in the 19th century—wrote about hats in a way that makes clear their importance:

> A fancy bonnet of this year's model unquestionably appeals to our sensibilities today more forcibly than an equally fancy bonnet of the model of last year, although when viewed in the perspective of a quarter of a century, it would. . .be a matter of the utmost difficulty to award the palm for intrinsic beauty to the one rather than to the other of these structures (Veblen 1959: 127).

His remarks are particularly applicable to Degas's millinery shop, with its emphasis on what Veblen no doubt would have called the "construction" of hats. Yet, a painting that delights in fashion seems to deny the very universality to which works of art aspire. If, in Degas's time, bonnets were considered to be utterly fashionable, paintings, by contrast, were supposed to express "intrinsic beauty." In *The Millinery Shop*, Degas confronted the conundrum of beauty in fashion, of the enduring in the ephemeral.

It is not known precisely when Degas began his methodical examination of the modiste. He made at least 15 pastels, drawings, and paintings of the subject, which are close enough in style and composition to suggest that they were done over a period no longer than a decade. *The Millinery Shop*, the largest and, in certain ways, the most ambitious of the group, is neither signed nor dated and generally has been placed in the first half of the 1880s. Two superb pastels representing the interior of a millinery shop were signed and dated 1882 (L. 681, 682); other known drawings and pastels are closely related to them. However, there are certain important differences between *The Millinery Shop* and the dated pastels which make it difficult to establish a sequence. All other finished works representing millinery shops have at least two figures and investigate the relationship between two women trying on hats (L. 683, 729, 774), between one customer and one shop girl (L. 682, 693, 709, 827), or between two hat makers (L. 681). The solitude and concentration of *The Millinery Shop* are absent from these wittier, sometimes even satirical representations of the social life of hat shops.

The Millinery Shop is unusually large for a painting by Degas from the 1880s. Only the portrait of Hélène Rouart (L. 869) is larger; the canvases that relate in scale most clearly are the portraits of Théodore Duret and Diego Martelli (L. 517, 519), both finished in 1879 and included in the Impressionist exhibition of that year. The connections between the identically sized *Martelli* and *The Millinery Shop* are particularly close. In each, a full figure—presented in an informal, asymmetrical pose—is engaged in work. Each is shown with the results of his labor, and each turns away from the center of the painting. In fact, the two works could be considered a pair, were their formats not different (*The Millinery Shop* is a horizontal, the portrait a vertical). Since both paintings were done on canvases (with a commercially prepared white ground) that were probably purchased prestretched from the same merchant, it is not unreasonable to suppose that both were begun at about the same time.

In order to determine the date of *The Millinery Shop,* one must also understand something more about its subject, particularly its relationship to the novels of Emile Zola. As we have seen (see cat. no. 57), Degas had begun to paint laundresses as early as 1869 and had returned to the subject following the publication in 1876 of Zola's *Assommoir.* Although his representations of millinery shops have no precise literary equivalent, it is fascinating and, indeed, essential to discuss them in relation to another Zola novel, *Au Bonheur des Dames,* published in installments during 1882 and as a whole in March 1883.

The seventh in Zola's famous Rougon-Macquart series, this novel deals primarily with the relationship between the burgeoning Paris department store (the largest, Bon Marché, opened in 1869) and the hundreds of small, traditional shops whose business was being undercut by those vast, modern markets. Its central character, Denise Baudu, is an orphan who, at the beginning of the novel, walks by Zola's fictional department store, Au Bonheur des Dames, on her way to a new life as an employee in her uncle's small drygoods shop. Because his customers are being enticed away by the glamor of this nearby establishment, eventually the uncle is forced to send Denise to seek work there.

Although *The Millinery Shop* bears no direct relationship to the novel, Degas's evocation of a silent hat shop without customers must be seen in contrast to a glamorous department store like that described in Zola's contemporary tale. *Au Bonheur des Dames,* like most of Zola's novels, is, in fact, a study in contrasts. Where the department store is a the-atrical fantasy—always light, brilliant, and active—the shops of the *"petits commerçants"* are dark and, most often, deserted. The small stores described in the book are owned by single families with close personal connections with their customers, while the large establishment is staffed by hundreds of employees, many of whom are single women—the famous *demoiselles* of loose morality who were the focus of writers and journalists of the period. For Zola and many of his contemporaries, the department store was an arena of greed and kleptomania, an environment that generated desire. The small shop, on the other hand, represented a faded dream for limited success harking back to the Paris described in the novels of Honoré de Balzac.

It seems more than likely that Degas, working actively on his series of milliners during 1882, changed the central character of his largest painting of that subject from a customer to a shop girl when he read or became familiar with Zola's novel. No other of Degas's millinery shops has quite the same message. In most, he gently mocked the vanity of women, concentrating on the larger problem of the quest for beauty in a consumer society. In *The Millinery Shop,* he focused on a single shop girl as she molds material into a hat; his message, if a masterpiece can have a single message, is that the process of creation is a lonely one, dependent ultimately on the whims of its audience. The hats become, in a very direct way, Degas's works of art; as we judge them, we judge the artist as well. (RB)

COLLECTIONS: Durand-Ruel, Paris, stock no. 4114 (purchased directly from the artist in 1903); Mrs. Lewis Larned Coburn, Chicago, 1929.

EXHIBITIONS: New York 1886; Chicago 1933, no. 286, pl. 53; Chicago 1934, no. 202; Northampton 1934: 20, no. 8, repr.; Toledo 1934, no. 1; Springfield 1935, no. 1; Philadelphia 1936, no. 40, repr. p. 92; Worcester 1941, no. 4, repr.; Cleveland 1947, no. 38, pl. 30; Philadelphia 1950-51, no. 74, repr.; Boston 1974, no. 20; Richmond 1978, no. 14; Albi 1980, no. 8, repr.

LITERATURE: *Fine Arts* 1932: 23, repr.; Rich 1932, p. 69, repr.; Mongan 1938: 297, repr.; Slocombe 1938: 22, repr.; Shoolman/Slatkin 1942, pl. 543; Huth 1946: 324, fig. 3; Lemoisne 1946, no. 832, repr.; Fels 1950: 98, repr.; Rich 1951: 108-09, repr.; Rich 1955: 75, repr.; Cabanne 1957, pl. 111; Chicago 1961: 121, repr. p. 336; Sweet 1966a: 203, fig. 33; Gaunt 1970: 244, pl. 95; Maxon 1970: 88-9, 280, repr.; Russoli 1970, no. 635, repr.; Danikan 1974: 4C, repr.; Kramer 1974: 19, repr.; Chicago 1978, no. 63, repr.; Marandel 1979: 106, repr. back cover.

64. Getting Out of the Bath, c. 1882

Crayon électrique and drypoint on ivory laid paper; first state?
Plate 127 x 127 mm; sheet 177 x 224 mm
Albert Roullier Memorial Collection, 1928.232

65. Getting Out of the Bath, c. 1882

Crayon électrique and drypoint on cream laid paper; fourth state?
Plate 127 x 127 mm; sheet 214 x 296 mm
Clarence Buckingham Collection, 1962.82

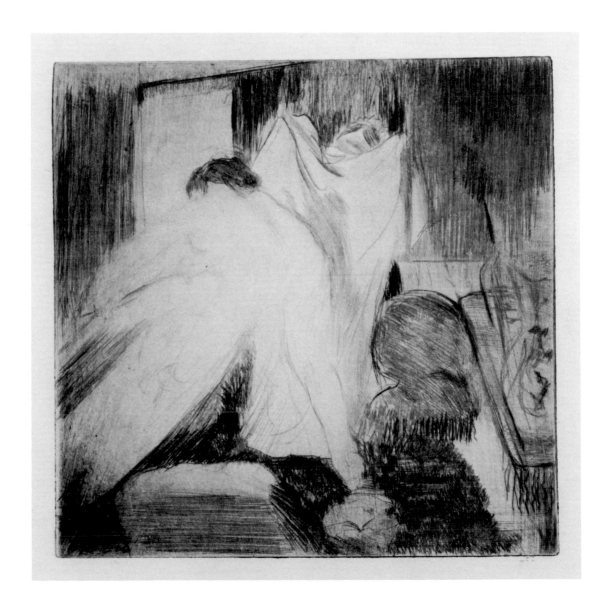

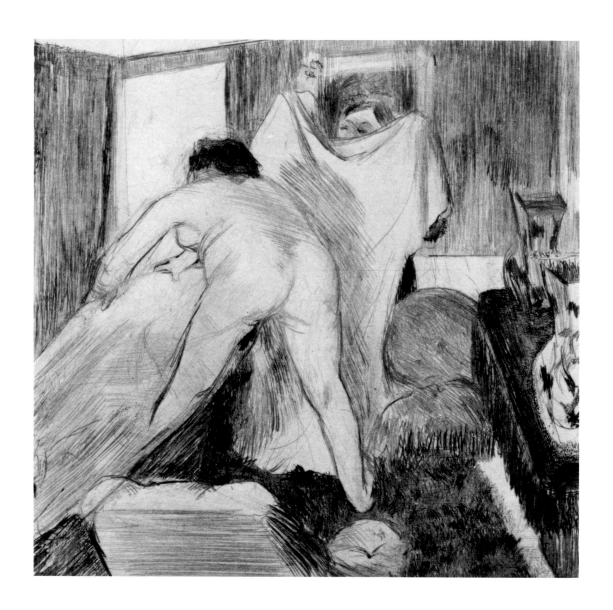

Getting Out of the Bath is the most complex of Degas's prints in terms of its progression through various states. Delteil, the first cataloguer of the artist's prints, listed seventeen states, but Adhémar increased that number to thirty-nine, not including what he referred to as ten "intermediate" ones. If Adhémar's count is correct, this small, relatively unambitious etching with drypoint and *crayon électrique* has more states than any other Impressionist print.

Legend surrounds the origin of the print (see Chicago 1964, no. 35). Degas apparently dined one evening, as he often did, with his friend Alexis Rouart and was forced to stay the night with the Rouart family because of a sleet storm. When he awoke the following morning—or so Rouart related—he asked for a copper plate and a tool and etched the first state (cat. no. 64) of this print. He based the composition somewhat on a monotype (C. 133) now in the Bibliothèque Nationale, Paris. Yet, the two are dissimilar enough to suggest that Degas worked directly on the copper from memory without consulting the monotype.

In any case, the etching in all its states shows us a middle-aged woman getting out of the tub as her maid extends an open bath towel to dry and cover her. Here, as in most of the bathers dating from the late 1870s and early 1880s, Degas was as interested in the setting as in the figures themselves. In this print, it perhaps is not a brothel, but rather a luxurious bathroom in a private house. The woman wears no jewelry, and the pair of rather grand Chinese vases on the table are not like the accouterments and knick-knacks included in Degas's many representations of brothels. We are probably observing a middle-class woman—and a rather awkward and ungainly one at that.

Faintly etched lines indicate that Degas labored over the position of the body. It is reversed from that in the Bibliothèque Nationale monotype, where the woman faces the viewer. There is considerable evidence, particularly in the Art Institute's impression from the fourth state (cat. no. 65), that the arms, legs, and even the torso of the figure were not only adjusted for compositional balance but were completely changed. Moving with greater assurance in earlier states, the woman now proceeds more cautiously, her leg resting reassuringly on the tub and her hands grasping the edges so that she will not slip.

Again, as in so much of his oeuvre, Degas chose to analyze a moment of transition, an instant of maximum strain in the otherwise lazy state of bathing. The nudes floating in bath water made famous later by Pierre Bonnard have no place in Degas's oeuvre, nor do the frolicking nymphs of Auguste Renoir or even of Camille Pissarro. Indeed, when we consider this carefully constructed world of mass in balance, we can see clearly why Degas admired the bathers of his slightly younger colleague Paul Cézanne, two of which he owned (Paris 1918, nos. 9, 11). (RB)

64.

WATERMARK: ORIGINAL/BASTED MILL/KENT

COLLECTIONS: Estate of the artist, stamp (Lugt 657) verso, lower left, in red; Vente d'estampes, 96; Pierre Bracquemond, Paris, 1919; The Art Institute of Chicago, stamp (Lugt Suppl. 32b) verso, center, in brown.

EXHIBITIONS: Chicago 1964, no. 35, repr.

LITERATURE: Delteil 1919, no. 39, repr. (first state); Adhémar 1974, no. 49, repr. (seventh and fifteenth states); Edinburgh 1979, no. 109, repr. (seventh state); London 1983, no. 19, repr. (eighth state).

65.

COLLECTIONS: Estate of the artist, stamp (Lugt 657) verso, upper right, in red; Vente d'estampes, 96; unknown German collector, inscription verso, lower right, in graphite; acquired by the AIC from Kornfeld and Klipstein, Bern.

EXHIBITIONS: Chicago 1964, no. 35, repr.

LITERATURE: Delteil 1919, no. 39, repr. (first, fifth, and fourteenth state); Adhémar 1974, no. 49, repr. (seventh and fifteenth states); Edinburgh 1979, no. 109, repr. (seventh state); London 1983, no. 19, repr. (eighth state).

66. Retiring, c. 1883

Inscribed recto, lower left of center, in charcoal: *Degas*
Pastel on laid paper, laid down
Max. 364 x 430 mm
Bequest of Mrs. Sterling Morton, 1969.331

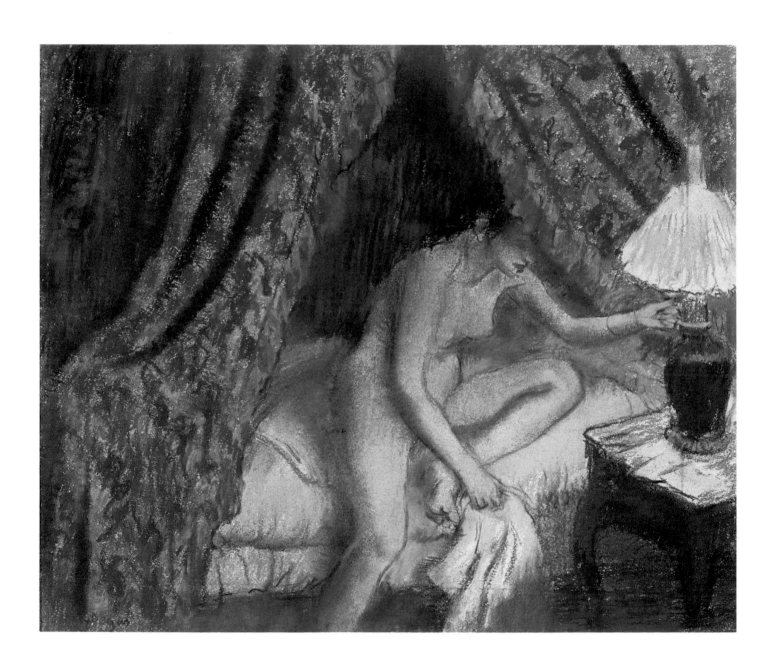

Before a detailed examination of *Retiring* was made, it was tempting to describe it as a pastel over monotype and to relate it to what seemed to be two cognate monotypes (C. 141; fig. 66-1) that were first published by Eugenia Janis (1967a: 79). Indeed, the composition, proportions, and chiaroscuro of *Retiring* are so close to a pastel over monotype, *Sleeping* (fig. 66-1), that surely they are related. However, examination of the Chicago sheet with a microscope and infrared reflectography proved conclusively that there is no monotype substructure and that the fully worked pastel was made without any use of the monotype process.

Thus, *Retiring* is a very rare example in Degas's oeuvre of a direct visual and compositional relationship between a monotype and a pure pastel. While Degas customarily made two impressions from his monotype plates and worked the second, paler impression with pastels, there are few instances in which he made a pure pastel based so closely on a pastel over monotype. This can be understood in light of his refusal to repeat compositions without making significant changes of medium, figural placement, proportion, or size. Although *Retiring* is larger than *Sleeping*, in every other way, the two are so similar that one wonders about Degas's reasons for the apparent duplication.

An explanation can be found in his intense fascination between 1879 and 1885 with the effects of artificial light on various surfaces. In the case of *Sleeping*, Degas made a monotype, an impression of which he worked with pastel. Not achieving the effects he desired, yet fascinated by the composition, he enlarged it slightly to form the basis for *Retiring*. Indeed, several straight, dark, vertical and horizontal lines under the final pastel layer indicate that he was concerned with an accurate transfer of the composition from the monotype to the pastel.

The primary sensation in viewing *Retiring* is one of silence and tranquility. The pastel exhibits little of the charged athleticism or indolent sensuality that characterize Degas's many representations of luxurious *maisons closes* and their permanent residents. Here, it is night and the woman is going to bed. She has just bathed and dried herself with the towel that she will drop on the floor as she turns out the light. Her body is pink with warmth, and the temperature of the room is high enough for her to be comfortable without clothing. Her head is partially hidden behind the bed curtain; she seems almost to shun the light, protecting her eyes from its glare. The entire pastel is suffused with pinks and ruddy oranges that triumph over the cool greens and deep blues. What is surprising is the extent to which Degas allowed the white paper to shine out from the drapery, bed, lamp, and two pieces of paper on the lamp table—all highly worked areas. Only in the woman's body and in the seductive darkness behind her have all traces of the paper support been obliterated. Degas seems almost to have conceived this pastel for night

viewing: the superbly controlled chiaroscuro functions best in very dim light, and the colors of the woman's skin and the drapery seem to throb with life in the half-light.

Degas made at least two drawings related to *Retiring*. In one of these (Vente III, 122/3), the woman wears a simple, ruffled nightcap, indicating that she is going to sleep alone. In the Art Institute pastel and the other drawing (L. 745), the averted gaze of the figure and modest position of her arm give her an almost chaste quality. The body of the figure in the pure monotype (C. 141) bends suddenly and impulsively toward the lamp. In *Retiring*, she sits solidly on the bed, leaning over just slightly to reach the light. The ultimate charm of the drawing lies in its temporal fragility, for, in a moment, all will be dark. (RB)

COLLECTIONS: Bernheim-Jeune and Co., Paris, 1910; Durand-Ruel, Paris; Prof. Werner Weisbach, Berlin and Basel, 1910; Kornfeld and Klipstein, Bern, 1954; Richard Zinser, New York; Mrs. Sterling Morton, Chicago.

EXHIBITIONS: Chicago 1969: [4].

LITERATURE: Vollard 1924, repr. p. 24; Hausenstein 1931, repr. p. 161; Rivière 1935, repr. p. 157; Lemoisne 1946, no. 743, repr.; Chicago 1969-70: 24; Chicago 1970a, repr. p. 2; Russoli 1970, no. 896, repr.; Chicago 1971: 28; Chicago 1979, 2F8.

Fig. 66-1. Degas. *Retiring (Le Coucher)*, 1883, monotype (L.744). Formerly Paris, Friedmann Collection. Photo: Lemoisne 1946.

67. The Bath, 1880/85

Monotype printed in black-brown ink on cream laid paper
Plate max. 314 x 278 mm; sheet 514 x 352 mm
Clarence Buckingham Collection, 1951.116

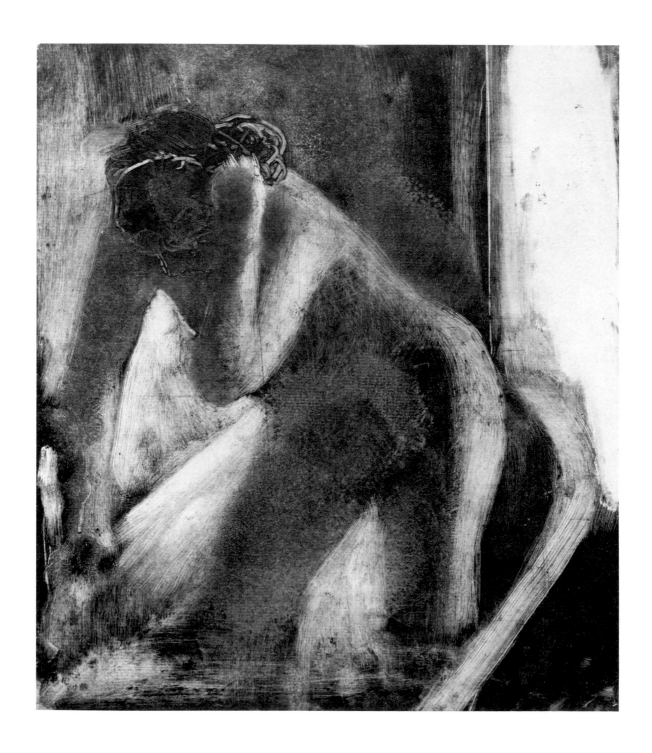

The activity of bathing fascinated Degas; in numerous works in many media, he analyzed the movements of female models entering the tub, washing, and getting out, as well as drying and combing their hair. Indeed, while Degas often chose to represent his two greatest subjects—the ballet and the horse race—by concentrating on the moments before and after the performance or race itself, he focused on the whole process of bathing, omitting no part of the action. Degas appears to have treated bathing as an aspect of the larger ritual of prostitution, contrasting the bather's active contortions, performed before sex, with the relaxation and sleep that come after (see cat. no. 66). Again, as always, performance is implied but never pictured. Despite the potential vulgarity of his subjects, Degas seems always to have been discreet.

In *The Bath*, Degas depicted a robust young woman in a large porcelain tub, her body turned from the window as she sponges her shoulder and the back of her neck. She moves naturally, seemingly unaware of the presence of a voyeur. Degas covered the plate used for *The Bath* with a thick coat of greasy ink and, as was his practice in the so-called dark-field monotypes, introduced a sense of daylight into the print by wiping, brushing, sponging, scraping, and even fingering the plate to remove and manipulate the ink. The body of the woman was created with innumerable scratches of a pin or etching needle, each stroke lifting a line from the mass of ink. Degas worked with a somewhat thicker tool to draw the face, hair, and bath sponge, and then used a sponge of his own on the figure as if to mimic her actions. Her right leg and torso have been sponged so thoroughly that they appear almost to move. The rather phallic water spiggot at the far left is almost a ghostly presence in gray.

Most of Degas's larger monotypes were done in two impressions. This is the first of two, the second and paler of which was used as the basis for a signed pastel (fig. 67-1) traditionally dated 1883. Brilliant in its use of cool blues and greens, the pastel makes explicit the water that is only suggested in the monotype. The presence of a larger plate mark surrounding that of the Art Institute monotype indicates that Degas made a counterproof of this impression while it was still wet. This explains both the loss of detail in the middle-value grays and the frequent interference of the chain lines from the heavy paper, especially in the sponged areas of the woman's body and in the background. The counterproof does not survive as such, although possibly it was incorporated into another work of art and covered with pastel, gouache, or tempera so as to be unrecognizable.

The principal problem of *The Bath* is its date. Traditionally placed in the first half of the 1880s because of its relationship to the pastel, which clearly was done at that time, it has been dated to early 1877 by Janis (1972: 69). While Degas did show monotypes in the Impressionist exhibition held in April of that year, as well as two works in other media called *Woman Leaving the Bath* (L. 422) and *Woman Taking a*

Bath, Evening, both the large scale of the figure in *The Bath* and the lack of a clearly defined, complex setting point to a date in the first half of the 1880s. Cachin has given *The Bath* a date of around 1882, but this is surely too narrowly defined. (RB)

WATERMARK: AM (in a crowned shield)

COLLECTIONS: Estate of the artist, stamp (Lugt 657) verso, upper center, in red; Vente d'estampes, 243; Ambroise Vollard, Paris; acquired by the AIC from Henri Petiet, Paris.

EXHIBITIONS: Cambridge 1968, no. 33, repr., checklist no. 123.

LITERATURE: Janis 1967a: 71-81, repr.; Janis 1972: 59, fig. 7; Cachin 1974, no. 155, repr.; Pasadena 1979: 41.

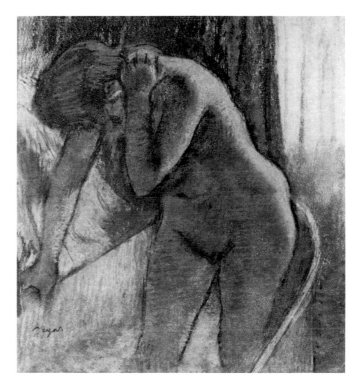

Fig. 67-1. Degas. *The Bath,* 1883, pastel (L.730). Private Collection. Photo: Robert Schmit, Paris.

68. Female Nude Reclining on Her Bed, 1880/85

Inscribed recto, upper left, in the monotype: *Degas à Burty*
Monotype printed in black ink on ivory laid paper
Plate 199 x 413 mm; sheet 221 x 418 mm
Clarence Buckingham Collection, 1970.590

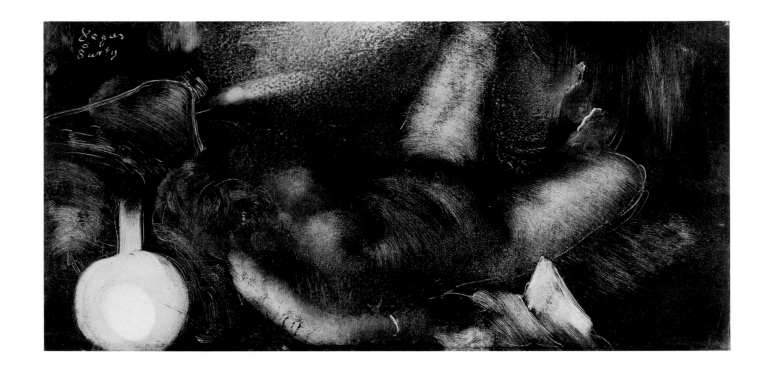

This superb monotype of a reclining nude woman is one of four similar works each dedicated by Degas to a male friend (C. 160, 161, 163, 165). In this case, the friend was Philippe Burty, a great print collector and critic whose influence on the graphic arts in France during the three decades before his death was unequaled. Degas seems to have marshalled all his forces to create a world of utter sensual pleasure in recognition of this print connoisseur's refined sensibilities.

Degas chose as the subject of the four monotypes a well-proportioned female nude, in this case probably a prostitute whose bracelet glistens on her right arm. She sprawls on her daybed, her muscles and limbs in a state of delightful enervation. Her hair, picked out from the black ink with an etching needle, is slightly tousled; her arms, breasts, and legs retain evidence of the artist's touch. The background and the space between her legs are softened by the slight contact of a sponge laid gently on the inked surface. In this way, the artist alluded subtly to the bath she has just completed and will take again. At present, her indolent reading has been interrupted; one cannot tell whether she has just put down the folded newspaper or is about to pick it up.

Degas's nude is revealed by the light of an oil lamp glowing in the lower left corner of the print. The white orb of light is nothing but the paper shining in splendid purity through the dark lithographic ink. Yet, even the lamp, large and bright as it is, possesses a softness of form; its light meanders lazily across the figure, isolating certain textures or forms. The

highlights are perfectly chosen and placed on the page—the bracelet and the edge of her right foot, created by a flick of Degas's wrist; and the newspaper, both wiped and drawn. The woman herself becomes almost a cushion of lines that resemble the wealth of etched strokes in Rembrandt's *Negress Lying Down* (fig. 68-1), a print that, though more chaste than the monotype, seems to have been Degas's model. Few 19th-century prints exhibit the control of chiaroscuro seen in this sheet, where Degas's lines appear even softer and more supple than those of his greatest master (Janis 1972: 62-3).

The dedication to Burty transports us into the world of Degas's friends and admirers, a world so much larger and more varied than those of his fellow Impressionists. The intimate brotherhood to whom the four monotypes were dedicated included, besides Burty, P. Rosanna, a young ceramicist whom Degas recommended in the years 1879-80 to his friend Haviland of Limoges; the great collector and minor painter Henri Michel-Lévy, whose portrait Degas painted in 1878 (L. 326; Reff 1976a: 125-9); and the rakish nobleman Viscount Lepic, a close friend of Degas (see p. 24) and the subject of one of his greatest portraits (L. 368). So few of Degas's letters survive and so little is known about his personal life that these four prints take on a biographical dimension beyond their manifold social and aesthetic meanings. Degas must have known Burty well in order to have dedicated and given such a print to him; it is even possible that Burty was present when the monotype was printed. The friendship between Degas

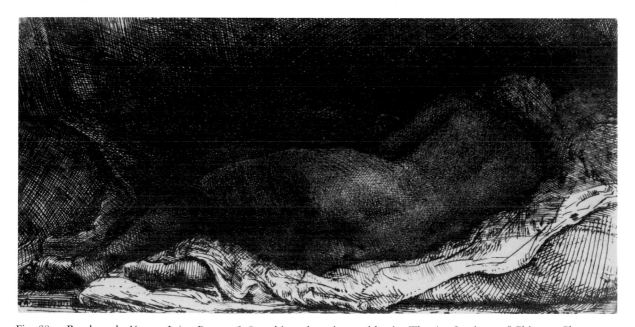

Fig. 68-1. Rembrandt. *Negress Lying Down*, 1658, etching, drypoint, and burin. The Art Institute of Chicago, Clarence Buckingham Collection (1954.11).

and the great critic has never been considered as having been particularly important to either man, yet the intimate nature of the subject of this print, as well as its forthrightly placed dedication and signature, suggests that the two men were close.

The second impression of this superb monotype was used as the basis for what Janis called a cognate pastel, dating from the mid-1880s (fig. 68-2). In this, as in other pastels over monotype, Degas departed substantially from the monotype to create a new work of art. He applied the pastel considerably beyond the area bounded by the original plate, expanding the new image into the blank margins of the paper. Perhaps the most striking changes are those made in the lamp—which becomes a simple object resting on the table rather than a disembodied glow of light—and in the woman—who is leaner, more defined, and harder than the model in the monotype. The pastel is athletic, the monotype sensual. (RB)

WATERMARK: Indecipherable letters

COLLECTIONS: Philippe Burty, Paris; Durand-Ruel, Paris; Gustave Pellet, Paris; Maurice Exteens, Paris; Paul Brame, Paris, 1958; Kornfeld and Klipstein, Bern (auction 108: May 1962, no. 247); H. Neuerberg, Cologne, stamp (Lugt Suppl. 1344a) recto, lower left, embossed; Kornfeld and Klipstein, Bern (auction 137: Jun. 1970, no. 318, repr.); acquired by the AIC from Kovler Gallery, Chicago.

EXHIBITIONS: Paris 1937, no. 208; Copenhagen 1948, no. 76; Bern 1960, no. 23; New York 1980, no. 24, repr.

LITERATURE: Guérin 1924: 80; Jamot 1924, no. 208; Rouart 1948, pl. 19 (as *Nu couché*); Pickvance 1966: 18, fig. 1; Janis 1967a: 80, fig. 40; Cambridge 1968, checklist no. 137; Janis 1972: 59-61, fig. 8; Cachin 1974, no. 163.

Fig. 68-2. Degas. *Nude Reclining,* 1883/85, pastel over monotype (L.752). Chicago, Private Collection. Photo: The Art Institute of Chicago.

69. Dancer Kneeling, Seen from the Back, c. 1880/85

Charcoal with pastel on cream wove paper
Max. 323 x 233 mm
Joseph Winterbotham Collection, 1954.328

70. Dancer at the Bar (On Point), c. 1885

Charcoal with pastel and estompe on tan laid paper
Max. 318 x 244 mm
Gift of Robert Allerton, 1923.292

Well over 100 rapid life drawings of dancers at practice or in rehearsal were discovered in Degas's studio after his death. Despite their compelling, on-the-spot realism, which might lead one to conclude that they were done in the rehearsal rooms of the Paris Opéra, more likely these hasty charcoal sketches were made of models posing in Degas's studio. Moreover, as Reff (1967: 260) has pointed out, the inscriptions they bear are probably Degas's comments on his own mistakes rather than on errors made by the dancers in the execution of positions, as Boggs and, earlier, Browse, believed (St. Louis 1966-67, nos. 118-22). Such insights require revision of our understanding of Degas's approach to dance, and suggest that the refinements of dance techniques mattered less to the artist, who took occasional liberties with classical ballet form in his pictures, than has been thought.

These drawings were roughly executed in charcoal; they often contain *pentimenti*, or evidence of multiple attempts at capturing a particular gesture or limb (cf. Vente III, 86/1-4). Sometimes, for rich effect, Degas rubbed the images with his finger or a stump, and frequently he added pink pastel to the dancer's shoes or tights. Most of these exercises were not intended necessarily to be works of art in themselves, nor were they preparatory to larger works. Rather, they were training exercises for the artist who, just like his subjects, had to observe and practice his art continually to keep limber. These sheets could have functioned like pattern books but, oddly enough, very few of the dancers depicted in them reappear in finished works. Moreover, they do not date to the time of Degas's earliest explorations of the subject, but rather mark his continuing investigations of the theme in later years.

These studies, with their similar handling and technique, may have been executed over the course of months or of years—they are difficult to date precisely, except insofar as they are distinct from the refined preparatory drawings for works Degas executed around 1874 and from the images of longer-limbed dancers he roughed out in charcoal on tracing paper around 1890. They are largely without props except for the bar; those that do contain further indications of setting can be dated from before 1876 into the late 1880s. Drawings of a dancer bent over a bass violin (Vente III, 86, 137) must relate to *Dance Lesson* (L. 625), which Pickvance (1963: 259 n. 38) assigned to before 1876, and to its slightly later version (L. 905), which Reff put in 1878/79 (1976b: 151, Notebook 31: 70). A study of a dancer mounting the stairs (fig. 69/70-1) clearly relates to a painting of that title generally dated 1885/90 (fig. 69/70-2). The physiognomy of this dancer is sufficiently close to the figure in the Art Institute's *Dancer at the Bar* (cat. no. 70) to justify a similar dating for it, around 1885. As Janet Anderson has pointed out (written communication), the dancer wearing the characteristic practice garb clearly is resting between exercises, leaning against the bar as she flexes her feet on point.

Dancer Kneeling (cat. no. 69) presents a pose that is surprisingly infrequent in Degas's many dance images; it is difficult to say whether the dancer is resting, rehearsing, or performing. Two other studies (Vente III, 126/3-4), probably of the same figure from the side and from the front, contain Degas's notation *"pour groupe,"* indicating that he intended it for a larger composition of the corps de ballet.

The two drawings shown here undoubtedly were drawn from life after the young ballet students at the Opéra, known as "rats." This appellation was given them by Nestor Roqueplan, director of the Opéra between 1849 and 1854, who described them as follows:

> The rat is a student of the school of dance, and it is perhaps because she is a child of the house, because she lives there, because she gnaws there, jabbers there, splashes there, because she corrodes and scratches the decor, frays and tears the costumes, causes a wealth of unknown injuries and commits a wealth of wrongdoings, occult and nocturnal, that she has received this name of rat (Coquoit 1924: 72).

(SFM)

69.
COLLECTIONS: Estate of the artist, Vente III, 139/4, repr., stamp (Lugt 658) recto, lower left, in red; Joseph Winterbotham, Chicago.

LITERATURE: Chicago 1979, 2F5.

70.
COLLECTIONS: Estate of the artist, stamp (Lugt 657) verso, lower right, in red; Vente III, 125/1, repr., stamp (Lugt 658) recto, lower left, in red; Robert Allerton, Chicago.

EXHIBITIONS: Chicago 1933, no. 861.

LITERATURE: Chicago 1979, 2F10.

Fig. 69/70-1. Degas. *Dancer Climbing the Stairs*, drawing (L.895). Private Collection. Photo: Lemoisne 1946.

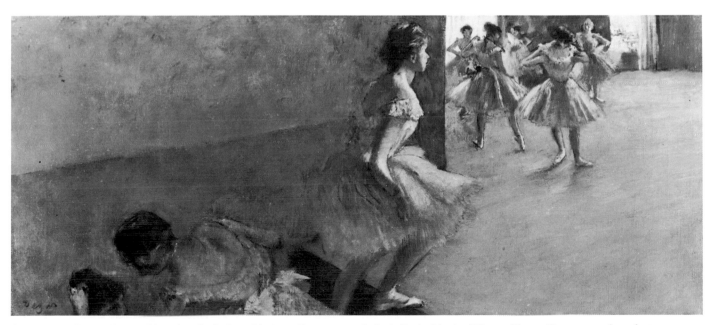

Fig. 69/70-2. Degas. *Dancer Mounting the Stairs,* 1885/90, oil on canvas (L.894). Paris, Musée d'Orsay. Photo: Documentation photographique de la Réunion des musées nationaux.

71. Preparation for the Class (formerly Dancers in the Wings), 1882/85

Inscribed recto, lower right, in black pastel: *Degas*
Pastel on ivory laid paper
Max. 648 x 497 mm
Bequest of Mr. and Mrs. Martin A. Ryerson, 1937.1032

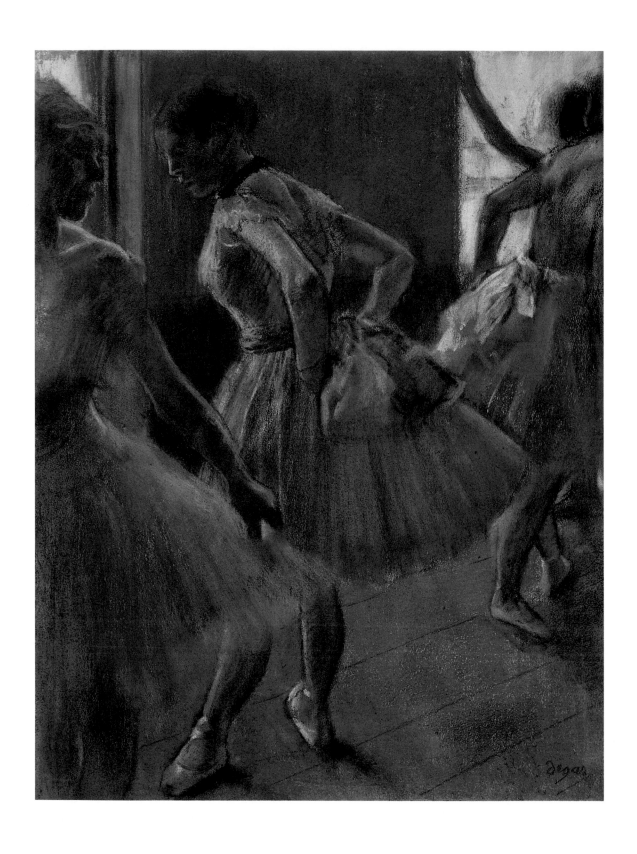

Although Lemoisne's title and date—*Dancers in the Wings,* 1890—traditionally have been accepted for this pastel, they are both inaccurate. Clearly, the dancers are not standing in the dark wings of a theater but before the large and luminous windows of a dance studio. Browse's title, *Preparation for the Class,* seems far more appropriate for the ostensibly candid composition of four dancers—their forms partially cut off by one another or by the frame—as they mingle casually and adjust their costumes.

The light playing on the dancers' imposing forms is critical in this composition. As Janet Anderson has observed (written communication), the long, deep windows against which the figures are silhouetted (*contre jour*) recall those of the old Opéra studios on rue le Peletier. Often, in his major paintings and pastels of dancers in the studio, Degas worked with similar lighting; many of these, such as *Dance Class* (L. 398) and *The Rehearsal* (L. 430), date to the mid-1870s. Slightly later works, such as *Ballerinas Exercising with a Violinist* (L. 537) and a number of the wide-format classroom scenes recently redated by Reff to 1878/79 (L. 900, 902, 905; Reff 1976b: 151, Notebook 31: 70), indicate Degas's active interest in such lighting throughout that decade. While the *contre-jour* motif persisted throughout Degas's late work, it occurs less

frequently; when it does, the windows are more remote, less clearly defined, and shed a diffused rather than a clarifying light (see fig. 85-1). Thus, it seems probable that *Preparation for the Class,* with its clear, indirect light, solid figures, and relatively shallow space, stems from Degas's extensive exploration of the effect in the 1870s.

Three features distinguish *Preparation for the Class* from most of Degas's other dance compositions: the unusually large scale of the figures in relation to the space; the subtle gray, olive, and periwinkle blue hues; and the pastel's pitted texture. Although the figures are fragmented and juxtaposed to create a tight, decorative surface pattern that relates to the Japanese compositional devices adopted by Degas around 1879, their three-dimensionality and weight could reflect Degas's work in sculpture in the early 1880s. In fact, several statuettes of figures with arms back and akimbo (Rewald 1957: 52-6) may have served as models for the dancer tying her sash; their relatively erect posture and smooth handling would place them in the early 1880s, close to the *Little Dancer of 14 Years* (fig. 42-1).

The closest two-dimensional comparisons to the *Preparation for the Class* are an oil painting, *The Green Room* (fig. 71-1), and a related pastel (L. 716 bis). In both works, dancers ad-

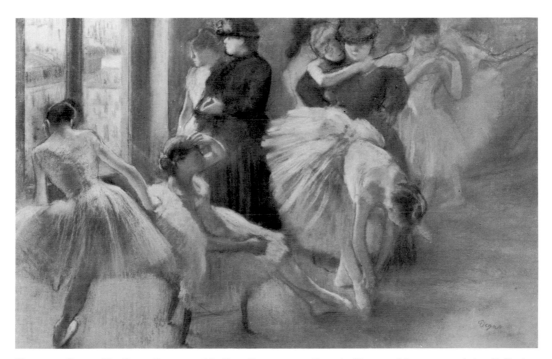

Fig. 71-1. Degas. *The Green Room,* c. 1880/85, oil on canvas (L.700). Glasgow Museums and Art Galleries, Camphill Museum, Burrell Collection.

justing their costumes are clustered together in a relatively shallow space, set off against the pattern of windows and walls. George Shackelford (oral communication) has noted that *The Green Room*, like the Art Institute pastel, contains figures that almost span the full height of the work; it, too, is executed in a somber palette. Lemoisne's date of around 1882/85 for *The Green Room* and its related pastel seems appropriate for the Chicago pastel, as well. The dancer cut off at the left seems, on close examination, to have been added somewhat later than the rest of the composition; slight changes were also made to the positions of the dancers' arms and feet.

A final word should be said about the unusual texture of *Preparation for the Class*: the pastel is more lumpy and less fragmentary than most pastels, forming a pockmarked crust across the paper. This effect seems to be the result of the humidifying technique described by Denis Rouart (1945: 22-5). Degas moistened his pastels with the steam from a tea kettle, melting them into a brittle glaze, as here, or reworking the pastel with a brush. Based on a reference to a "pastel-soap" recipe in Degas's notebooks of that period (Reff 1976a: 277), one can date his use of this technique to around 1880. A work cited by Rouart and Reff as an example of this process, *Dancer with a Fan* (L. 545), bears great resemblance to the Art Institute work, as does *Three Dancers in a Room* (fig. 71-2). Thus, *Preparation for the Class* represents Degas's reconsideration of his favored *contre-jour* motif, informed by his work in three-dimensional media and expressed with the creative originality he brought to the art of pastel. (SFM)

WATERMARK: MICHALLET

COLLECTIONS: M. Paulin (sale: Paris, May 22, 1919); jointly purchased by Durand-Ruel, New York, and Knoedler and Co., Paris; purchased by Martin A. Ryerson, Chicago, Nov. 1919.

LITERATURE: Manson 1927: 47; Lemoisne 1946, no. 1012, repr.; Browse 1949, no. 187, repr.; AIC 1961: 121; Sweet 1966a: 200, 202, fig. 27; Russoli 1970, no. 858, repr.; Chicago 1971: 28; Chicago 1978, no. 64, repr.; Chicago 1979, 2G6.

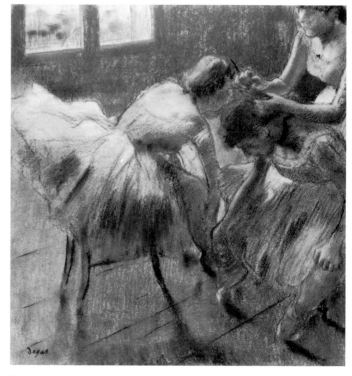

Fig. 71-2. Degas. *Three Dancers in a Room*, c. 1879, pastel (L.542). New York, The Metropolitan Museum of Art.

72. Dancer Ready to Dance, the Right Foot Forward, c. 1882

Bronze; foundry no. 57
56.2 x 33.7 cm
Wirt D. Walker Fund, 1950.112

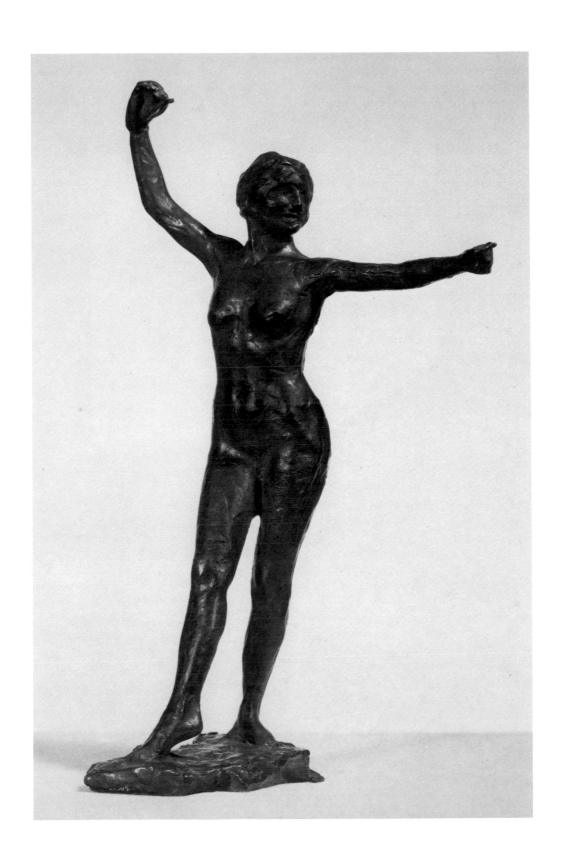

When Degas died in 1917, more than 150 wax sculptures, most of them in fragments, were found in his studio on rue de Clichy. The surviving waxes reflect the artist's most compelling interests: horses, dancers, bathers, nudes, and portraits. He never sold any sculpture and, in his lifetime, exhibited only one piece, *Little Dancer of 14 Years* (fig. 42-1), in 1881. Although Degas mentioned to friends that he would cast some of his waxes in bronze, he reworked them to such an extent, filling them with so much metal and cork for support, that many of them eventually fell apart. Certainly, Degas was aware of the fragility of the waxes and could have insured that more of his sculpture would endure, had he truly been so inclined. "To be survived by sculpture in bronze," he said, "what a responsibility! Bronze is very indestructible" (Failing 1979: 38).

Nonetheless, much of Degas's sculpture does survive, not only in the waxes found in his studio, but also in the posthumous casts that A. A. (Adrien) Hébrard made of 73 of them. Hébrard was the appropriate founder, for it was he whom Degas had commissioned to make plaster casts of three of his waxes around 1900. Hébrard purchased the waxes at the sale of Degas's studio; he then rehired his most trusted founder, Albino Palazzalo, who used the lost-wax casting process. The job was not completed until 1932.

Because they were cast posthumously with neither the knowledge nor the supervision of the artist, Degas's bronzes have a problematic existence as works of art. Like the bronzes cast after Daumier's plaster sculptures now in the Musée d'Orsay, Paris, Degas's bronzes resemble the originals in form, but differ considerably in hue, density, and surface quality. While most of the waxes are monochrome, certain of them were made of red, brown, and green waxes mixed by the artist with apparent glorious abandon. The bronzes vary considerably in patination—presumably in response to the original wax—but cannot by their nature retain the qualities of the wax surface. The same problems of translation extend to the mounts and supports. Degas used wood-mounted metal armatures on which he constructed the wax sculptures. In the bronzes, the distinction between the base, support, and wax—clearly observable in the originals—is lost. Indeed, in evaluating a bronze by Degas, the viewer must always be aware that he is looking at a brilliant reproduction of an original work of art that, in most cases, was made of wax.

Why, one must ask, did Degas make sculpture that he did not intend to cast? The answer lies in his working methods. As has been amply demonstrated here, Degas performed complex experiments, tracings, and reversals in executing a work of art; in several instances, we have noted how the artist's wax sculptures played a role in this process (see cat. nos. 61, 76, 78-83). While it is true that Degas made life studies of both horses and the female human form, he also made sculptured models of them in several poses for the purpose of analysis. If Degas observed and drew a pose or gesture while watching a ballet or horse race, he could translate that pose into three dimensions, thereby enabling him to study the figure from all points of view. Also, by choosing a relatively small scale and a continuously malleable material, Degas was able to adjust and alter these "models" to assume new postures. By heating these wax studies, he could re-form contours and lines in the figure; and by breaking the wax-laden armature, he could free the limbs of his horses and nudes before adding new wax and letting them harden again into their new positions. In fact, recent study of the Degas waxes given by Paul Mellon to the National Gallery of Art, Washington, DC, indicates that many metal armatures were broken numerous times; indeed, surface examination even of the bronzes reveals the resulting cracks and fissures.

From all this, several conclusions can be drawn: First, Degas did not intend that the majority of his sculpture endure forever; second, he made extensive use of the medium for purposes of study; and third, by casting a wax into bronze, Hébrard was unable to translate the original's real sculptural values. Unfortunately, the Art Institute does not possess a wax original by Degas, making a thorough analysis of any individual sculpture difficult. Therefore, we have confined our remarks to the problems of iconography, function, and dating that the bronze casts can elucidate.

Dancer Ready to Dance was cast from a wax made by Degas about 1882. The sculpture's relatively smooth surface, as well as the figure's pose and immobility, link it to waxes Degas made in relation to and just after the *Little Dancer of 14 Years*. Although Charles Millard (1976: 66-7) related it to classical sculpture in both the Vatican and the Louvre, cat. no. 72 undoubtedly derives from the artist's direct observation of ballet dancers. Janet Anderson (written communication) has indicated that the figure has assumed a *pointe tendue*: her head is raised as if in rehearsal or performance, and both legs are correctly turned out from the hips. Only three dancers in the same position appear in Degas's two-dimensional oeuvre (Vente III, 101/1, 126/1, 126/2), indicating that this classical position interested Degas for only a very short period. As is most often the case with Degas's figures, she stands poised between dance movements, alert and ready. (TP/RB)

FOUNDRY MARK: $\frac{57}{\text{HER D}}$

COLLECTIONS: Acquired by the AIC from E. and A. Silberman Galleries, Inc., New York.

LITERATURE: Rewald 1944: 25, pl. 47 (AIC); Rewald 1957: 151, pls. 34-5; Russoli 1970, no. S36, repr.; Millard 1976: 24, 67, fig. 51.

73. Spanish Dance, c. 1883

Bronze; foundry no. 45
43.2 x 21 cm
Wirt D. Walker Fund, 1950.111

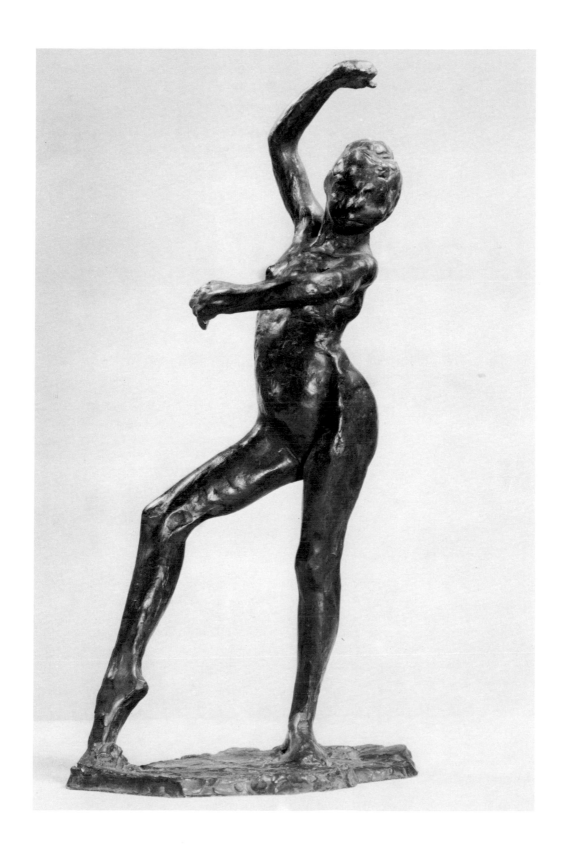

The wax from which cat. no. 73 was cast is one of two sculptural studies by Degas of a Spanish theme. The direct inspiration for the sculpture was most likely an 1837 bronze of the famous ballerina Fanny Elssler, by Jean Auguste Bayre, a cast of which was owned by Degas's lifelong friend Henri Rouart (Millard 1976: 67). The most celebrated dancer of the Romantic era, Elssler was commemorated in many popular prints and statuettes; her greatest success was in the *Cachucha*, a Spanish dance in Corelli's ballet *The Devil on Two Sticks (Le Diable boiteux)*, first performed in 1836 (Janet Anderson, written communication).

The style of the wax suggests a date in the first half of the 1880s, making the work difficult to connect in any direct way with the Bayre bronze. However, it is possible that Degas took up the subject after the 1884 memorial exhibition at the Ecole des Beaux-Arts of the work of Manet, who had died in 1883. *Spanish Dance* of 1862 (fig. 73-1) was shown there at that time (Rouart/Wildenstein 1975: 64). The position of Degas's dancer, called a *cambré*, is similar to that of the dancers in Manet's painting. Perhaps Degas, having seen again Manet's early investigation of the dance, decided to make a Spanish dance of his own, combining the *cambré* of Manet's dance with the *Cachucha* immortalized by Bayre. In any case, he returned to this extraordinarily active pose nearly ten years later, making a second wax (foundry no. 20).

A single drawing for the wax survives (Millard 1976, fig. 74). In it, Degas executed separate delineations of various sections of the dancer's body: shoulder, nipples, pelvis, left leg and heel. Interestingly, there are no representations of the Spanish dancer in Degas's two-dimensional oeuvre; it appears that he confined the theme to sculpture. (TP/RB)

FOUNDRY MARK: $\frac{45}{\text{HER D}}$

COLLECTIONS: Acquired by the AIC from E. and A. Silberman Galleries, Inc., New York.

EXHIBITIONS: New Orleans 1965: 92, pl. XXV.

LITERATURE: Rewald 1957, pls. 46-50; Russoli 1970, no. S17, repr.; Millard 1976: 24, 30, 35, 67, 102-04, 106, 111, fig. 69; Northampton 1979, no. 30, repr.

Fig. 73-1. Manet. *Spanish Dance,* 1862, oil on canvas. Washington, DC, The Phillips Collection.

74. Arabesque penchée, c. 1885/90

Bronze; foundry no. 16
39.4 x 70 cm; base 20.3 x 12.7 cm
George F. Porter Collection, 1925.1641

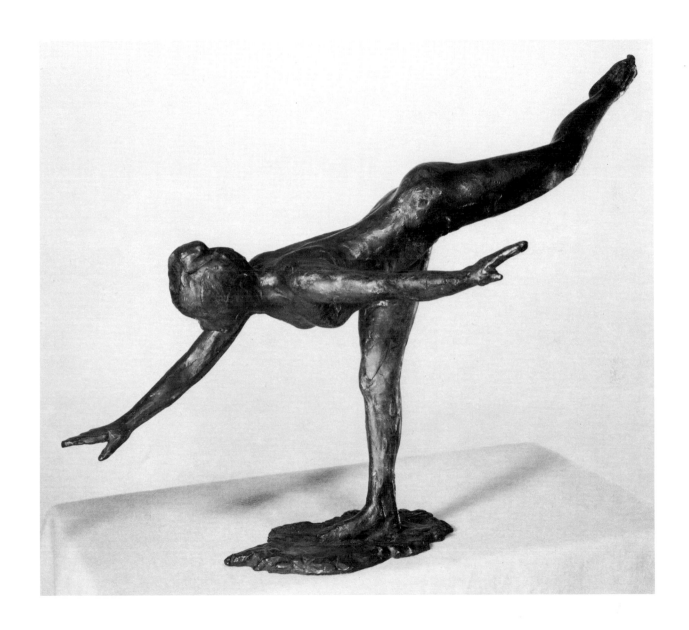

Degas studied the ballet position called the *arabesque* frequently and in all media, particularly pastel (see cat. no. 29) and wax. He made at least eight different waxes (foundry nos. 1-3, 14-16, 18, 60) in order to realize in sculptural form this spatially and physically complex position. In the *arabesque,* an essential movement of classical ballet, all parts of the body are extended from the central body mass and balanced on one foot. Difficult to maintain for any length of time, the position would have been hard for Degas to capture by studying actual dancers, which is why he turned to wax.

In the wax from which cat. no. 74 was cast, Degas depicted a dancer at the lowest point of the position: her head, in line with her spine, must be raised along with her upper torso in order to complete the movement. Degas followed the sequence of movement in other waxes. In isolating the moments leading to the final, static *arabesque,* Degas seems to have been influenced by the motion photography of the great British photographer Eadweard Muybridge (see fig. 74-1). Yet, whereas Muybridge froze the motion of horses and fig-

ures on the photographic plane, Degas realized his *arabesque* sequence in three dimensions. In this way, the weights and counterweights, the thrusts and balances leading to the perfect *arabesque* could be fully understood. Certainly, Degas studied these waxes when he made his many pastels and drawings of the pose.

Arabesque penchée was accessioned by the Art Institute in 1925, making it not only the first bronze by Degas to enter this museum but probably the first to become part of an American public collection. (TP/RB)

FOUNDRY MARK: $\frac{16}{r}$

COLLECTIONS: H. Berlin (sale: Lucerne, Sept. 1, 1931, no. 35, repr.); George F. Porter, Chicago.

EXHIBITIONS: Chicago 1933, no. 1121; Chicago 1934, no. 749.

LITERATURE: Zorach 1925: 263, repr.; Rewald 1957: 149, pl. 33; Russoli 1970, no. S8; Millard 1976: 24, 35, 37 n.55, 68, 105, 106, pl. 91.

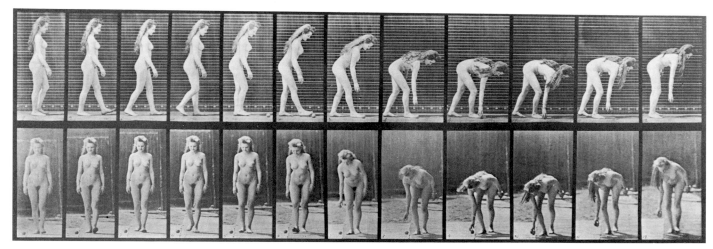

Fig. 74-1. Eadweard Muybridge (British, 1830-1904). *Female Nude,* from *Animal Locomotion* 3 (Philadelphia, University of Pennsylvania, 1887), pl.204. The Art Institute of Chicago, Ryerson Library.

75. Harlequin, 1885

Inscribed recto, lower left, in brown pastel: *Degas/85*
Pastel on cream laid paper, pieced at bottom and right
Max. 645 x 578 mm (bottom piece 50 x 578 mm; side piece
645 x 115 mm)
Bequest of Loula D. Lasker, 1962.74

The brilliantly colored *Harlequin*, signed and dated 1885, is one of the artist's most dramatic and provocative dance compositions. The work depicts a moment in a harlequinade (a dance devoted to Harlequin, the *commedia dell'arte* buffoon) in which the traditional ballet character, clad in his familiar red and green costume, bends over a recumbent, cloaked figure. The scene has been observed from backstage—a stage flat obstructs the view at the right; at the upper left, other dancers are glimpsed in the wings beyond the stage. With no further information to explain the nature of the action featured here, an air of mystery and malevolence prevails, created by the shrouded, inert form and by the harlequin's turned back and long stick, held behind him as though he has just dealt the figure a blow.

The somewhat curvaceous body of the harlequin and the angle from which the scene has been observed may be explained by the fact that the part was played by a female. It was common practice in later 19th-century France for male dance roles to be filled by women. A group of six other related pastels by Degas also depict female dancers as harlequins in a variety of costumes and activities (L. 771, 806, 818, 1032 bis, 1033, and Browse 1949, no. 170).

All seven pastels are signed, indicating that Degas considered them finished, self-sufficient works. One (fig. 75-1), bearing a dedication to Hortense Valpinçon (the daughter of Degas's childhood friend Paul Valpinçon), ostensibly on the occasion of her marriage in 1885, is particularly close to the Art Institute example in subject and costume. It depicts a harlequin actually performing the malicious act to which the Art Institute work alludes—the character, bent and turned away from the viewer, batters the covered form while other dancers mill around in the background, oblivious to the scene before us. Two other pastels show a harlequin from the side as he/she lunges at other dancers on and off stage (L. 771; Browse 1949, no. 170); from this angle, the dancer's buxom form is readily apparent, although her masked face hides her identity. Finally, two horizontal compositions (L. 1032 bis, 1033) depict a slimmer, supposedly younger figure (Harlequin junior) wearing a jaunty hat and dancing spiritedly with other ballerinas.

Browse (1949: 58, 169-71, 392-3) first identified three of these scenes (L. 771, 1032 bis, and Browse 1949, no. 170) with the harlequinade in Act I of *The Twins from Bergamo,* which was choreographed by Louis François Mérante and starred

Fig. 75-1. Degas. *Harlequin,* pastel (L.818). Private Collection. Photo: Robert Schmit, Paris.

Alice Biot as Harlequin junior and Mlle. Sanlaville as Harlequin senior. She cited the special gala performance given on the occasion of the Parisian Industrial and Commercial Festival on January 26, 1886; apparently unaware of the dated work now in the Art Institute, she dated the pastels to that year. It seems clear, based on their similar style, subject, and handling, that all seven pastels were executed close in time to one another. The period of 1885 to early 1886 would accommodate both the inscribed and deduced dates. However, as Janet Anderson has recently pointed out (written communication), there were other harlequinades in 19th-century French ballet. Thus, these works need not have been inspired by that one performance. Indeed, because of their enigmatic and dramatic character, the two pastels that can be dated to 1885 seem the most mature and daring of the series and would appear to have evolved from the other, more direct studies of the harlequin figures. Just as he rarely signed and dated his dance subjects, Degas rarely depicted specific performances or at least did not deliberately identify them. One is prompted to ask why, in the mid-1880s, Degas embarked on this harlequin series, whether the pastels were conceived as a unit and signed for display or sale, and, if so, why he gave a major one away as a wedding present—a bizarre and macabre choice, indeed.

A number of the works that Degas dated fall within the years 1885-86. While some are nudes and other subjects, most are portraits. Three of the latter have been identified as Opéra dancers who specialized in mime: Mlle. Sallandry (1885; L. 813) and Mlle. Salle (1886 and 1887; L. 868 and 897). Two undated portraits (L. 898, 899) could depict one or the other of these personalities, whose identities were often confused, or, according to Jean Boggs (1962: 130), could represent the Mlle. Sanlaville mentioned above. No depictions by Degas of Mlle. Sanlaville are known beyond the harlequin series (if, in fact, the series can be identified with her performance in 1886), but Degas dedicated a sonnet to her in which he extolled her talent as a mime. It would appear, then, that in the years 1885-87 Degas was especially interested in several dancers known for their ability in pantomime. His portraits or pastels of them might even have been occasioned by a commission. Whether these may have inspired the dramatic harlequin series or vice-versa is hard to say; in any case, his fascination with this kind of dancer and his impulse to complete and/or sign the sheets comprising this coherent group are noteworthy.

None of this serves to explain the overtly dramatic and menacing quality of the Art Institute and Valpinçon pastels. The blatantly aggressive action of the latter is most unusual for Degas, and it carries ominous meanings as a wedding present. Could these scenes suggest the cunning and sinister nature of overly forceful, "masculine" women as perceived by Degas? Was this a warning to Hortense Valpinçon's fiancé? Both compositions reveal the harlequin from behind, recalling the adage that one can tell all about a person from his back. Obviously, Degas felt this posture expressed enough to make the pastel's meaning clear. It should be recalled that in his pastel-heightened etching of *Mary Cassatt at the Louvre* (cat. no. 53), also signed and dated 1885, another strong female personality is depicted from the back. It is highly speculative but tempting to relate these two contemporary works and to postulate that in them some of Degas's own antagonism or fear of women was being expressed. (SFM)

WATERMARK: MICHALLET (on two added pieces)

COLLECTIONS: Jacques Dubourg, Paris (per Lemoisne); Loula D. Lasker, New York.

LITERATURE: Lemoisne 1946, no. 817; Maxon 1970: 268, 280, repr.; Russoli 1970, no. 829, repr.; Chicago 1971: 28; Chicago 1979, 2F9.

76. The Morning Bath, 1887/90

Inscribed recto, lower right, in blue pastel: *Degas*
Pastel on off-white laid paper mounted on board
Max. 668 x 450 mm
Potter Palmer Collection, 1922.422

A nude woman, having just risen from her bed, steps into the bathtub. She holds either her nightdress or a towel in her hand and reaches behind the bath curtain for support as she moves. Her position is active and unstable, relating her to Degas's "athletic" nudes of the period after 1885 rather than to the indolent or stationary nudes of the previous decade. Unlike many other images by Degas of the bath that evoke the nocturnal world of prostitution, there is something invigorating and healthy about *The Morning Bath*. This mood is acknowledged in the pastel's title, which must have come in part from the artist himself: the pastel was purchased directly from him by Durand-Ruel, from which time the title has existed.

Interestingly, the position of this figure relates it to a small group of wax sculptures by Degas, all of which have been titled *Dancer Looking at the Sole of Her Right Foot* (see fig. 76-1; also foundry nos. 40, 59, 67). Each wax is reversed from the figure in the pastel, and it is difficult to determine precisely the mechanics of the transfer. Degas probably worked directly in wax from a model in the studio, creating a three-dimensional piece from which he could work at leisure when the model went home. From the wax, he made a charcoal drawing (Vente III, 348) and from that drawing a counterproof which he then redrew to create a superbly balanced sheet (Vente IV, 366). The figure in this and another sheet (Vente IV, 315) faces in the same direction as the one in *The Morning Bath*. What is fascinating, however, is that Degas changed a crucial element of the pose, presumably when making the pastel itself or a related lost drawing. In the pastel, the figure's knee is bent to suggest action, a feature also found in the waxes. Degas seems to have altered at least one of the waxes—breaking, bending, and partially repairing the knee with hot wax so that he could work not only from his drawings but from the three-dimensional model, as well. It is possible that Degas used a mirror to "reverse" the sculpture as he worked on the pastel. All of these various methods—sculptural sketching, drawing, counterproofing, and reversing with mirrors—demonstrate both the thoroughness and the unconventionality of his working procedure. In this, he was not alone, for in the 1890s Pissarro, Gauguin, and Seurat employed equally complex practices. However, Degas's approach involved a step absent in all but Gauguin's—the use of sculpture.

One of the interesting aspects of *The Morning Bath* is its relationship to an oil painting of the same general subject (fig. 76-2). Both include the same figure type and similar settings, and both can be seen as suggesting the next moment in a sequence of movements. The nude in *The Morning Bath* puts one leg into the tub; in the painting, she has placed her weight on that leg and is drawing her other leg after her. In both works, the unmade bed provides the beginning of the sequence of positions, each of which can be imagined separately like the photographs of figures in sequential movement made by Eadweard Muybridge, which were published completely in 1887 (see fig. 74-1).

Although Degas's horses often have been discussed in terms of Muybridge's photography, too little attention has been paid to the relationship between Degas's female nudes and those of Muybridge. Not only did the photographer record the simple and "neutral" actions of women walking, climbing stairs, and carrying buckets or baskets, but he also represented such subjects as "Woman picking up clothes," "Woman standing drying her face and breasts," "Woman sitting on a chair drying her feet," and, more to the point in this case, "Woman uncovering herself and rising from bed." Familiarity with Muybridge's photographs helps decode the sequential movements of many figures caught by Degas in the middle of an activity.

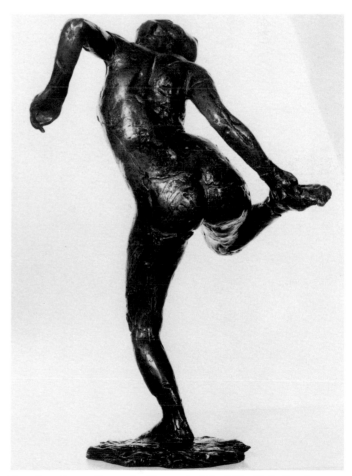

Fig. 76-1. Degas. *Dancer Looking at the Sole of Her Right Foot*, bronze. Chicago, Mr. and Mrs. R. Stanley Johnson.

Degas's achievement was to compress the work of Muybridge so that one image implies an entire sequence of separate actions. In this way, not only do the props create a plausible physical setting, but they also indicate past or future actions, enriching the temporal as well as the visual contexts of the figure. While Muybridge's photographs rarely were the direct source of paintings or pastels by Degas, he clearly was influenced by the work of the photographer: the similarity in subject and pose between their respective representations of nude women is startling (Scharf 1968: 156-9).

In the end, as one stands before *The Morning Bath*, the sheer brilliance of Degas's technique triumphs. The pastel is fully worked and layered. The wall behind the woman glows with separate applications of yellow, red-orange, blue, green, and pale pink. Sometimes, these colors were laid on directly; sometimes, they were crumbled, dissolved in a rapidly drying medium, and "painted" on the paper. Degas worked into the pastel with liquid solvents, using both brushes and various stumps; he also "etched" fine lines into the thick layers of pastel with knives and needles. His handling of the body of the nude is even more spectacular: it virtually glows as it receives all the morning light and every color in the rest of the pastel. Only the bed in the foreground, with its sleight-

of-hand lines and thinly applied areas of powder blue, lilac, and pale green, is technically simple. Degas was a master technician; his fascination with his materials and their expressive potential—with the alchemy of art—establishes him as one of the great experimentalists in the history of modern art.

It is worth noting that Claude Monet was working throughout the 1890s on pictures about time and light as they play on form. Degas, always the humanist, even if a cynical one, dealt with time in the motion of the human figure. Here, as light shifts over the scumbled pastels, creating reflections on the shiny skin of the figure, the morning is embodied. Like Monet, whom he disliked, Degas *was* an Impressionist. (RB)

COLLECTIONS: Durand-Ruel, Paris; Mrs. Potter Palmer, Chicago, 1896.

EXHIBITIONS: Chicago 1933, no. 287; Chicago 1934, no. 203; Philadelphia 1936, no. 43, repr.

LITERATURE: Manson 1927: 47; Rich 1929: 127, repr.; Rich 1933: 76, repr.; Slocombe 1938, repr. p. 19; Lemoisne 1946, no. 1028, repr.; Rich 1951: 116-17, repr.; Chicago 1961: 121; Sweet 1966a: 193, 195; Werner 1968: 74; Russoli 1970, no. 946, repr.; Bellony-Rewald 1976, repr. p. 196; Chicago 1979, 2G7.

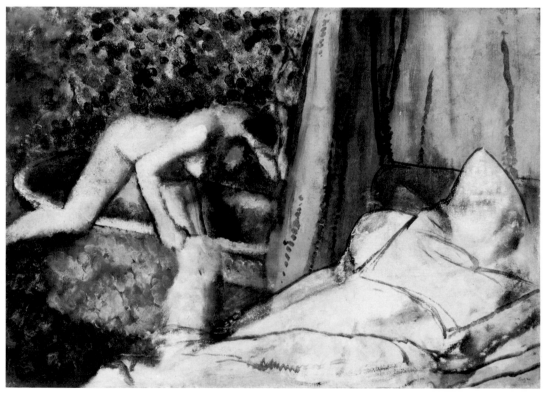

Fig. 76-2. Degas. *The Bath*, c. 1890, oil on canvas. Pittsburgh, The Carnegie Institute, Museum of Art, Presented through the generosity of Mrs. Alan M. Scaife.

77. The Tub, 1889

Bronze; foundry no. 26
47 x 42 cm
Wirt D. Walker Fund, 1950.114

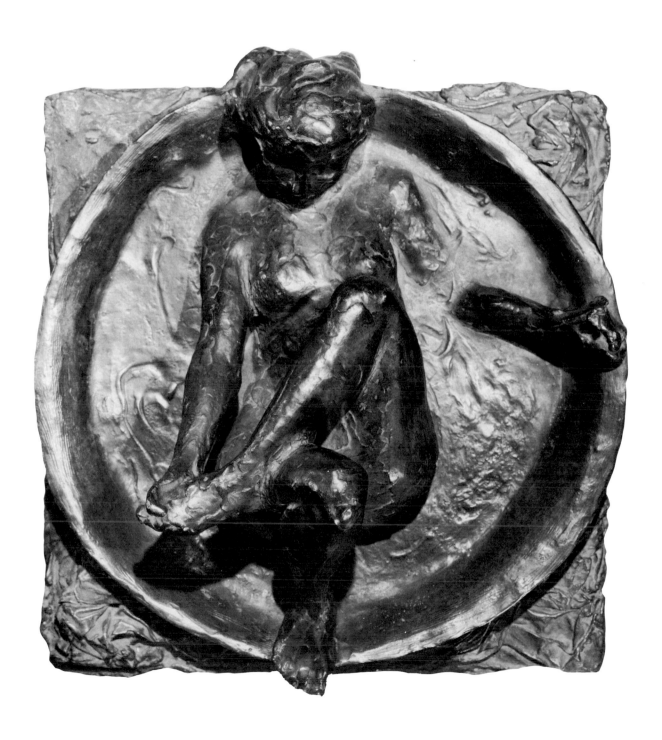

The Tub, completed in 1889, is one of Degas's greatest works. In a letter of June 13 of that year, he told his friend the sculptor Bartholomé: "I have worked the little wax a great deal. I have made a base for it with rags soaked in a more or less well mixed plaster" (Guérin 1947: 135). These rags, the actual metal basin, and the sponge in the hand of the original wax figure combine to produce a sculpture that is unique in Degas's oeuvre, at once illusory and real. The tub, rags, and ground serve both to frame the bather and to extend her into the viewer's space. The realistic effect is reinforced in the original by the perspective and coloration: the white of the plaster-soaked rags, the gray of the lead tub, and the red-brown of the wax figure (Millard 1976: 63).

A figure in this position appears only one other time in Degas's two-dimensional oeuvre (Vente I, 207), and there the figure is depicted outdoors. However, a number of pastels deal with women crouched and bathing in their tubs (see fig. 77-1; also L. 765, 816, 876). Many of these were exhibited in the 1886 Impressionist exhibition, at which time Degas may have begun the wax.

It is difficult to exaggerate the brilliance and originality of *The Tub.* In it, Degas submerged the subject of the sculpture, the nude, in plaster water, forcing the viewer to look down as she bathes. Her oblivious self-involvement—indeed innocence—gives her a special vulnerability made all the more poignant by her small size. (TP/RB)

FOUNDRY MARK: $\dfrac{26}{D}$

COLLECTIONS: Acquired by the AIC from E. and A. Silberman Galleries, Inc., New York.

EXHIBITIONS: New Orleans 1965, pl. XXVI; Los Angeles 1980, no. 109, repr.

LITERATURE: Lemoisne 1919: 116, repr.; New York 1955, no. 26, repr.; Rewald 1957: 146, pls. 76-8; Russoli 1970, no. S56; Millard 1976: 9-10, 20 n.72, 24, 38, 63, 68, 69, 75, 80, 83 n.56, 107-08, 114, fig. 92.

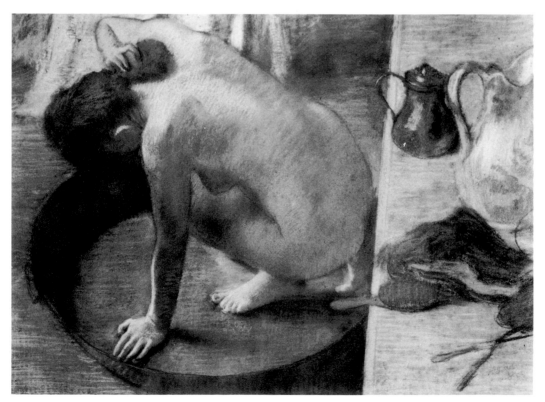

Fig. 77-1. Degas. *The Tub,* 1886, pastel (L.872). Paris, Musée d'Orsay. Photo: Documentation photographique de la Réunion des musées nationaux.

The Bather Lithographs, c. 1890/91

78. Standing Woman Drying Herself

Lithograph on ivory wove paper; third state of five
Image 333 x 246 mm; sheet 422 x 300 mm
Clarence Buckingham Collection, 1962.81

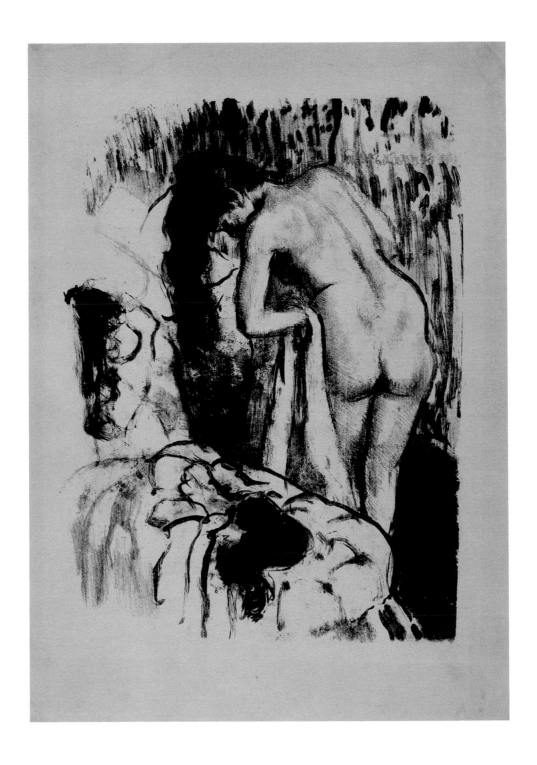

79. After the Bath

Lithograph on ivory wove paper; fourth state of six
Image 235 x 187 mm; sheet 303 x 220 mm
Bequest of Walter S. Brewster, 1954.1102

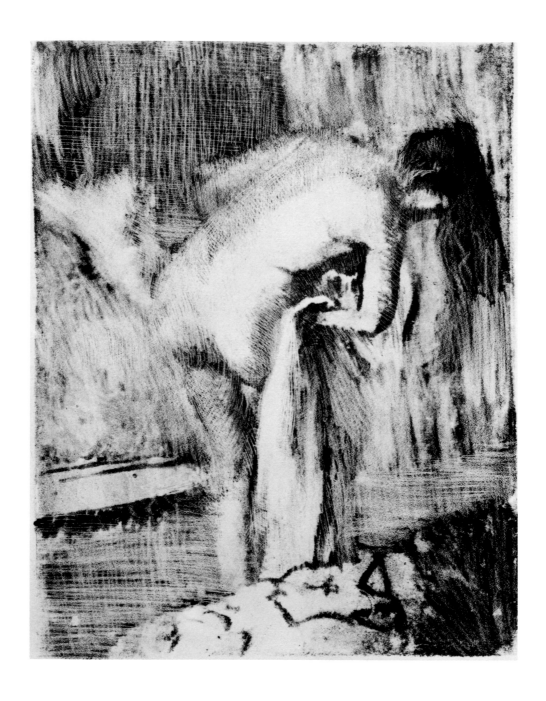

80. After the Bath (small plate)

Lithograph on cream wove paper; first state of two
Image 280 x 249 mm; sheet 375 x 315 mm
Prints and Drawings Purchase Fund, 1946.431

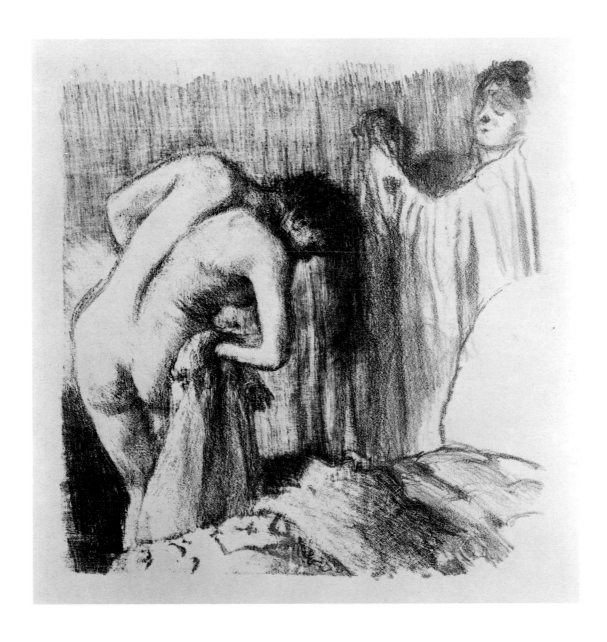

81. After the Bath (large plate)

Lithograph on white wove paper; third state of five
Image max. 302 x 327 mm; sheet 317 x 446 mm
Clarence Buckingham Collection, 1962.80

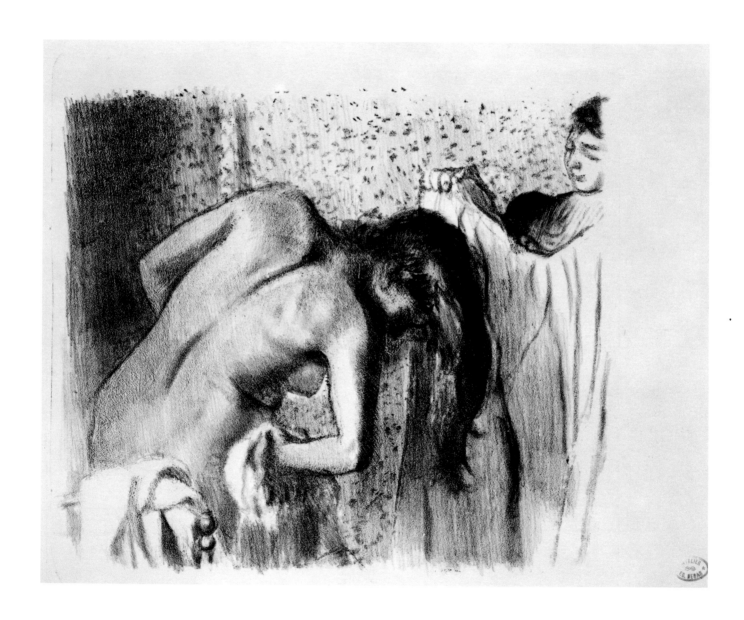

82. After the Bath (large plate)

Lithograph on light gray laid paper; fifth state of five
Image max. 350 x 313 mm; sheet 431 x 485 mm
Joseph Brooks Fair Collection, 1932.1332

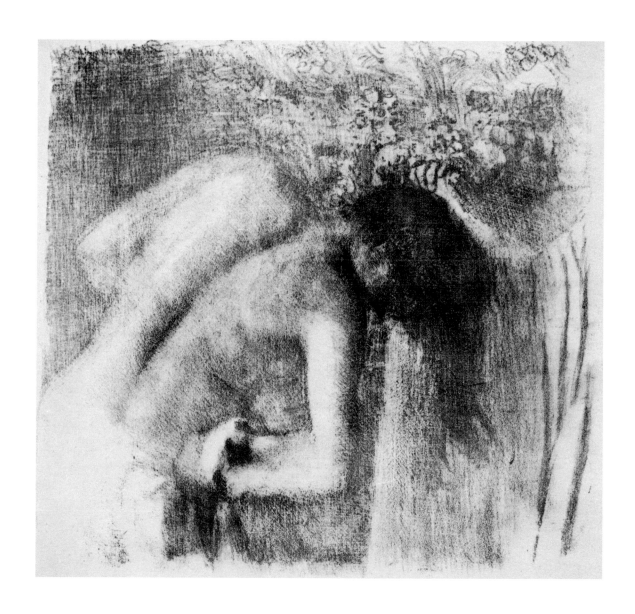

Degas's last great series of lithographs depicting a female nude drying herself after bathing can be appreciated in depth at the Art Institute. In two (cat. nos. 78, 79), she is alone, bending down so that her long hair floats freely in the air while she rubs her hip with a towel. In the other three (cat. nos. 80-82), her pose and gesture are the same, but a maid awaits her with an outstretched robe as if to signal the completion of her action. In the series, Degas displayed his mastery of the lithographic medium, which he used not only to produce diverse visual effects but also to integrate a single figure into variously composed pictorial contexts.

Degas, like Monet, worked in series. Yet, whereas Monet aimed to create a group of interdependent works of art that have, at least in part, a collective identity, Degas obsessively altered his images from one context to another. Thus, this series of five lithographs was considered by the artist not as a unit but as an exploration of a particular pose in a particular medium. It was the expressive potential of that pose that Degas aimed to exhaust. He made at least 17 drawings of it before and during the preparation of the lithographs in 1890 and 1891. Interestingly, there is no surviving monotype that includes this figure, despite the resemblance of cat. no. 78 to a monotype (see below). It is likely that the pose derives from one of Degas's wax figures which has always been titled *Dancer Fastening Her Tights* (fig. 78/82-1). Although the feet of the figure are definitely in a balletic position, the arms and upper torso are arranged exactly in the same manner as those of the bathers. Degas's transformation of the pose shows the extent to which his waxes formed a repertory of gestures to be appropriated for various purposes. It also suggests the difficulty of classifying many of his sculptures as either bathers or dancers, which is why the earliest inventory of his studio describes most of his wax figures simply as "nudes." In this and many other cases, Degas was interested in the joints of the human body. Here, the figure draws attention to her hips and pelvis, and her torso bends as if to demonstrate the flexibility of that joint. Other nudes touch or dry their feet, shoulders, ankles, or elbows.

Standing Woman Drying Herself (cat. no. 78), perhaps the earliest of the group, often has been dated around 1890, but its liberal use of tusche relates it to the light-field monotypes of ten years earlier (see C. 129-30, 132). In making it, Degas first drew the figure lightly and neatly with a grease crayon, shading with parallel hatching. It is possible that this "layer" of the lithograph was transferred from a drawing on a sheet of celluloid. He then painted freely on the stone with a thick tusche ink, which he applied with stiff brushes and allowed to splatter across the surface. In this way, he maintained a balance between drawn and painted marks, demonstrating the elasticity of the lithographic medium.

Degas departed totally from the look of his monotypes in *After the Bath* (cat. no. 79). This print was begun as a transfer lithograph from a grease-crayon drawing on celluloid. After it was transferred to the stone, Degas made many additional marks with both the tip and side of a grease crayon and then scraped at this "positive" image with instruments such as needles, knives, and even blunt tools. The effect is extraordinary;

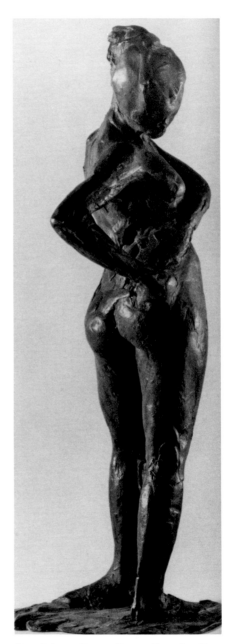

Fig. 78/82-1. Degas. *Dancer Fastening Her Tights,* wax. Photo: Rewald 1957, pl.69.

the figure seems to vibrate with the kind of kinetic linear energy normally associated with wood engravings.

The last three prints, each entitled *After the Bath* (cat. nos. 80-82), were made at virtually the same time or perhaps shortly after nos. 78 and 79. The so-called small-plate print (cat. no. 80) and the first of the large-plate prints (cat. no. 81) were drawn almost entirely on the surface of the stone with grease crayon; they have little of the technically experimental quality of the two lithographs already discussed. The small-plate print is very close in its use of the daybed to cat. nos. 78 and 79, but in the larger prints Degas eschewed this prop and allowed the viewer immediate access to the nude. Indeed, it is possible to consider the series as a gradual approach to the figure, in which impediments to our contact are removed. What seems for this reason to be the last print in the series (cat. no. 82) is in fact a transfer lithograph with very little additional work done by Degas on the stone. Because of what might be called its double indirectness—in that it is a print from a print—the woman dissolves into her own softness and is represented with an extreme *sfumato*. In that no edge is delineated and the whole seems less form than a breath of form, the print relates closely to contemporary lithographs by Eugène Carrière.

The pose that Degas chose for this, his final group of prints, is rich in associations. His preference for the back of the female nude can be traced back to Ingres's great *Valpinçon Bather* (fig. 78/82-2), which Degas drew in a notebook as early as 1855 (Reff 1976b: 40, Notebook 2: 59), when it was exhibited at the Exposition Universelle in Paris. Yet, while Ingres's monumental nude is simple and tranquil, withdrawn into a private world of thought and beauty, Degas's bather is active, depicted as she cleanses herself by an artist of modern life. There is another important precedent for Degas's bather lithographs—Rembrandt's *Woman with the Arrow* (fig. 78/82-3). Like Ingres's bather, Rembrandt's nude rests beside the water, but the wonderful folds of flesh and definition of body mass through the use of dramatic chiaroscuro link the print to Degas's later lithograph.

Degas was not the only artist of his circle to do bather lithographs: Fantin-Latour, Pissarro, Renoir, and Cézanne all worked with the subject in this medium. Because of the way in which it allows for the soft definition of tones and because of its association with charcoal drawing, lithography was an excellent means by which to represent the nude. However, all the artists just mentioned placed their figures out-of-doors, free of clothes and any indications of time or history. Although Degas progressively generalized his bathers, removing them more and more from the realm of the prostitute with which he began his investigation of the subject, he never allowed them to be anything other than 19th-century Parisian women. (RB)

Fig. 78/82-2. Jean Auguste Dominique Ingres (French, 1780–1867). *Valpinçon Bather,* 1808, oil on canvas. Paris, Musée du Louvre. Photo: Documentation photographique de la Réunion des musées nationaux.

Fig. 78/82-3. Rembrandt. *Woman with the Arrow,* 1661, etching, drypoint, and burin. The Art Institute of Chicago, Clarence Buckingham Collection (1961.346).

78.

COLLECTIONS: Richard S. Davis, Minnesota; acquired by the AIC from Robert M. Light and Co., Boston.

EXHIBITIONS: St. Louis 1967, no. 18, repr.

LITERATURE: Delteil 1919, no. 65, repr. (fourth state); St. Louis 1967, no. 19, repr. (fourth state); Kornfeld 1965, n.p., repr. (third and fourth states); Reff 1971: 153-5, repr.; Adhémar 1974: xlviii, xlix, no. 63, repr. (third state); Passeron 1974: 70-4.

79.

COLLECTIONS: Estate of the artist, stamp (Lugt 657) recto, lower right, in red; F. E. Bliss, London, stamp (Lugt 265) recto, lower right in black; Walter S. Brewster, Chicago, stamp (Lugt Suppl. 2651b) recto, lower left, in red.

LITERATURE: Delteil 1919, no. 60, repr. (second and fourth states); Adhémar 1974, no. 64, repr. (AIC); Passeron 1974: 70-4.

80.

COLLECTIONS: Acquired by the AIC from Jean Goriany, New York.

LITERATURE: Delteil 1919, no. 63, repr. (first state); Lemoisne 1946, I, repr. opp. p. 138 (first state); Kornfeld 1965, n.p., repr. (first and second states); St. Louis 1967, nos. 13-14, repr. (first and undescribed states); Adhémar 1974, no. 67, repr. (AIC); Passeron 1974: 70-4.

81.

COLLECTIONS: Estate of the artist, stamp (Lugt 657) recto, lower right, in red; M. Carré, 1919; acquired by the AIC from Richard Zinser, New York.

EXHIBITIONS: St. Louis 1967, no. 15, repr.

LITERATURE: Delteil 1919, no. 64, repr. (first and third states); St. Louis 1967, no. 16 (fifth state); Kornfeld 1965, n.p., repr. (second, third [AIC], and fifth states); Adhémar 1974 no. 68, repr. (first state); Passeron 1974: 70-4; London 1983, no. 28, repr. (first and third states).

82.

COLLECTIONS: Acquired by the AIC from Frederick Keppel and Co., New York; The Art Institute of Chicago, stamp (Lugt Suppl. 32b) verso, lower left, in brown.

LITERATURE: Delteil 1919, no. 64, repr. (first and third states); St. Louis 1967, nos. 15-16, repr. (third and fifth states); Kornfeld 1965, n.p., repr. (second, third, and fifth states); Adhémar 1974, no. 68 (first state); Passeron 1974: 70-4; London 1983, no. 28, repr. (fifth state).

83. Two Dancers, c. 1890

Inscribed recto, lower right, in charcoal: *Degas*
Pastel on cream wove paper, pieced and laid down
705 x 536 mm (bottom piece 82 x 536 mm)
Amy McCormick Memorial Collection, 1942.458

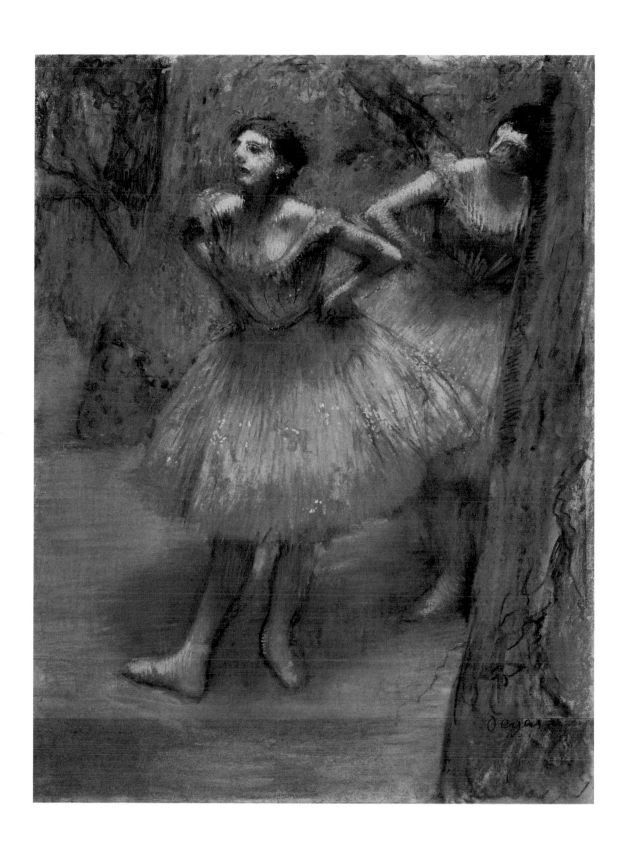

The latest pastel of a ballet subject in the Art Institute, *Two Dancers* played a seminal role in another series in which Degas obsessively explored certain figural motifs. In this group of works, the artist was fascinated by the relationship between dancers waiting offstage and the space and light in which they stand. Lemoisne dated the series to three periods—1890, around 1896, and 1904/06—while Browse placed it around 1900/05. Earlier examples of the subject are discussed in *Dancers Preparing for the Ballet* (cat. no. 22). In *Two Dancers,* the artist was less interested in the last-minute grooming of the dancers than he was in the bored restlessness of two performers waiting in the wings to go on stage. The composition offered the artist many interesting angles and juxtapositions—the dancers' bent elbows and torsos, their voluminous tutus, and the shifting patterns of the stage flats depicting a woodland setting.

The essence of the composition and the mood it communicates are embodied in the dancer in the foreground. As Janet Anderson has pointed out (written communication), she stands in a relaxed fourth position, her hands on her hips and her torso bent forward at the waist as though she is straining to see something on the stage or beyond; yet, the tilt of her head and forward thrust of her jaw suggest an air of confidence and even of indifference. Two charcoal nude studies of the figure (Vente III, 255, 256) reveal the care with which Degas studied that pose, undoubtedly tracing one drawing from the other but slightly altering elements of the torso to capture more effectively the figure's movement. About this time, Degas also made a charcoal study of the two figures clothed (fig. 83-1), establishing their positions. The second dancer is depicted with a haunting, masklike face; although fully described from the waist up, she is shown with only one leg and half a skirt—allowing for the intrusion of a stage flat at the right.

As in the case of *Preparation for the Class* (cat. no. 71), a wax statuette may well have served Degas as a model for the foreground figure. Of the three or four sculptures that come closest in stance to this figure (Rewald 1944, pls. 52-6; foundry nos. 8, 41, 51, 63), the latest one, of the dancer clothed, resembles the Art Institute pastel most closely; not

Fig. 83-1. Degas. *Two Dancers,* charcoal heightened with pastel (L.453).
Photo: Vente III, 316.

only do they both feature a figure with a low waist, but the rough handling of the dancer and her skirt approximates the pastel's dappled effects.

A pastel sketch (L. 1016) probably constituted the final preparation for the Art Institute pastel, which is the first coherent, finished statement of the theme; one can tell that it is an early presentation not only because of its relatively firm and clear handling of forms, but because of the convincing substantiality of the figures and the dappled light which helps throw the figures into relief. The Art Institute sheet has been extended by a strip at the bottom. Judging from its different tonality, it would seem that at some point—possibly after Degas had completed the main portion of the pastel—he decided to lengthen the composition. Indeed, examination with an infrared vidicon light revealed a second signature at the lower right of the principal sheet (not visible to the naked eye), indicating that it was signed before it was lengthened; other slight alterations in the arms, feet, and profiles of the figures were also discovered. In any case, this is the only instance in the series in which so much empty foreground space occurs. Other drawings and pastels (Vente II, 275; L. 1018) attest to Degas's further investigation of these two figures, exhibiting different spacing between the elbows and broader handling of the pastel medium. These studies resulted in *Dancers in the Wings* (L. 1015), a scene suffused with light that disintegrates and blends the figures and scenery into extraordinary chromatic passages.

Having exhausted the two-figure motif, Degas introduced a third figure. In charcoal drawings of the dancers, both nude and clothed (Vente II, 284; III, 222, 240, 261, 284; L. 1250 bis), the artist revealed some indecision regarding the new figure's stance. The unusually broad and bold draftsmanship of a related pastel study (L. 1019) indicates its relatively late date. After he had resolved the placement of the three figures, Degas executed more drawings in which he situated the dancers in relation to the flat in the foreground

(Vente III, 219, 325), gradually edging the dancer forward to the right so that her elbow overlaps the previously dominant figure. Ultimately, Degas abstracted the subject in a very painterly, thickly encrusted pastel (L. 1448); its narrower, more vertical resolution was aided by the addition of a small strip at the bottom like that of the Art Institute's pastel.

Degas did not leave the composition at this point. He went on to explore the motif of the dancer on the right by moving her even further forward (Vente III, 204) and added a fourth dancer to her right in *Pink Dancers* (L. 1449). Degas aligned the three dancers and depicted them in three-quarter length, in a charcoal nude study (Vente III, 381) and in a pastel (L. 1253). He placed the stage flat in various configurations in a major pastel (L. 1250), which Pickvance dated to 1905 (Edinburgh 1979, no. 121). In several charcoal and pastel compositions (Vente III, 257, 258; L. 1251, 1252), he worked with a lower, more curvaceous flat. These, too, display the extremely broad handling, luminous color, and disintegration of form that are characteristic of Degas's last works.

As we have seen, the evolution of this theme involved a progression from two to three dancers, the addition of a fourth dancer, and various shiftings of both the dancers and stage flats. More significant is the chromatic development seen in these works: the colors become increasingly bolder, eventually dominating the forms. While the Chicago pastel dates from the beginning of this exploration, the complex mixing and layering of lustrous, multicolored pastels clearly indicate what was to come in the later works of the series. (SFM)

COLLECTIONS: Estate of the artist, Vente I, 129, repr.; Trotti Collection, Paris; Durand-Ruel, New York; Robert R. McCormick, Chicago.

EXHIBITIONS: Paris 1937, no. 165, pl. 27.

LITERATURE: Lemoisne 1946, no. 1017, repr.; Browse 1949, no. 211, repr.; Chicago 1961: 121; Chicago 1979, 2G5.

84. Dancer Resting with a Fan, 1890/95

Charcoal on tan wove tracing paper, laid down
Max. 505 x 448 mm
Gift of Robert Allerton, 1922.5517

The large charcoal study *Dancer Resting with a Fan* depicts a pose highly favored by Degas throughout his career. Freely drawn on tracing paper, it also offers insight into Degas's working methods in his later years.

A weary dancer has collapsed on a bench; she rests her head on her hand, which is propped up on her knee. The fan in her right hand creates a compositional counterpoint to the angle created by her bent torso and arm and the sweeping curve of her tutu. Reminding us of the fluttering lightness of a dancer in performance (as Lisa Passaglia has noted [written communication]), the fan also serves to suggest the profound exhaustion of the performer.

Thirty years earlier, Degas had used the device of a raised leg to enliven the seated form of Giulia Bellelli in the *Bellelli Family* (fig. 3-1). But it was to recur primarily as a pose for tired or languishing ballerinas in such compositions as *Dancer Resting* (L. 659) and *The Dance Class* (L. 820), which date to the mid-1870s. Brothel and bathing scenes of the 1880s, such as *Retiring* (cat. no. 66), show further modifications on the posture, but Degas's most extensive exploration of the motif is to be found in his dance images of the 1890s. In a number of works, variations on *The Dance Class*, Degas introduced new figures (such as one holding a fan or tying a shoe) or elements (such as a post in the middle of the room). In other, perhaps

later works, like the famous pastel in the St. Louis Museum (fig. 84-1), he juxtaposed a sequence of dancers of descending heights—some standing, some seated.

The existence of a full-scale charcoal study in reverse (or counterproof) of the St. Louis pastel (Vente II, 386) suggests Degas's working methods in these late series and the role played by drawings on tracing paper, such as cat. no. 84, in his development of a concept. Such tracings enabled Degas to copy a motif without destroying the original form and to experiment with reversals or with variations of the figure. No less than four similar charcoal drawings, probably on tracing paper, of the same figure, both naked and clothed, can be related to the Art Institute sheet (Vente III, 253, 274, 349; IV, 154); in at least four others (Vente III, 62, 241, 264, 297), Degas investigated the relation of that figure to the other dancer who accompanies her on the bench in the St. Louis pastel.

The Art Institute's *Dancer Resting with a Fan* is not only the most advanced of the studies of the lone dancer with a raised leg, but its broad background hatching, which roughly indicates the setting, is also unusual. This establishes the *Dancer Resting with a Fan* as an independent work in its own right, distinguished from the series to which it clearly belongs. It expresses wonderfully the total exhaustion and well-deserved relaxation of a dancer; her summarily described, heavy limbs and decorative pose are fully convincing. (SFM)

COLLECTIONS: Estate of the artist, Vente III, 260, repr., stamp (Lugt 658) recto, lower left, in red; Albert Roullier Gallery, Chicago; Robert Allerton, Chicago, inscribed recto, lower right, in graphite: *152*.

EXHIBITIONS: Chicago 1933, no. 863.

LITERATURE: Manson 1927: 47; Chicago 1979, 2F7.

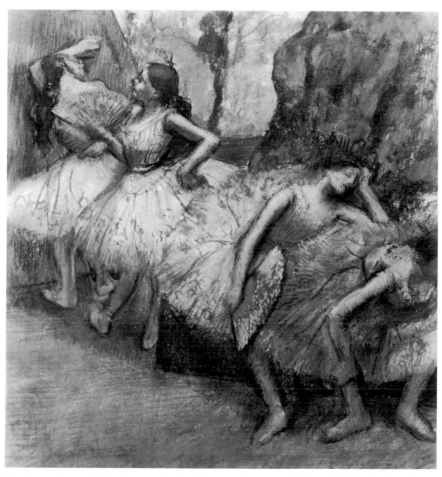

Fig. 84-1. Degas. *Ballet Dancers in the Wings,* c. 1895, pastel (L.1066). The St. Louis Art Museum (24:35).

85. Dancer Putting on Her Shoe,
c. 1892/95

Etching on white wove paper; first state of two
Plate 178 x 117 mm; sheet 249 x 171 mm
Joseph Brooks Fair Collection, 1932.1334

One of the most unusual and troublesome etchings in Degas's oeuvre is the spare, linear *Dancer Putting on Her Shoe*. A very rare print, according to Delteil, who knew of only a half-dozen impressions, it has been difficult for most scholars to relate to the rest of Degas's graphic work. The double, wiry contour line that defines the figure indicates some hesitation on the part of Degas, as if he lacked the assurance of an accomplished etcher, and yet the elongated proportions and abstract description of the figure place the print late in the artist's career. There is little to compare it with and no known motive for its execution.

One curious element of the etching is that, although it clearly centers on the act of a dancer putting on her toe shoe, both the shoe and foot in question are described only by a double line indicating the cocked sole. Marks next to the weight-bearing foot hint at an untied ribbon; possibly, another ribbon lies below the bench.

Unlike the highly worked aquatints of the late 1870s and 1880s, *Dancer Putting on Her Shoe* is a print of understatement. This quality is due in part to the fact that the impression is a hitherto undescribed first state (see Boston 1984). The interplay of the single and double contour lines mitigates the

blunt, even quality of the etching and transforms the generally crisp effect of the lines against the white paper into a shimmering evanescence not unlike that of Degas's late pastels. Despite its initially awkward and unfinished appearance, the print is yet another example of Degas's triumph over a medium: here he has made etching, in its purest and simplest form, describe color, light, and movement as only a master draftsman can do.

In all the examples in Degas's art of dancers lacing shoes, there are surprisingly few figures in this position. One drawing (Vente III, 163) roughly approximates the etching in reverse and may well be a preparatory study for one of the artist's friezelike compositions of dancers resting, at least two of which (fig. 85-1 and L. 1294) contain a figure leaning on a bench to fasten her shoe. These works have been dated to the 1890s and 1900s by Lemoisne and Browse (1949, nos. 198, 199, 246); George Shackelford (oral communication) believes they could date from the 1870s through the 1890s. The painted compositions display the general dissolution of form characteristic of Degas's latest works, a disintegration that is seen as well in this etching.

Moses (Chicago 1964) was the first to recognize the relatively late character of this work, dating it around 1890. Adhémar dated it to around 1894 on the assumption that it was intended as an illustration, like two unusual late etchings Degas made after his own paintings for Georges Lecomte's *Art impressionniste d'après la collection privée de M. Durand-Ruel* (Paris 1892). These two etchings, however, were executed in a soft-ground technique (one with aquatint), which gives them a far different line and a greater descriptive quality befitting their function as both reproductive prints and book illustrations. Thus, their only clear connection with this delicate, light-struck image is their late date and unique position within Degas's oeuvre. It seems likely that the Chicago etching was a one-time exercise by an aging artist whose eyes were failing but who nonetheless sought to achieve the effects of his late pastels in the naked, quivering lines of the etching medium. (SFM)

COLLECTIONS: A. H. Rouart, Paris, stamp (Lugt Suppl. 2187a) recto, lower right, in purple; The Art Institute of Chicago, stamp (Lugt Suppl. 32b) verso, lower right, in brown; acquired by the AIC from Marcel Guiot, Paris.

EXHIBITIONS: Chicago 1964, no. 37, repr.

LITERATURE: Delteil 1919, no. 36, repr. (second state); Adhémar 1974, no. 60, repr. (AIC).

Fig. 85-1. Degas. *Dancers in the Foyer,* c. 1900/05, pastel (L.1394). Photo: Lemoisne 1946.

86. Head of a Woman, 1892

Bronze; foundry no. 42
25.4 x 21.6 cm
Gift of Justin K. Thannhauser, 1959.16

Correspondence dating from the summer of 1892 between Degas and his friend the sculptor Bartholomé allows us to date rather precisely to that year the clay and plaster head from which this cast was made (Millard 1976: 10, Letter LVII, p. 73). *Head of a Woman* was one of only three sculptured portraits left by Degas; its subject is a ballerina known as Mlle. Salle. Degas had known the dancer at least since 1883, when he wrote to their mutual friend Ludovic Halévy that he thought her contract should be renewed. Little else is known of her; Boggs's assertion (1962: 130) that she danced at the Paris Opéra between 1888 and 1919 is difficult to believe if she was indeed the same dancer that Degas had known in 1883: a 36-year career for a dancer seems virtually impossible.

Degas made several pastel portraits of Mlle. Salle (L. 868, 882, 897, 898), all of which date from the second half of the 1880s, indicating that she was unusually important to him. In his most significant pastel of Mlle. Salle (fig. 86-1), signed and dated by the artist in 1886, she is represented three times—frontally, in profile, and in three-quarter views. Degas's simultaneous execution of three conventional views of a head indicates that he conceived and executed the pastel with a sculpture in mind. Thus, the pastel functioned in the same way as *Three Studies of a Dancer* (cat. no. 42). That six years elapsed before Degas continued with the Mlle. Salle project is not surprising, given his erratic working procedures. Degas

may have been prompted to work on his sculpture of Mlle. Salle by the example of Bartholomé's marble portrait of the same subject. Degas's choice of clay and plaster as media suggests that he intended the figure to be cast and used materials for that purpose.

Head of a Woman is enlivened by the rough handling of the mouth, fleshy cheeks, and right eye. After modeling this eye, Degas made a hole in it, imitating in clay the way in which it would have been done in marble as well as echoing the deep holes that Bartholomé drilled to make the eyes in his sculpture. The eyes are the most disturbing aspect of Degas's portrait: one is closed, the other open, and both are rendered violently. During the year in which this head was modeled, Degas's recurring problem with his vision flared up; he had to wear a corrective patch over one eye. *Head of a Woman* may embody the fear Degas was experiencing at his own impending loss of vision. (TP/RB)

FOUNDRY MARK: $\frac{42}{D}$

COLLECTIONS: Acquired by the AIC from Justin K. Thannhauser Gallery, New York.

LITERATURE: Rewald 1957: 147, pl. 30; Russoli 1970, no. 870, repr.; Millard 1976: 10-11, 37 n. 57, 77 n. 29, 108, fig. 117.

Fig. 86-1. Degas. *Mlle. Salle,* 1886, pastel (L.868). Photo: Lemoisne 1946.

87. Dancer Putting on Her Stocking, 1900/12

Bronze; foundry no. 70
34.9 x 27.3 cm
Gift of Robert Edelman, 1960.5

This bronze is an especially important document of Degas's work, as the wax original was destroyed during the casting. It is one of three related sculptures by Degas, all in the same general pose (see also Rewald 1957, pls. 56, 57). Another group in which the model is involved in a similar action, but reversed (Rewald 1957, pls. 45, 49, 60, 61), has been assigned to the period between 1900 and 1912 (Millard 1976: 18). The nature of the movement represented and the handling of the wax place *Dancer Putting on Her Stocking* within the same period as the waxes of *Dancer Looking at the Sole of Her Right Foot* (fig. 76-1).

The dependency of the three versions of *Dancer Putting on Her Stocking* on classical sources—a drawing from Degas's student days and an 18th-century dancing faun—has been noted by Millard. In its depiction of an everyday action, the sculpture represents the blend of realism and classicism that pervades Degas's work. Understood in this way, the sculpture demonstrates how the distinctions between two of the major subjects of Degas's career—dancers and bathers—at some point cease to exist. The figure is neither a dancer nor a bather, she is simply a nude. (TP/RB)

FOUNDRY MARK: $\frac{70}{K}$

COLLECTIONS: Robert Edelman, Chicago.

LITERATURE: Minneapolis 1956: 27, cover repr.; Rewald 1957: 154, pl. 73; Russoli 1970, no. S13, repr.; Millard 1976: 35 n. 49, 69.

88. Woman Seated in an Armchair, c. 1903

Bronze; foundry no. 43
32 x 43 cm
Wirt D. Walker Fund, 1950.113

As we have seen, Degas seems to have used wax models as intercessors between his live models and his pictorial oeuvre. The stylistic and psychological ramifications of this method are significant. Unlike many other artists who dealt with the identities and idiosyncrasies of specific models, Degas, in making his wax figures, generalized his subjects into types without personality or individuality. This abstracting process explains in part the psychological neutrality or objectivity of Degas's late work and suggests the vital role his waxes played in the creation of his art.

Woman Seated in an Armchair can be assigned a date of around 1903, based on contemporary reports (Millard 1976: 18). Degas produced wax figures of seated and standing bathers sometime between 1900 and 1912. As in *The Tub* (cat. no. 77) and many of the bathers that followed, here Degas created a setting for the figure, placing her in an armchair with a towel thrown over the back. There are three additional variations of this seated figure, sponging or drying herself (foundry nos. 44, 54, 46).

Woman Seated in an Armchair is related to more than 40 pastels of bathers, usually seen from behind, in nearly the same pose: the bather leans forward, one hand washing the opposite side of the body, the other hand raised in the air. Some of the bathers stand alone in the middle of a room, others are seated before a mirror, and still others—prostitutes—dry themselves before their client. *Woman Drying Herself* (L. 1342), more than any other pastel, reflects the pose of the sculpture. However, the left arm of the figure in the original wax model was broken, perhaps several times, as can be seen in the repairs to the armature which are evident even in the bronze. Therefore, the wax of *Woman Seated in an Armchair* at different times could have related to other variations in pastel. It is tempting to conclude that *Woman Seated in an Armchair* was one of the waxes which Degas, his eyesight failing, created at the end of his life, when, with a model present, he would alternately touch the body of the model, then work the wax, returning to the pastels only on the days when his vision was improved. (TP/RB)

FOUNDRY MARK: 43

COLLECTIONS: Acquired by the AIC from E. and A. Silberman Galleries, Inc., New York.

EXHIBITIONS: Philadelphia 1952: no. 24.

LITERATURE: Rewald 1944: 28, pl. 52; Russoli 1970, no. S6o, repr.; Millard 1976: 109, pl. 134.

89. Woman at Her Toilette, 1895/1905

Pastel on tissue paper, pieced and mounted on sulphite board
746 x 713 mm (piece at right 746 x 81 mm, at left 746 x 40 mm, at top 48 x 713 mm)
Bequest of Mr. and Mrs. Martin A. Ryerson, 1937.1033

Woman at Her Toilette is the most brilliantly worked late pastel in the collection of the Art Institute. Although neither as large nor as ambitious as *The Bathers* (cat. no. 91), it is much more consistently "finished" and, despite the fact that it was not signed, can be accepted as fully realized. Traditionally dated 1903 or 1905, the pastel and at least ten drawings closely related to it (L. 935 ter, 1422, 1423 bis, 1424, 1425; Vente II, 268; Vente III, 139, 294, 330; Vente IV, 320) could have been made before that date, even as early as 1890. The

image of a bather who fills a large percentage of the picture surface first appears in a signed and dated pastel of 1885 (fig. 89-1) and began to dominate the artist's oeuvre by about 1895. It is likely, however, given the complex technique—with layers of pastel suspended in fixative—that *Woman at Her Toilette* was done between 1895 and 1905.

The group of nine closely related pastels and drawings mentioned above suggests that Degas worked obsessively on a number of versions of the same general composition or

184

figure—very much like Monet at the end of his life. Yet, where Monet seldom altered the scale or medium of a particular painting in a series, Degas changed virtually every variable. For example, the works showing bathers engaged in drying the backs of their necks while holding their wet hair away from their bodies are of different sizes with various props. And they were never created to be exhibited simultaneously. Rather, they demonstrate the fertility of Degas's imagination as he moved restlessly from one variation to another. In Lemoisne's catalogue, the Chicago version of the composition is incorrectly called a "study" or "replica" of the other closely related versions. Yet, it is clear that Degas did not conceive of certain works as "studies" or "replicas" at this point in his career. Rather, in each he addressed a slightly different problem, and in each he ceased work at a different stage of completion. Hence, the one or two objects in a series that are more highly finished than the others are not necessarily better or "final"—they are simply more fully worked. This is apparent when one compares *Woman at Her Toilette* (L. 1423 bis) at The Museum of Fine Arts, Houston, with the Chicago composition. Each is of a slightly different size and, in each, the figure is differently treated and placed on the paper. In fact, the Chicago version is the only one of the group in which the figure's buttocks are covered. Degas stopped working on the Houston version at an earlier stage, perhaps because it failed to sustain the artist's interest or because he considered it successful without having to do extensive additional work.

The Chicago pastel was executed on four separate sheets of tracing paper carefully glued to a board. The figure exists completely on the largest sheet of paper; it may have been traced from another version of the composition. To this sheet, Degas added three variously sized strips of paper—at the left, the right, and the top—to create a new "whole" of a size different from any other composition in the series. These sheets were mounted early in the development of the work, because, unlike *The Bathers* (cat. no. 91), the quality of the pastel is completely consistent on the four separate sheets. Thus, Degas first seems to have conceived or traced the figure and then to have decided on an appropriate format before laboriously working the surface.

Woman at Her Toilette is alive with color. The hues range from red-oranges and salmon-pinks to pale greens and lilacs, a palette so wonderfully varied and masterfully balanced that even Matisse could hardly compete. Indeed—and despite his repeated insistence to the contrary—the colorist in Degas triumphed more often than not in his late work. Here, he applied the colors in layers, fixed them at different times, sponged them with solvents and fixatives, and manipulated them almost alchemically. The resulting intermingled hues produce effects that vary greatly when the pastel is viewed from different distances. From fifteen feet or less, the salmon

curtain to the right of the figure is shot through with mustard-yellow and a deep blood-red, and the wall covering in the upper left corner, almost a monochrome rose from a distance, when viewed from under ten feet, is perceived as lilac, yellow, dark gray, and magenta. The woman's body appears to be the vortex of a whirling rainbow, encircled by juxtapositions of orange-blue and yellow-green so powerful that they are apparent from afar. By covering the woman's buttocks with drapery, Degas effectively suspended her in color, denying the wholeness of her form. Indeed, the figure barely survives the riot of pastel in which she exists. (RB)

COLLECTIONS: Estate of the artist, Vente I, 127, repr., stamp (Lugt 658) recto, lower left, in red; G. Bernheim, Paris, 1920; Paul Rosenberg, Paris; Mr. and Mrs. Martin A. Ryerson, Chicago.

EXHIBITIONS: Paris 1937, no. 165.

LITERATURE: Manson 1927: 47; Slocombe 1938: 21, repr.; Lemoisne 1946, no. 1426, repr.; Rich 1951: 124-5, repr.; Werner 1968, no. 32, repr.; Chicago 1971: 28; Chicago 1979, 2G10; Shapiro 1982: 12-16, repr.

Fig. 89-1. Degas. *Woman Drying Herself,* 1885, pastel (L.815). Photo: Lemoisne 1946.

90. After the Bath (Woman Drying Her Feet), c. 1900

Pastel, charcoal with estompe, black wash, and touches of red and blue chalk on buff wove tracing paper, pieced and laid down on sulphite board
Max. 567 x 408 mm (piece at right max. 44 x 408 mm)
Gift of Mrs. Potter Palmer II, 1945.34

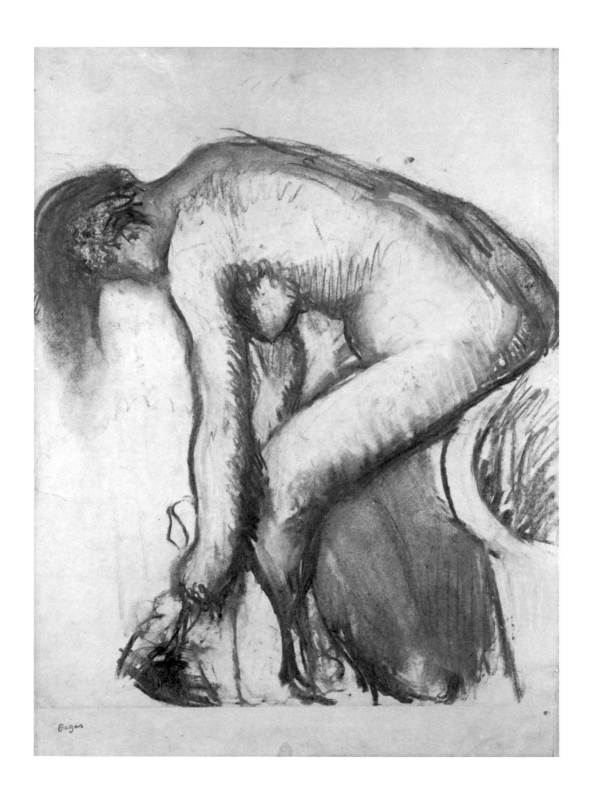

This generously proportioned female nude bends down to dry her feet from a risky perch on the edge of her tub. Degas defined her with thick, confident charcoal lines that seem almost as weighty as the figure they describe, and added touches of pastel to the edges of the composition. The whole evidently was traced from another image (now lost) or was drawn rapidly on a sheet of tracing paper which was then laid down on a slightly longer board. After this step, the drawing was evidently abandoned, for there are no marks on the strip of board except the studio stamp in red.

The sheet is related to a very large group of late drawings in charcoal and pastel, of which nine, showing a figure in a virtually identical pose, also seated on a bathtub, are closely connected (L. 917, 918, 1381, 1383, 1383 bis; Vente I, 333; Vente II, 315; Vente III, 271; Vente IV, 186). Of these, two are reversed from the direction of the Art Institute pastel; several others, probably drawn on tracing paper, could have been conceived in either direction. There are, however, two basic differences between the Chicago sheet and the other nine—the figure is not nearly so bent in her posture and her arm is straight rather than crooked at the elbow. This, together with the fact that there exist at least eleven additional sheets drawn from a similarly posed model, indicates that Degas did not trace them all from one prototype but rather drew them one at a time from a similarly posed model viewed from slightly different vantage points (L. 1074, 1380, 1382, 1384; Vente I, 248, 336; Vente II, 290, 291; Vente III, 250, 270, 338). He undoubtedly used tracing paper not only because of its reversibility, but also because it is lightweight, relatively cheap, and easily mounted.

There is a certain cruelty in *After the Bath*. The figure is almost a caricature of an overweight nude, modeled in great soft spheres and cylinders of flesh. The precarious balancing of this great weight on the edge of the tub certainly was intended to amuse the viewer. Degas made two major changes on the sheet to strengthen this aspect of the drawing. First, he reduced the size and, hence, the "supportability" of the tub, moving it to the extreme right of the composition and throwing the bulk of the figure's weight to the left and center. Second, he enlarged the nude considerably along her back and buttocks. In fact, Degas may have been forced to abandon the sheet because of problems that resulted from the shift of the tub. When the original tub was rubbed out, the area became so dark that he was unable to maintain the figure's right leg within the same value-structure as that of the rest of her body. Hence, only a hint of that leg remains.

In spite of all these shifts and areas of indecision, the drawing has an undeniable power. The bold handling of the charcoal, both directly and with the stump, unifies the sheet, and the sudden bursts of hatching give it a remarkable and intense vibrancy. In Degas's hands, the body of the bather becomes potent and expressive. In fact, her volume threatens to overpower the space in which she moves. This figure would find few rivals by other artists until the weighty nudes created by Georges Rouault, Marcel Duchamp, and Fernand Léger within the next decade. (RB).

COLLECTIONS: Estate of the artist, Vente II, 307, repr., stamp (Lugt 658) recto, lower left, in red; acquired by the AIC from Jacques Seligmann and Co., New York.

EXHIBITIONS: Chicago 1946, no. 11, repr.; Washington, DC. 1947, no. 1; New York 1963, no. 105; Paris 1976-77, no. 59, repr.; Frankfurt 1977, no. 60, repr.

LITERATURE: Mongan 1962, no. 791; Chicago 1979, 2G9.

91. The Bathers, 1895/1905

Pastel and charcoal on tracing paper, pieced and mounted on board
Max. 104.6 x 108.3 cm (middle sheet max. 65.8 x 108.3 cm; top sheet max. 19.3 x 108.3 cm; bottom sheet max. 19.5 x 108.3 cm)
Gift of Nathan Cummings, 1955.495

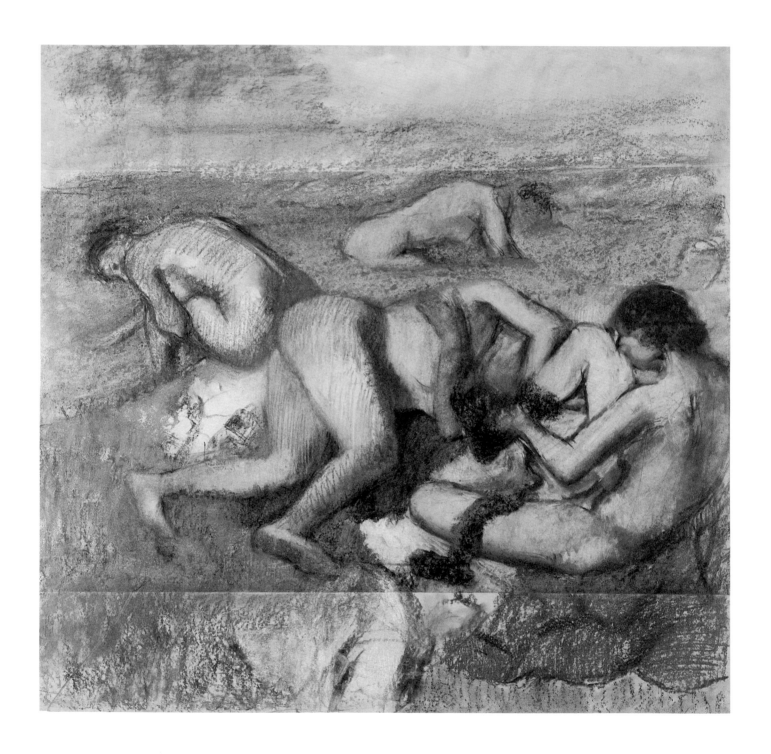

Sometime within the last decade of his active life—that is, between 1895 and 1905—Degas worked on *The Bathers*. Like *Young Spartans* (cat. no. 9), the first major work in this book, *The Bathers* was left unfinished and bears the artist's estate stamp in the lower left corner. Also, like *Young Spartans,* it is both large in scale and ambitious. In each work, Degas placed several nude figures in an ideal landscape setting, activating their bodies and freeing them from the constraints—both social and physical—of clothing. Yet, whereas *Young Spartans* is painted in the traditional medium for ambitious works of art, oil on canvas, *The Bathers* is composed of the most ephemeral of materials—charcoal, pastels, and various fixatives on tracing paper mounted on board. Whereas the earlier work has clear historical referents, the later one seems to exist almost outside of time. Whereas *Young Spartans* signals Degas's initial exploration of the subject of exercise, *The Bathers* represents the culmination of his subsequent fascination with the practices of bathing and ablution.

While Degas executed virtually hundreds of works representing horses, ballerinas, performers, and prostitutes, he did only sixteen clearly identifiable representations of bathers out-of-doors. The earliest (L. 375, 376, 406) were made between 1875 and 1877 when Degas, like Monet and Manet, frequented the beach resorts of the Channel coast. In Degas's early bathers, the figures are most often dressed in walking or bathing costumes and are therefore contemporary Frenchmen with clear parallels in tourist literature, Realist fiction, and popular illustration. The thirteen later bathers date from the end of Degas's career and fall into two loosely identifiable groups. The most consistent of these, representing nude women combing their hair (L. 1070-72; Vente IV, 254), derive quite clearly from the earlier bathers, who perform the same action. The later group of bathers combing their hair culminates in two very large pastel drawings (L. 1070, 1071), one of which (L. 1071) is virtually identical in size (108 x 109 cm) to *The Bathers* and may have been conceived in relation to it.

The Bathers is the most fully developed of the second group of nine compositions, three of which (L. 1075-77) represent bathers frolicking in the water and the remaining six of which (L. 1078-83) concentrate on figures stretching and relaxing on the banks of the water. In *The Bathers,* four nude women perform separate actions: one, the furthest from the viewer, is immersed in water; a second sits on the bank and washes her feet; another stretches and rolls about on her rug or towel; and a fourth is engaged in putting on her stockings. Thus, a sequence is established in space and time—background-to-foreground becomes past-to-present or early-to-late steps in the process of bathing. This can be read in reverse if the foreground figure is taking off her stockings. Although the other pastels in the late group relating to *The Bathers* explore general situations of immersion in water and drying, only one, *Two Women Bathing* (L. 1080), has precisely analogous figures.

Why did Degas make these bathers so late in life? While it has long been recognized that his bathers of the 1870s stem directly from the bather compositions by his friend Manet, Degas's late treatments of the subject rarely have been connected to what might be called the Post-Impressionist bather tradition. It is likely that *The Bathers* resulted from Degas's study of the paintings of out-of-door bathers by Cézanne, Renoir, and Gauguin. It is surely no accident that Degas's own collection included Cézanne's *Bather Beside the River* (Paris 1918, no. 9), from which he derived the pose of the central figure of *The Bathers;* and Gauguin's *Day of the Gods* (Paris 1918, no. 43), in which female nudes are posed in contorted, symbolic positions at the edge of the sea. Both paintings were purchased by Degas in 1895.

That there was an intense fascination with the subject of bathers in French painting of the last quarter of the 19th century goes without saying. *L'Oeuvre,* published by Zola in 1886, is a cynical portrait of the modern artist as a pathological failure; Zola's failed artist, Claude Lantier, worked throughout the novel on a painting of monumental bathers along the Seine, a painting destined never to be finished because of the enormity of Lantier's ambitions and the poverty of his talent and self-esteem. The novel served almost as a challenge for real artists to "complete" Lantier's masterpiece; there is scarcely an important French painter who, in the years between 1886 and 1910, did not do a monumental bather composition. The most dedicated to the subject were Cézanne and Renoir, whose efforts certainly inspired the great series of bathers by Matisse, Picasso, and Léger. Yet, Degas, too, made his contributions to that genre, and, when *The Bathers* came to The Art Institute of Chicago in 1955, Daniel Catton Rich was the first to recognize its place in the modern tradition (Rich 1955: 70).

Although Degas's bathers are clearly meant to be out-of-doors, he never actually witnessed such a scene and, in fact, constructed it in his studio. Like certain of the last pastels and oils of ballet dancers—particularly those depicting Russian performers (L. 1181-93), *The Bathers* situates carefully posed and interrelated figures in a setting that seems to derive less from life than from the stage sets observed so often by Degas. Yet, while Degas was assiduous in his earlier ballet scenes in representing the painted flats from the side so as to emphasize their artifice and thereby to render them "real," in the late pastels of both dancers and bathers he allowed the illusion to be complete, creating settings that are totally theatrical. One does not see behind these landscapes to the darkened wings of a stage. Rather, the bathers are powerful and actual as they move in Degas's imaginary landscape setting.

Technically, *The Bathers* is both fascinating and elusive. Degas seems to have begun the composition by working on the central sheet of tracing paper, and there is at least one indication that he took full advantage of its translucency to trace two figures, that in the center and that at the left, from

another pastel, *Two Women at the Bath* (L. 1080). The ultimate source for the central bather may be one of two closely related pastels of the mid-1880s (L. 854, 855). While she is reversed in these earlier pastels, she is otherwise identical in size and holds virtually the same pose. Indeed, Degas's repeated use of tracing paper in his later years indicates that, although he continued to work directly from hired models posed in his studio, he also made direct use of other works of art in the creation of his complex, multifigural compositions.

The most active and fascinating figure is the bather putting on her stockings. She has no precise analogue in other bather compositions, but originated deep in Degas's past. In his student years, Degas made a tentative graphite drawing of a male figure from Michelangelo's *Battle of Cascina* (Vente IV, 101a) that is startlingly similar in pose to this bather. This action was depicted frequently by Degas in the 1890s, particularly among his figures of dancers preparing for the ballet. There is no direct source for a tracing of the figure, however; thus, Degas seems to have traced the two figures at the center and left and then to have improvised the remaining two figures from various sources.

Unfortunately, we do not know enough about how Degas mounted his tracing paper drawings onto board. A label on the back of the mount reads: *"encadrements/19 rue Fontaine/ Adam Dupré,"* which suggests that he sent the partially traced sheet of paper to these framers with instructions that it be mounted as he specified. One thing is clear: The three separate sheets of tracing paper were mounted at the same time, indicating that Degas therefore had already decided that the central composition was too crowded, too bulging with bodies to be contained on its single sheet. The two sheets of approximately the same size that were added to the top and the bottom together balance the frieze of the central portion.

Even after he had settled upon this enlarged format, Degas remained ambivalent about its implications, refusing to unite the three sheets to form a seamless whole. He did add pastel after the mounting, particularly on the upper portions where several areas of pastel definitely overlap the boundary between the abutted sheets of paper. Yet, the whole cannot be read without effort, and the viewer is left with the impression that *The Bathers* either is unfinished or that it is a large-scale drawing made in preparation for another work of art.

This latter reading of *The Bathers* was advanced by Rich (1955:68), who considered most of Degas's late works as steps "towards a great composition in which all his researches would some day culminate." For Rich, "Degas was dreaming of a major painting which would sum up all he had discovered in more than four decades of creation." No matter how eloquent and compelling this explanation might appear, it is surely unlikely. By this time, Degas seems not to have considered oil painting the highest medium in a hierarchy familiar to students of 19th-century Western painting. Rather, he had begun to glorify the graphic arts, which became the

containers—or, literally, mediums—for his boldest aesthetic ambitions. With *The Bathers,* Degas stretched the art of drawing in pastel to limits it had attained only rarely before. In this, he was not completely alone. One need only look superficially through the history of the pastelist in France to find the truly monumental pastel portraits by Quentin de la Tour, works praised in Degas's lifetime in the brilliant prose of the Goncourt brothers (1948: 174-8). Yet, there is a great gap between such a work as de la Tour's life-sized portrait of Mme. de Pompadour exhibited at the Salon of 1755, with its utterly refined and finished surface, and Degas's boldly drawn nudes, who seem almost to burst out of the thin sheet of tracing paper on which they were drawn. In the hands of Degas, pastel, that most decorous and polite of media, associated as it has been with portraiture and, most often, with women, is given a power that makes one think of Matisse's *Blue Nude* of 1907.

The only analogies in the history of drawing that seem appropriate to make with *The Bathers* are the great series of cartoons for tapestries and frescoes by such artists as Raphael, Rubens, le Brun, and others. Many of Raphael's great tapestry cartoons were executed on paper so that they could be easily transported to a distant workshop or even cut up into separate sheets for transfer to a huge surface. Because the paper support strains under the apparent weight of the monumental figures and their setting, the viewer is confronted with an image of immense grandeur and power that seems scarcely to exist, or, at the very least, to be precariously fragile. This same impression is made by many of Degas's largest and most important pastels, and *The Bathers* is among the very greatest of these, not only for its ambition, but for the brilliance with which it was executed.

Degas, the pastelist, was a master without peer when he made *The Bathers*. He constructed his image with an incredible assurance and with techniques that even today elude us. He applied the pastel in various ways—drawing with it; blowing it on; dissolving it into liquids and painting with it; and rubbing it with his hands, with rags, and with unidentifiable sharp tools. As he worked, he fixed the pastel to create skeins of color embedded in layers of translucent fixative. Certain of the hues—the bright blue and the gold in the landscape—sparkle with metallic energy, much of which must derive from the fixatives rather than the pastels themselves. Others, like the earthy red-brown of the rug on which the women sit, are dry and nonreflective. In the central figure, Degas seems to have dissolved much of the charcoal underdrawing and rubbed the surface of the tracing paper as if it were the very flesh he chose to represent. Late in his process of creation, he redrew the figure on the right with a large piece of charcoal and defined her contours so that she seems to throb with life and energy.

As is always the case with the late works by Degas, this pastel exhibits remarkable vitality. Gone are the contrivances

Family and Friends in New Orleans . . . On the Occasion of an Exhibition of Degas' New Orleans Work. Essays by John Rewald, James B. Byrnes, Jean Sutherland Boggs. 1965.

New York 1886
New York, National Academy of Design. *Works in Oil and Pastel by the Impressionists of Paris.* Exh. cat. Essay by Théodore Duret. 1886.

New York 1934
New York, Marie Harriman Gallery. *Degas.* Exh. cat. 1934.

New York 1938
New York, Carroll Carstairs. *The 1870s in France.* Exh. cat. 1938.

New York 1939
New York, J. Seligmann Galleries. *The Stage. A Loan Exhibition for the Benefit of The Public Education Association.* 1939.

New York 1941
New York, The Metropolitan Museum of Art. *French Painting from David to Toulouse-Lautrec.* Exh. cat. 1941.

New York 1949
New York, Wildenstein Gallery. *A Loan Exhibition of Degas for the Benefit of the New York Infirmary.* 1949.

New York 1955
New York, M. Knoedler. *Edgar Degas: Original Wax Sculptures.* Exh. cat. 1955.

New York 1958
New York, Charles E. Slatkin. *Renoir, Degas: a Loan Exhibition of Drawings, Pastels, Sculptures.* 1958.

New York 1960
New York, Wildenstein Gallery. *Loan Exhibition [of] Degas for the Benefit of The Citizens' Committee for Children of New York, Inc.* 1960.

New York 1961
New York, The Museum of Modern Art. *The Mrs. Adele R. Levy Collection. A Memorial Exhibition.* Preface by H. Rockefeller, Alfred M. Frankfurter, Alfred H. Barr, Jr. 1961.

New York 1963
New York, Wildenstein Gallery. *Master Drawings from The Art Institute of Chicago.* Exh. cat. by Harold Joachim and John Maxon. 1963.

New York 1977
New York, The Metropolitan Museum of Art. *Degas in the Metropolitan.* Checklist comp. by Charles S. Moffett. 1977.

New York 1980
New York, The Metropolitan Museum of Art. *The Painterly Print: Monotypes from the Seventeenth to the Twentieth Century.* Exh. cat. 1980.

Nicolson 1960
Nicolson, Benedict. "The Recovery of the Degas Race Course Scene." *Burlington Magazine* 102 (Mar. 1960): 526-37.

Nochlin 1966
Nochlin, Linda. *Impressionism and Post-Impressionism, 1874-1904: Sources and Documents.* Englewood Cliffs, NJ: Prentice Hall, 1966.

Northampton 1933
Northampton, MA, Smith College Museum of Art. *Edgar Degas.* Exh. cat. 1933.

Northampton 1934
Northampton, MA, Smith College Museum of Art. [Loan Exhibition of Degas.] *Bulletin of the Smith College Museum of Art* 15 (Jun. 1934): 20.

Northampton 1979
Northampton, MA, Smith College Museum of Art. *Degas and the Dance.* Exh. cat. by Linda Muehlig. 1979.

Palm Beach 1974
Palm Beach, Society of the Four Seasons. *Drawings from The Art Institute of Chicago.* Exh. cat. 1974.

Paris 1879
Paris. *Catalogue de la 4me exposition de peinture.* 1879.

Paris 1898
Paris, Goupil. *Degas: vingt dessins, 1861-1896.* Exh. cat. [1898].

Paris 1918
Paris, Galerie Georges Petit. *Catalogue des tableaux modernes et anciens . . . composant la collection Edgar Degas.* Sales cat. Mar. 24-25, 1918.

Paris 1924
Paris, Galerie Georges Petit. *Exposition Degas.* 1924.

Paris 1931
Paris, Musée de l'Orangerie. *Degas, portraitiste, sculpteur.* Exh. cat. Preface by Paul Jamot, essay by Paul Vitry. 1931.

Paris 1936a
Paris, Galerie Bernheim-jeune. *Cent Ans de théâtre.* Exh. cat. 1936.

Paris 1936b
Paris, Galerie Vollard. *Degas.* 1936.

Paris 1937
Paris, Musée de l'Orangerie. *Degas.* Exh. cat. by Jacqueline Bouchot-Saupique and Marie Delaroche-Vernet, preface by Paul Jamot. 1937.

Paris 1955a
Paris, Galerie des Beaux-Arts. *Degas dans les collections françaises.* Cat. by Daniel Wildenstein. 1955.

Paris 1955b
Paris, Musée de l'Orangerie. *De David à Toulouse-Lautrec: chefs d'oeuvres des collections americains.* Exh. cat. 1955.

Paris 1960
Paris, Galerie Durand-Ruel. *Edgar Degas.* Exh. cat. 1960.

Paris 1969
Paris, Musée de l'Orangérie. *Degas, oeuvres du Musée du Louvre, peintures, pastels, dessins, sculptures.* Exh. cat. Pref. by Hélène Adhémar. 1969.

Paris 1976-77
Paris, Musée du Louvre. *Dessins français de l'Art Institute de Chicago de Watteau à Picasso.* Exh. cat. 1976-77.

Pasadena 1979
Pasadena, The Baxter Art Gallery, California Institute of Technology. *Nathan Oliveira, A Survey of the Monotypes, 1973-78.* Exh. cat. Essay by Lorenz Eitner. 1979.

Passeron 1974
Passeron, Robert. *Impressionist Prints.* New York: Dutton, 1974.

Joly 1967
Joly, Anne. "Sur Deux Modèles de Degas: Mlles Bécat et Ellen André [sic]." *Gazette des Beaux-Arts* 69 (May-Jun. 1967): 373-4.

Kelley 1952
Kelley, Charles Fabens. "Chicago: Record Years." *Art News* 51, 4 (Jun.-Aug. 1952): 52-65.

Kornfeld 1965
Kornfeld, Eberhard. *Edgar Degas: Beilage zum Verzeichnis des graphischen Werkes von Loys Delteil.* Bern: Kornfeld and Klipstein, 1965.

Kramer 1974
Kramer, Hilton. "Edgar Degas, the Reluctant Modernist, at a New Exhibition in Boston." *The New York Times,* Jul. 7, 1974: 19.

Kunst und Künstler 1927
Kunst und Künstler 25, 7 (Oct. 1926-Sept. 1927): 40.

Lafond 1918-19
Lafond, Paul. *Degas.* 2 vols. Paris: Floury, 1918-19.

Lemoisne 1919
Lemoisne, Paul André. "Les Statuettes de Degas." *Art et Decoration* 214 (Sept.-Oct. 1919), pp. 109-17.

Lemoisne 1921
Lemoisne, Paul André. "Les Carnets de Degas au Cabinet des Estampes." *Gazette des Beaux-Arts* 111 (Apr. 1921): 219-31.

Lemoisne 1946
Lemoisne, Paul André. *Degas et son oeuvre.* 4 vols. Paris: Paul Brame and César de Hauke, 1946-49.

Levin 1982
Levin, Gail. "Symbol and Reality in Edward Hopper's 'Room in New York.'" *Arts Magazine* 56 (Jan. 1982): 148-60.

Life 1941
"Articles on Art." *Life* 11 (1941): 213.

London 1905
London, Grafton Galleries. *A Selection from the Pictures.* New York and Paris: Durand-Ruel and Sons, 1905.

London 1983
London, Artemis Group. *Edgar Degas.* Exh. cat. by Ronald Pickvance. London: David Cawitt, 1983.

Los Angeles 1958
Los Angeles County Museum of Art. *Exhibition of Works by Edgar Hilaire Germain Degas.* Cat. by Jean Sutherland Boggs. 1958.

Los Angeles 1980
Los Angeles County Museum of Art. *The Romantics to Rodin: French Nineteenth-Century Sculpture from North American Collections.* Exh. cat. by Peter Fusco and Horst W. Janson. 1980.

Lugt
Lugt, Fritz. *Les Marques de Collections de dessins et d'estampes.* Amsterdam: Vereenigde Drukkenjen, 1921.

Lugt Suppl.
Lugt, Fritz. *Les Marques de Collections de dessins et d'estampes.* Supplement. The Hague: Martinus Nighoff, 1936.

Manson 1927
Manson, J. B. *The Life and Works of Edgar Degas.* Ed. by Geoffrey Holme. London: The Studio, 1927.

Marandel 1979
Marandel, J. Patrice. *The Art Institute of Chicago Favorite Impressionist Paintings.* New York: Crown Publishers, 1979.

Mauclair 1903
Mauclair, Camille. "Edgar Degas." *La Revue de l'Art Ancien et Moderne* (Nov. 1903): 381-98.

Mauclair 1937
Mauclair, Camille. *Degas.* Ed. by André Gloeckner. Paris: Hyperion Press, 1937.

Mauclair 1945
Mauclair, Camille, *Degas.* Paris: Editions Hyperion, 1945.

Maxon 1966
Maxon, John. "Some Recent Acquisitions." *Apollo* 84, 8 (Sept. 1966): 216-25.

Maxon 1970
Maxon, John. *The Art Institute of Chicago.* New York: Harry N. Abrams, 1970.

Meier-Graefe 1923
Meier-Graefe, Julius. *Degas.* Trans. by J. Holroyd-Reece. London: Ernst Benn, 1923.

Millard 1976
Millard, Charles. *The Sculpture of Edgar Degas.* Princeton, NJ: Princeton University Press, 1976.

Minervino 1970
Minervino, Fiorella. *L'opera completa di Degas.* Presented by Franco Russoli. Milan: Rizzoli, 1970; French ed., Paris: Flammarion, 1974.

Minneapolis 1956
The Minneapolis Institute of Arts. "Sculpture by Painters." *The Minneapolis Institute of Arts Bulletin* 45, 3 (May-Jun. 1956): 27-35.

Mongan 1938
Mongan, Agnes. "Degas as Seen in American Collections." *Burlington Magazine* 127 (Jun. 1938): 290-302.

Mongan 1962
Mongan, Agnes. *French Drawings.* Vol. 3 of Ira Moskowitz, *Great Drawings of All Time.* New York: Shorewood Publishers, 1962.

Moore 1890
Moore, George. "Degas, the Painter of Modern Life." *Magazine of Art* 13 (1890): 416-25.

Moreau-Nélaton 1931
Moreau-Nélaton, Etienne. "Deux Heures avec Degas." *L'Amour de l'Art* 12, 7 (Jul. 1931): 265-70.

Morisot 1950
Morisot, Berthe. *Correspondance de Berthe Morisot.* Documents réunis et presentés par Denis Rouart. Paris: Aux Quatre Chemins, 1950.

New Orleans 1965
New Orleans, Isaac Delgado Museum of Art. *Edgar Degas: His*

Dunlop 1979
Dunlop, Ian. *Degas*. New York: Harper and Row, 1979.

Edinburgh 1979
Edinburgh, National Gallery of Scotland. *Degas 1879: Paintings, Pastels, Prints and Sculpture from Around 100 Years ago in the Context of His Earlier and Later Works*. Exh. cat. by Ronald Pickvance. 1979.

Failing 1979
Failing, Patricia. "The Degas Bronzes Degas Never Knew." *Art News* 78, 4 (Apr. 1979): 38-41.

Fels 1950
Fels, Florent. *L'Art vivant de 1900 à nos jours* 1. Geneva: Pierre Callier, 1950.

Fèvre 1949
Fèvre, Jeanne. *Mon Oncle Degas*. Geneva: Pierre Callier, 1949.

Fine Arts 1932
Fine Arts 19 (Jun. 1932): 23.

Fort Worth 1954
Fort Worth Art Center. *Inaugural Exhibition*. 1954.

Fossi Todorow 1977
Fossi Todorow, Maria. *I disegni del Pisanello e della sua cerchia*. Florence: Olschki, 1966.

Frankfurt 1977
Frankfurt, Stadtische Galerie. *Franzosische Zeichnungen aus dem Art Institute of Chicago*. Exh. cat. by Margaret Stuffman. 1977.

Frankfurter 1938
Frankfurter, Alfred M. "Panorama of a Great Decade: 'The 1870's.'" *Art News* 37, 10 (Dec. 3, 1938): 9-13.

Gaunt 1970
Gaunt, William. *Impressionism: a Visual History*. New York: Praeger, 1970.

Giese 1978
Giese, Lucretia H. "A Visit to the Museum." *Bulletin of the Museum of Fine Arts, Boston* 76 (1978): 42-53.

Goncourt 1948
Goncourt, Edmond and Jules de. *French XVIII Century Painters: Watteau, Boucher, Chardin, La Tour, Greuze and Fragonard*. London: Phaidon, 1948.

Goncourt 1971
Goncourt, Edmond and Jules de. *Paris and the Arts, 1851-1896: From the Goncourt "Journal."* Ed. and trans. by George H. Becker and Edith Philips. Ithaca and London: Cornell University Press. 1971.

Grabar 1942
Grabar, Hans. *Edgar Degas nach eigenen und fremden Zeugnissen*. 2d rev. ed. Basel: Benno Schwabe, 1942.

Grappe 1908
Grappe, Georges. *Degas*. Paris: Librairie Plon, 1908.

Grappe 1908 [?]
Grappe, Georges. *Edgar Degas*. Moderne französische Maler. Berlin: Verlagsanstalt für Litteratur und Kunst, 1908?.

Grappe 1920
Grappe, Georges. *Degas*. Paris: Librairie Artistique Internationale, 1920.

Grappe 1936
Grappe, Georges. *Degas*. Paris: Editions d'histoire et d'art, Librairie Plon, 1936.

Guérin 1924
Guérin, Marcel. "Notes sur les monotypes de Degas." *L'Amour de l'Art* 5 (Mar. 1924): 77-80.

Guérin 1931-45
Guérin, Marcel. *Lettres de Degas*. Paris: Editions Bernard Grasset, 1931-45.

Guérin 1942
Guérin, Marcel. "Additions et rectifications au catalogue par L. Delteil des gravures de Degas." Unpub. ms. Paris: Bibliothèque Nationale, Cabinet des Estampes. 1942.

Guérin 1947
Guérin, Marcel. *Letters* [of Degas]. Trans. by Marguerite Key. Oxford: B. Cassirer, 1947.

Hausenstein 1931
Hausenstein, W. "Der Geist des Edgar Degas." *Pantheon* (Apr. 1931): 161-6.

Huth 1946
Huth, Hans. "Impressionism Comes to America." *Gazette des Beaux-Arts* 29 (Jan.-Jun. 1946): 225-52.

Huysmans 1883
Huysmans, J. K. *L'Art moderne*. Paris: Librairie Plon, 1883.

Iowa 1951
State University of Iowa. *Six Centuries of Master Drawings*. Exh. cat. 1951.

Jamot 1924
Jamot, Paul. *Degas*. Paris: Editions de la Gazette des Beaux-Arts, 1924.

Janis 1967a
Janis, Eugenia Parry. "The Role of the Monotype in the Working Method of Degas." *Burlington Magazine* 109 (Feb. 1967): 20-7, 71-81.

Janis 1967b
Janis, Eugenia Parry. [Review of *Degas Drawings* by Jean Sutherland Boggs.] *Burlington Magazine* 109 (Jul. 1967): 413-17.

Janis 1972
Janis, Eugenia Parry. "Degas and the 'Master of Chiaroscuro.'" *The Art Institute of Chicago Museum Studies* 7 (1972): 52-71.

Joachim 1968
Joachim, Harold. "The Print Collection of The Art Institute of Chicago." *Artist's Proof* 8 (1968): 8-17.

Johnson 1981
Johnson, Deborah. "The Discovery of a 'Lost' Print by Degas." *Bulletin of the Rhode Island School of Design: Museum Notes* 68 (Oct. 1981): 28-31.

Chicago 1925
The Art Institute of Chicago. *A Guide to the Paintings in the Permanent Collection.* 1925.

Chicago 1932
The Art Institute of Chicago, Antiquarian Society. *Exhibition of the Mrs. L. L. Coburn Collection: Modern Paintings and Water Colors.* 1932.

Chicago 1933
The Art Institute of Chicago. *Catalogue of a Century of Progress: Exhibition of Paintings and Sculpture.* 1933.

Chicago 1933a
The Art Institute of Chicago. *Bulletin of The Art Institute of Chicago* 27, 3 (Mar. 1933): 49-51.

Chicago 1934
The Art Institute of Chicago. *A Century of Progress: Exhibition of Paintings and Sculpture.* 1934.

Chicago 1941
The Art Institute of Chicago. *Masterpiece of the Month* (Jul. 1941).

Chicago 1946
The Art Institute of Chicago. *Drawings Old and New.* Cat. by Carl O. Schniewind. 1946.

Chicago 1955
The Art Institute of Chicago. *Great French Paintings: an Exhibition in Memory of Chauncey McCormick.* 1955.

Chicago 1960-61
The Art Institute of Chicago. *Annual Report 1960-61.*

Chicago 1961
The Art Institute of Chicago. *Paintings in The Art Institute of Chicago: Catalogue of the Picture Collection.* 1961.

Chicago 1964
The University of Chicago, Renaissance Society. *An Exhibition of Etchings by Edgar Degas.* Exh. cat. by Paul Moses. 1964.

Chicago 1969
The Art Institute of Chicago. *Masterpieces from Private Collections in Chicago.* Exh. cat. 1969.

Chicago 1969-70
The Art Institute of Chicago. *Annual Report 1969-70.*

Chicago 1970
The Art Institute of Chicago. *Drawings Given to The Art Institute of Chicago, 1944-1970, by Margaret Day Blake.* Cat. by Harold Joachim. 1970.

Chicago 1970a
The Art Institute of Chicago. "Mrs. Morton's Bequest." *The Art Institute of Chicago Calendar* 64, 3 (Jan. 1970): [2-5].

Chicago 1971
The Art Institute of Chicago. *Supplement to Paintings in The Art Institute of Chicago: A Catalogue of the Picture Collection.* Cat. by Sandra Grung. 1971.

Chicago 1973
The Art Institute of Chicago. *Major Works from the Collection of Nathan Cummings.* Exh. cat. 1973.

Chicago 1974
The Art Institute of Chicago. *The Helen Regenstein Collection of European Drawings.* Cat. by Harold Joachim. 1974.

Chicago 1978
The Art Institute of Chicago. *The Art Institute of Chicago: 100 Masterpieces.* Chicago: Rand McNally, 1978.

Chicago 1979
The Art Institute of Chicago. *French Drawings and Sketchbooks of the Nineteenth Century. The Art Institute of Chicago* 2. Chicago Visual Library. Cat. by Harold Joachim and Sandra Haller Olsen. Chicago and London: The University of Chicago Press, 1979.

Cleveland 1929
Cleveland Museum of Art. *French Art Since 1800.* Exh. cat. 1929.

Cleveland 1947
Cleveland Museum of Art. *Works by Edgar Degas.* Picture book no. 3. Exh. cat. 1947.

Cleveland 1981
Cleveland Museum of Art. *The Realist Tradition: French Painting and Drawing, 1830-1900.* Exh. cat. by Gabriel Weisberg. 1981.

Copenhagen 1948
Copenhagen, Ny Carlsberg Glyptotek. *Edgar Degas, 1834-1917, Skulpturer og monotypier, tegninger og malerier.* Exh. cat. 1948.

Coquiot 1924
Coquiot, Gustave. *Degas.* Paris: Librairie Ollendorff, 1924.

Danikan 1974
Danikan, Caron Le Brun. "Degas' Story Told in MFA Exhibition." *Christian Science Monitor,* Jul. 2, 1974, sec. C.

Degas 1973
Degas' Drawings. New York: Dover, 1973.

Delteil 1919
Delteil, Loys. *Le Peintre-graveur illustré* 9. Paris: the author, 1919.

Denis 1931
Denis, M. *Henry Lerolle et ses amis.* Paris, 1931.

Detroit 1922
The Detroit Institute of Arts. "Purchases for the Collection." *Bulletin of The Detroit Institute of Arts* 3, 4 (Jan. 1922): 39.

Detroit 1927
The Detroit Institute of Arts. *The More Important Paintings and Sculptures of the Detroit Institute of the City of Detroit.* 2d ed. 1927.

Detroit 1930
The Detroit Institute of Arts. *Catalogue of Paintings.* 1930.

Detroit 1951
The Detroit Institute of Arts. *The French in America, 1520-1880.* Exh. cat. 1951.

Bibliography

Adhémar 1974
Adhémar, Jean, and Françoise Cachin. *Degas: The Complete Etchings, Lithographs and Monotypes.* Trans. by Jane Brenton. New York: Viking Press, 1974.

Alaux 1933
Alaux, Jean Paul. *Académie de France à Rome.* Paris: Editions Ducharte, 1933.

Albi 1980
Albi, Musée Toulouse-Lautrec. *Trésors impressionistes du musée de Chicago.* Exh. cat. 1980.

Alexandre 1918
Alexandre, Arsène. "Degas; graveur et lithographe." *Les Arts* 171 (1918): 11-19.

Amsterdam 1952
Amsterdam, Stedelijk Museum. *Edgar Degas.* Exh. cat. 1952.

Arms 1951
Arms, John Taylor. "Joseph Tourny, Engraver, by Hilaire Germain Edgar Degas." *Print* 7 (Aug. 1951): 26-8.

***Art News* 1926**
"Double Portrait by Edgar Degas Coming Here." *Art News* 25, 2 (Oct. 16, 1926): 1-2.

Baltimore 1962
Baltimore Museum of Art. *Manet, Degas, Mary Cassatt and Berthe Morisot.* Exh. cat. 1962.

Bazin 1931
Bazin, Germain. "Degas et l'objectif." *L'Amour de l'Art* 12, 7 (Jul. 1931): 303-309.

Bellony-Rewald 1976
Bellony-Rewald, Alice. *The Lost World of the Impressionists.* Boston: New York Graphic Society, 1976.

Bern 1951-52
Bern, Kunstmuseum. *Degas: Paintings, Drawings, Monotypes.* Exh. cat. 1951-52.

Bern 1960
Bern, Kornfeld and Klipstein. *Choix d'une collection privée.* 1960.

Boggs 1956
Boggs, Jean Sutherland. " 'Mme. Musson and Her Two Daughters' by Edgar Degas." *Art Quarterly* 19 (Spring 1956): 60-4.

Boggs 1962
Boggs, Jean Sutherland. *Portraits by Degas.* Berkeley: University of California Press, 1962.

Boime 1971
Boime, Albert. *The Academy and French Painting in the Nineteenth Century.* London: Phaidon, 1971.

Boston 1974
Boston, Museum of Fine Arts. *Edgar Degas: The Reluctant Impressionist.* Exh. cat. 1974.

Boston 1984
Boston, Museum of Fine Arts. *Edgar Degas: The Painter as Printmaker.* Exh. cat. by Clifford S. Ackley, Sue W. Reed, Barbara J. Shapiro. 1984 (at press).

Browse 1949
Browse, Lillian. *Degas's Dancers.* London: Faber and Faber, 1949.

Burkholder 1943
Burkholder, Charles H. "Potter Palmer and Business Administration." *Bulletin of The Art Institute of Chicago* 37 (Nov. 1943): 85.

Burnell 1969
Burnell, Devin. "Degas and His 'Young Spartans Exercising.' " *The Art Institute of Chicago Museum Studies* 4 (1969): 49-65.

Cabanne 1957
Cabanne, Pierre. *Edgar Degas.* Paris: Tisné, 1957.

Cabanne 1958
Cabanne, Pierre. *Edgar Degas.* Trans. by Michel Lee Landra. New York: Universe Books, [1958].

Cachin 1974
See Adhémar 1974.

Cambridge 1929
Cambridge, MA, Harvard University, Fogg Art Museum. *Exhibition of French Painting of the Nineteenth and Twentieth Centuries.* 1929.

Cambridge 1968
Cambridge, MA, Harvard University, Fogg Art Museum. *Degas Monotypes.* Exh. cat. by Eugenia Parry Janis. 1968.

Carandente 1966
Carandente, Giovanni. *Degas: I maestri del colore.* Milan: Fratelli Fabbri Editori, 1966.

Carpentras 1963
Musée de Carpentras. *De Valernes et Degas.* Exh. cat. 1963.

Champigneulle 1952
Champigneulle, Bernard. *Degas dessins.* Paris: Éditions de Deux Mondes, 1952.

Charles 1918
Charles, Etienne. "Les Mots de Degas." *La Renaissance de l'Art Français et des Industries de Luxe* 2 (Apr. 1918): 3-7.

Chicago 1893
Pocket Guide to the World's Columbian Exposition. Chicago: 1893.

Chicago 1910
The Art Institute of Chicago. *Paintings from the Collection of Mrs. Potter Palmer.* Exh. cat. 1910.

Chicago 1920
The Art Institute of Chicago. *Paintings and Drawings by Edgar Degas.* Exh. cat. 1920.

Chicago 1922
The Art Institute of Chicago. *Bulletin of The Art Institute of Chicago* 16, 1 (Jan.-Feb. 1922): 11-12; 16, 3 (May-Jun. 1922): 37-8, 47.

of the young Degas, the artist who exhibited with the Impressionists and scandalized them with his caustic tongue and ready aphorisms. Instead, one finds an artist of an almost unsurpassed authority. One wonders what *The Bathers* might have looked like if Degas had finished it. Would the figures have become even stronger and clearer? Would the head of the central figure have emerged from the rubbed and worked-over area in which it is buried? Would the figure on the left, her body bent double as if to protect herself from our prying eyes, have looked at us with more authority? Would the classical allusions to the *Hermaphrodite* in the Louvre, to the *Crouching Aphrodite* in Naples, or to the *Venus of Vienna* in the Louvre have been asserted with more force? Would the landscape have been more fully formed, more actual?

These questions—and many others—will always pique and fascinate the viewer of *The Bathers*. As we have seen, *Young Spartans* was left incomplete in emulation of another—and greater—unfinished painting, Leonardo's *Adoration of the Shepherds*. It is perhaps no accident that Degas ended his career as he had begun it, by creating ambitious, large, and unfinished works. While Zola's Claude Lantier failed in his vaunting ambitions, Degas did succeed in his. Yet, neither finished his bathers. *The Bathers* might well be the great work, never totally attainable, for which Degas was forever searching. (RB)

COLLECTIONS: Estate of the artist, Vente I, 211, stamp (Lugt 658) recto, lower left, in red; Ambroise Vollard, Paris; Nathan Cummings, Chicago.

EXHIBITIONS: Paris 1936b; Washington, DC 1970, no. 10, repr.; Chicago 1973, no. 8, repr.

LITERATURE: Lemoisne 1946, no. 1079, repr.; Rich 1955: 68-70, repr.; Chicago 1961: 121; Russoli 1970, no. 1003, repr.; Maxon 1970: 268, 280, repr.; Chicago 1971: 28; Chicago 1979, 2G8; Marandel 1979: 38, repr. p. 39.

Pau 1877
Pau, Les Amis des Arts. *Livret du Salon de 1877*. Exh. cat. 1877.

Philadelphia 1936
Philadelphia, Pennsylvania Museum of Art. *Degas*. Exh. cat. Intro. by Agnes Mongan. 1936.

Philadelphia 1950-51
Philadelphia Museum of Art. *Diamond Jubilee Exhibition: Masterpieces of Painting*. 1950-51.

Philadelphia 1952
Philadelphia Museum of Art. *Sculpture of the Twentieth Century*. Exh. cat. 1952.

Pickvance 1963
Pickvance, Ronald. "Degas's Dancers: 1872-6." *Burlington Magazine* 105 (Jun. 1963): 256-66.

Pickvance 1966
Pickvance, Ronald. "Some Aspects of Degas's Nudes." *Apollo* 83 (Jan. 1966): 17-23.

Pittsburgh 1936
Pittsburgh, Carnegie Institute. *A Survey of French Painting*. Exh. cat. 1936.

Pool 1964
Pool, Phoebe. "The History Pictures of Degas and Their Background." *Apollo* 80 (Oct. 1964): 306-11.

Providence 1975
Providence, Rhode Island School of Design Museum of Art. *French Watercolors and Drawings from the Museum's Collection, ca. 1800-1900*. Exh. cat. by Deborah Johnson. 1975.

Raimondi 1958
Raimondi, Riccardo. *Degas e la sua famiglia in Napoli*. Naples: SAV, 1958.

Reff 1963
Reff, Theodore. "Degas's Copies of Older Art." *Burlington Magazine* 105 (Jun. 1963): 241-51.

Reff 1964
Reff, Theodore. "New Light on Degas's Copies." *Burlington Magazine* 106 (Jun. 1964): 250-9.

Reff 1967
Reff, Theodore. "An Exhibition of Drawings by Degas." *Art Quarterly* 30 (Fall-Winter 1967): 252-63.

Reff 1968
Reff, Theodore. "Some Unpublished Letters of Degas." *Art Bulletin* 50 (Mar. 1968): 87-94.

Reff 1970
Reff, Theodore. "Degas' Sculptures, 1880-84." *Art Quarterly* 33 (Autumn 1970): 276-98.

Reff 1971
Reff, Theodore. "The Technical Aspects of Degas's Art." *The Metropolitan Museum of Art Journal* (1971): 141-66.

Reff 1976a
Reff, Theodore. *Degas: The Artist's Mind*. New York: The Metropolitan Museum of Art and Harper and Row, 1976.

Reff 1976b
Reff, Theodore. *The Notebooks of Edgar Degas*. 2 vols. Oxford: Oxford University Press, 1976.

Reff 1981
Reff, Theodore. "Degas and de Valernes in 1872." *Arts Magazine* 56 (Sept. 1981): 126-7.

Rewald 1944
Rewald, John. *Degas: Works in Sculpture*. New York: Pantheon Books, 1944.

Rewald 1957
Rewald, John. *Degas Sculpture, The Complete Works*. New York: Thames and Hudson, 1957.

Rewald 1973
Rewald, John. "Theo Van Gogh, Goupil, and the Impressionists." *Gazette des Beaux-Arts* 81 (Feb. 1973): 65-108.

Rich 1929
Rich, Daniel Catton. "A Family Portrait of Degas." *Bulletin of The Art Institute of Chicago* 23 (Nov. 1929): 125-7.

Rich 1932
Rich, Daniel Catton. "Bequest of Mrs. L. L. Coburn." *Bulletin of The Art Institute of Chicago* 26 (Nov. 1932): 66-71.

Rich 1933
Rich, Daniel Catton. "Französische Impressionisten im Art Institute zu Chicago." *Pantheon* 2 (1933): 76.

Rich 1951
Rich, Daniel Catton. *Degas*. Library of Great Painters. New York: Harry N. Abrams, 1951.

Rich 1954
Rich, Daniel Catton. "A Double Portrait by Degas." *The Art Institute of Chicago Quarterly* 48 (Apr. 1954): 22-4.

Rich 1955
Rich, Daniel Catton. "Bathers by Degas." *Bulletin of The Art Institute of Chicago* 49 (Nov. 15, 1955): 68-70.

Richmond 1978
Richmond, Virginia Museum. *Degas*. Exh. cat. 1978.

Rivière 1935
Rivière, Georges. *M. Degas, bourgeois de Paris*. Paris: Librairie Floury, 1935.

Rouart 1945
Rouart, Denis. *Degas à la recherche de sa technique*. Paris: Librairie Floury, 1945.

Rouart 1948
Rouart, Denis. *Degas: les monotypes*. Paris: Aux Quatre Chemins, 1948.

Rouart/Wildenstein 1975
Rouart, Denis and Daniel Wildenstein. *Edouard Manet: catalogue raisonné*. Lausanne: Bibliothèque des Arts, 1975.

Russoli 1970
See Minervino 1970.

St. Louis 1966-67
St. Louis Art Museum. *Drawings by Degas*. Exh. cat. by Jean Sutherland Boggs. 1966-67.

St. Louis 1967
St. Louis, Washington University, Museum of Art. *Lithographs by Edgar Degas*. Exh. cat. 1967.

Scharf 1968
Scharf, Aaron. *Art and Photography*. London: Penguin. 1968.

Shapiro 1980
Shapiro, Michael Edward. "Degas and the Siamese Twins of the Café-Concert: The Ambassadors and the Alcazar d'Eté." *Gazette des Beaux-Arts* 95 (Apr. 1980): 153-64.

Shapiro 1982
Shapiro, Michael Edward. "Three Late Works by Edgar Degas." *Bulletin of The Museum of Fine Arts, Houston* 8 (1982): 9-22.

Shoolman/Slatkin 1942
Shoolman, Regina and Charles E. Slatkin. *The Enjoyment of Art in America*. Philadelphia: Lippincott, 1942.

Slocombe 1938
Slocombe, George. "Artist and Misanthrope." *Coronet* 3 (Apr. 1938): 19-27.

Springfield 1935
Springfield (MA) Museum of Art. *French Painting, Cézanne to the Present*. Exh. cat. 1935.

Sweet 1966a
Sweet, Frederick A. "Great Chicago Collectors." *Apollo* 84 (Sept. 1966): 190-207.

Sweet 1966b
Sweet, Frederick A. *Miss Mary Cassatt, Impressionist from Pennsylvania*. Norman: University of Oklahoma Press, 1966.

Tietze 1947
Tietze, Hans. *European Master Drawings in the United States*. New York: Augustin, 1947.

Tokyo 1976
Tokyo, Seibu Museum of Art. *Exposition Degas*. 1976.

Toledo 1934
Toledo, (OH) Museum of Art. *French Impressionists and Post-Impressionists*. Exh. cat. 1934.

Veblen 1959
Veblen, Thorstein. *The Theory of the Leisure Class; an Economic Study of Institutions*. New York: New American Library, 1959.

Venice 1926
Venice. *La quindicesima esposizione d'arte a Venezia—1926*. Bergamo: Istituto Italiano d'Arti Grafiche, 1926.

Vente d'estampes
Paris, Galerie Manzi-Joyant. *Catalogue des eaux fortes, vernis-mous, aquatintes, lithographies, et monotypes par Edgar Degas et provenant de son atelier*. Nov. 22-23, 1918.

Ventes I–IV
Paris, Galerie Georges Petit. *Catalogue des tableaux, pastels et dessins par Edgar Degas et provenant de son atelier*. Vente I: May 6-8, 1918. Vente II: Dec. 11-13, 1918. Vente III: Apr. 7-9, 1919. Vente IV: Jul. 2-4, 1919.

Vollard 1924
Vollard, Ambroise. *Degas*. Paris: G. Cres, 1924.

Walker 1933
Walker, John. "Degas et les maîtres anciens." *Gazette des Beaux-Arts* 10 (Oct. 1933): 173-85.

Washington, DC, 1947
Washington, DC, The Phillips Collection. *Loan Exhibition of Drawings and Pastels by Edgar Degas*. Exh. cat. 1947.

Washington, DC, 1970
Washington, DC, National Gallery of Art. *Selections from the Nathan Cummings Collection*. Exh. cat. 1970.

Washington, DC, 1974
Washington, DC, National Gallery of Art. *Recent Acquisitions and Promised Gifts: Sculpture, Drawings, Prints*. Exh. cat. 1974.

Wells 1972
Wells, William. "Who was Degas's Lydia?" *Apollo* 95 (Feb. 1972): 129-34.

Werner 1968
Werner, Alfred. *Degas Pastels*. New York: Watson-Guptill, 1968.

Worcester 1941
Worcester (MA) Museum of Art. *The Art of the Third Republic*. Exh. cat. 1941.

Zola 1962
Zola, Emile. *L'Assomoir*. Trans. by Atwood H. Townsend. New York: New American Library, 1962.

Zorach 1925
Zorach, William. "The Sculpture of Edgar Degas." *The Arts* 8 (Nov. 1925): 263-5.

Index of Illustrations